# "Event" Arts
# and Art Events

# Studies in the Fine Arts: The Avant-Garde, No. 57

Stephen C. Foster, Series Editor
Professor of Art History
University of Iowa

## Other Titles in This Series

# "Event" Arts
# and Art Events

Edited by
Stephen C. Foster

UMI Research Press
Ann Arbor / London

Produced and distributed by
UMI Research Press
an imprint of
University Microfilms Inc.
Ann Arbor, Michigan 48106

Library of Congress Cataloging in Publication Data

"Event" arts and art events.

(Studies in the fine arts. Avant-garde ; no. 57)
Includes bibliographies and index.
1. Avant-garde (Aesthetics)—History—20th century.
2. Arts, Modern—20th century. 3. Events (Philosophy)
I. Foster, Stephen C. II. Series.
NX456.E74    1988      700'.9'04      87-19049
ISBN 0-8357-1814-X (alk. paper)

British CIP Data is available

# Contents

# Figures

# Foreword

It is a commonplace practice, especially on a common parlance basis, to perceive "events" as the means or mechanisms of "how things happen," or of "how historical change occurs." Emerging from both the popular and professional literature, this *historiographic* concept has deeply permeated Western consciousness. That it is as present today as it was, at the point of its conceptual formulation, two hundred years ago, is not hard to understand in view of the extreme historical self-consciousness of our own period and of the recent past.

The following essays seek to explain certain early twentieth-century artists' understanding of "the event" as a means by which historical change occurs, and their transposition of such a concept into purposeful "artistic events" which reflect both their creation of aesthetic strategy and their identification and aesthetic use of what was believed to be one significant dimension of cultural dynamics. Oftentimes described as "transactional" (a word that has been applied to a broad range of both past and present artistic activities), most of these event-based arts involved performing actions on the cultural environment with the purpose of its aesthetic exploration, conceptualization, or modification. Most were participatory in some important sense. Although the subjects of the following essays may have used "objects" for purposes of realizing their intentions, the "works" were, in their essential aspects, not directed towards the creation of the more familiar "art object." More a question of strategy, the event was viewed as a potentially effective means of providing transition points between the past, present, and future. They typically avoided expression and presentation in favor of enactment and engagement. In this context, the present volume proposes to investigate the subtle distinctions between concepts of events as performance, actions, manifestation, theatre, and the cabaret; as "objects" of documentary and reconstructive processes; and as a basis for the conceptualization of art, and the crisis of art, in general. Events are examined for what they represent as aesthetic structures and what they reveal about avant-garde programs and actions. Taken together, the essays will trace their individual developments through a varied cross-section of movements, discuss their overall importance for the direction of art work in a particular period, and indicate their recurrence as a major historical and theoretical aspect of the twentieth-century

avant-garde. Because of the interdisciplinary nature of the topic, scholars from a wide variety of disciplines have been enlisted as contributors.

Although the event (it will be repeatedly noted) was a phenomenon rarely overlooked by the avant-garde artist, it has, alas, been largely ignored by these same artists' historians. This is due, in no small part to the persistent assumption that if "works" of art are not dependent upon "idealistic" aesthetics for their primary justification, they are not worth examining. Nothing could be further from the truth. Scrutiny of the "event" discloses both a sense of aesthetic purpose and crisis rarely surpassed in twentieth-century art. Faced with historical imperatives of the first order, the avant-garde confronted questions concerning both the social function of art and its capabilities for addressing contemporary issues. The importance of this intention ultimately rests (both specifically in this era and in general) in its attempted transposition of the problematics of culture into living aesthetic statements. This book seeks to illustrate that certain activities of the avant-garde, (specifically event-based activities) can be best understood as artistic examinations, uses, and critiques of what the avant-garde perceived to be essential operational and functional bases of culture. The development of the "event" was undertaken by conceptually sophisticated and highly motivated groups of artists and poets committed to living *through* the early twentieth century.

As preparation for the present volume, The Fine Arts Dada Archive conceived, coordinated, and executed "The Arts and the Event," the Third Annual University of Iowa Humanities Symposium in October 1985 (Stephen C. Foster, Project Director and Estera Milman, Project Coordinator). Its scholarly purposes were severalfold: to establish a working research design for the historical problem of the event, to determine its relevance to other fields, and to establish a wide context within which work on the event could best and most profitably proceed. Since the symposium was organized to promote a significant dialogue across disciplines, participating scholars were invited from a broad cross-section of fields including History, German Studies, Urban Design, Modern Languages, History of Art, and others. It was the shared consensus of all those involved in the symposium that— to the extent that man makes history, and to the extent that the event is perceived to constitute the means of introducing movement into history—the event is a crucial area of study with extremely wide ramifications across fields. This book reflects the success of that dialogue, the energy it created, and the growth of our original intentions during the intervening two years.

*"Event" Arts and Art Events* seeks to analyze and evaluate the event, understood generally, in terms of its manifestations in art, and especially in the context of various avant-garde centers of activity. Attention is paid equally to group and individual events and to the relationships between them. While this, in part, involves reconstructing the events (a difficult task at best), it also requires an historical examination of the concept itself, how and why the concept was perceived as valuable for avant-garde artists' intentions, how their events were structured and executed, the nature of the artists' expectations of their audiences, and the character and extent

of the events' impact. Although evidence for the importance of the event is surprisingly plentiful, it has been neither systematically nor sustainedly studied. It is hoped that this book will constitute a basis for further work on the questions it raises.

Although a complete list of those who assisted in the preparation of the book would be impractically long, the editor does wish to acknowledge the crucial role of Estera Milman's contributions to the realization of the book and the conference that preceded it. Thanks are also due to Professor Wallace J. Tomasini (Director, School of Art and Art History, University of Iowa) for his unfailing support of the Fine Arts Dada Archive from which the project was launched, to Rebecca Miller and Laurilla Sundt, graduate assistants to the project, and to the University of Iowa Humanities Task Force, the University's Museum of Art, and the Iowa Humanities Board for supporting the initial symposium which facilitated the development of this book.

# Part One

# Theoretical Considerations

Part Title Page Illustration:   *Dada-Trott: dadaistische Holzpuppentanz,* performed by
                                 Musikdada Preiss
                                 Published in *Der Dada,* No. 3 (April 1920). Edited by Raoul
                                 Hausmann, John Heartfield, and George Grosz (Berlin: Der
                                 Malik-Verlag).

# 1

# Event Structures and Art Situations

*Stephen C. Foster*

*Every philosophy of history which recognizes that men can and do make their own history also concerns itself with the conditions under which it is made. It assesses in a broad and general way the relative weight, for a certain period, of the conditions under which men act and of their ideals, plans, and purposes. These ideals, plans, and purposes are causally rooted in the complex of conditions, but they take their meaning from some proposed reworking of conditions to bring them closer to human desire.*

Sidney Hook, *The Hero in History*

In the course of confronting and criticizing its value structures or social systems, culture has frequently attempted to reiterate its spiritual basis, rehearse its future or, by intervention, alter its historical trajectory, *through events.* To the degree that art has applied itself to these self-reflective areas of culture, the artist has, in one way or another, entered into dialogue with what he or she has perceived as the wider historical processes for realizing such purposes. Based on its widely assumed, and pivotal role in history (as well as in historical theory and criticism), the event was adopted as a theoretical reference point, or medium of artistic action, and became a major component of twentieth-century aesthetic activism.

From the beginning, the event played a crucial role in modernism's definition and presentation of itself. Indeed, the event can be seen as one of the period's pivotal means of confronting its audience in both the small (attending) and the large (social and cultural) senses. The event served the artists as an instrument for achieving, in reality or by illusion, a positioning of themselves and their audiences in a hostile and self-destructive world and as a potential instrument of change. As a phenomenon, it was frequently perceived—especially from the point of view of its audience—as simultaneously provocative, shocking, and dangerous; promising,

liberating, and exhilarating. Its rationale, in any case, was informed by an intense seriousness and deep conviction. The "artistic event" made a live, active response to live "social events," and served as an alternative to the presentation of ideas through a conventional art and literature that had clearly been rendered impotent by the abuses of a dysfunctional and failing society.

In an art-historical context, the importance of the event can be measured by the extent to which it provided the very rationale for the avant-garde. "Art, the expression of society, manifests, in its highest soarings, the most advanced social tendencies: it is the forerunner and the revealer. Therefore, to know whether art worthily fulfills its proper mission as initiator, whether the artist is truly of the avant-garde, one must know where Humanity is going, know what the destiny of the human race is" (Laverdant).[1] In regular use since the 1830s, the term "avant-garde" was originally coined to define the futuristic thrust of revolutionary political activity in the mid-nineteenth century. From slightly before the turn of the present century, it has been applied as well to progressive or revolutionary activities identified specifically with the fine arts. The term has shown remarkable staying power and, to a surprising degree, has maintained its original message.

The early avant-garde formulated an aggressive revisionism in attempting to charter what they thought would be the new society emerging from the mid-nineteenth century revolutions. Even in 1825, the French Utopian Socialist, Saint-Simon, described the new destiny of the arts as the spearhead of social progressivism and, in his essay entitled "Literary, Philosophical, and Industrial Opinions," projected a ruling committee composed of philosophers, artists, statesmen, scientists, and others. In an imaginary dialogue between parties, he asserted, "What a magnificent destiny for the arts is that of exercising a positive power over society, a true priestly function, and of marching forcefully in the van of all the intellectual faculties."[2]

Although the avant-garde was composed of people representing a variety of activities, its basic posture was political. This early identification of art with politics, the politicizing of art, remains a basic fact of the avant-garde to the present day. Throughout the nineteenth century, the concept and spirit of the avant-garde myth were kept very much alive but were increasingly applied to the particular kinds of progressivism and revisionism offerable by specific activities within the fine arts; a revisionism aesthetically formulated through the events of social movement rather than in the enjoinment of the purely political praxis. The pointed political thrust of the early twentieth-century avant-gardes was to be found in its ambition to change consciousness, and it is in this context that the avant-gardist, as event-maker and historical configurer, must be understood.

With the avant-garde, we are faced with a situation that attempts to meet the social imperatives of a period, one which tries to establish itself as an advanced position in the social world. Normally this requires, as a precondition, some mythical or ideological basis for formulating a long-range social destiny. If the artist is to

speak to this social destiny through his art, there must be beliefs available which are capable of converting the artist's ideas into formal stratagems; historical *modus operandi* of sorts. In context of this collection of essays, the event is understood as precisely such a belief.

As a live structure, perceived in relationship to larger aspects of culture, the event promised to escape the limitations imposed by the conventions of the arts as commonly understood, be they the theater, literature, the fine arts, dance, music, architecture, or whatever. The event, it was hoped, would work more effectively as an instrument of aesthetic positioning within culture, and ultimately help account for social change. It would reconstruct or reorganize social experience, critique that experience, and facilitate new experience. The psychic distance so characteristic of traditional art attitudes was drastically diminished. The easy discounting typically applied by culture to the arts was made more difficult. In the event's convergence with operational aspects of culture at large, its capabilities, as cultural or social strategies, were immeasurably sharpened. The event-based arts, in largely abandoning historically sanctioned aesthetics, indicated a fundamental change from artistic or significant form to aesthetic strategies of transaction. It is this aspect of the event that frequently provided, and continues to provide, a meeting point, substructure, or congruency between all the arts, and provides the medium or critical instrument of art's role in shaping human affairs.

Since significant sectors of the avant-garde viewed "style," various conventional art support structures, theory, ideology, and other aspects of normal art production as passive and inactive reflections of the very society they were impugning, they sought an avenue of communication which neither conceded ground to the establishment nor jeopardized their own relevance and effectiveness as social critics. Once unburdened of idealistic aesthetics, the arts moved much closer to other (nonaesthetic) dimensions of life; indeed, in cases became almost indistinguishable from them . . . and for good reason: the structure of art's intentions began to coincide with the structure of events in the everyday and historical worlds. The use of the event as a "given" in social and aesthetic communication gave to art a working access to real or functional aspects of culture which it had heretofore only been able to *re*present. This is not merely the erasing of distinctions between art and life, but the use of the everyday and historical structure of the event, real or imagined, as a vehicle of artistic and/or critical purpose. The arts began to present their content through the structure of outside, nonart events rather than to *re*present the world's events through traditional art genres.

These outside events—for example, influential social events—have long provided individual artists and groups with a concept of "movement" indicating a "connected and long continued series of acts and *events* tending towards some more or less definite end"; "an agitation in favor of some principle or policy."[3] They provide at once both their sense of principle (or social mission) and the means or weapons for effecting change from one place to another. The event became the basis of renewal and redefinition of purpose. The "revolution," as one such event,

historically provided the avant-garde with a major paradigm (fantasy?) for sharpening art's focus and rejuvenating art's purpose.

Forsaking the normal practice of the arts, then, the avant-garde created new means for "holding up a mirror" to society, a means that could, either in fact or fiction, effectively alter consciousness and dissolve destructive, meaningless cultural norms. Art and literature, as they are conventionally understood, continued to interest the individuals and, in most cases, their art production continued more or less unabated throughout the period. Yet, it is not that part of their activity that indicates the center of their radicalism. Some artists were aware that just as "old" art could too easily be appropriated by society, "new" art was the art of a settled future. What was needed were means of dealing with the present; and it was to the event that they turned in their attempt to formulate the basis for raising social consciousness to a place required of the transition *between* old and new worlds.

Thus, events cannot be regarded merely as pivotal twentieth-century contexts for art objects; nor are they to be viewed as mere reflections of a culture or as comments on, or alternatives to, that culture. Rather, they are unique and profoundly innovative uses of "live" structures as instruments for examining and analyzing the very facts and concepts of culture. For these early-twentieth-century artists, aspects of cultures, per se, became the content and means of achieving their work.

Although in the world of everyday affairs an "event" may be, quite simply, what it is that happens, within the context of a social crisis, it becomes something much more, something that carries with it both the preconditions for its happening and the potential for some further developments. The "event," thus perceived, becomes a pivot point or watershed in a related series of incidents or occurrences that are seen to be casually related. Thus it is that distinctions are made between "everyday" events, newsworthy events, and great events. It is not so much a matter of the relative or absolute importance of the events as it is the role they are seen to assume in the particular context from which they are perceived. The more strongly the context is established as historical, the more the event is perceived as the means, or mode, through which historical movement is triggered. Such modes, to the degree that they are established causally, are identified and isolated as "configurations" more than they are as things that happened. In this light, it is no accident that the concept of staging events grew up with the concept of history, understood as a discipline and as a field of study. The event became part of the mechanics of that history and an important basis of its explanatory power. As Sidney Hook noted so many years ago, there are events and event-makers. Put somewhat less romantically, "establishing cause" can be either the task of the historian or the historical agent (according to some philosophers of history, virtually the same thing). In the latter case, the event was quickly recognized for its potential as a strategy or model by those interested in changing society or moving history from one place to another.

Thus, events are intimately linked to our concepts of historical causation. They are at once the fruits of prerequisite circumstances and the harbingers of something new. Events imply occurrences worthy of a cause-and-effect explanation. They require a purposeful action or an intentionality (in the acting or in the perceiving of an action) that matters *as a point from which one explains* and that has the capability of identifying what *appear* to be consciously worked out causal chains between reasons and actions. For our purposes, events might, in fact, be defined as the form taken between programs and actions.

That the historical concept of the event coincides with the intentions of the avant-garde is no accident. This concept of the event (''revolution'' presents itself as the most obvious example) is fundamental to the avant-garde's concept of itself and to its concept of the facilitation of change. Here, events are postulates or propositions *about* relationships between the past, present, and future. Yet, notwithstanding what they are *about,* they are conceptually never more nor less than acts in the present. That is, events may be described as the *content* (what they are about) of acts (past, present, future) which are formulated in the present. Looked at in this way, events are rationales or justifications of acts perceived in the context and through the intentionality of historical movement.

This point of view rejects a naive, everyman's concept of the event (something that happened) no less than it does the naive, everyman's concept of history (the totality of things that happened). Events are no less made than history and, as such, become configurations of pivotal *historical realities.* They are no less important for being *historical* realities. It is from our invention of historical realities that we perceive something as an event.

The purposeful alteration of culture has rarely occurred without a *concept* of how that change would be configured, without some notion of the shape of change. Cultural patterns and processes are nothing if they are not perceived as such. The event, as part of the *chain* of events, is *recognized* as a pattern and *employed* as a process. This is the case whether perceived internally (by the ''agent''), or externally (by the observer) or in hindsight (by the historian). The revolutionary's intention would be worthless were it not recognizable as part of such a pattern by those willing (or unwilling) to follow or support him. This causality, as perceived by all parties, is not unlike that of the historian for whom the event must be compelling in its relationships to other events or to the occurrences which give it context. The event represents nothing less than the shape or configuration of change.

While the success of the artists' employment of events may be arguable, what is clear is that its possibilities rested, as do (did) all vocabularies for art, in situations prerequisite for their sympathetic reception. That is, the use of the event operated best out of contexts in which they not only could be created but *understood*; where the initiation of events was *imaginably* possible or where the conditions for its operations were favorable. What is at issue here, then, is not so much the reconstruction of events as it is the analysis of the structure of events (as historically

perceived or as a means by which history may be made, written, enacted, or critiqued). The *reconstruction* of events is of most interest to those who are about to construct them; that is, those who are interested in the pragmatic examination of the concept "event," the hows and whys of its value in terms of its structure and execution, the nature of an audience's expectations, and the character and extent of the event's potential impact.

Two of these constructors of events, Raoul Hausmann and Johannes Baader, serve as cases in point. My purpose here is not to reconstruct the events referred to below so much as it is to reconstruct the artists' intentions in *their* constructions and reconstructions of the event.

In 1919, Hausmann and Baader jointly planned a revolution by which they were to establish a Dada Republic in the Berlin suburb of Nikolasse. Although projected as bloodless—"an affair of the typewriter"—its motivation was clearly based on the fact that, according to Hausmann, "there were riots and revolutions on all sides, most of them bloodily stifled."[4]

The purpose of these artists was clearly to offer what Hausmann himself characterized as "an ironic commentary on serious political events."[5] But, in fact, the issue is really more complicated than that. Adopting the language of political events, it signifies both the humor of parody and the pathos of hopeless conviction. The German Revolution accomplished nothing (from their point of view) nor, ultimately, did any of the others. Yet the concept of revolution was crucial to their criticism of Weimar's reactionary and ill-fated coalitions. The implications of their actions point (1) to the opposite of those typically intended by revolutionaries, and (2) to the idealistic aspirations of the concept of revolution itself. Hausmann ironically remarks that the revolution failed because its plan was discovered beforehand. The upshot of all this was the Dadaists' foundation of the Bureau for Separatist States, an organization no doubt dedicated, if only in spirit, to yet more events.

The event was both a means of precipitating crisis and dissolving it. In the first case, the event facilitated awareness to the point that one could perceive crisis where it was imagined that none existed. In the second case, the event became the means of configuring meaningful movement from one historical place to another. The Dadaists were profoundly involved in both these activities.

In the course of 1918, the year that Dada really got under way in Berlin, a major mutiny erupted in the imperial fleet at Kiel; working councils were formed (similar to those of the Russians), and Kaiser Wilhelm II abdicated. In December of 1918, the Germans, in a state of hopeless economic and moral chaos, experienced a full-scale social revolution. It was an "eventful" period!

It is little wonder that Berlin Dadaists advocated a stance of political and social involvement. Little concerned with art, the purpose of the Berliners was to take a position—one which often reflected the farcical, ridiculous, and impossible nature of their situation. The "artistic" activity resulting from this attitude both intended to create a biting social criticism and the basis, in art action, for change. Johannes

Baader offered the most consummate formulation of the Dada event and was conceded to have done so by even the most event-oriented of his Dada contemporaries. In the context of the present paper, Baader's importance involves his almost single-minded pursuit of the event as the most important center of gravity in Dada's definition of its purpose and in the execution of its program.[6]

On July 16, 1919, Baader won a degree of fame for distributing his pamphlet, "The Green Corpse," to the National Assembly in Weimar. The Assembly, the founding celebration of the first German Republic, was conducted at the Weimar Hoftheater and provided a perfect forum for an extravagant Baader event. Quiet for the initial parts of the ceremony, Baader suddenly let forth with a speech pertaining to The Stations of the Cross to Weimar, revealed to him alone, and whose meaning he was now prepared to share. Although immediately arrested, Baader managed to hurl the pamphlets into the press boxes. Following a careful examination by the police, Baader was exonerated both on grounds of his legal certification as insane, and on evidence of his correspondence with various statesmen involved. The incident was widely reported. The value of mentioning this action is, for present purposes, severalfold. The government itself pursued the assembly as though it were an historically perceived event, yet an event as understood and presented through the theater and the theater's perception of the event. That it occurred in a theater is crucial and indicates the state's willingness to consult the arts for persuasive, live *modus operandi*. The government understood well that it should promote an affair that would be perceived *by the public* as an historical event of the kind through which change and history are made. The proceedings were distanced comfortably as events, occurring as they did in Weimar, venerable seat of German culture, rather than in the uneasy political atmosphere of Berlin. Baader well understood the government's strategy and quickly turned it to his own advantage, not the least by asserting his own superior (nontheatrical) reality. It was by such actions that Baader exerted his mock jurisdiction over the Weimar authorities and ultimately laid claim to being President of the World. And there was more—for example, Baader's attempts to run for public office, his nomination of himself for the Nobel Prize, the events of the Jesus Christ Club and last, but by no means least, his death and resurrection on April 1 and April 2, 1919. And yet, although Baader forged a near-perfect marriage between the arts and the event, he is but one event-maker we can cite from the Dada period.

In attempting to affect consciousness, the event and the event-maker became crucial to those arts identified with social purpose and provided an important strand of historical continuity between the arts of such a persuasion. An exploration of the variety of responses by the early-twentieth-century arts to the event, where the latter was perceived as an instrument, or live framing device, for criticizing, clarifying, altering, or projecting the unfolding of human affairs, is essential to any understanding of the intentionality of the avant-garde.

## Notes

1.  Linda Nochlin, "The Invention of the Avant-Garde: France, 1830–1880," in *Avant-Garde Art,* ed. Thomas Hess and John Ashbury (New York: Collier, 1968), p. 6.

2.  Ibid., p. 5.

3.  See "movement" in *Webster's International Dictionary,* Second Edition (Northampton, Mass.: G & C Merriam Co., 1934), p. 1604.

4.  Raoul Hausmann, *Am Anfang war Dada,* ed. Karl Riha and Gunter Kampf (Giessen: Anabas-Verlag, 1980), pp. 58–60.

5.  Ibid.

6.  For discussions of Baader, see the following publications by Stephen C. Foster: "Johannes Baader: Kunst und Kulturkritik," *Dada: Sinn aus Unsinn,* ed. W. Paulsen (Bern/Munich: Franke Verlag, 1980), pp. 153–76; "Mediale Wahrnehmung und städtische Realität: Die Kunst des Johannes Baader," *Die Zunkunft der Metropolen* (Berlin: Dietrich Reimer Verlag, 1984), pp. 528–31; "Johannes Baader: The Complete Dada," *Dada/Dimensions,* ed. Stephen C. Foster (Ann Arbor: UMI Research Press, 1985), pp. 249–71; "hausmann-baader: Der eigentliche Dada," *Kurt Schwitters Almanach,* ed. Michael Erlhoff (Hanover: Postskriptum Verlag, 1986), pp. 163–89. See also, *Johannes Baader, Oberdada,* ed. Karl Riha, Hannah Bergius, and Norbert Miller (Lahn-Giessen: Anabas-Verlag, 1977).

# Crisis as Event: The Avant-Garde, Revolution, and Catastrophe as Metaphors

*Rainer Rumold*

Political and historical episodes, alongside emerging innovative "avant-garde" art forms, constitute a context. Any singular interpretation of the significance of a context, however, is a definition and thus potentially more a limitation and a fixation than an elucidation of the dynamic interchange between a context's components. The artistic and political manifestos of the German Expressionist or Italian Futurist movements, for example, and even such "pure" theories of art like those of the *"Sturm"-Kreis*, are public and, therefore, highly ideologically coded kinds of interpretation. New art forms and their theories cannot be understood as the expression of such exclusionary political or artistic approaches, be they tagged "revolutionary," "reactionary," or otherwise. Rather, they must be subjected to scrutiny which addresses a "living," that is to say open-ended, sequence of events. Thus, the historically probing question "What did the text say?" should always be complemented by a reflection of one's own horizon of understanding: "What does the text say to me?" and "What do I say to it?" Ideally, we should engage in "literary communication with the past to measure and broaden the horizon of one's own experience vis-à-vis the experience of the other."[1]

The progressively self-reflective disillusionment about their political efficaciousness evidenced by avant-garde movements from the expressionist decade to the present, provides us with a lesson about their own learning experience and identifies the symptoms of an underlying and pervasive crisis in the Western ideal of progress. In an evolutionary sense, this progressive disillusionment must be taken into account alongside the avant-garde's original, subversive, revolutionary claims—now commonly recognized as utopian projections onto the historical process and as ideological reactions. In other words, the yearning for a human state so ideal that it exists nowhere (utopia), reveals itself as the flip side of a persistent

human condition of misery (dystopia). However, rather than arguing that this continued utopian/dystopian crisis signals a decline or "doomsday" of the avant-garde, I prefer to see its historical trajectory as that of a heightened power of critical reflection.

Let us, for example, closely examine one of the commonplaces and truisms concerning the relationship of art and politics within the expressionist decade, namely, that the political radicalization of the expressionist revolt occurred in response to the developments of World War I which culminated in defeat and revolution. This seems obvious in the case of writers who were both taking an explicit antiwar stand and, in unequivocal political manifestos, also calling for fundamental social changes. However, an analysis of the subject matter of "revolt" and "revolution" (for example, in representative expressionist drama) will invariably disappoint superficial expectations. Hasenclever's *Der Sohn* (The Son), 1914, had, according to its author, "the goal to change the world," and it was celebrated as *the* revolutionary play by an enthusiastic antiauthoritarian generation. Yet, the play falls short of advocating a concretely political revolution as the rebellious son fails to pull the trigger. The representative of the old order is instead made to fall by a heart attack. Ernst Toller's drama *Die Wandlung* (Transformation), written towards the end of the war, still could not clearly decide between political revolution and cosmic visions. The same unresolved tensions continue to dominate postwar expressionist drama: it becomes thematic in Georg Kaiser's *Gas* trilogy (1917–20), or in Toller's *Masse Mensch. Ein Stück aus der Revolutionsgeschichte des 20. Jahrhunderts* (October 1919). These plays all seem to end up essentially in the fashion of Franz Kafka's dramatic novella, "The Judgment": the sons struggle briefly, only to succumb ultimately to the powers of the fathers, the powers-that-be. Many expressionist activist dramas—*nolens volens*—point to the indestructibility of the most powerful institutions of the state: industry and the army; that is to say, money. Measured against the institution of money, the concrete metaphor of the social essence of society, the seductively idyllic anarchist topoi of regeneration and rebirth of the "New Man" in an ideal *Gemeinschaft* (community) are, *au fond*, the expression of a more or less conceded auctorial irony. By contrast, the original and authentic Stürmer und Dränger ("storm and stress" generation) of the 1770s had a cause that was both "just" and real. Their cause was real in so far as the bourgeoisie had begun to take total control of the "institution of art," the public media of the time, the burgeoning industry of printing, the publication of books and journals, and the theater and concert halls. Although the *Stürmer und Dränger* generation did not attain the concrete goal of political power, they had, at least, identified the ideological power of the bourgeoisie.

The twentieth-century expressionist plays, however, conceived as concrete reactions to the events of war and revolution in Russia and in Germany, *the* events of their time, are, in essence, as dystopian as they are utopian. These expressionist reversals can, of course, be explained as reactions to the failure of the revolution in Germany, and the revolution's incipient perversion in Russia, but they had been

essentially latent from the very beginning. Unlike Georg Lukacs, however, I do not discard Expressionism as a "counter-revolutionary" expression of *Scheinrevolution* (fake revolution).[2] I see in Expressionism, beyond its formal innovations, nothing concretely revolutionary at all. I would rather side with Ernst Bloch, Lukacs' central opponent in the Expressionism debate of 1937–38 (Moscow), who points to the "anticipatory" social function of the utopian in Expressionism, and who projects the utopian as a concrete element of history itself (perhaps a belief most easily available to someone who has been a participant in the expressionist era). The significance of the Janus-headed, messianic *"O Mensch-Expressionismus,"* decades after World War II, which are still determined by the War's consequences, will give only limited credence to the "principle of hope." At best, its significance may be an integral part of dystopia or a symptom of a protracted crisis, a crisis that will never be discharged by way of a decisive turn of events. In that sense, the concrete "avant-garde" literary event must be seen in the utopian/dystopian reversal. There lies its actual complex of meaning, unless we still believe in the subversive function of art which makes visible the contradictions from which the Marxists expect salvation.[3]

But what about quintessentially expressionist formal experimentation and iconoclasm, Expressionism as artistic "revolution"? Truly modernist Expressionism, in the course of World War I, clearly intensified its debunking of conventional art forms. Taking its origins in *fin de siècle* attacks on Realism, this debunking ultimately turned against the "expressionist movement" as well, no matter how "revolutionary" by intention its largely conventional rhetorical gestures had been. Thus, a great deal of the literary wartime production of writers like Carl Sternheim, Carl Einstein, Gottfried Benn, and the Dadaists reads today like an inner-literary feud with fashionable—*"O Mensch"*-Expressionism.[4] Were they not saying, however, in radical departure from all traditional humanistic perception, that the illusion of the autonomous, rationally and ethically responsible individual, the mentality of activist pacifism, and the mentality of a "glorious" war for the "honor of the nation" were, deep down, of the same origin? The implication of such a view is that the individual's supposed autonomy is merely a metaphor for man's drive to subjugate nature and his fellow man for materialist purposes, a guise for the fact that "reason" and "morality" have been perverted to instrumental categories. In short, for these modernist Expressionists, mainstream Expressionism was revolutionary neither in a political nor in an artistic sense.

The universalist gist of such antimaterialist, antirationalist/realist, antirhetorical argument, applied to the wider cultural context of modernity, had already been delivered by Wassily Kandinsky in his treatise *Concerning the Spiritual in Art* (1911). But it was still to find its specifically anticapitalist formulation in Carl Einstein's *Negerplastik,* which was "the book of the year 1915" according to Wilhelm Hausenstein. Here, in essence, the subject-object dualism of the mimetic conventions of the Western world view are rejected as the correlate of the exploitive nature of capitalist materialism. From this predicament, only the destruction of the object

can liberate the creativity of the subject, since the object in capitalist culture (according to the Simmelian argument) is and has always been a market commodity. Hence Einstein elevates African "primitive" art to the status of an archetype and model for the European "cubist" experiment, which he understands to be moving towards a truly *collective* creative cultural experience. What seems to have been a fundamentally aesthetic issue, has, in the first year of the war, received an essentially political valorization. But, did the attack on perspective in the visual arts, on metaphor in experimental modernist expressionism, and on the notion of style as masks of alienated subjectivity actually ever generate new social forms? Was the construction of a new language in literature and the arts ever more than just a revolution of the means of representation? Did it ever become a new organizational principle of reality?[5] In other words, in the terms of our contemporary theoretical discourse, did the assault on the coercive power of the patriarchal grammar of language and thought, in the course of the war or any time thereafter, ever result in a collectivist utilization of "primitive" forms? Did the modernist revolt ever provide a pragmatic strategy for the translation of aesthetic revolutionism into social life forms? Did the Russian Futurists, writers and painters, achieve this in the communities of the Soviet councils, or the German Expressionists in the anarchist circles inspired by Gustav Landauer? Rather than searching empirically for answers, let us further specify—by means of an even wider historical contextualization—the paradigmatic case of Carl Einstein, whose relevance for literary history and theory, as well as for the history and theory of art, recently has been rediscovered.[6] His complex path reflects the entwinement, if not sheer entanglement, of political event and the arts. From 1915 onward, his belief in the politically revolutionary significance of "absolute art" proliferates. An advocate of the Russian Revolution, Einstein enthusiastically endorsed the Russian Futurists in one of his most radical theoretical essays which addresses the liberation of the human imagination from the tyranny of the object.[7] Later, in the Spanish Civil War, Einstein participated on the side of Buenaventura Durruti's anarchists. He delivered the obituary for the fallen leader who—as he believed—had eradicated from grammar the word "I" for the sake of a new "collective syntax" and who had translated revolutionary thought into the "immediacy of action." The obituary is, implicitly, a death-sentence of "art." Its criticism is aimed explicitly at the subjectivity of the "literati." The significance of the anarchist argument can be truly understood only as part of a process of events: from Hitler's seizure of power in 1933, to the bloody suffocation of the revolution in Spain, to what for many more intellectuals was to mean the deathblow to their revolutionary communist ideals: the Hitler-Stalin pact of 1939. The unholy alliance is perceived as the epitome of rhetorical mendacity and power-play in the interest of the status quo—the real "locomotive of history" is at a standstill. Einstein's terse apotheosis of anarchist action as an absolute *sui generis* had been prepared by an earlier, almost neurotically verbose theoretical-political assault on all modernist culture, i.e., the lengthy invective of *Die Fabrikation der Fiktionen,* originally subtitled as "a defense of the

real." In a total reversal of his former pro-Cubist and pro-Futurist position, all art here is viewed as being nothing but a fiction, at the core of which lies not the unmasking of the bourgeoisie, but its cultural and thus political legitimization. In short, to restate the argument in more recent theoretical terms, Einstein now says that the artistic "revolution" merely fostered innovation of the inner-literary relations, or the medium of the visual arts.[8] It merely dynamized the bourgeois "institution of art," the voracity of which had been stimulated and heightened by the new. Could it be that this is the process that unveils itself as concretely "avant-garde," not the myth of the traditional, radically reconstituted by veracity? Is the "avant-garde" then the capitalist process itself[9] which, like changes in fashion, capitalizes on the changing movements of the "consciousness industry" (Enzensberger)? Such a materialist analysis, of course, flies in the face of all for which the "mythical method" of idealist modernism stood. Even its most nihilistic strand was propelled by a belief in its ability to express "life" in its existential truths. Indeed, if we were to carry the sociological argument to its extreme, we would be forced to subscribe to the frivolously gay, popularized vulgar "postmodern" pronouncement for the arts that "anything goes." At any rate, the question arises: What is, in fact, the central event of modernity, if its culture cannot be revolutionary?

On the other hand, the paradigm reveals that the "artistic revolution" cannot be extricated from the specifically political altogether. We cannot, to give another example, maintain that pre-World War I poetry merely reacted against the literary tradition, the literary "establishment", or that it merely rebelled on an "inner-literary'" level. One cannot say, in socio-cultural terms, that it merely responded to a general *Zeitgeist* or to something ominous "in the air." For example, Georg Heym's apocalyptic poem *Der Krieg* (September 1911) frequently has been cited by traditional German scholarship (with vested interests in the "autonomy" of art) as "visionary prophecy." As such, it was a case in point for an idealist view of the affinity between art and politics. It has finally been traced, in a competent scholarly case study,[10] through its imagery and corresponding diary entries, as a concrete reaction to and expression of the feeling of crisis in the wake of the notorious "Panther leap" to Agadir (September 1911)—the so-called second Morocco crisis. The military incident signaled that the rivalries of the European superpowers—France and Germany—might soon explode in a full-fledged military conflict. It is very well conceivable—any attempt of proof would itself be a worthwhile undertaking—that the poem *Weltende* (Doomsday, published in January 1911), by Jakob van Hoddis, intimately kindred to Heym, also has its point of reference in the Morocco crisis. In that case, Wilhelminian German diplomacy, not the Expressionist poet, was the true prophet of imminent warfare. Yet is that, in effect, what the poem gives voice to?

> Dem Bürger fliegt vom spitzen Kopf der Hut,
> in allen Lüften hallt es wie Geschrei.

Dachdecker stürzen ab und gehn entzwei,
Und an den Küsten—liest man—steigt die Flut.

Der Sturm ist da, die wilden Meere hupfen
An Land, um dicke Dämme zu zerdrücken.
Die meisten Menschen haben einen Schnupfen.
Die Eisenbahnen fallen von den Brücken.

(The citizen's hat is blown off his pointed head.
and sounds of screaming rend the air;
tilers fall off the roof, their bodies split,
and the tide, so one reads, is rising round the shores.

The tempest is here; the savage seas leap
onto the land to crush the thick embankments.
Most people have colds.
The trains fall off the bridges.)[11]

In the straightforward terms of a historicist reading, with proof or without, the poem can quite generally be interpreted as a poetic response to the event of a political crisis. In the specific terms of its reception, it must be understood as a combination of possible political allusions with the critical strategies of insult, shock, and the jarring of the expectations of the contemporary reading public. After all, the *Bürger* addressed in the poem itself, at least in the Germany of 1911, is still almost as undisturbedly steeped in his newspaper as in the classicist canon or neoromantic imagery for which beauty equals truth. Of that world view, merely the rhyme seems to be left. In fact, however, the convention of verse is destroyed in the irony which insists on it. Indeed, the poem not only seems to signal possible catastrophe in the political realm, the explosive potential crisis of a global war, but it is, at the same time, revolutionary in terms of the literary tradition. As such, it was understood in literary circles as *the* poem of the *Kunstrevolution* which, according to van Hoddis's fellow author and critic, Kurt Hiller, marked the beginnings of German "progressive" Expressionist poetry.[12] But was it meant to be "revolutionary" beyond its attack on the conventions of the contemporary institution of literature? Johannes Becher's account of its enthusiastic reception by like-minded artists, on the surface, seems to imply just that. In his novel *Farewell* (1940), the autobiographical account of an era on the brink of World War I, Becher remembers the poem as "the *Marseillaise* of the expressionist rebellion," an anthem of *rebellion* rather than *revolution*, the "hieroglyphs" of which, Becher writes, were above the head of the Wilhelminian officials. Such characterization appears to be rather incompatible with his evocation of the poem's *revolutionary* tenor.

How do we explain the mixed signals given? After all, the burgher loses his hat, not his head. Roofers and trains fall and go to pieces—a modern variant of the deluge crushing all protective dams. In the terms of this thematic reading, instead of "revolution" the poem seems to signal "demise." But what kind of a

demise will this be, if a chief characteristic is the common cold ("Die meisten Menschen haben einen Schupfen")?! Is it really the eschatological catastrophe which renders many an expressionist topos of catastrophe, and in the cases of expressionist painters like Kandinsky (e.g., *The Last Judgment*, 1910) or Franz Marc (e.g., *Fate of the Animals*, 1913) of resurrection? Is not van Hoddis here rather anticipating the Dadaist's mockery of the discrete charm of the bourgeoisie by pointing to the devastations which mark the other side of the coin of the rituals of daily trivialities, of its sickness and boredom "beyond good and evil"? Only from a Spenglerian view is such a state of affairs a *Weltende*, the dreaded but acknowledged end of the *Kulturkreis*. In the case of this poem we sense a certain diabolic urge, a vitalist impulse towards destruction with a certain joy. At no point can the poem be read as a warning prophecy. Likewise, Georg Heym, the author of the poem "War," eagerly longed for the catastrophic, indeed for war, while drowning "merely" in boredom. The adage of "deadly boredom" seems to be the poignant summary of the case of spiritual and emotional alienation of the individual in modernity. Is this not the very sentiment which rests, not at all unconsciously it seems, at the bottom of Becher's Marxist nostalgia, his attachment to and quasimythical understanding of van Hoddis's poem? Contrary to the political message of the *Marseillaise,* the poem seems to have been enchanting as a chant of a total *Aufbruch* (awakening), albeit without a distinct goal. I quote merely a few lines from Becher's remembrance in *Das poetische Prinzip* (1952): "My poetic power is not sufficient to reconstitute the impact of this poem. . . . These two verses, these eight lines seemed to have changed us into different human beings, to have lifted us up out of the world of a dull bourgeoisie, which we despised and *which we could not leave as we did not know how to. . . . These eight lines abducted us* [emphasis added]."

On the whole, the prewar expressionist "revolutionary" attitude was, in the original sense of the word (*re-volvere*), a hope for a *return* to a primordial age through the destruction of a decadent age, through "Holocaust . . . mass deaths, hence the birth of a new man" (Becher).[13] There is a certain double-bind of such a pseudo-Nietzschean state of mind: it implies a latent "deathwish" or wish for a "return to the womb." The suicidal note of the sons of the bourgeoisie, as a very part of the bourgeoisie, is intertwined with the clarion call of the sons revolting against the fathers' way of life for life. This is how Georg Grosz later critically analyzed his activities as a satirist of "the visage of the ruling class" of the Weimar Republic: "In reality I was everyone I sketched. . . . In a way I was split in two."[14] The early Expressionist spontaneously bared his state of mind in highly ambivalent terms, mixing images denoting a return to a primordial essence of life with a whole range of metaphors as *progressive* revolutionary symbols. Witness the "Jacobin cap" with which Heym, in a diary entry of September 19, 1911, imagines himself on the barricades of the French Revolution. At the same time, the would-be Jacobin is capable in his diary (as in a poem like *War*) to conjure

up the spirit of total war as a natural force beyond good and evil, which he describes in vivid images ranging from tocsins to swords, rent shirts, and the faces of the people as much orgiastic as torn by fright. In the aftermath of the event of the Morocco crisis, he writes: "My God—with all my fallow enthusiasm I will suffocate in these trivial times. I hope at least for a war. But also that has come to naught. My God, could I have been born in the French Revolution. . . . "

In the center of the network of prewar Expressionism's multiple and contradictory "hieroglyphs" of war and revolution rest the metaphors of the individual's alienation in the trivial and the void of meaninglessness: the metaphors of the "common cold" (van Hoddis), "apathy of life" (Heym), and the "world of a dull bourgeoisie" (Becher). They seem to be the generative metaphors of all subsequent metaphors and, in themselves, the metaphors of the crisis of modernity as the concrete event. The crisis of modernity appears to mean a fundamental dilemma of signification in a metaphysical, cognitive, artistic, and political sense. The crisis of modernity does not forebode or anticipate a "turning point in an unfolding sequence of events"; rather, it fundamentally "produces uncertainties in assessing the situation and in formulating alternatives in dealing with it."[15]

Of course, it was Friedrich Nietzsche and not Karl Marx who inspired the expressionist revolt and anticipated much of the European modernist experience. Indeed, Nietzsche's work was rich enough to inspire would-be revolutionary utopians such as the young Hasenclever or the Italian Futurists and their madman writer Marinetti. It was simultaneously the source of the pessimistic "black" outlook of Benn, Beckmann, Kubin, the "dystopians," if you will. In fact, Nietzsche's work was so abundant with multiple insights that in the history of its reading, it has generated various contradictory strands of creative misreadings, each according to particular historical, philosophical, even political needs, be they existentialist, humanist, Christian, Marxist, or the willfully constructed distortions of the Nazis. The Expressionists, in particular, idolized Nietzsche's Zarathustra as the personified model of a revolutionary poet of cultural rejuvenation. They were neither willing nor able to understand the figure as a philosophical-poetic construct through which the philosopher intended to dissolve all ideology into the spectrum of perspectivism. The very contradictory history of reading Nietzsche may basically indicate that Nietzsche was neither a thinker of revolution nor a thinker of catastrophe—neither utopian nor dystopian—but a thinker in times of crisis who invalidated the crutches of ideology as metaphors of multiple vested interests.[16] His answer to an age of ideologies, of course, was that "there exists nothing but interpretations of interpretations."

The utopian, in the tradition of the Enlightenment, was identical with and drew its legitimation from the rationalist belief in progress. However, the expressionist utopian, in his contradictory projections of war and revolution, is the essential expression of a significant dilemma. None other than Wilhelm Worringer, the theoretical pioneer of Expressionism in the arts, recognized this particular crux

of modernity. In 1920 he delivered a prodigiously early obituary of the promise of the era: "Exactly because the legitimacy of Expressionism does not rest in the rational, but in its vitalism, we are today confronted with its crisis. . . . Vitally its time is up, but not rationally. And therefore it is a hopeless case." Following Worringer, then: The inhumanity of modernity, typified by the technological nature of modern warfare and the failure of any revolution to fulfill its promise, has disproved the vitality of Expressionism. Expressionism's unique rationality was the belief in the essential representativeness of the individual, rather than of the *citizen*, for the social organization of experience. However, it did not stand a chance against that type of rationality which was instrumental in bringing about the specific qualities of modernity. Worringer's statement is a verdict on an age in continual crisis. The Expressionists' literary and artistic circles were not revolutionary but secessionist. What was true for them may have become the predicament of everyone today. The claims of Expressionism for the universal validity of the uniqueness of the individual as part of a free *Gemeinschaft* (community) has become the standard and official ideological consolation prize for the most technologized mass societies of the Western world. Modernity's very rationale, however, will disallow any cashing-in of that promise. In the words of Worringer: "The hopelessly lonely want to pretend community. But it stays mere simulation; here also merely a desperate philosophy 'as if.' "[17] At the same time, our society (*Gesellschaft*) will insist on the potential of cashing in the coupons which we retain from the revolutions of the past. If the potential of revolution has been overtaken by the presence of a permanent crisis, the following question may be relevant: What happens to the arts if this interpretation of the contemporary condition is widely accepted as valid?

On the whole, the intellectual during the first third of our century was motivated by a belief (or at least by an intensely felt need for a belief) in the cultural, if not distinctly politically revolutionary, function of art. This did not rule out an awareness—expressing itself more or less between the lines—of the fact that this belief may not be much more than the need for illusions. It becomes critical with the Nazi seizure of power, against which the intellectual and the artist had experienced an extreme degree of powerlessness. The Hitler-Stalin pact of 1939, for the leftist intellectual the most disillusioning event of the period, constituted the major event that exposed the futility of the revolutionary imagination. The unspeakable horror and terror of World War II was to bring this point home to more than just a few, so that George Grosz's watercolor *Painter of the Hole* (1947–48) could be called a key image, a nihilistic emblem of the whole era. It is the polar opposite of Scheerbart's utopian valorization of translucent space (glass) at the beginning of the century. The intellectual typically felt himself forced to unmask the whole of modernist development, including his own work as ideology (cf. Carl Einstein's *Die Fabrikation der Fiktionen*). As implicitly stated in Heinrich Mann's novel *Der*

*Empfang bei der Welt,* written between 1941 and 1945 while the author was in exile in the United States, the modernist artist has always supplied the ruling class with art as a commodity. Culture has served to legitimize the interests of the status quo (as symbolized in Mann's satire by the construction of the opera house, the splendor of which is to conceal the decay of an era) rather than the real, concrete needs of the underprivileged. Thomas Mann, in *Dr. Faustus* (1947), went so far— and too far, at that—as to criticize the modernist artist by way of his composer genius Adrian Leverkuehn (alias Schoenberg, alias Nietzsche) for having concluded a pact with the devil for the sake of continued creativity in an age overburdened with history. The significance of these works marking a starkly *catastrophic* view of modernist art, however, probably rests within the particular historical period in which they arose. Conversely, Walter Benjamin's *Geschichtsphilosophische Thesen* (1940), written in the aftermath of the Hitler-Stalin nonaggression pact, are a highly ideosyncratic blend of political despair, a messianic embrace of art as redemption from the historical towards a mythical "now-time," and an ice-cold, critical, and far-reaching analysis of all ideology of progress and historical utopianism. As such they situate themselves like no other document of modernity as the watershed between the modernist era of a quasireligious belief in the project of art and a post-World War II era marked by a growing crisis of belief in the meaning of art.

Benjamin's "angel of history," a metaphorical derivation from Paul Klee's *Angelus Novus* (1920), the painting which the critic had acquired early and which was to become his very personal, problematic symbol,[18] has turned its face to the past: "where before *us* appears a chain of events, *he* sees a single catastrophe, which ceaselessly heaps ruins upon ruins which it dumps at his feet". The image projects a permanency of death and destruction of all our illusions while, in its very own dialectics, it retains a vision of redemption: after all, the angel's face, turned to the past, is still directed towards paradise, even if it is a paradise lost. Hence a wind called "progress" carries him. While Benjamin's interpretation of Klee's image clearly recognizes the unique subjectivity of art, the *Geschichtsphilosophische Thesen* are directed primarily towards the unmasking of the idea of "progress" as the central metaphor of the subjectivity of modern rationalism. Like Carl Einstein before him, Benjamin attacks the liberalist world view as propagating fictions of "progress" ("wie er sich in den Koepfen malte"/"as it was visualized in the heads"), which ultimately serve the interests of oppression in the social realm. Social democracy's theory and practice, for Benjamin, is a product of the uncritically allegorical notion of the progress of "mankind itself (not only of its skills and knowledge)," and of the transcendent concept of "an infinite perfectibility of mankind." Social democracy views progress as an "incessant process automatically pursuing a straightforward or spiral trajectory." Thus only to liberalist minds can the rise of the Nazis to a world power come as such a surprise "that the events which we experience are still possible in the twentieth

century." In turn, Benjamin unmasks the concept of history as permanent prog-
ress; in Benjamin's theses, the reality of history is instead one of a permanent
catastrophe. However, he does not use the term "catastrophe" in a mythical-
eschatological "expressionist" sense, but rather in a critical sense. Thus, he writes
elsewhere: "The concept of progress has to be grounded in the idea of the
catastrophe. That it 'goes on like that' *is* the catastrophe. It is not what is ever
in front of us, but that which is always the given." The given, however, consists
for Benjamin in the circumstance that social oppression persists not in spite of,
but because of the illusionary ideology of "progress": "The tradition of the sup-
pressed teaches us that the state of emergency in which we live is the rule."[19] In
other words, Benjamin—in contrast to the doomsday-prophets in the 1940s—comes
to grips with the underlying phenomenon of a permanency of crisis. The growing
insight into the "static" nature of history is, in spite of Nietzsche's later views
and those of his poetic witness Gottfried Benn, something altogether alien to the
culture of the first half of our century. We have seen this in the case of the Expres-
sionist movement, a prime example of the "mythical method" of modernism. This
insight has precipitated an identity crisis of the avant-garde as avant-garde in the
sense of "anticipatory" (Bloch). The thrust of this crisis can be interpreted as
resulting in a cynical "anything goes"-attitude that seductively offers a false sense
of freedom.

In Germany, the attempts of the members, sympathizers, and the heirs of the
legacy of the Group 47 (Grass, Boell and Enzensberger among them) to come to
terms with the past, were thwarted and exhausted by the relentless permanence
of a Cold War. I cite the dilemma of the postwar German intellectual as a paradigm
for a traumatic global circumstance where the credibility of art to contribute effec-
tively to a practiced memory of history seems to have been progressively under-
mined and eroded. Since the mid-seventies, a radical critique of ideology sweeps
through the forest of our postwar dreams. It leaves a clearing which permits us
to see what many did not and do not want to see. For example, Hans Magnus
Enzensberger, spokesman of the literary New Left and editor of the notoriously
radical *Kursbuch,* had in 1968 (the year of the student "revolution") pronounced
the death of bourgeois literature as a politically relevant medium. A decade later
he began to maintain that the spectacle of revolution was over. For Enzensberger,
the concept of revolution had turned into an escapist metaphor for a global civiliza-
tion in discontent. Whether the metaphors of attempts to maintain distinctions of
value are "Third World," "Second," or "First," "capitalist" or "communist,"
today's concrete avant-garde event is an acceleration of a worldwide commodifica-
tion process. It is a battle of all against all for a share of the pie. It is this "pie"
that the underdeveloped nations really mean when they cry out for "revolution."
Thus wrote Enzensberger.[20]

In this vein, more and more German intellectuals in both the East and the
West have rejected a traditional Marxist critique of ideology as ideology and have

replaced it with what appears to be a critically broken Nietzschean critique of ideology—a modernist critique of modern rationalism, often bordering on a Kafkaesque vision. In a paradigmatic play by the East German Heiner Mueller, *The Mission,* the concepts of freedom and revolution are unmasked as a cyclical series of masks of treason: the true revolutionary is the doomed victim; revolutionary poetry has always been the poetry of futility. By 1980 Peter Weiss had completed his monumental *Aesthetics of Resistance,* a three-volume fictional case study of the political and social relevance of the arts from antiquity to surrealism for twentieth-century activism. Enzensberger's ideological opponent on the left, Weiss, the author of the activist plays *Lusitanian Bogey* and *Vietnam Discourse* (in which the cause of the so-called Third World is emphatically and openly propagandistically embraced), retracts. In writing political history as art history and vice versa, he is forcing himself to admit that the attempts of the avant-garde to integrate aesthetics with the social life-forms have been doomed to failure. Political resistance can only be *aufgehoben*—sublated, saved and conserved—in the realm of art or in the death of the martyr, for which Auschwitz is a universal symbol. On the other hand, in the midst of mutual destruction, art remains the locus of resistance—as a critique of the silence of resignation and the shrillness of ideology. As every future is instantaneously filled anew with torture, arson, and murder, "Utopia would be necessary." (III, 265). Any hard-line Marxist critic will call these related German literary developments, from the sixties to the eighties, a *Tendenzwende* (reversal of tendency) reflecting obvious economic-political developments in West and East Germany. However, this shift of point of view, I feel, should instead be addressed in its concrete sociopolitical trends which have a larger scope than Germany.

It is true that Enzensberger, in his play *The Habana Inquiry* (1970), shared Peter Weiss's optimism, derived from his initial Cuban experience, that is, that the "Third World" offers the possibilities of "art being part of life," as expressed in Weiss's Angolan play. But Castro's persecution of critical writers and intellectuals in a Cuba more and more dominated by the geopolitical economic interests of the Soviet Union, and Vietnam's imperialist reversal in Cambodia, leads Enzensberger to disillusionment with the intellectual and political home he believed himself to have found. This dislocation expresses itself in his poetry, the *Mausoleum. 37 Ballads from the History of Progress* (1975) and *The Sinking of the Titanic. A Comedy* (1978), in a sense representative of (but in terms of literary and critical quality far superior to) a whole trend of current "doomsday" literature.[21]

*The Sinking of the Titanic* is fundamentally a hermeneutic argument concerning the relationship of utopia and dystopia in history. The cycle, published in the Germany of 1978, attempts to define the nature of history from the point of view of a supposedly lost, but now creatively remembered, poem written a decade earlier in Castro's revolutionary Habana about the Titanic catastrophe in 1912. It does so by discussing its own heuristic function—that of a work of art. The long poem invariably returns, after numerous episodes either relating to the sinking ship (the "Titanic", of course, is a symbol for the supposed indestructibility of the ideal

of progress) or to the Cuban revolution to its own status rendered by the lyrical I: "In reality, nothing has happened. The sinking of the Titanic has not taken place; it was only a film, an omen, a hallucination: because what happens, happens, "all or nothing in my head of forty-six thousand gross registered tons." This admittedly solipsistic position is critical to the degree that it makes both its own solipsism, and the utopian notions of history the "object" of the poem: "At that time we still believed in it (who: 'we'?). . . . We still believed in an end at that time/when? ('at that time'? 1912, 1918, 1945, 1968?) and that means: in a beginning."

Aside from a digression à la Nietzsche on the truth and lies of language itself, the paradigms for such reflection are taken from the visual arts. The examples range from *Apokalypse. Umbrisch, etwa 1490,* which thematizes the artist's paradoxical pleasure at expressing images of the *Weltuntergang* (end of the world), to *Die Ruhe auf der Flucht, Flaemisch, 1521 (Rest in Escape)* a Bruegel-like tableau. In the cycle's four poems, dedicated to the problem of art via paradigms from the visual arts, the relationship between the idyllic and the catastrophic is defined as an existential intertwinement of idealization and social power. The argument is inclusive of the oppression which language, as a means of communication and art, exerts on the phenomena. In the last "iconology," this relationship is finally unmasked as the relationship of "blindness" and violence. Thus begins the poem, the haunting, opaque beauty of which can only be suggested here:

> Ich sehe das spielende Kind im Korn
> das den Bären nicht sieht.
> Der Bär umarmt oder schlägt einen Bauern.
> Den Bauern sieht er,
> aber er sieht das Messer nicht,
> nämlich im Rücken des Bären.
>
> (I see the child playing in the corn
> who does not see the bear.
> The bear embraces or strikes a farmer.
> He sees the farmer,
> but not the knife
> which is stuck in his back;
> namely in the back of the bear.)

In the face of the deeply comprehended inexplicability of the phenomena and their quasimonadic appearance, utopia, idyll and dystopia, and catastrophe are ultimately equivalent. They are tautological crisis-reactions to the impossibility of the knowledge of truth and to the immutability of violence. The "Kafkaesque" impenetrability of the world is seen as relative to the subject who, after all, acknowledges his very blindness to his own condition and who thus does, after all, understand through reflection, even though it is a reflection that admits to the impossibility of knowing: "I have seen all this except for the knife in my back."[22]

Images like these function quite differently from the "dialectical images" of Benjamin, who clings to the vision that it is possible to derive, after a reduction of all illusion of evolutionary or revolutionary "development," a certain knowledge at the moment of "dialectics at a standstill" and to obtain a certain profoundly revolutionary epiphany from the work of art: "In each work of art there is a locus at which the absorbed viewer is touched as if by the cooling wind of an incipient dawn."[23] The goal for Enzensberger and Benjamin is the unmasking of the idea and ideal of *Fortschritt*; for both, "progress" and "decline" are merely two sides of the same thing; namely, the concept as a *rational* device. They are metaphors for events that cannot really be conventionally named or signified. Enzensberger, however,—and this is significant for an understanding of the critical nature of contemporary art—denies any possibility of an alternative vision beyond open-ended reflection. He does not believe in any anticipatory dynamics of the artistic image—the traditional alternate mode to the rational concept from Schlegel (*Gespräch über Poesie*) to Hölderlin, Hofmannsthal (Lord Chandos) to Benjamin.

Enzensberger's view, manifest in his poetry since the mid-seventies, seems to have come full circle. The avant-garde of the mid-seventies and eighties confirms, in its own ways, the historical experience of the avant-garde of the pre- and post-World War I era. If the sons have returned to their fathers, they have critically absorbed the older generation's experience. Benjamin understood by "catastrophe" the continuation of the suppression of the fact of continued oppression by means of illusions: "That it 'goes on like that,' *is* the catastrophe." In other words, the concrete form of the demise is normally the seemingly "trivial"— the event as the daily event, or in Jacob van Hoddis's words (from *Weltende* of 1911) "die meisten Menschen haben einen Schnupfen." Following two World Wars, the atom bomb, and numerous full-fledged wars in Asia and the Middle East, Hans Magnus Enzensberger, in a 1978 essay on the theme of *Weltuntergang* (end of the world), critically evaluates the collective "images of catastrophe" as "realistic." Are they not, he asks, an expression of the subconscious reacting to our daily experiences in front of the television, which show that we are in a continuous state of war, filling hospitals and jails? In a critique of the ideologies from the political right and the political left (his sympathies resting with the latter) he criticizes the latter's anachronistically naive utopianism in a sobering attempt to refine its critical capacity.

Enzensberger decries the left's dogmatic "academic exorcism," its fearful and undialectically defensive attempts to ban the power of myths by edicts. He reminds his friends that classical Marxism itself for a hundred years has reversely exploited the mythical mode by equating the collective images of catastrophe with the immanent collapse of capitalism. And he reveals as a commonplace taboo the assertion that any comparison between natural and societal processes be a "reactionary" design to undermine the progressive revolutionary principle of hope: "The elementary force of the imagination teaches millions of people consistently to break this prohibition. Our ideologues make fools of themselves when they try to eradicate

inextinguishable images like flood, fire, earthquakes, and hurricanes.'' These images of the collective subconscious, one might add, are also projections of a collective ''bad conscience.'' The images of the apocalypse and the secularized concept of the *Weltuntergang* also contain a reversed, positive potential: ''The idea of the apocalypse has accompanied utopian thinking since its beginnings; it follows it like a shadow, it is its flip side. . . . without catastrophe no millenium, without apocalypse no paradise.'' In that omnipresent sense, the catastrophe has not taken place, is not ''real.'' It is ''a second reality, an image that we form, an incessant production of our imagination, the catastrophe in the head.''[24] However, the peculiar reality of the negative utopia, the metaphorical reflection of the daily crisis-event of modernity, constitutes a real challenge to rational discourse. Its compulsive coalescence into an imaginary totality (the catastrophe per se, the flip side of utopia), in the absence of any cure-all global rational recipes for the future and in the light of the invalidity of stagnate dogmas of *Weltverbesserung* (betterment of the world), must in turn be subjected to an open-ended reflection. This reflection derives its freedom from the apperception of phenomena—hence its distance from any immediate global application—and from the avoidance of any and all systematic theories. In this sense, reflection for Enzensberger is not Habermas's ''metapower'' which grasps and dissolves all other powers.[25] Here also lies the difference from the monomania of the mythical expressionist vision of a Heym or van Hoddis, whose ''rationale'' was to rejuvenate through a ''revolution'' unreflected.

Long before Horkheimer's and Adorno's unmasking of the terror of reason in *Die Dialektik der Aufklärung* (1947) and Enzensberger's continuation of its thought patterns, Kubin in his paintings and in his 1909 novel *Die andere Seite* (The Other Side), anticipated the horror and terror of a Kafkaesque penal colony. Kubin rendered provocatively the images of the indissoluble entwinement of reason and myth, of enlightenment and terror, of the conscious and the subconscious, of life and death—of utopia and dystopia as a unity beyond categories. Enzensberger, some seven to eight decades later, more programmatically attempts to salvage a certain portion of enlightenment from the mythical mode of experience, previously the target of his own Marxist inspired political criticism. In this sense, Enzensberger himself may appear like a recent version of the rationalist Herkules Bell, who set out to defeat Patera (the tyrant of Kubin's dystopian community, the ''dream state'') before we detect that modern rationalism (Bell) and irrationalism (Patera) are but the two sides of the same coin. Has the rationalist Enzensberger himself capitulated to the capitalist ''dream state'' of the East and West? How should one interpret Enzensberger's statement that ''whoever produces literature as art can neither be justified nor refuted any longer''?[26] The statement was originally made in the ''revolutionary'' days of 1968, but seems to be uniquely valid still today. Yet, is it a powerful statement on the dissolving of the *raison d'être* of art, or does it enhance art by giving it a special status? Should this special status be attributed on the basis of recognizing the isolating division-of-labor status of the elitist ''institution of art,'' or does Enzensberger idealistically reserve for art a genuine spon-

taneity, a realm *sui generis*? Must the implications of this evaluation be understood as an admission of the total decline of the power of the artist and intellectual in the state, or as the symptom of art's accomplished liberation from all ideology and external authorities? Or is the other side the same side here, too? This is merely a sample of the questions provoked by Enzensberger's poetic and essayistic work. It is a project of enlightenment which takes its departure from the insight that "the law of progressive reflection is inexorable" (*Aporien der Avantgarde*, 1962).

The crisis we have traced is ultimately a crisis of our concepts, of our language, which Nietzsche had already perceived at the roots of the modern crisis of interpretation. It is the very crisis of art for our age, and goes altogether beyond Nietzsche's insistence on "art as the intrinsic task of life, art as its metaphysical activity." Enzensberger's formula of the utopian/dystopian inversion had already been expressed as such at the beginning of the expressionist decade by seemingly apolitical yet critical artists such as Kafka, Alfred Kubin, or Trakl, each signifying an essential dualism of the modernist sensibility in their interpretations of modernity. In other words, in the hermeneutic light of the event of art, the actual event of modernity can be seen neither in the utopian revolutionary (which the strategies of aesthetic transaction of various movements in the arts set out to propagate) nor in its dystopian reversal. Rather, a permanent, all-pervasive, omnipresent crisis is felt in the presence of the immutability of man's subconscious, as well as in the continued immobility of the modern institutions whose power emanates from a totalizing "instrumental reason" (Horkheimer/Adorno). Created by modern mass culture, "instrumental reason" in turn controls it. This crisis, after all, underlies the mythmaking mentality of the revolutionaries who are inspired by the myth of rebirth, as it conditions the mentality of those whose imagination is captured by the primordial phenomenon of decay and death. Where, then, are our choices? This question cannot be answered outright. It can only lead to further reflection and to a mature art prohibitive of indulgence in illusions or indulgence in alienation.[27]

## Notes

1. Hans-Robert Jauss, *Toward an Aesthetic of Reception* (Minneapolis, 1982), pp. 146ff. (selected essays; translated by Timothy Bahti).

2. See Hans-Jürgen Schmitt (ed.), *Die Expressionismusdebatte. Materialien zu einer marxistischen Realismuskonzeption* (Frankfurt a. M., 1973).

3. Jean-François Lyotard, *The Postmodern Condition: A Report on Knowledge* (Minneapolis, 1984), p. xxiv. (*La condition postmoderne* [Paris, 1979]).

4. See Rainer Rumold, *Gottfried Benn und der Expressionismus. Provokation des Lesers; absolute Dichtung* (Königstein/Ts., 1982), pp. 55ff.

5. Rainer Naegele, "Modernism and Postmodernism: The Margins of Articulation," *Studies in Twentieth Century Literature* 5, no. 1 (Fall 1980): 17.

6. See the extensive edition of his *Werke*, vols. I–III, ed. by a group of scholars (Vienna/Berlin: Medusa Verlag, 1980–85).

7. "Absolute Kunst und absolute Politick," *alternative* 57: 254.

8. Peter Burger, *Theory of the Avant-Garde*, trans. Michael Shaw (Minneapolis, 1984) (*Theorie der Avant-Garde* [Frankfurt, 1974]).

9. Gerald Graff, *Literature against Itself* (Chicago, 1979), p. 8.

10. Dammann, Schneider, Schoeberl, *Georg Heym's 'Der Krieg'. Handschriften und Dokumente. Untersuchungen zur Entstehungsgeschichte und zur Rezeption* (Heidelberg, 1978).

11. Trsl. R. Taylor, *Literature and Society in Germany 1918–1945* (Sussex, 1980), p. 81. All other translations are mine. R. R.

12. Paul Raabe, ed., *Expressionismus, Aufzeichnungen und Erinnerungen der Zeitgenossen* (Olten und Freiburg i.Br., 1965), pp. 24ff. (In translation, by J. M. Ritchie: *The Era of German Expressionism* [London, 1974].)

13. Ibid., pp. 51ff; 317.

14. For George Grosz as a paradigm for the artist in crisis, cf. Rumold, "Ein kleines Ja und ein grosses Nein. Georg Grosz im Spiegel seiner Begegnung mit Gottfried Benn u. Bertolt Brecht," in *Probleme der Moderne*, eds., Kaes, Bennett, Lillyman (Tübingen, 1983), p. 403.

15. James A. Robinson, "Crisis," *International Encyclopedia of the Social Sciences* (1968), pp. 510ff. While the central thesis of my essay has been inspired by Enzensburger and Benjamin, I realize the potential of further research on the basis of Reinhardt Koselleck, *Kritik und Krise. Ein Beitrag zur Pathogenese der bürgerlichen Welt* (Munich, 1959) and *Futures Past. On the Semantics of Historical Time* (Cambridge, Mass., 1985).

16. See Rudolph Kuenzli, "Nietzsche's Zerography: Thus Spake Zarathustra," *Boundary* 2 (special issue on Nietzsche) (1981): 95–105; Rumold, "Nietzsche and the Miscarriage of the Avant-Garde," *International Nietzsche Symposium*, Madison (forthcoming).

17. Wilhelm Worringer, *Künstlerische Zeitfragen* (Munich, 1921), pp. 9, 16; critically cited and discussed from a conservative Marxist perspective by Georg Lukács in "Grösse und Verfall des Expressionismus" (1934).

18. See O. K. Werckmeister, "Walter Benjamin, Paul Klee und der Engel der Geschichte," *Versuche ueber Paul Klee* (Frankfurt a. M., 1981), pp. 98–123.

19. Walter Benjamin, "Über den Begriff der Geschichte," *Gesammelte Schriften*, ed. Tiedemann/Schweppenhaueser, I, no. 2 (1974): 693–704.

20. See Hans Magnus Enzensberger, "Eurozentrismus wider Willen. Ein politisches Vexierbild" (1980) and "Der höchste Stand der Unterentwicklung. Eine Hypothese über den Real Existierenden Sozialismus" (1982), in *Politische Brosamen* (Frankfurt a. M., 1982).

21. See Reinhold Grimm, " 'Eiszeit und Untergang' zu einem Motivkomplex in der deutschen Gegenwartsliteratur" (1981), in *Texturen. Essays und anderes zu Hans Magnus Enzensberger* (New York, Bern, Frankfurt, 1984).

22. Hans Magnus Enzensberger, *Der Untergang der Titanic. Eine Komödie* (Frankfurt a. M., 1978), pp. 79, 101.

23. Walter Benjamin, "Das Passagenwerk, Aufzeichnungen und Materialien," *Gesammelte Werke*, vol. 5, no. 1, p. 593.

24. H. M. Enzensberger, "Zwei Randbemerkungen zum Weltuntergang," *Politische Brosamen,* pp. 225, 234, 236.

25. Naegele, "Freud, Habermas and the Dialectic of Enlightenment. On Real and Ideal Discourses," *new german critique* 22 (Winter 1981): 43.

26. H. M. Enzensberger, "Gemeinplaetze, die Neueste Literatur betreffend," *Kursbuch* 15 (1968): 195; "Commonplaces on the Newest Literature," in *Critical Essays,* ed. Reinhold Grimm and Bruce Armstrong (New York, 1982), p. 43.

27. *Literature against Itself,* p. 62.

# Part Two

# Movements and Movement

# Revolutionary Events, Revolutionary Artists: The Hungarian Avant-Garde until 1920

*Steven A. Mansbach*

The American humanist philosopher Sidney Hook created a useful category for understanding the historical relationship between events and individuals. The man to whom one might legitimately attribute a "preponderant influence in determining an issue or event whose consequences would have been profoundly different if he had not acted as he did" deserves the appellation, "the hero in history."[1] By this term, Hook did not mean that these heroic historical figures were necessarily virtuous, evil, or even worthy of admiration. Rather, whether like the conquering Alexander or like the legendary Dutch boy who plugged the hole in the dike and thereby saved his town, the hero is heroic less by virtue of his moral character than by the result of his deed. Invoking this useful category, one may argue that members of the Hungarian avant-garde early in this century were "heroic" in their response to the great events of their time, namely the two revolutions that took place in Hungary in 1918-19, especially the latter bloodless communist revolution of Béla Kun. Once again it should be stressed that neither the artists nor the revolutionary regimes to which they so creatively responded were necessarily morally, socially, or even "historically" good or evil. Rather, the heroism derives from the profound impact on and implications for modern art and theory that resulted from the avant-garde's response to the revolutions of 1918-19.

## The Artistic Prelude

Long before anyone had heard of Béla Kun, there was serious interest in modern art among Hungarian intellectuals. In 1896, ten years after Kun's birth in Transylvania, the most important and most progressive Hungarian artists' colony was established in the same region of the Hungarian kingdom. To a large extent, the colony at Nagybánya (today, Baia Mare, Rumania) was the creation of Simon Hollósy, an

emerging young painter who had grown disenchanted with his formal Academic training in Munich. Along with István Réti, an artist who provided a theoretical foundation for a Hungarian alternative to the (primarily German) Academic training traditional for aspiring Hungarian painters, Hollósy effected a new style in Hungarian art that would have significant impact over the next several decades. Affirming the value of Impressionist plein-airism of contemporary France, the "school" of Nagybánya represented a fundamental shift of emphasis in Hungarian painting from the academic style of the Munich Academy towards a new, unfettered naturalism. As a result both of Nagybánya's emphasis on a "naturalist" training and of the reputation of the established Hungarian painters who chose to join this "colony," Nagybánya was able to attract numerous young artists from all over the Austro-Hungarian Empire, and beyond. Among these was Károly Ferenczy (1862–1917) whose work from the 1890s marks the artistic highpoint of Impressionism in East-Central Europe (fig. 3.1). Just as Ferenczy was popularising the progressive French style of the 1870s and 1880s, Jószef Rippl-Rónai (1861–1927) brought to Hungary via Nagybánya the style of the Nabis with whom he had been working and exhibiting in Paris (fig. 3.2).

While late-nineteenth-century French art was actively emulated and enthusiastically received by artists, critics, and collectors in Budapest and other Hungarian centers, the 1896 celebrations to commemorate one thousand years of the Hungarian nation prompted other artists to turn to an art style that conjoined progressive formal trends with more traditional iconography. For many, such as János Vaszary (1867–1939) (fig. 3.3), this led to an embrace of symbolism which, on the one hand, allowed painters to affirm the growing sympathy for contemporary French style and, on the other, to satisfy a more tradition-minded patron class (and state) with identifiable, often patriotic subject matter.

In the years immediately following the 1896 millennial progressive Hungarian artists were self-consciously aware of the singularity of their historical position: they were looking toward the West while celebrating their ties to the East, both as a historical nation-state and as the contemporary political center of a multinational eastern empire. To some extent, one can recognize this contradiction in the unique form that Hungarian Secessionist art took. Like both French "art nouveau" and Austro-German "Jugendstil," the Hungarian style reached its acme in the decorative and architectural arts. And like its counterparts, many of the nation's most forward-looking artists and craftsmen (not to mention private and public patrons) were enraptured by the idea of creating a total environment, entirely determined by "art." Even more than elsewhere, the Hungarian secessionist "Gesamtkunstwerk" was related to an idealistic view of reconstructing the material world by using art as a spiritual model.[2]

With historical hindsight, one might argue that despite the impressive quality of the art produced by the artists of the Nagybánya colony, the symbolist movement of the millennial period, or the secessionist style, these artists were more forward-looking than fully modernist. By this I mean that a mature integration of style and

Figure 3.1. Károly Ferenczy, *Morning Sunshine*, 1905
Oil on canvas, 91.5 × 92.3 cm.
*(Magyar Nemzeti Galéria, by permission of the Hungarian National Gallery)*

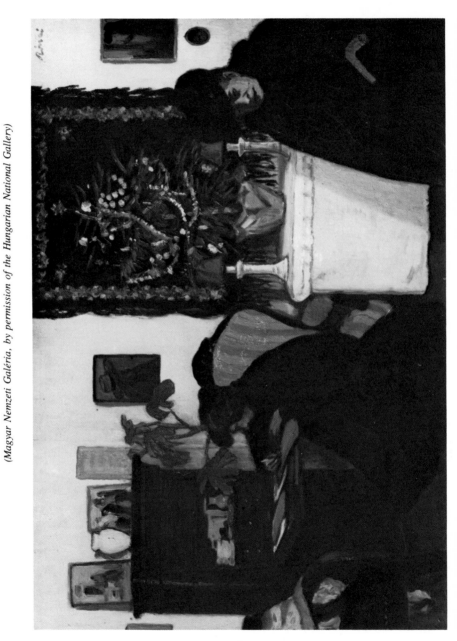

Figure 3.2. József Rippl-Rónai, *Christmas*, 1903
Oil on cardboard, 67 × 99 cm.
*(Magyar Nemzeti Galéria, by permission of the Hungarian National Gallery)*

Figure 3.3. János Vaszary, *The Golden Age*, 1898
Oil on canvas, 92.5 × 155 cm.
*(Magyar Nemzeti Galéria, by permission of the Hungarian National Gallery)*

philosophy—or theory and practice—was never completely realized. Often the painters would borrow current stylistic idioms and adapt them to contemporary needs or circumstances without rooting them in a philosophic matrix. Certainly, this worked extraordinarily well in the embrace of Impressionism by the Nagybánya painters; however, by about 1905 many felt a need for a modern Hungarian art that would assume both aesthetic and social responsibilities. And once again, Hungary looked westward to France for inspiration.

At the artists' colony of Nagybánya, younger Hungarian painters such as Béla Czóbel, Lajos Tihanyi, Sándor Galimberti, Vilmos Perlrott-Csaba, among others chose to follow the path established by the art of Cézanne and the Post-Impressionists. In an attempt to differentiate themselves from other Nagybánya artists, the younger group assumed the name "Neo-Impressionists," usually shortened to "neos"; increasingly they pursued a style parallel to fauvism in France and (early) expressionism in Germany. The emphasis on a return to a more free, almost natural, seemingly "primitive" style of art and life appealed to these painters as a means of affirming their "authenticity" as artists as well as their "modernity" as Hungarians. Moreover, emphasizing the free expression of the "natural" in life and art had been a Nagybánya characteristic from its founding a decade earlier and thus provided a native "tradition" to encourage this group both intellectually and artistically. So comfortable were the Hungarian painters with French fauvism that Czóbel (1883–1976) even exhibited with the fauves at the *Salon d'Automne*. Indeed, between 1905 and 1907 there was a positive flood of Hungarian painters pouring into Paris to absorb the newest ideas in art and culture: Czóbel, Ödön Márffy, Dezső Czigány, Sándor Galimberti, Valéria Dénes, Róbert Berény, János Máttis-Teutsch, Károly Kernstok, only to name the most prominent. Although unquestioningly important for introducing Post-Impressionist and later French styles into Hungary,[3] this group of artistic francophiles is significant for our purposes less for what they did than for what they would soon become: the first truly modern Hungarian movement, later known as The Eight.

From 1906 there appeared in Hungary, primarily in Budapest, a succession of increasingly radical artistic groups which drew intellectual nourishment from the various loose associations of poets, philosophers, composers, and students who were moving ever more to the leftist margin of a civilization they perceived as ossified.[4] In the summer of 1908, two specific events triggered the emergence of the band of radical painters which first called themselves—following the symbolist model—the "Seekers" but later assumed the name by which they achieved their greatest successes: The Eight.[5] First, the National Salon (*Nemzeti Szalon*) held an extraordinarily influential exhibition of "Hungarian Impressionists and Naturalists," an umbrella term under which artists of every antitraditional style or temperament banded together in a joint display of antiestablishment art. Rejecting the aristocratic emphasis on heroic subject matter rendered in a mimetic style, these painters sought to break down the assumptions on which traditional upper class taste was founded. Believing that art could spearhead the assault on society's conventions, eight of the

exhibiting painters decided to join together in a common effort to champion a new, politically engaged aesthetics. At almost the same moment as the artists were uniting in an assault on aristocratic values, the second triggering "event" occurred when a number of university students from Budapest formed a section of the Union of Freethinkers, a name which soon was changed to the Galilei Circle.[6] It was this circle of young radicals that served as the meeting ground for progressive intellectuals throughout the country; and from this association issued the intellectual and social theories that served as the ideological foundation of The Eight's (and later artists' movements') opposition to the prevailing class system. Thus the dual coincidence in 1908 of an art exhibition and an intellectual debating association brought together like-minded painters at a moment when they were well-disposed to be influenced by the ideas of social radicalism.

The Eight sought to create through their art a new system of values, social as well as aesthetic. Encouraged by the young György Lukács and other activists in the Galilei Circle. The Eight became convinced that art could mould the character of the age. Artists such as Károly Kernstok (1873–1940), the leader of the group, demanded that the modern painter also assume profound social responsibilities, thereby giving a political dimension to modern art. To enhance or exalt the social role of art, the artist would need to transform the structure and form of visual expression. Thus, The Eight consciously sought to penetrate the superficialities of appearance in order to reach the very structure of being through which to regenerate man. To do this, The Eight combined a manifestly antiimpressionist style with an heroic subject matter. This forced marriage of, variously, "Cézanneism", Cubism, and Expressionism with traditional genre types (still-lifes, nudes, portraits, and landscapes) produced striking results (figs. 3.4, 3.5). It was an original combination that affirmed The Eight's rejection of received values. Indeed, commenting on The Eight's first public exhibition, Lukács wrote of these new works as a declaration of war.[7]

To a large extent, the art of The Eight represented a social and aesthetic rebellion against what was perceived as the decadence of the prevailing culture, and especially its bourgeois values. Like others of their generation, they proclaimed themselves victims of society and denounced industrial capitalism with its emphasis on bourgeois individualism as the enemy of true social integration and cultural creativity. In this conviction they were spiritually akin to many nineteenth-century romantic revolutionaries who "despised the framework of the given world in order to be able to build another, future world at least on a few square feet of canvas."[8] What they desired was a radical restructuring of social relations in which the artist, would, according to Kernstok, "stand on the highest rung of the social ladder, where even if he will not enter into discussion with the gods, he will direct the spirit of the masses."[9] Thus the artist would move from the periphery of society to its very center, from being the servant of the ruling powers to arrogating to himself the authority of intellectual director. In this inverted hierarchy, it should be noted that the deposed classes, which in pre-World War I Hungary included both the powerful

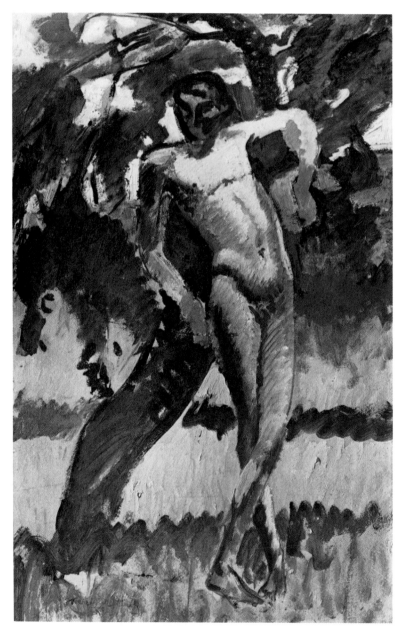

Figure 3.4.   Károly Kernstock, *Nude Boy Leaning against a Tree*, 1911
Oil on cardboard, 66 × 44 cm.
*(Magyar Nemzeti Galéria, by permission of the Hungarian National Gallery)*

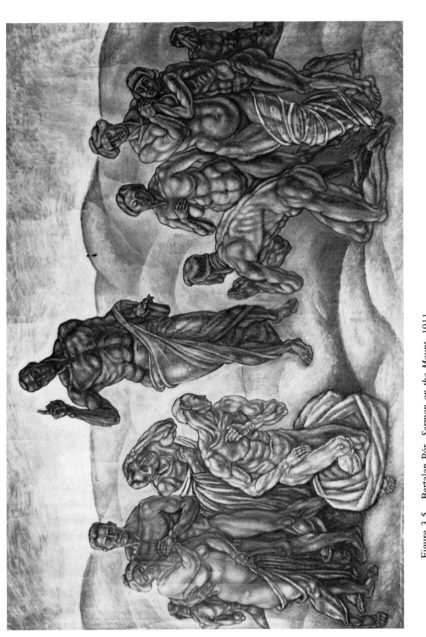

Figure 3.5.  Bertalan Pór, *Sermon on the Mount*, 1911
Oil on canvas, 245 × 445 cm.
*(On deposit with the Magyar Nemzeti Galéria, by permission of the Hungarian National
Gallery)*

aristocracy and the urban middle classes, were to be absorbed into the "spirit of the masses." Hence, at the heart of The Eight's artistic program was a fundamentally leftist social ideology. In the words of Róbert Berény, one of the artist-theoreticians of the group, the "artist must have recourse to those methods of communication which are capable of having an influence . . . which still possess the power to upset" and which will point the way to a new order.[10]

It should be noted that the artists of The Eight were hardly systematic philosophers or even serious scholars. Much of their philosophy of art—and by extension, life—was borrowed from what they heard discussed by the young intellectuals of the Galilei Circle. Their focus was on articulating the problems of the past and present, not on consolidating or systematizing an ultimate solution. As such, there is a naivety to their theory which often took the form of sloganeering. It is in their paintings, however, that one sees incarnated a powerful expression of a radically new view (fig. 3.6). Moreover, it was this belief in the obligation of modern art to transfigure reality into the "spirit of the masses" that galvanized the second, and most important, generation of avant-garde Hungarian artists.

As the authority and influence of The Eight diminished about 1913–15, there emerged in Budapest a new and far more radical band of artists who declared themselves "Activists."[11] Embracing literature, politics, and the arts, the Activists allied themselves with the cause of the workers' movement; and building upon The Eight's vision of a new, urban socialist arcadia, they, too, projected a utopian world in vaguely marxian terms.

Unlike The Eight, many of the Activists did stem from the lower or the lower middle classes, and thus their identification with the interests of the masses was perhaps more genuine, if not less romantic, than all earlier Hungarian artist movements. What the Activists lacked in formal education, they tried to pick up from attending the popularizing lectures offered by the young intellectuals of the Galilei Circle. It was from these impassioned university thinkers that they received their ideological indoctrination. From attending the debates held by the Circle, the Activists were persuaded that each creation of the modern artist was a *political* as well as an *aesthetic* act. This realization led the Activists to assert that the "poet and artist should go out and stand in the tempest" of political events. In order to unite the political and the artistic, it is not surprising to discover that these painters turned to a new medium as an appropriate expression of their commitment: the poster.

The importance of the poster in the art of the avant-garde will be discussed below. However, it is worth noting here that the Activists' embrace of poster art was only part of a broader commitment to new and more universal art forms that could address the conditions of an emerging new age. The principal vehicle for communicating this modernist message was *MA* (Today), the most important Activist periodical and one of the leading European "little reviews" of the epoch. *MA* was founded and edited by Lajos Kassák, the spiritual impresario behind the new Hungarian art, and a poet and essayist of note.

Figure 3.6. Ödön Márffy, *Old Customhouse in Vác*, ca. 1911
Oil on canvas, 69.5 × 90 cm.
*(Magyar Nemzeti Galéria, by permission of the Hungarian National Gallery)*

*MA* was not Kassák's—or the Activists'—first attempt to spread the revolutionary message of the new art (and literature). The year before *MA* was founded in 1916, Kassák published a short-lived innovative periodical entitled significantly *A TETT* (The Deed). This periodical, closely modelled after the German journal *Die Aktion* of Franz Pfempfert, was extraordinarily important at the time. In 1915, Hungarian artists felt themselves to be completely isolated and hard-pressed due to the World War, and this journal served as an avant-garde "lifeline" to what was progressive in contemporary literature and art. Additionally, the number of exhibitions, artists' gatherings, and intellectual meetings which had always nourished the avant-garde had been curtailed due to the exigencies of the war; *A TETT* helped to fill the vacuum. Finally, the Austro-Hungarian government exerted a relatively strict censorship on political and cultural activities which affected directly the left-leaning artist groups. These constraints severely hampered Activist contacts, communication, and expression. In these circumstances, the journal *A TETT* assumed a prominent role as a principal organ of avant-garde communication and activity among the Activist intelligentsia. Among the numerous articles of social commentary that appeared were several that challenged the validity of Hungary's participation in the war; others questioned the motives of the nation's leaders whom the Activists decried as the corrupt representatives of a stultified society. These articles, coupled with those that praised the work of such "enemy" (i.e., Czarist Russian) artists as Kandinsky, led to governmental confiscation and eventual proscription of the publication less than a year after its initial appearance in November 1915. However, within weeks, Kassák was able to bring out the first issue of *MA* (Today), the greatest periodical of the Hungarian avant-garde and one which far surpassed *A TETT* in artistic originality and intellectual rigor.[12]

**The Events**

Taking as its point of departure Kassák's belief that the Activists were witnessing the "beginning of a new epoch in the development of mankind,"[13] *MA* committed itself unreservedly to the newest and most engaged artistic and social manifestations of the international avant-garde. By virtue of *MA*'s manifold activities, Budapest achieved a stature as an avant-garde center, fully the equal to any to be found elsewhere in East-Central Europe at the time, a status that Budapest would enjoy until the great events of 1919. Already in 1917, *MA* and its supporters had begun to publish the work of the most progressive artists from Russia to Holland, to promote Béla Bartók and the "new music," to found one of Europe's most innovative theatres, to introduce new forms of typography to Eastern Europe, and in general to conduct through its pages the most elevated intellectual discourse in East-Central Europe. By July 1918, *MA* had attracted to the Activist cause most of the left-leaning Hungarian intelligentsia, either as contributors or as subscribers. In large measure this is directly attributable to Kassák's strength as an intellectual impresario of the

first order. Recognizing that the bourgeois radicalism espoused by The Eight (and even by many Activists) was out of step with the mood and the perceived needs of the collapsing Empire in 1918, Kassák steered the group of artists, philosophers, and literary radicals which coalesced around *MA* to an idealized view of the proletariat as the bearer (and receiver) of a new culture; and on their behalf the MA group demanded a social revolution which they themselves would help precipitate and from which they would become, ironically, among the first victims.

From October 1917 to October 1918, the MA Group of Activists increased its profile through the articles which appeared in its journal, and especially through the numerous exhibitions held under its aegis, particularly those which presented the radical art of Béla Uitz, Sándor Bortnyik, József Nemes-Lampérth, and János Máttis-Teutsch (figs. 3.7, 3.8). The government, which had successfully banned *A TETT*, was unable to censor *MA* effectively, for its very authority to govern at all was severely compromised by the disastrous course the war was taking, and even more by the domestic consequences of the military losses. Mounting domestic shortages of necessary goods and supplies, restive national minorities clamoring for independence from Magyar rule, and a working class radicalized by social democratic intellectuals (many of whom were avant-garde artists) further sapped the imperial government's authority. The Monarchy in Budapest was so weak that by October 1918 a Hungarian National Council arose under the leadership of Count Mihalyi Károlyi (1875–1955), a longstanding left-liberal opponent of the prevailing order.

The manifesto of the National Council demanded an immediate end to Hungary's participation in the war and complete secession of the Hungarian nation from the Dual Monarchy. Károlyi's National Council also demanded freedom of the press, amnesty for political prisoners, land reform, partial expropriation of "accumulated capital," and other radical reforms.[14] Nevertheless, despite the leftist nature of the National Council, the liberal aristocrat Károlyi desired royal sanction for his program and even wanted the King to appoint him prime minister. King Charles, a peace-loving and enlightened monarch, was unprepared to name Károlyi prime minister; neither was he receptive to a National Council made up primarily of Jewish socialists from Budapest. Events, however, were not under the King's control.

Already on 28 October 1918, units of the army were unable to quell the mass disturbances and protests against the government and in favor of the National Council. By 30 October, Budapest fell completely into the hands of radical soldiers' councils (soviets) which soon declared themselves loyal to Károlyi's leftists. Even the police rallied to the National Council; and on 31 October Károlyi presented a government to the people for popular acclamation. Later that day, the King reluctantly bestowed royal approval on the new government.

This October revolution was hailed as a great triumph for the workers and soldiers of Budapest; and many in the countryside hoped that social justice and peace would be the fruits of the new regime. Most shared the belief that the fran-

Figure 3.7. Béla Uitz, *Seated Woman*, 1918
Oil on cardboard, 87 × 69 cm.
*(János Panonius Museums, Pécs)*

Figure 3.8.   János Máttis Teutsch, *Dark Landscape*, 1918
Oil on cardboard, 60 × 69 cm.
*(János Panonius Museums, Pécs)*

cophilic Károlyi would be able to negotiate a generous peace treaty with the victorious Entente powers. These optimistic expectations would soon prove illusory.

Artists, too, rallied to the cause of the new National Council government. Károly Kernstok, leader of the former Eight, readily accepted an active role in the political and cultural policies of the Károlyi regime. Members of the Activist and MA groups also took up brushes and pens on behalf of the new government, especially after Hungary was declared a republic in mid-November 1918. Kassák brought out special supplements to *MA* to celebrate the new social possibilities; to demonstrate Activist support, he published in these *MA* supplements politically charged etchings by Bortnyik and extracts from Lenin's essay on "The State and Revolution".

Despite the enhanced activity by avant-garde figures on behalf of the new regime, many of the more radical painters felt frustrated. At base, the Károlyi government was a bourgeois republic. The form of social revolution for which the leftist painters, poets, and theorists had been clamoring was more in the Bolshevik vein. Moreover, these artists could see in nearby Russia the realization of a "truer" revolution that came into power only by toppling the liberal government of Kerensky, an event many artists wanted to emulate. Aggravating the Hungarian artists' disappointment with their liberal government was Károlyi's reluctance to invite the artists' participation in more than a purely incidental or symbolic role. Given the disastrous state of national dissolution, with innumerable competing parties and interests, Károlyi was hardly in a position to allow groups of extremely left-wing artists to introduce a comprehensive and costly cultural restructuring of society. By this time, however, the majority of the avant-garde had already been swept up in the swelling sympathy for Béla Kun's communist alternative.

The Communist Party of Hungary, founded on 20 November 1918 mostly by returned prisoners of war held and indoctrinated in (Soviet) Russia, never attained the cohesion or ideological discipline of the Russian party. Perhaps, this was part of its appeal to the (mostly urbanized, Jewish) Hungarians: the communists were perceived to be philosophically broad-based and "tolerant." With Russian Bolsheviks already in power, the Hungarian communists recognized a similar opportunity of becoming a government. These parallels with Soviet Russia were encouraged by Béla Kun, the returned prisoner of war who founded and led the Hungarian communists. In fact, Kun and his associates drew various analogies between the liberal Károlyi government and the ill-fated Kerensky regime, much to the popular discredit of Károlyi. So influential was the Communist Party's assault and so profoundly distressing were the economic and social conditions in Hungary during the Károlyi republic, that the communist propaganda and its political agitation seriously imperiled the liberal (bourgeois) republic. All that was needed to ensure its collapse was a further setback, and the Entente powers unwittingly provided it. On 20 March 1919, the Entente gave the Károlyi government an ultimatum according to which Hungary was to surrender even more territory to Roumania as a prelude to a peace treaty. By acceding to the Entente demand, Károlyi recognized that his government

would be denounced by Hungarians of every political persuasion for sanctioning the dismemberment of the nation. Rather than incur this ignominy, Károlyi resigned. The next day the Hungarian October revolution collapsed.

With the fall of Károlyi, the communists immediately and bloodlessly proclaimed a dictatorship of the proletariat with Béla Kun as *de facto* head of government.[15] The intelligentsia learned of the new Republic of Councils from György Lukács who was at that moment delivering a lecture to radical artists on "Culture: Old and New." This fortuitous coincidence of politics and culture presaged the close connection that would exist between Kun's communist regime and the Hungarian avant-garde.

The sympathy for the Republic of Councils on the part of radical artists was both immediate and genuine; for the first time artists perceived that the profound social reconstruction they had long desired might be realized. Additionally, they were offered a direct role by the Republic of Councils in shaping the culture of the new society, something they were denied under the Károlyi and royalist govern-ments. In a manner of speaking, Hungarian modernist artists were perfectly poised to exploit this opportunity since, for years, they had been agitating socially for revolu-tion and had been experimenting with visual vocabularies and forms of expression they thought ideal to serve the proletarian classes. Kun gave further encouragement to their hopes when he appointed to the position of people's commissar for culture and education none other than Lukács, the longtime advocate and theoretician of the artistic avant-garde.

With Lukács as commissar of culture, the Hungarian avant-garde was stimulated to heightened productivity. Moreover, the Republic of Councils, perhaps following the lead set by Soviet Russia with the encouragement of its "commissar for enlighten-ment" Lunacharsky, created a Directorate for Arts and Museums. To the Direc-torate's powerful central board were appointed other members of the avant-garde, most notably the painter and poster artist Róbert Berény, a member of The Eight and Activists. The Directorate was charged with a variety of responsibilities, all of which affected the avant-garde favorably. In order to reform higher education, the Directorate introduced radical changes to be executed by leftist artists. The School of Fine Arts, previously a bastion of academicism under the Monarchy and Károlyi government, was reconstituted and put under a new director more sympathetic to the style and aims of the avant-garde. So radical was the change there that Bertalan Pór (1880–1964), also an Activist veteran of The Eight, joined the faculty; and Róbert Berény was asked to teach master classes. To augment the School of Fine Arts, and to ensure that an avant-garde pedagogy was made widely available, the govern-ment created the Proletarian Fine Arts Workshop with the committed communist Activist Béla Uitz (1887–1971) as its director and with other Activists and MA sup-porters appointed to the faculty. In addition to these "formal" academies in Budapest, the Directorate encouraged the establishment of a series of free schools for the educa-tion of the masses. Károly Kernstok himself, who had previously served Károlyi,

now founded in the provinces a free school for young artists of proletarian origin. Even summer "art" camps for proletarian youths were projected, these to be staffed also by members of The Eight and Activists.

To publicize its goals and to advertise its proclamations, the government resorted to extensive use of posters, thereby putting into practice the program that Kassák advocated in 1916.[16] Those who were commissioned to execute posters reads like an index of the avant-garde: Mihály Biró, Berény, Pór, Uitz, Nemes-Lampérth, and many others who would continue to make major contributions to Kun's regime. Moreover, the government commissioned numerous art works in order to further its social policies, such as the serious campaign waged against alcoholism. Those avant-garde artists who were not directly commissioned often received indirect government support through the purchase of their work for state collections, especially for the Museum of Art in Budapest.

It should be stressed that the communist regime was hardly as tolerant as many, including the artists, had hoped. *MA,* the preeminent avant-garde periodical, immediately came into conflict with the new regime when Kassák and his Activist supporters refused to join the communist party, believing instead that they could best serve socialism by remaining an independent—though sympathetic—voice.[17] When Kun publicly disagreed, Kassák reproved the communist leader. Kun's outraged response was to label *MA* "an excrescence of bourgeois decadence," and to suppress it, thus chastening Kassák for his independent stand. The regime's programs were often excessive, in execution if not always in theory, in the field of education as well.[18] The government forbade nuns and priests to teach; and it nationalized all schools, thereby creating a critical shortage of trained teachers, a shortage hardly redressed by sending political ideologues and artists into the classrooms. In addition, Latin and Greek, perceived by the government as symbols of the academicism of the old regime, were forbidden to be taught. The attempt to reform education in order to ensure the "health" of the proletarian youth seemingly knew no bounds. A particularly controversial government decree required that "private individuals, possessing a bath tub, once a week all day Saturday, to allow children, with proper school certificates, to take a bath. The owners were to supply the necessary heat, light, towels, and soap without compensation."[19]

Through a series of excessive measures, the Kun government lost a great deal of its popularity. Moreover, the bloodless communist "revolution" was, in fact, less a revolution against Hungary's own bourgeoisie than an expression of Hungarian nationalism in the face of a devastating defeat and a humiliating occupation by "foreign" nationalities.[20] Thus, the very foundations of the Republic of Councils were unstable. Receiving little aid from the Soviet Union, and being unable to control dissident members of its own government, the communist regime was imperiled from its inception—despite the enthusiastic support of many radical artists. When Royal Roumanian troops began to defeat the makeshift Red Army of Kun's proletarian followers in the summer of 1919, the Republic of Councils was pushed to

the brink of collapse. Having lost the support of the majority of the Hungarian people and being faced with imminent military occupation by aggressive foreigners, Kun's regime turned even more to the artistic avant-garde to galvanize popular support. It was the greatest moment for the radical artists.

To inspire support for the embattled Republic of Councils, the avant-garde created some of its most potent imagery. Admittedly, the perilous condition of the country hardly left room for subtle expression. The artists, therefore, abandoned much of their internecine contention over the purposes and forms of modernist art in favor of agreeing on the necessity of straightforward propaganda on behalf of the communist regime. Facilitating this rapprochement was the absence of *MA*; for this journal of reasoned theoretical and artistic debate had already been banned by Kun in the summer of 1919. Paradoxically, what the government demanded from the artists, and what they so brilliantly delivered, had been originally advocated by Kassák in one of the first issues of *MA*: a poster art that could be employed for revolutionary effect. The avant-garde response to this revolutionary call necessitated a shift from "fine art" painting to large scale mass-produced art. Some of the consequences of this aesthetic revolution can be illustrated by comparing Bortnyik's *Red Locomotive* of 1918 with Uitz's *Red Soldiers, Forward!* of 1919.

In the *Red Locomotive* (fig 3.9), Bortnyik relies heavily on recognizable and associative imagery to communicate his message. Emerging from a cubist-derived background of flat planes of color, one sees frontally the red geometry of the locomotive rushing towards the spectator. The "tracks", though flattened so as to be compositionally contained within the picture plane, do break through the white "rhomboid" and penetrate to the very edge of the canvas. This suggests that the red train of the communist future is about to burst through the white area of reaction to enter our presence.[21] The selection of the locomotive imagery was deliberate, for in Hungary the railroad had served as an emblem of a dynamic new culture of industrial development since the third quarter of the nineteenth century, when Hungary had achieved a leading position in the manufacture of engines and had constructed one of Europe's most comprehensive network of railroads.[22] The choice of the color red for this engine reinforces the emblematic nature of the image: it is the motor force of the communist culture which approaches. In the turbulence of 1918, this was both a powerful and prescient theme. Bortnyik enhances the "modernism" of the message by exploiting the geometry of compositional forms. By employing overlapping planes, he both suggests and negates depth, thereby establishing a formal tension among the planes. Moreover, the colored planes both constitute and deconstruct the "imagery" of the locomotive and the railroad bridge in the upper left corner. This formal tension and pictorial vacillation is in itself suggestive of the political conditions at the moment of creation.

Formal references to synthetic cubism—which Bortnyik could have gleaned from *A TETT* and *MA*—and to the specifically Hungarian iconography of railroads suggest that Bortnyik was in 1918 still addressing his art to a rather elite audience

Figure 3.9.  Sándor Bortnyik, *Red Locomotive*, 1918
Oil on cardboard, 44 × 34 cm.
*(Museum of the History of the Hungarian Labor Movement, Budapest, by permission of the Hungarian National Gallery)*

of fellow members of the avant-garde and their supporters who would have been completely familiar with both the meanings and the language of this form of visual expression. By the next year, however, Bortnyik and his colleagues willingly accepted the necessity of addressing a much wider audience, if their art was to serve the revolution and defend the communist government of Béla Kun. Thus, Uitz largely abandoned the small, almost personal, scale of easel painting in favor of the heroic proportions and straightforward message of the political poster.

*Vörös Katonak, Elöre! (Red Soldiers, Forward!)* (fig. 3.10) was among the most effective of the posters intended to stimulate public support for the embattled Republic of Councils. It also demonstrates the stylistic compromises that addressing a mass public imposed on avant-garde artists. Here, Uitz capitalizes on expressionist drawing to simplify the forms, but he is careful to ensure that the advancing figures are easily recognizable. He "standardizes" the soldiers' bodies and reduces the individuality of the physiognomies. Nevertheless, in the relation between the four foreground figures and the seemingly endless procession of background figures, the composition is least effectively resolved. To ensure clarity of communication, Uitz employs bold red letters in the lower register of the poster to carry verbally the message that is only partially realized visually.

Perhaps, it was Bortnyik and Uitz's colleague, Bertalan Pór who most successfully resolved the conflicting demands of uniting in a poster a modern style, in this case a blend of futurism and expressionism, with an easily understood exhortatory message: *Világ Proletárjai Egyesüljetek! (Proletarians of the World, Unite!)* (fig. 3.11). Drawing on his familiarity with the Cézannesque heroic figure from his days as a member of The Eight and Activists, Pór here substitutes for the arcadia of the past a dynamically charged environment of the present. Heroically scaled nudes bearing elongated red banners stride forward, thereby creating a compositional vortex, the powerfully affecting movement of which is enhanced by the thick brushstrokes and roughly defined surfaces. Style and iconography unite to goad the spectator to action.

Despite the heroic efforts of the avant-garde on behalf of the Kun government, nothing could save the Republic of Councils. The proletarians who made up the Red Army were badly defeated in battle against the Czechs and Roumanians, and the squads of ideologues known as the "Lenin Boys" so terrorized the population that few new recruits to the communist cause were enlisted even with the exhortation of the avant-garde. Eventually, those Hungarian nationalists who had lent some legitimacy to the regime abandoned the government totally when their hopes for maintaining the territorial integrity of Greater Hungary were frustrated. On the first of August 1919, 133 days after it assumed power in a nonviolent revolution, the Republic of Councils collapsed as royal Roumanian troops entered Budapest.[23] That very day, Kun and a number of his commissars boarded a special train to Vienna to assume a life of exile.[24]

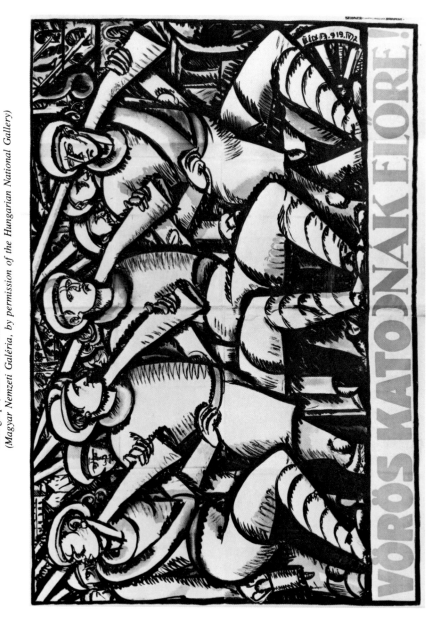

Figure 3.10.    Béla Uitz, *Red Soldiers, Forward!*, 1919
Lithograph, 126 × 192 cm.
*(Magyar Nemzeti Galéria, by permission of the Hungarian National Gallery)*

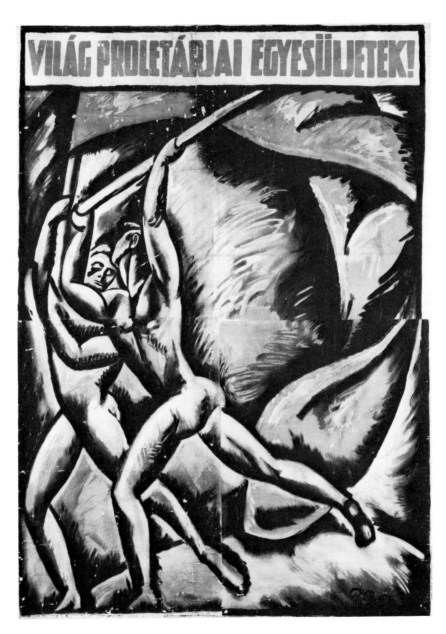

Figure 3.11.  Bertalan Pór, *Proletarians of the World, Unite!*, 1919
Lithograph, 237 × 184 cm.
*(Museum of the History of the Hungarian Labor Movement, Budapest, by
permission of the Hungarian National Gallery)*

**Aftermath**

Upon Kun's departure, a series of rather conservative prime ministers took over the government. All attempted to overturn the revolutionary changes promulgated under the Republic of Councils. Affirming the right to private property and the importance of traditional values, these governments took action against the supporters of the radical red regime. Communists were arrested, and their sympathizers faced interrogation and prosecution. By the time Admiral Horthy became regent in March 1920, almost the entirety of the avant-garde had fled Hungary in the face of the reactionaries' "white terror." The great revolutionary events of 1918–19 which catapulted the artists of the avant-garde to positions of prominence commensurate with their dreams were now to exert unanticipated effects.

Most of the Hungarian avant-garde went first to Vienna.[25] The choice of the Austrian capital was a logical one, and not just because Vienna was the former capital and cultural center of the Austro-Hungarian Empire and thus a natural focus for Hungarians. The new Austrian government was socialist and was thus perceived by the leftist artists as tolerant of their views. Additionally, by 1920 there was virtually an artistic vacuum in the Austrian capital which the Hungarians might effectively fill. Schiele, Klimt, and many other members of the Viennese Secession and expressionist movements, artists whose works were exhibited early in Budapest under the aegis of Hungarian avant-garde associations, were dead and their mantle had not been assumed by others. Kassák and his MA group hoped to take advantage of this opportunity to establish themselves as leaders of the new art in a major European capital. To a large extent, Kassák was successful: MA was reestablished both as an influential periodical and, at least until about 1922–23, as a loose association of avant-garde exiles. The Vienna MA group sponsored important art exhibitions, held intellectual "soirees" through which Russian and West European avant-garde art was introduced to Central Europe, and perhaps most importantly, created a new form of avant-garde expression.

Through the art and critical articles published in *MA,* as well as through the "Special Evenings" series of slide presentations—especially the Russian evening of 13 November 1920 in which slides of Kandinsky, Malevich, Rodchenko, Stepanova, Tatlin, and other modernist Russians were shown—Kassák was prompted to move beyond poetry to become a visual artist. Over the next two years, he steered *MA* towards Constructivism and even created his own unique variant, *"Bildarchitektur"* (fig. 3.12). With this "picture-architecture,"[26] Kassák attempted to move the Hungarian avant-garde away from its preoccupation with politically engaged modernism, a viewpoint which he had already advocated in the 1919 article that led to Kun's banning of *MA.* Kassák asserted that art must be absolute, universal, and autonomous. Its abstract quality must be both visual and philosophical, and no longer corrupted into functioning as proletarian art. In essence, he declared himself in favor of an "ideological anarchism" whereby he could partake aestheti-

Figure 3.12.   Lajos Kassák, *Bildarchitektur*, 1922
Ink and pencil on paper, 49 × 31.5 cm.
*(János Panonius Museums, Pécs)*

cally in "an endless revolutionary assault against the reader, the viewer, the listener, against the state, society, against the defender of the status quo."[27] Naturally, this view was not accepted by all; in fact, the more politically committed of the MA group, including Bortnyik and Uitz soon abandoned MA and Vienna in order to develop their own expressions of politically engaged modernism. However, Kassák was able to exploit his extensive experience as a publicist and his manifold contacts within the international avant-garde to solidify his position. *MA* was able to draw upon the work of Dadaists, Expressionists, Suprematists, and especially the emerging Constructivists (Dutch, German, and Russian) to fill its pages and enhance its stature. Moreover, Kassák's own *"Bildarchitektur,"* heavily indebted to Lissitzky's Proun compositions and philosophy of 1919–21, had almost immediately attained a level of sophistication that attracted favorable attention. Even Bortnyik pursued *"Bildarchitektur"* before leaving Vienna for Paris in 1924. Moreover, a younger generation, including Moholy-Nagy who (despite his noninvolvement with the Kun regime) followed Kassák to Vienna, readily allied itself to *MA*'s "absolutist" position. Moholy-Nagy was so influenced by Kassák at this time that he borrowed heavily from Kassák's *"Bildarchitektur"* to form his own "Glass Architecture" Constructivism, an early example of which Kassák published in the 1 May 1922 issue of *MA* (fig. 3.13).[28]

Although Vienna was a magnet for Hungarian exiles, a number of artists elected to emigrate to other capitals, especially after *MA* took a decidedly constructivist and less overtly political turn. Some, especially those who continued to work in an expressionist or futurist mode such as Hugo Scheiber (1873–1950) looked to Berlin where Herwarth Walden, a champion of progressive Hungarian art, seemed a promising source of support. Others, such as Bortnyik and Uitz, migrated to Paris or Moscow where they felt freer to create a politically charged modernism. But it was those Hungarians who eventually worked their way to Weimar who were, in the long run, to exert the greatest impact on the course of modern art.

Filled with the idealism of Hungarian modernism, yet chastened by the profound "events" of the 1918–19 revolutions, the younger followers of the Hungarian avant-garde were attracted to the promise of Walter Gropius's Weimar Bauhaus. The experience of living through a revolutionary epoch with all its great expectations and harsh realities conditioned these aspiring artists to recognize in the Bauhaus a haven where they might remain perpetual revolutionaries of radical liberation while building a new reality. Believing in Gropius's path to spiritual as well as artistic reconstruction, László Moholy-Nagy, László Péri, Alfréd Forbát, Marcel Breuer, and others eagerly moved to this new center for the education of the new man through the new art. There, the young Hungarian exiles would, in turn, infuse the Bauhaus, and through it, the modern environment, with a new vision forged in the crucible of Hungary's revolutionary events.

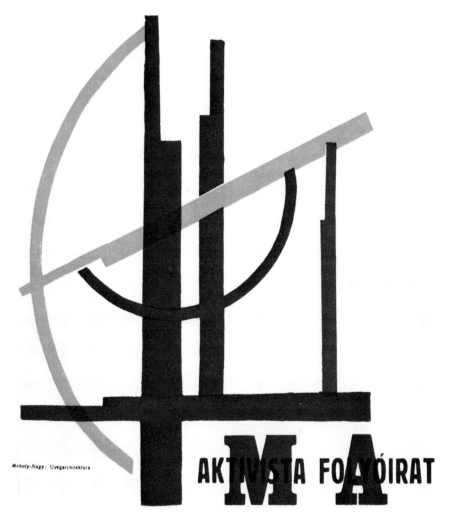

Moholy-Nagy: Üvegarchitektura

AKTIVISTA FOLYÓIRAT

MA

Figure 3.13.   László Moholy-Nagy, *Glass-Architecture*, Cover of *MA*, Ed. Lajos Kassák, 1 May 1922.
Based on a 1920 oil on canvas painting, *Bildarchitektur III*, now in Museum Wiesbaden.

## Notes

1. Sidney Hook, *The Hero in History* (Boston, 1943), p. 153.

2. For discussions of the political, artistic, and philosophical implications of Hungarian "Art Nouveau," see the exhibition catalogue, *Form and Spirit* (*Lélek és Forma: Magyar Művészet, 1816–1914*). ed. Gyöngyi Erí and Zsuzsa O. Jobbagyi (Budapest, 1986).

3. As early as May 1907, major exhibitions of the work of Cézanne, Gauguin, and the Post-Impressionists were able to be seen in Budapest. Especially important were those held at the National Salon (*Nemzeti Szalon*). See Julia Szabó-Marosi, "The Exhibitions of the International Avant-Garde in Budapest, Vienna and Berlin and their Influence on the History of the Hungarian Avant-Garde Movements," in the special publication on "Der Zugang zum Kunstwerk: Schatzkammer, Salon, Austellung, 'Museum,'" of the XXV. International Congress for the History of Art (CIHA) (Vienna, 1983).

4. For an excellent English language discussion of the intellectual climate in Hungary at this time, particularly as it affected the leftist intelligentsia, see Mary Gluck, *Georg Lukács and His Generation, 1900–1918* (Cambridge, Mass., 1985).

5. From the summer of 1909, the members of The Eight (Nyolcak) were Róbert Berény, Béla Czóbel, Desző Czigány, Károly Kernstok, Ödön Márffy, Desző Orbán, Bertalan Pór, and Lajos Tihanyi.

6. I know of no comprehensive studies of the Galilei Circle in Western languages. For a Hungarian discussion of the early phase of the Circle, see Zs. Kende, A., *The Foundation of the Galilei Circle* (*Galilei kór megalakulasa*) (Budapest, 1974).

7. G. Lukács, "The Ways Have Parted," in *Nyugat* (*The West*), vol. 1. (1910). Cf. Kernstok's programmatic lecture of 9 January 1910 to the Galilei Circle, later published as "Art as Exploration," in *Nyugat*. For an excellent English language discussion of the philosophical context of The Eight and the Activists, see Julia Szabó, "Ideas and Programmes: The Philosophical Background of the Hungarian Avant-Garde," in *Hungarian Avant-Garde: The Eight and the Activists*, exh. cat. (London, 1980), pp. 9–18. In 1909 Leo Popper, a member of Lukács's Sunday Circle discussion group, wrote from Paris that the road to contemporary art led "out of the stylistic chaos of Impressionism toward the solidity of still life, which, no matter what form it takes . . . it will bear the mark of the same inner certitude and simplicity of which architecture is the embodiment." Quoted in Gluck, p. 19.

8. Szabó, p. 12.

9. K. Kernstok, "The Social Role of the Artist," *Huszadik Század* (Twentieth Century), 1912.

10. R. Berény, "Communication in Painting," *Nyugat* (1913); also quoted in Szabó, p. 12.

11. The Activists was always a rather loose organization of artists, poets, critics, and others who joined together in order to sign manifestoes, exhibit works of art, hold public readings, or engage in debates. Although there never existed a "membership list", it is safe to label as "Activists" those painters who coalesced around Kassák's *MA*, both in Budapest and later in Vienna.

12. The *MA* that today is widely recognized as a major Constructivist periodical is the "second" journal edited by Kassák to bear the name. See below.

13. L. Kassák, "Programs," in *A TETT*, II, no. 10 (1916): 153.

14. For a summary of the National Council program, see Istvan Deak, "The Decline and Fall of the Habsburg Hungary, 1914–1918," in Ivan Volgyes, ed., *Hungary in Revolution, 1918–1919: Nine Essays* (Lincoln, Nebraska, 1971), especially p. 30.

15. Károlyi, who desperately sought to avoid a bloody revolution among the contending leftist parties, resigned in favor of a communist-dominated Revolutionary Governing Council under the presidency of Sándor Garbai. Not until early April was an election held for a National Congress of Soviets. Although Kun was officially one of the 34 commissars, he executed effective government leadership from the beginning of the Revolutionary Governing Council to the collapse of the Republic of Councils.

16. L. Kassák, "Posters and the New Painting," *MA* 1, no. 1 (November 1916).

17. In his "Letter to Béla Kun in the Name of Art," *MA*, 4, no. 7 (1919), Kassák wrote, "I honor you as one of the greatest political leaders, but allow me to express doubts about your understanding of art. . . . Your superficial criticisms harm . . . the fulfillment of the revolution." (Quoted in Gluck, pp. 215–16.) For an interpretation of Lukács's attitude toward Kassák and *MA* at this time, see Lee Congdon, *The Young Lukács* (Chapel Hill, 1983), esp. pp. 159–61.

18. See Frank Eckelt, "The Internal Policies of the Hungarian Soviet Republic," in Volgyes, *Hungary in Revolution.*

19. Quoted in Ibid., p. 64.

20. For a similar interpretation, see Alfred Low, "Soviet Hungary and the Paris Peace Conference," in Volgyes, *Hungary in Revolution,* p. 137.

21. An instructive stylistic and iconographic comparison might be drawn with El Lissitzky's 1919 political poster, "Beat the Whites with the Red Wedge." For the Activist debt to Lissitzky, see below.

22. For a discussion of the role of railroads in Hungary, see Ivan T. Berend, "From the Millennium to the Republic of Councils—Introduction," in Erí and Jobbágyi, *Form and Spirit,* p. 53ff.

23. As the ultimate consequence of Soviet Hungary's defeat by the Roumanians, Hungary's dismemberment was assured. Once codified in the Paris Peace Treaty, Hungary was to shrink from a pre-War size of 325,000 sq. km. to 93,963 sq. km., a loss of almost 72 % of its territory. Moreover, of about 10 million people of Magyar tongue before the War, more than 3,000,000 were assigned by the Peace Treaty to Successor States (Roumania, Czechoslovakia, Yugoslavia ).

24. Fleeing to Vienna, Kun was hardly warmly received. After being confined in various Austrian internment camps and hospital security wards, he was finally allowed to go to Russia in August 1920. After volunteering in the Russian Civil War and therein distinguishing himself, he was appointed Chairman of the Crimean Soviet where he was put in charge of the Bolshevik military and civilian forces. Acting against Moscow's orders, Kun ordered a mass execution of between 10,000 and 20,000 White Russian prisoners. Moscow then ordered Kun to Berlin where he was instructed to foment revolution. Once again, Kun acted excessively and his *putsch* was brutally suppressed with numerous communist casualties. Lenin personally ordered Kun back to Moscow where, upon being redressed by the Russian leader, the Hungarian communist suffered a heart attack. Kun was given a series of insignificant party posts until, in early June 1937, Stalin had him arrested for treason. On 30 November 1939, Béla Kun was executed in Moscow's Butyrka prison. See Rudolf L. Tokes, "Bela Kun: The Man and the Revolutionary," in Volgyes, *Hungary in Revolution.*

25. There has yet to be a comprehensive study of the Hungarian avant-garde in exile. For an excellent introduction to the subject, see Eva R. Bajkay, "Les Activistes Hongrois en emigration," in *Bulletin analytique des périodiques d'Europe de l'Est: Art, Architecture, Design* (Paris: Centre National d'Art Culture Georges Pompidou, 1981): 17–22; and Bajkay, "Die ungarische Avantgarde-Kunst im Wiener Exil 1920–1925," *Alte und moderne Kunst* 182 (1982): 34–37;

Eva Koerner, *Die ungarische Kunst Zwischen den beiden Weltkriegen* (Dresden, n.d.), (originally published in Hungarian, Budapest, 1963). See also Congdon, *The Young Lukács*, pp. 170–75.

26. See Eva Koerner, *Die ungarische Avant garde, 1909–1930* (Munich, 1971); Janos Brendel, "The *Bildgedichte* of Lajos Kassák: Constructivism in Hungarian avant garde Poetry," in exh. cat. *The Hungarian Avant-Garde: The Eight and The Activists*, pp. 31–37.

27. L. Kassák, "Letter about Aesthetics," in *Viennese Hungarian Daily (Bécsi Magyar Újság)*, 10 September 1920, quoted in Gluck, *Georg Lukács and His Generation*, p. 216.

28. For a discussion of Moholy-Nagy's relationship to Kassák and *MA*, see Krisztina Passuth, *Moholy-Nagy* (London, 1985), passim.

# 4

# From Energy to Idea:
# The Origins of "Movement" in the Event

*Roy F. Allen*

We conventionally define movements as manifestations of aesthetic and ideational trends. Cubism aims to complete our knowledge of reality by presenting different facets of objects simultaneously, superimposing one on another or depicting them monodimensionally side by side. Futurism tries to create an art more suited to the modern world by using telegraphic language, pictorial dynamism, simultaneity, and bruitistic sound based on noises in industrialized metropolises. Expressionism attempts to broaden perception of our world by means of intensive representation or distortion and concentration on internal states of being at the expense of reproducing external consensus reality. Dadaism rejects the restrictions of logical faculties by stressing arbitrary and illogical states of mind, abstraction, and nonsensical and incoherent forms of expression. Surrealism strives to lay bare the latent workings of the subconscious by favoring the representation of dream states and employing unrestrained modes of artistic expression, such as psychic automatism.

Such definitions are not inaccurate; they highlight distinctive and essential features. Their weakness is simply their limitedness, myopia, and selectivity. They telescope the perception of the art they define through a narrow lens, focusing on those features originally of interest to the artist only in his role as craftsman. They are reflective of a perspective on the work of art which results from removing it from its native context: once created by the artist, a work is capable of assuming an autonomous life in a museum or library; it has left the mind and hands of the artist who conceived it and gave it concrete form and has begun living a separate existence outside its source. But this sort of existence is only fragmentary.

All art, the moment it is given to the public, can be (and frequently is) reduced through critical analysis to certain stylistic and thematic ingredients. Such ingredients are only fragmentary reflections of the totality of factors which produced the work, a totality in which the artist was guided, and his work shaped,

by both his immediate intent and, in varying degrees of self-consciousness, his membership in a specific historical setting. The resultant work thus communicates, seen from one perspective, certain aesthetic and ideational features; from another, evidence of its origins in the actions and cultural heritage of its creator. The first message is usually evident but often ambiguous, the second usually unequivocal but often elusive. The two messages are thus potentially complementary: the first can give the second coherence, the second the first perspective.

Sensitivity to the conditioning matrix of art is especially important in the case of movements. Movement art is created not only out of a specific historical setting but also out of cooperation. The movement artist is working in collaboration with other artists and in the coaction of the activities which they are sponsoring. He is responsive, therefore, not only to his own impulses and aims, but also to those of his fellow artists and to those set in motion by events of which they are a part. A coherent understanding of the intrinsic implications of his work clearly requires insight into its extrinsic framework.

The voluminous records kept for us by adherents of Expressionism document the fact that the movement began as a mere gathering of artists in cafés, around editors of journals, in literary recitals, in parties and festivities, in demonstrations and exhibitions. The Expressionists were first brought together primarily by the accidental conjunctions of age, social background, attitude toward the status quo; by a mutual desire for freedom in life style, in thought, in artistic expression; by a mutual antagonism toward their elders; and by an indeterminate desire for change. Alternatives to established ideas and aesthetics were vague, tentative, and contradictory at the outset. Kurt Hiller's programmatic preface to a 1913 review of recent "progressive" poetry is typical of such statements in the early stages of the movement. He is evidently very sure of what he opposes, but is still groping for an alternative stance, and thus able to offer only the broadest of guidelines for a break with established canons in verse: the depiction of the two faces of urban life and the inclusion of language not traditionally accepted as poetic:

> I see the aim of poetic composition to be the intense exploration of experiences which the refined type of individual encounters daily, i.e., the faithful rendering of the myriad small and great splendors and afflictions in the lives of the intellectual urbanite. One does not have to eschew, amongst other things, foreign words and all manner of technical terms, rule out intellectual ingredients in the stuffy classical manner; one must offer concise and irridescent syntheses of our unique analytical sensations.[1]

It was only after some four years of activities, (not all of them exactly artistic, and very few of them determined by a coherent articulation of goals) that a lucid direction, shared in common by most of those involved, emerged. About this same time a name for the movement was adopted.[2] In a lengthy discussion of contemporary poetry written at this time (1915), which is much more manifesto than review, Kurt Pinthus could already write from a conscious sense of the developmental history behind the group whose work he advocated here. He was also able to act as

spokesman for its now elaborate and specific program, which he had been helping to develop during the years previous: the reorientation of poetic perspective away from consensus (middle-class) reality towards imponderabilities; sensitivity to the conditioning influence of social, cultural, political, and economic factors in urban life; the recognition of the value of nonrational experience and the questioning of the value of hyper-rationalism; the adoption of an ethical stance as the basis of art; and the attempt to encompass the totality of human experience in poetry.[3]

In the end, what coalesced virtually all the forces of the movement behind distinct principles was not an inherent force but a fortuitous, extrinsic, political event, by which the Expressionists were victimized as much as anyone else: the First World War. The dominant principles were thus political, not artistic. As the war progressed, and especially as it neared its end, the movement was politicized. Because of the simplification of issues this generally involves, politicization is, of course, one of the most efficient ways to achieve unity ideologically, a unity which can be translated easily—as Socialist Realism has taught—into artistic terms. The programs, like most of the art, are expectedly political in this period of Expressionism.[4]

The demise of the movement after the war is most generally attributed to its degeneration through popularization. But it can as easily be ascribed to its trivialization through a hard push of all adherents towards radical, systematic conformity—stylistically and thematically—by politicization. Futurism, which traveled to Germany from Italy via France just before the First World War, played a large role in providing Expressionism with a clearer perspective on how to make art and how to approach life philosophically. But even Futurism, which, upon its arrival in Germany in 1912/13, had a much more precise program than did Expressionism in the same period, had emerged out of mostly quasi-artistic events and tub-thumping stunts by F. T. Marinetti and company in Rome and Paris. R. W. Flint depicts the busy goings-on at the onset of the Italian movement in this way:

> Between 1909 and 1914, when D'Annunzio was self-exiled in France, Marinetti was master of the revels in Italy. Very rich, personable, loyal and courtly toward friends, immensely energetic, a maniac for action and overtness at any cost, he aroused and divided the cultural scene. Having broadcast his credo in the First Manifesto of 1909 and seized the initiative from D'Annunzio, who had been in many but not all respects his master, he scourged and ridiculed the quasi-academic routine of Italian cultural life. He was everywhere at once, thanks to the railroads, organizing, orating, propagandizing, staging exhibitions and theatrical "evenings" of music, recitation, and riot; clowning, providing a screen of systematically irrational uproar behind which his friends for the most part enjoyed themselves immensely.[5]

That first manifesto of 1909, generally known as the "Founding Manifesto of Futurism," is a sweepingly broad outline of a philosophical stance. It gives no space to specific ideas on style or a program of action for the future. It advocates a position that most any undiscriminating opponent of the status quo could adopt: love of danger, courage, and the beauty of speed; devotion to poetic ardor and

splendor; the glorification of war, and opposition to institutions such as libraries and museums which force man to live in the past. It opens with a stress on the activities which conditioned its composition, rather than on aesthetics or philosophical matters: "We had stayed up all night, my friends and I, under hanging mosque lamps with domes of filigreed brass, domes starred like our spirits, shining like them with the prisoned radiance of electric hearts. For hours we had trampled our atavistic ennui into rich oriental rugs, arguing up to the last confines of logic and blackening many reams of paper with our frenzied scribbling."[6]

The "Technical Manifesto of Futurism" of 1912, on the other hand, is a true exercise in fixing artistic strategy. It was drafted by Marinetti and his group three years into their concerted efforts. They had obviously discovered where they wanted to go by this time. After a short introduction, which gives the cultural setting of the composing of this broadsheet, it enumerates a very specific program: destruction of syntax, use of infinitives, abolition of the adjective, stress on the use of compound nouns, and abolition of punctuation. The specific philosophical perspective is set in later items, centering on an advocacy of the destruction of the "I" in literature: i.e., substituting for human psychology an attempt to give objective representations of matter, allowing objects to speak for themselves without having to submit to anthropomorphism.

It is important to recall that Futurism entered Germany not by subtly infiltrating the minds and aesthetic sensitivities of avant-garde writers, but in event form. The movement was introduced to the Germans through the iconoclastic antics of Marinetti as he rode through the streets of German cities in one of the new-fangled horseless carriages, flinging his manifestoes into the hands of bystanders, or as he gave provocative lectures at exhibitions sponsored by Herwarth Walden's journal *Der Sturm*. The kind of obtrusive public exposure which his program enjoyed forced German critics and writers to come to direct and conscious terms with his radical demands for change.

Two young writers, who had served their apprenticeships in Expressionism under the tutelage of Wassily Kandinsky and others in Munich, came to Berlin just before the outbreak of the First World War. They subsequently carried the legacy of Marinettiesque tactics with them to Zurich, where they initiated another movement. The writers were Hugo Ball and Richard Huelsenbeck; the burgeoning movement was Dadaism. Ball, however, added an even more strongly event-oriented thrust to things, imposed on him, willy-nilly, by his and Emmy Henning's year of minimal vaudeville existence in Switzerland, just prior to being joined there by Huelsenbeck, Tristan Tzara, Hans Arp, Marcel Janco, and Marcel Slodki at the Cabaret Voltaire in Zurich in 1916. Records of Dada demonstrate that Ball and Hennings did not establish the Cabaret Voltaire—out of which Dada, in scarcely more than name only, was eventually to emerge—on the basis of a set of specifically aesthetic or philosophical principles. It was the product of a material need, the need to survive in a world made difficult by the restrictions on emigré labor prescribed by the Swiss government. The press notice which Ball and Hennings issued in early February

1916, calling for supporters of their new venture, foresaw initially no more than the erection of a stage on which gainful employment for artistic talent could be pursued:

> Cabaret Voltaire. Under this name a group of young artists and writers has been formed whose aim is to create a center for artistic entertainment. The idea of the cabaret will be that guest artists will come and give musical performances and readings at daily meetings. The young artists of Zurich, whatever their orientation, are invited to come along with suggestions and contributions of all kinds.[7]

Once brought together in the motley mix fostered by Ball's indiscriminate call in that ad, the Dadaists produced in the next three months of activities on the Cabaret Voltaire stage, through the artistic stimulation induced by the demands of daily performances, and in the many conversations before and after performances in their favorite meeting places, no coherent formulations of an aesthetic or ideological direction, either in artistic creations or programmatic pronouncements. Ball described what they had accomplished in the meantime in the introduction to their first group-initiated publication, the almanac *Cabaret Voltaire,* which appeared in May, 1916. The placement of this contribution on the first page of such a publication would normally make it read as the group's position statement; it is, in reality, only a discursive tale of events that immediately preceded and followed the Cabaret Voltaire's founding:

> When I founded the Cabaret Voltaire, I was sure that there must be a few young people in Switzerland who like me were interested not only in enjoying their independence but also in giving proof of it. I went to Herr Ephraim, the owner of the Meierei, and said, "Herr Ephraim, please let me have your room. I want to start a night-club." Herr Ephraim agreed and gave me the room. And I went to some people I knew and said, "Please give me a picture or a drawing, or an engraving. I should like to put on an exhibition in my night-club." I went to the friendly Zurich press and said, "Put in some announcements. There is going to be an international cabaret. We shall do great things." And they gave me pictures and they put in my announcements. So on 5th February we had a cabaret. Mademoiselle Leconte sang French and Danish chansons. Herr Tristan Tzara recited Rumanian poetry. A balalaika orchestra played delightful folk-songs and dances.[8]

We should not read this as Dadaist tongue-in-cheek flimflam, but as a simple, straightforward record of the facts.

The extant correspondence of Ball, Tzara, and others involved in those events corroborates such a reading of Ball's statement.[9] Dada was, as other reports by Ball and his associates make evident, initially no more than an entertainment scheme, with no more underpinning of thought than the desire to retain, and give artistic expression to, individual "independence." But even such independence was checked consistently by the audience whose responses largely guided the works and actions of the performers both on- and offstage. Ball entered in his diary under March 2, 1916:

Our attempt to entertain the audience with artistic things forces us in an exciting and instructive way to be incessantly lively, new, and naive. It is a race with the expectations of the audience, and this race calls on all our forces of invention and debate. One cannot exactly say that the art of the last twenty years has been joyful and that the modern poets are very entertaining and popular. Nowhere are the weaknesses of a poem revealed as much as in a public reading.[10]

The focus on the need to survive materially and the relegation of artistic and programmatic consistency to after-the-fact or adventitious gains informed Dada in Zurich from beginning to end. The energy of the Zurich Dadaists was funneled mainly through cabaret performances, recitals, exhibitions, and preparations for publications of new journals and series. Little stylistic or thematic conformity developed; what there was of it seemed to appear always as a by-product. Tzara's official declaration of the launching of the movement in the entry for July, 1917, in his "Zurich Chronicle" is still anticipatory. The lack of artistic cohesion was also a major cause of the dissolution of Dada in Zurich and its emigration to Germany and France.[11] Some of the artistic tendencies which had become characteristic of the work of the Zurich Dadaists had found parallel artistic expression in Germany and France by the end of the war, having either filtered through from Switzerland or developed in response to similar cultural circumstances. In both instances, however, the development of group alignments under the banner of Dada, as concept or mere name, was precipitated by events staged by ex-Zurich Dadaists. In Berlin, it was Huelsenbeck, who had moved there from Zurich in early 1917, that got things started through his cooperation with the circle around *Neue Jugend* and the staging of the first Dada event: the reading of his "First Dada Speech in Germany" in the art salon of I. B. Neumann on January 22, 1918. In like manner, Tzara launched Dada in Paris, where he arrived in early 1920, through his cooperation with the group around *Littérature* (Breton, Aragon, Soupault, et al.) and participation in a number of public soirées in the first months of his residence in the city.

In such a short treatise there is no space to consider in any degree of detail more of the many movements which have appeared in our century. But they all, if they become full-fledged movements (i.e., groups or complexes of groups of artists who work self-consciously in concert towards specific goals), begin and mature, not in the quiet, ingenuous adoption of strictly textual or painterly principles, but in the busy doings or noisy hubbub of palpable confrontations with social reality. In such a context, the energy artists put into their activities is transformed into a new set of aesthetic and ideological principles by the structure and coherence which the tangible nature of their text or canvas demands. The event, moreover, remains, even after a movement's inception, an integral part of its life and a necessity for its continuing vitality. André Breton thus placed the staged event ahead of all other forms of expression when he described, in his "Second Manifesto of Surrealism" (1930), the essential Surrealist act in this way: "The simplest Surrealist act consists of dashing down into the street, pistol in hand, and firing blindly, as

fast as you can pull the trigger, into the crowd.''[12] Certainly the most obtrusive expressions of movements are normally registered in such events: the participation of Expressionists in the German Revolution at the close of World War I, Marinetti's memorable rides through the streets of Berlin on campaigns for Futurist programs, Johannes Baaders' aggressive intrusion (in the name of Dada) into the very first meeting of the new National Assembly of the Weimar Republic in Germany in February, 1919. And it was no different with Surrealism, despite the heavy overtones of seriousness which Breton's papal severity lent to the movement and which seemed to distinguish it so dramatically from Dada.[13] From the proto-Surrealist trial of Maurice Barrès in Paris in 1921, which marked the end of Tzara's collaborative work with Breton and his associates, to the establishment of the Bureau of Surrealist Research and its organ *La Révolution surréaliste* in 1924, stagy actions and organizational maneuvers were more decisive than recondite program or enigmatic canvases in Surrealism's rise to fame.

Artistic or quasiartistic activities of the sort I have described, which have a formal structure and issue from a central impulse to create a public forum for artistic expression, require organizers. Such figures seem of critical importance to the creation of movement art. Each movement in our century has had one. They have been, most often, ambitious individuals with a talent for finding financial support and unifying, behind a single cause or direction, a disparate group of very individualistic artistic personalities. They have been most often entrepreneurs as much as formulators of a new aesthetic theory, manipulators of the organizational and promotional services crucial to public success as much as articulators of a new conception of reality, editors and patrons of others' work as much as creators of their own. Most often the ability of such architects of the event to muster financial support and creative talent needed to start a new journal, publishing house, exhibition, or cabaret has been more decisive in the initiation of a new movement than any purely artistic factors. Expressionism would, in this sense, hardly have been possible *as a movement* without Kurt Hiller's leadership of the "Neuer Club," Franz Pfemfert's editorship of *Die Aktion,* Herwarth Walden's management of the many enterprises of the *Sturm* circle, Alfred Richard Meyer's and Paul Cassirer's sponsorship of a host of painters and writers. In the same sense, Futurism could clearly have been called with equal justice, although not equal sonority, Marinettiism. Dada broke up in Zurich because of the questionable effectiveness of Tzara's leadership and his inability to replace Ball's efficacious guidance.[14] The later successful consolidation of its representatives in Berlin and the continuing conflicts and fallings-out amongst its adherents in its Parisian version can just as well be attributed to the actions of its respective leaders at these stages—namely, Wieland Herzfelde in the former and Tzara in the latter case—as it can to other, more purely artistic or ideological factors or any intervening politico-economic and social conditions. The degree of cohesion within movements seems to depend first and foremost on the intentions and talents of such individuals. To use Dada as an ex-

ample once more: Herzfelde had clear, straightforward artistic and political aims in mind for his Berlin group; Tzara, on the other hand—as one chronicler of his activities has reported—never wanted anything but scandals.

Restoring to our awareness the event origins of movement art is of value if it accomplishes no more than requiring us to recall, with refreshing honesty and humility, the beginnings of all art in what are generally quite mundane, quotidian, even trivial doings. But, of course, such an awareness can do much more for our critical perception. By helping us to understand better the conditioning framework of a work of art, it can help us in turn to appreciate better its original intent. In some cases, it may give us our only coherent comprehension of a work. Intrinsic approaches to Dada poetry, for example, have harvested little meaning. Ball's sound poem "Karawane," to cite a notorious instance, has consistently resisted such interpretation. We need only recall, however, that the poem was written to be recited on a cabaret stage, whose major objective was, of necessity, to be "incessantly lively, new, and naive."[15] We need only recall, in addition, that it was first presented in such a forum by Ball himself, dressed in a madcap version of what he later described as a bishop's robe and miter, chanting in liturgical style. By doing this, we restore to the poem its original context and thereby rediscover its original waggishly parodical intent. With this knowledge in mind, we can then better assess the importance of secondary implications of the resultant work (e.g., the degree of self-conscious thought behind a seemingly new aesthetics of poetic language).[16]

Most importantly, the reconstruction of these basically human origins of art also restores to art its humanity. A work appreciated for its separate manifestation of certain qualities of form and content alone is, in my view, art robbed of its human essence. The single work represents only a fragment of meaning. It can only recover its total significance through its relationship to a larger context. Movement art can, in the same way, only recover its fullest and clearest meaning in the context of its wholeness, which is the event staged by the artist.

### Notes

1. Kurt Hiller, "Zur neuen Lyrik," *Expressionismus: Der Kampf um eine literarische Bewegung,* ed. Paul Raabe (Munich: Deutscher Taschenbuch Verlag, 1965), p. 25. Trans. into English mine.

2. *Der Kampf,* ed. Raabe 296; Armin Arnold, *Die Literatur des Expressionismus: Sprachliche und thematische Quellen* (Stuttgart: Kohlhammer, 1966), p. 11; Roy F. Allen, *German Expressionist Poetry* (Boston: Twayne, 1979), pp. 18–20.

3. Kurt Pinthus, "Zur jüngsten Dichtung," *Der Kampf,* ed. Raabe, pp. 68–79.

4. Eva Kolinsky, *Engagierter Expressionismus: Politik und Literatur zwischen Weltkrieg und Weimarer Republik* (Stuttgart: Metzler, 1970), passim; Allen, *German Expressionist Poetry,* pp. 75–76. Roy F. Allen, *Literary Life in German Expressionism and the Berlin Circles* (Ann Arbor: UMI Research Press, 1983), pp. 31 ff. and passim. See the manifestoes reprinted, e.g., in Paul Pörtner, *Literatur Revolution 1910–1925: Dokumente, Manifeste, Programme* (Neuwied: Luchterhand, 1961), vol. 2.

5. R. W. Flint, "Introduction," Marinetti, *Selected Writings,* ed. R. W. Flint, trans. R. W. Flint and Arthur A. Coppotelli (New York: Farrar, Straus and Giroux, 1972), pp. 3-4.

6. F. T. Marinetti, "Manifesto of Futurism," *Selected Writings,* trans. Flint, p. 39.

7. Hugo Ball, *Flight Out of Time: A Dada Diary,* ed. John Elderfield, trans. Ann Raimes (New York: Viking, 1974), p. 50.

8. Hans Richter, *Dada: Art and Anti-Art* (New York: Oxford, 1978), pp. 13-14.

9. Hugo Ball, *Briefe: 1911-1927,* ed. Annemarie Schütt-Hennings (Einsiedeln: Benziger, 1957), 45ff; Hugo Ball and Emmy Hennings, *Damals in Zürich: Briefe aus den Jahren 1915-1917* (Zürich: Arche, 1978); *Zürich, Dadaco, Dadaglobe: The Correspondence between Richard Huelsenbeck, Tristan Tzara and Kurt Wolff (1916-1924),* ed. Richard Sheppard (Fife: Hutton Press, 1982); *New Studies in Dada: Essays and Documents,* ed. Richard Sheppard (Driffield: Hutton Press, 1981), pp. 107-43. See also Ball, *Flight,* pp. 17-130.

10. Ball, *Flight,* p. 54.

11. I investigated Zurich Dada's failure to become a full-fledged movement in Roy F. Allen, "Zurich Dada, 1916-1919: The Proto-Phase of the Movement, " *Dada Dimensions,* ed. Stephen C. Foster (Ann Arbor: UMI Research Press, 1985), pp. 1-22.

12. André Breton, "Second Manifesto of Surrealism," André Breton, *Manifestoes of Surrealism,* trans. Richard Seaver and Helen R. Lane (Ann Arbor: The University of Michigan Press, 1986), p. 125.

13. Maurice Nadeau, *The History of Surrealism,* trans. Richard Howard (Middlesex: Penguin Books, 1973) p. 93.

14. See note 11, above.

15. Ball, *Flight,* p. 54.

16. Ibid., pp. 70-71.

# 5

# *Portugal Futurista*

*Hellmut Wohl*

On April 14, 1917 the Portuguese writer and painter Almada Negreiros organized a Futurist evening at the Teatro República in Lisbon in the course of which he read manifestos by himself, Marinetti, and Valentine Saint Point. The event was sparsely attended by an audience composed of intellectuals, artists, writers, and journalists, and was frequently interrupted by protests from the hall. It was fully covered by the newspapers, who ridiculed it and characterized its protagonist as a madman. Seven months later, in November 1917, Almada published the first and only number of the review *Portugal Futurista,* its title adapted from the Italian review *L'Italia Futurista,* which had a run from June, 1916 to February, 1918. *Portugal Futurista* was confiscated by the police before it could be distributed. Only a few copies have survived, though a reprint of it was issued in 1981. The action of the police effectively brought to an end the already faltering episode—it can hardly be called a movement—of Portuguese Futurism.[1] In order to understand Almada's initiatives, we must look at them in the context of the historical events which shaped modern Portugal and to which they could not help but respond.

Futurism in Portugal differs from avant-garde movements in Italy, France, Germany, or England in degree: while it shared with these an advocacy of the overthrow of the past, it more aggressively sought to revive and recuperate aspects of this past than did those other movements. For Portugal, historic eminence had evaporated at the end of the Age of Discoveries in the second half of the sixteenth century. Nine years before Almada's Futurist evening, the one thread that connected the nation with its former greatness was broken. On February 1, 1908 King Carlos I was shot through the head as he rode with his family across Lisbon's Praça do Comércio in an open carriage. A second shot killed his son and heir, Prince Luís Filipe and the monarchy received a mortal blow. The role of king, inaugurated in the twelfth century by Afonso Henriques as the symbol of Portuguese independence from Spain, and renewed by João of Avis as he defended that independence at the Battle of Aljubarota in 1385 (that role so intimately bound up

with Portugal's national identity) was ended. The murdered king was succeeded briefly by his younger son, Manuel II, but in October 1910 Manuel was unable to rally a defense against an uprising by elements of the army and navy and by Republican revolutionaries. When a young German diplomat was seen walking slowly to the Rotunda of Lisbon with a white flag the fighting stopped. The revolutionary forces marched down the Avenida da Liberdade, behind the German, who had, in fact, merely been accompanying some of his compatriots to safety. King Manuel drove by car to the coastal town of Ericeira and embarked by yacht for England.

The Republic was proclaimed on October 5, 1910. A provisional government was formed, with Teofilo Braga as president; Bernardino Machado (professor of philosophy and head of the Republican party) as minister of foreign affairs; and Afonso Costa as minister of justice. On February 24, 1916, acting upon a British request, the Portuguese seized thirty-six German ships in their ports, and Germany declared war. Two Portuguese divisions were trained and sent to the front in northern France; other forces were sent to Africa to fight the Germans there. After the Armistice of November 1918, Portugal received a share of reparations and, more importantly, obtained recognition of her African colonies; however, the war had been unpopular with the Portuguese, and their dissatisfaction had led to revolt. Despite the able management of Afonso Costa, the government had not been able to prevent shortages of commodities and food. Rationing had been instituted and repressive measures taken to curb social unrest. In December, 1917, one month after the publication and confiscation of the single issue of *Portugal Futurista,* a military revolt with popular support put its leader, Major Sidónio Pais, in power. Although his regime was modeled on American presidential lines, it merely disrupted existing structures without effectively dealing with the problems that had brought about the revolt. One year later, Pais was assassinated, and Portugal was faced with an alarming crisis that was to last for some years. Rampant inflation and economic and social problems exploded, and although these problems began to abate after 1923, anarchy and dissatisfaction persisted. The old political cadre had lost the power to govern. A new group of military officers, returned from the war with the experience of leadership and public prestige, began to involve themselves in politics, using as their models the new Fascist regimes in Italy and Spain. There were open calls for dictatorship as the only solution to Portugal's ills. On May 28, 1926, the war hero General Gomes da Costa rebelled in Braga and marched on Lisbon. Four days later, President Bernardino Machado resigned and General Carmona became the head of government. António de Oliveira Salazar, an obscure professor of economics from the University of Coimbra, was appointed minister of finance and after his first year in office turned the nation's staggering deficit into an almost equally large surplus. By 1929, Salazar began to be perceived as the Man of Providence for whom the Portuguese messianic tradition had always sought, and in November, 1932 he became prime minister, a post he held until

he was felled by a stroke in 1968. By the new constitution put into effect by Salazar, in 1933, Portugal became a corporate, authoritarian state. Political parties, unions, and strikes were outlawed; censorship—including prior censorship in the case of newspapers, periodicals, and films—was enforced; and the political police were reorganized and strengthened with German and Italian advice. This system remained in place until April 25, 1974, at which time a group of junior military officers staged a revolution in Lisbon and the Salazar regime was overthrown.

As early as 1880, Republicans had sought to present themselves and their cause as renewing the greatness of the Portuguese past. The spectacular tercentenary celebrations in that year of the death of Luís de Camões had paraded the great poet of the Age of Discoveries as a symbol and focus for patriotism. Thus, at the Republic's inception patriotism and pride in the past were allied with hope for the future. For some this hope meant an ideology that would link the remote and mythic past with a vigorous modernity. For a handful of Portuguese artists and poets living in Paris at that time, it became what Renato Poggioli has identified as the "activist moment" of Futurism, when an avant-garde movement "takes shape and agitates for no other end than its own self, out of the sheer joy of dynamism, a taste for action, . . . and the emotional fascination of adventure."[2] Nineteen years later, Marinetti's *Futurist Manifesto* was published in *Le Figaro* on February 20, 1909. Its second publication was in the February–March issue of the review *Poesia,* and its third appearance was in Portuguese, in the *Diário dos Açores* on April 5, 1909. The first Portuguese painting that made a decisive break with both the naturalistic and academic traditions of the nineteenth century and the linear stylization of the *fin de siècle* was the savage *Head* of 1910 by Santa Rita (fig. 5.1), executed in the year of that artist's arrival in Paris as a *boursier* of the Lisbon Académia de Belas Artes. The work's ironic, mechanical-primitive-musical character, indebted to ideas of Marinetti as well as to Cubist compositions by Picasso of 1909–10, justifies Santa Rita's claim to the director of the conservative Lisbon journal *A Idea Nacional* (in a letter of April 26, 1916), that "Portugal has one declared Futurist—myself."

Futurist ideas were brought to Lisbon by Santa Rita and the poet Mário de Sá-Carneiro, when they returned home following the outbreak of hostilities. Both had been greatly impressed by Marinetti's glorification of the machine and by his call for liberation from the bonds of the past through violence and revolution. Lisbon Futurism never spread beyond the confines of the capital and was restricted to the collaborators of the review *Orpheu,* the most important of whom, besides Santa Rita and Sá-Carneiro, were Almada Negreiros and Alvaro do Campos (one of the heteronyms of the poet Fernando Pessoa). *Orpheu* ended after two issues in March and July, 1915. The first issue included Alvaro de Campos's Whitmanesque *Triumphal Ode,* written in London in 1914. Its first two stanzas adumbrate the whole of this long poem:

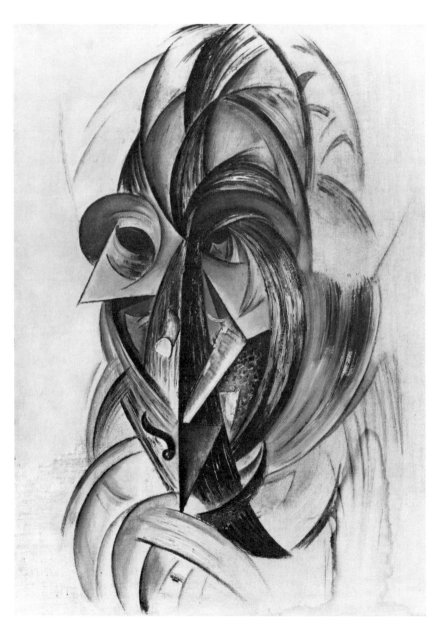

Figure 5.1.  Santa Rita, *Head*, 1910
Oil on canvas, 65 × 45 cm.
*(Secretaria de Estado da Cultura, Lisbon)*

By the swinging glare of the factory's powerful electric lamps
I have a fever and write.
I write grinding my teeth, a wild beast for the beauty of that,
For the beauty of that, that was absolutely unknown to the ancients.

O wheels, O gears, everlasting r-r-r-r-r!
Strong, contained spasm of the mechanisms in fury!
In fury outside and in me,
Through all my dissected nerves outside,
Through all the nipples on the outside of whatever I perceive with!
I have lips parched. O huge modern dins,
From hearing you intemperately close to,
And my head is burning from trying to sing of you with an excess
Of expression for every one of my sensations,
With an excess that is your contemporary, O machines![3]

The second number of *Orpheu* contained Sá-Carneiro's poem *Apotheosis* celebrating industrial typography, commercial signs, billboards, numbers, letters, and the noises of the street, in the manner of Marinetti's *parole in libertà*. *Orpheu 2* also included reproductions of four Cubist collages by Santa Rita whose titles were derived from the text signed by Boccioni, Carrà, Russolo, Balla and Severini in the catalogue of the Italian Futurist exhibition at the Galerie Bernheim-Jeune in February, 1912; for example, *Dynamic Decomposition of a Table. Rendering of Movement (Plastic Intersectionism)*. They provoked a machine caricature of Santa Rita by the Lisbon illustrator Stuart Carvalhais, published in *O século cómico* of July 8, 1915, contemporary to the month of Francis Picabia's machine portrait of Marius de Zayas in the July-August, 1915 number of *291*.[4]

The most gifted and productive painter associated with Portuguese Futurism, though stylistically he was not a Futurist but a Cubist, was Amadeo de Souza Cardoso.[5] The only picture by Amadeo that is connected with Italian Futurism at all is so by virtue of its title, which was bestowed on the painting by the Lisbon Futurists (Amadeo himself worked in the north of Portugal near Amarante) when the work was shown at the Liga Naval in Lisbon in December, 1916: *Dynamic Arabesque / Royal / Ochre Rouge Café / Zig-Zag / Metallic Vibrations / Mechano-Geometric Splendor / Vagabond / Cuirassier / Mandolin* (fig. 5.2). Almada Negreiros seized the occasion of Amadeo's exhibition to write a manifesto, published in the catalogue, expressing his characteristically brash hopes for national renewal:

> The exhibition of Amadeo de Souza Cardoso at the Liga Naval in Lisbon is the concise document of the Portuguese race of the twentieth century. The Portuguese race does not need to be rehabilitated, as short-sighted traditionalists would have it; what is needed is that it is born for the century in which the world is living. The discovery of the sea route to India no longer belongs to us because we did not physically participate in it, and also because for Portugal it belongs to the fifteenth century.
>
> We, the Futurists, know no history. We know only life as it exists for us. . . . In even greater measure, Amadeo de Souza Cardoso belongs to the avant-garde in the greatest of conflicts, universal thought.

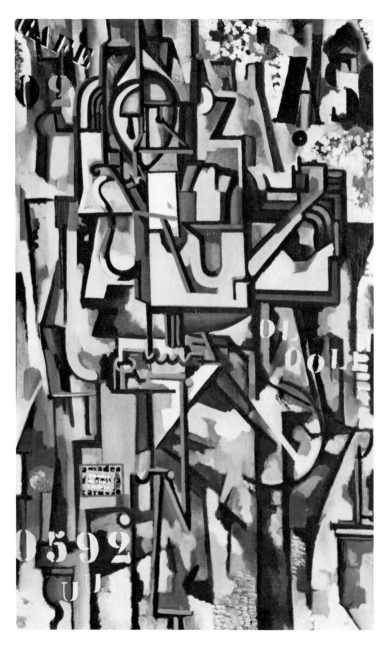

Figure 5.2   Amadeo de Souza Cardoso, *Dynamic Arabesque*, 1915–18
Oil on canvas, 100 × 60 cm.
*(Centro de Arte Moderna, Fundação Calouste Gulbenkian, Lisbon)*

Amadeo de Souza Cardoso is the first discovery of Portugal in the twentieth century. The limit of discovery is infinite because the meaning of discovery changes in substance and grows in interest—which is why the discovery of the sea route to India is less important than the exhibition of Amadeo do Souza Cardoso at the Liga Naval in Lisbon.[6]

In order to fully understand Almada's hyperbole we should remember that, although from the chroniclers of the fourteenth century such as Fernão Lopes to the time of Fernando Pessoa (and Almada himself) Portugal had an unbroken tradition of poetry and prose comparable to that of any of the great European national cultures, this was not true of painting. In 1696 the Lisbon painter Felix da Costa completed a treatise entitled *The Antiquity of the Art of Painting* in which he argued for the foundation in Portugal of an Academy of Fine Arts based on the models of the academies of Italy and France. He observed that artists in other European nations "were famous because of their activity in academies, for the great honor shown them by kings; for the great prizes given for their works; and for the great praise and good fame (they enjoyed) among all nations." Portuguese artists, he pointed out, "lack academies and are poorly schooled, without gratitude from the kings, living in misery on small rewards, and enjoying little fame because of the small affection and limited knowledge people have of painting."[7] Three centuries later the Lisbon art critic Rui Mário Gonçalves described the situation of Portuguese artists in words remarkably similar to Felix da Costa's: "Contemporary painting in Portugal struggles against a marked public reluctance to accept innovation. Furthermore, the market is very small; art teaching is generally poor; there is no significant museum of modern art; and painters seldom maintain close contacts with creative artists working in other fields."[8]

Yet Portugal does claim one towering painter—it is still not clear whether he is real or mythic—of the dawn of the Age of Discoveries. In 1882, masons working on repairs to the palace of the Cardinal Patriarch of Lisbon at the Augustinian monastery and church of São Vicente de Fora found the panels attributed to Nuno Gonçalves which are now in the Museu de Arte Antiga at Lisbon. Such is their fame and status that they are referred to simply as "the panels." According to the research of Charles Sterling, they were painted to glorify the conquest of Arzila and Tangiers as a crusade against the Moors under the protection of St. Vincent, the patron saint of Portugal. With the appearance of the panels, the Portuguese painter became heir (or declared himself to be heir) to an artist of the national past whose work embodied all that (in the words of Fernando Pessoa) "makes the soul be the soul of a hero."[9] The rediscovery and adulation of an artist of the past whose work is seen as an expression of something essential and fundamental in the spirit of a race, nation, or culture is characteristic of modern movements other than Portuguese. In 1916, for example, the Italian Futurist (by then become Metaphysical) painter Carlo Carrà published articles on Giotto and Paolo Uccello in the Milanese avant-garde review *La Voce,* proclaiming that in the works of these painters he found the "primitive and universal principle, true for all times, climes

and latitudes.''[10] The Russian collector and friend of avant-garde artists, Ilya Ostroukov, had written a few years earlier that the "ancient Russian icon, so joyously close and comprehensible to Russian people of old, is revealed to an astonished world as an art of highest achievements of the human spirit.''[11] In the *Chronik der Brücke* of 1916, Ernst Ludwig Kirchner recalled that he and his fellow artists found their "first art historical corroboration in Cranach, Beham and other medieval German masters.''[12]

Through the efforts of Almada Negreiros, the role played in Italy by Giotto and Uccello, in Russia by medieval icons, and in Germany by the masters of the sixteenth century was assigned in Portugal, to Nuno Gonçalves. Almada's interest in the panels went back to his Futurist days when, as he remembered in his preface to the catalogue of the retrospective exhibition of Amadeo de Souza Cardoso in Lisbon in 1959, Amadeo, Santa Rita, and he, "in front of the fifteenth century panel of the *Ecce Homo* in the Museu de Arte Antiga (also attributed to Nuno Gonçalves) signed the pact of the great enterprise of poetry: in the absence, for the time being, of poetry itself.''[13] In a series of eight interviews, published in 1960 in the *Diário de Notícias*, Almada made known the results of his investigations of the mathematical relationships underlying "the panels''' organization. By means of elaborate diagrams he sought to show that their geometric scheme was based on the ratio of nine to ten, a proportion he had come to consider as fundamental to all cultures, and thus to demonstrate that "the panels" thereby made visible the ancient, mythic cultural lineage of the Portuguese, or Lusitanian, race. Almada's quest was for a renewal of national identity and he was committed to correlating the new horizons and demands of the twentieth century with the vision of a Portugal able to hold her head high as of old. This mission was one of rousing his contemporaries to the consciousness of "the conflict between our country (*a nossa terra*) and the epoch in which we came into the world''.[14] It led him, after 1933, to seize the opportunities provided by the Salazar government to use modernist art as propaganda for the state. But in 1917, a year of discontent with the war, of seething unrest, and of incipient revolution, the self-styled Futurist was perceived as a madman and a threat to society.

On the stage of the Teatro República, on April 14, 1917, Almada read his own *Futurist Ultimatum to the Portuguese Generations of the Twentieth Century,* the *Manifesto of Sensuality* (*Manifeste de la luxure*) by Valentine Saint Point, and Marinetti's manifestos *Music Hall* and *Let's Kill the Moonlight* (*Tuons le clair de lune*). It is clear that Almada included the *Manifesto of Sensuality* in the hopes of attracting a large audience, for on April 13 the daily *A Capital* published a letter by him, purported to be an answer to questions by ladies of his acquaintance, about whether the text by Madame Saint Point would respect their presence at the Teatro República. Madame Saint Point's manifesto, he wrote, "was read publicly in Paris to an almost entirely feminine audience, who acclaimed the lecturer as a 'liberator.' "
Had the evening been free of charge, Almada's letter might have filled the hall. But admission was by paid ticket, and the seats in the orchestra were barely half

filled. The evening began with the text that Almada himself had written for the occasion. "I believe," he declared, "that as a Portuguese I have a right to demand a fatherland that is worthy of me. . . . I am in no way at fault for being Portuguese, but I feel the strength to reject the cowardice of the rest of you, letting the fatherland go to rot. . . . The mission of the Republic . . . was to reveal the decadence of the race." He urged his generation—he was twenty-two at the time—to support the war. "War," he proclaimed, "awakes the creative and constructive spirit and stifles nostalgic and regressive sentimentality."[15] According to the report on April 15 in *A Capital,* hardly twenty lines of the *Futurist Ultimatum* went by before the speaker was interrupted by laughter, cat calls, and protests. Santa Rita, who was in the audience, did his best to keep things going. At the end of the first part of the evening, Almada walked off the stage amid hoots and rude gestures.

For the reading of the *Manifesto of Sensuality* which followed, the few ladies in attendance left the theatre, with the exception of a black lady from Cape Verde who was a member of bohemian circles and was alleged to have fought bulls in the arena at Cascais. Madame Saint Point's manifesto calls for the liberation of sensuality from social and religious constraints. "The carnal exploration of the unknown," it affirms, "stimulates energy and unleashes form." It equates sensuality freed from the inuries inflicted on it by Christian morality with heroism, and asserts the need for a conscience of sensuality, stripping it of "romantic trapping" and of "all sentimental veils that deform it," and transforming it into "a work of art." Sentiment, the manifesto concludes, follows fashion; "sensuality is eternal, sensuality is might."[16] The first of the two manifestos by Marinetti that took up the evening's third part was *Music Hall,* in which the author extols the phenomenon and spectacle of the music hall as the paradigmatic "Futurist wonder." The proceedings concluded with the ironic, iconoclastic *Let's Kill the Moon.*

On April 20 *A Capital* published the following masterful, ironic letter in which Almada thanked the press and the public for their receptivity to what he had pronounced on the stage of the Teatro República:

In gratitude for the Futurist cameraderie of the Lisbon press, especially *A Capital,* and with true amazement at the extraordinary success of my lecture at the Teatro Republica, I would beg for space in your columns to congratulate this one time the public of Lisbon for the brilliant apotheosis of which I have been the target. Several newspapers have expressed vexation at having understood my lecture, and the audience showed surprise at the same thing. However, I have found the explanation for this in the extraordinary Futurist aptitude of the intelligent public of Lisbon. Proof of this is that the Lisbon that listened to me was not satisfied with my theoretical lecture, necessary as it was. Consequently Lisbon will shortly witness a practical and positive Futurist spectacle. . . .

Since it is completely impossible for me grammatically to describe its program, I restrict myself to announcing that the second part is a Futurist comedy in which the best variety acts playing in Lisbon and other spontaneously civic elements will intersectionistically take part.

In this way we shall succeed in our urgent mission of making our Portugal youthful and merry.[17]

The second—and last—manifestation organized by Almada was, however, not the promised spectacle, but the publication in November, 1917—a month prior to the successful revolt against the government of Afonso Costa by Sidónio Paris—of *Portugal Futurista* (figs. 5.3, 5.4). The specific reason for its suppression was a literary tour-de-force by Almada entitled *Os Saltimbancos*, a denunciation that caught the attention of the police for its impudence and licentiousness of language.

*Portugal Futurista* also presented the complete text of the *Futurist Ultimatum* that Almada had read at the Teatro República. But its most significant contribution was the *Ultimatum* by Álvaro de Campos, one of this complex poet's most paradoxical and mystifying works. It begins with a vituperative attack on contemporary literature, along the lines of Wyndham Lewis in *Blast:*

> Eviction notice to the mandarins of Europe! Out!
>
> Out, Anatole France, Epicurus of homeopathic farmacopeia,
> tapeworm-Jaurès of the Ancien Régime, Renan-Flaubert salad
> in fake eighteenth-century china!
>
> Out, Barrès, feminist of action, Chateaubriand of bare walls,
> panderer of the scenario of the fatherland with the mouldy charter
> of Lorena, pawnbroker of others' dead, decked out in its traffic!
>
> Out, trader Kipling, business man of verse, imperialist of scrap iron,
> Empire-Day of the slang of uniforms, tramp-steamer of little immortality!
>
> Out, George Bernard Shaw, vegetarian of paradox, charlatan of
> sincerity, cold tumor of Ibsenism, orchestrator of unsuspected
> intellectualism, Kilkenny-Cat of yourself, Irish-Melody Calvinist
> with the handwriting of *The Origin of Species!*[18]

What can be called the text's doctrine follows, beginning with a call for the abolition of the dogma of personality and of the concept of individuality, and concluding with the celebration of an *Übermensch:*

> I proclaim the necessity of the coming race of engineers!
>
> I proclaim the scientific creation in the near future of supermen!
>
> I proclaim the coming of a mathematical and perfect human race!
>
> I also proclaim: first:
> The superman shall be not the strongest but the most complete.
> I also proclaim: second:
> The superman shall be not the most resilient but the most complex.
> I also proclaim: third:
> The superman shall be not the freest but the most harmonious.

We have here reached a concept of Futurism that is no longer compatible with the ideas of Marinetti. Álvaro de Campos's *Ultimatum* takes us, instead, into the realm of messianic futurism that has always been at the center of the Portuguese

Figure 5.3.  Untitled Front Cover of *Portugal Futurista*, ed. Almada Negreiros, 1917, Lisbon
*(Collection: Royal Academy of Arts, London)*

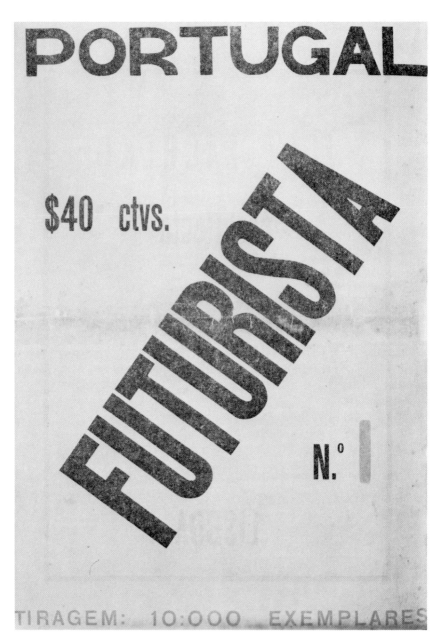

Figure 5.4.   Untitled Back Cover of *Portugal Futurista*, ed. Almada Negreiros, 1917, Lisbon
*(Collection: Royal Academy of Arts, London)*

soul. Almada de Negreiros was also touched by it, and in this we have the explanation for the difference between Futurist thought in Portugal and in the rest of Europe.

In a valuable study of Portuguese Surrealism (which was an important focus for literary and pictorial artistic activity in Lisbon from 1947 to 1953), Pierre Rivas makes a useful distinction between avant-garde movements at the center and at the periphery.[19] Seen in the light of Rivas's distinction, the Portuguese Futurist episode was clearly a peripheral, marginal movement. However, perhaps the most quintessentially Portuguese quality of the story of *Portugal Futurista,* the one that most reveals the Portuguese character, is the fact that when the review of that name was apprehended at the premises of the firm of Monteiro and Company on Lisbon's Rua Áurea, where the printed edition had been deposited, the police made sure that the collaborators of the review saved as many copies as the officers could prudently allow them to keep. We do not know if these collaborators had or would have planned another issue of *Portugal Futurista* or other Futurist activities. We do know that the death of Santa Rita in 1918, at the age of twenty-nine, deprived Almada Negreiros of his indispensable ally. Almada's days as an *enfant terrible* were at an end.

### Notes

1. For documents and studies on Portuguese Futurism, see P. Ferreira, *Correspondence de quatre artistes portugais, Almada Negreiros, José Pacheco, Souza Cardoso, Eduardo Viana avec Robert et Sonia Delaunay* (Paris, 1972); J.-A. França, *A arte em Portugal no século XX* (Lisbon, 1974), pp. 51ff.; J.-A. França, "No cinquentenario do Futurismo em Portugal," *Colóquio* (June 1967): pp. 41ff.; M. A. D. Galhoz, "O momento poético do *Orpheu,*" *Orpheu* I (Lisbon, 1971) (reprint); A. Hatherly, "Extase e herança," *Loreto 13* (April 1978): unpaginated; N. Judice, "A Futurismo em Portugal," *Portugal Futurista* (Lisbon, 1981) (reprint), pp. VII–XL; G. Nobre, "José 'Pacheko','' *Colóquio/Artes* (December 1977): 34ff.; J. A. das Neves, *O movimento futurista em Portugal* (Oporto, 1966); P. Rivas, "Frontières et limites des futurismes au Portugal et au Brésil," *Europe* 53 (March 1975): 126ff.; J.-A. Seabra, *Le retour des dieux: manifestes du modernisme portugais* (Paris, 1973); J. Gaspar Simões, *Vida e obra de Fernando Pessoa* (Lisbon, 1972), pp. 401ff.; R. M. Gonçalves, *Os pioneiros da arte moderna portuguesa* (Lisbon, 1976); H. Wohl, *Portuguese Art since 1910* (London, 1978), passim.

2. R. Poggioli, *The Theory of the Avant-Garde* (Cambridge, 1968), p. 25.

3. See J. Griffin, *Álvaro de Campos* (Oxford, 1971), pp. 3ff. For the influence on Álvaro de Campos of Whitman, see Almeida Faria, "Pessoa che pensa Campos ne sente," *Quaderni portoghesi* 2 (Autumn 1977): 11ff.; Eduardo Lourenço, "Walt Whitman e Pessoa," *Quaderni portoghesi* 2 (Autumn 1977): 155ff.

4. See França, *A arte em Portugal,* p. 59; W. A. Camfield, *Francis Picabia* (Princeton, 1979), fig. 109.

5. For documents and studies on this important artist, see (in addition to the references listed in note 1) P. Ferreira, "1887–1918: Amadeo de Souza-Cardoso, le metéore portugais," *L'Oeil* (November 1975): 30ff.; J.-A. França, "Amadeo/1959," *Colóquio* (July 1959): 6ff.; J.-A. França, *Amadeo de Souza Cardoso* (Lisbon, 1972); H. Gaudier-Brzeska, "Allied Artists'

Association Ltd., Holland Park Hall,'' *The Egoist* (June 15 1914): 227ff.; F. Guedes, ''No cinquentenário de Amadeo de Souza Cardoso,'' *Panorama* (March 1971): 40ff.; F. Lanhas, ''Amadeo de Souza-Cardoso,'' *Estrada larga* II (1959): 91ff.; M. Laranjeira, *Cartas* (Lisbon, 1943), passim; D. de Macedo, *Amadeo Modigliani e de Souza-Cardoso* (Lisbon, 1959); H. Wohl, ''The Short Happy Life of Amadeo de Souza Cardoso,'' *The Man Who Never Was* (Providence, 1982), pp. 167ff.; H. Wohl, ''Paris-Lisbon: The Cubist Work of Souza Cardoso,'' *Persona* 11/12 (December 1985): 36ff.

6. See Wohl, *Portuguese Art since 1910,* pp. 138f.

7. Felix da Costa, *The Antiquity of the Art of Painting,* ed. G. Kubler (New Haven, 1967), p. 469.

8. R. M. Gonçalves, ''Brief Notes on Contemporary Portuguese Painting,'' *Journal of the American Portuguese Cultural Society* V (Winter–Spring 1974): 20.

9. The line is from the poem entitled ''Night'' in the series ''Os tempos'' at the end of Pessoa's *Mensagem.*

10. See M. Carrà, *Metaphysical Art* (London, 1971), p. 13.

11. See M. Belz, ''The Icon and Russian Modernism,'' *Artforum* 15 (Summer 1977): 39.

12. See H. Chipp, *Theories of Modern Art* (Berkeley, 1968), p. 150.

13. See Wohl, *Portuguese Art since 1910,* pp. 139f.

14. See *Desenhos de Almada* (Lisbon, 1978), unpaginated.

15. See *Portugal Futurista,* p. 36.

16. See Gaspar Simões, *Vida e obra de Fernando Pessoa,* p. 433.

17. Ibid, p. 436.

18. Ibid., p. 441.

19. P. Rivas, ''Periphérie et marginalité dans les surréalismes d'expression romane: Portugal, Amérique Latine,'' *Surréalisme periphérique* (Montreal, 1984), pp. 12ff.

# Part Three

# The Cabaret as Event

# 6

# An Eventful Interior:
# Some Thoughts on the Russian and Soviet Cabaret

*John E. Bowlt*

In 1912 the St. Petersburg playwright and producer, Nikolai Evreinov, staged a play called *In the Side-scenes of the Soul* at the St. Petersburg cabaret, The Crooked Mirror.[1] The distinguishing feature of this short piece was that the dramatic events took place inside the human body (fig. 6.1). Here you could actually see the mounting excitement through the inflating lungs and beating heart. This was intimate theater in the true sense of the word and symbolized a primary aspiration of Russian experimental theater of the 1910s—to move inwards psychologically and physically. Such performances were, of course, close to the theatrical searches of the avant-garde and also served as a laboratory for the remarkable experiments in "mass action" just after 1917. Above all, such performances represented an essential characteristic of the cabaret, and it is not accidental that Evreinov's production was realized precisely within a leading cabaret of the time. Much later, however, Soviet culture of the Stalin epoch assumed principles diametrically opposed to those of Evreinov's internal drama—engendering what might be called a "cabaret inside out." The comments below are devoted to both the inside and the outside story of this phenomenon.

Within the space of a single article, it is difficult to provide an adequate impression of the wealth and diversity of the little theaters in Moscow, St. Petersburg/Petrograd/Leningrad, Kiev, Odessa, Tiflis/Tbilisi, and the émigré centers in Berlin, Paris, and New York during the 1910s–1920s. In any case, the term "cabaret" came to be applied indiscriminately to any theatrical manifestation of *Kleinkunst*, especially just before and after 1917, and numerous restaurants, nightclubs and dubious locales adopted the title of cabaret. Some, such as The Bat (*Chauve Souris*), founded in Moscow in 1908, The Crooked Mirror (founded in St. Petersburg in 1908), Crooked Jimmy (founded in Kiev in 1919) and *Kimerioni* (founded in Tiflis in 1917), received wide recognition for their literary and artistic achievements;[2] others such as The Little Berry (Petrograd, 1923) and The Peacock's Tail (Moscow, 1922–23) were

Figure 6.1.   Mikhail Bobyshev, Stage Design for Nikolai Evreinov's *In the Side-scenes of the Soul* at the Crooked Mirror Cabaret, St. Petersburg, 1912

ephemeral and quickly forgotten. In the German and Austrian tradition, the cabaret was used to criticize and censure social and political mores. The Simplicissimus in Munich and the Fledermaus in Vienna, for example, were arenas for incisive political discourse, but it must be emphasized that their Russian counterparts such as The Bat, The Stray Dog (founded in St. Petersburg in 1911) and The Café Pittoresque (founded in Moscow in 1918) did not support or condemn any particular ideological system. Satire and parody were applied, but out of esthetic and ''domestic'' motives (the love triangle, the boudoir, the rich prince and the poor waif, etc.), rather than for the coverage of a political event. Moreover, these establishments did not share a single political world view, and even the terms ''rightist'' and ''leftist'' are not especially valid here inasmuch as the Russian cabaret tended to use the political and social event simply as a pretext for artistic experimentation and entertainment. Also important is the fact that, except for the Blue Blouse theaters of the 1920s (to be described below), none of the leading Russian cabarets played to a proletarian audience. This is certainly true of The Stray Dog and The Café Pittoresque,[3] two intellectual and artistic centers that deserve extended commentary.

The format of the Russian cabaret—a confined stage housed in a small restaurant or café providing amusement through variety sequences—owed much to Western models (Nikita Baliev's Bat, for example, carried an obvious reference to the Fledermaus) (figs. 6.2, 6.3). However, the Russian cabaret also relied upon several

Figure 6.2.   Photograph of Interior of The Bat, Moscow, before 1918
*(Reproduced in N. Efros:* Teatr Letuchaia mysh, *Moscow: Solntse Rossii,
1918, p. 43)*

idiosyncratic characteristics that were peculiar to Russian culture. One reason why
Russian soil nurtured the spirit of cabaret so successfully was surely because of
its dependence on public involvement, on the spontaneous gesture, on a rapid se-
quence of numbers, and on the inclusion of "banal" disciplines such as the *pliaska*
(Russian folk dance), the *chastushka* (topical ditty), pantomime, and clowning. To
a considerable extent, the bourgeois St. Petersburg and Moscow publics who came
to the cabaret witnessed, and responded to, an extension of the ancient Russian
folk theater. Those élite audiences of fops, intellectuals, and businesspeople were
encountering a modern interpretation of indigenous performing arts such as the
*balagan* (Punch and Judy show) and even the religious procession (fig. 6.4). In
turn, these audiences were attending rituals formalized and adjusted by the agit-
producers and designers who followed the Revolution.

It should be recalled that, as early as 1912, Vsevolod Meierkhold wrote a long
appreciation of the *balagan* and then consciously applied its principles (and those
of the circus) to his avant-garde productions of the 1920s.[4] It should also be re-
called that some of the most elegant and synthetic theatrical productions of the Silver
Age (e.g., Igor Stravinsky's *Petrouchka,* produced by Sergei Diaghilev in Paris

Figure 6.3.  Photograph of One of the Numbers at The Bat, Moscow, before 1918
The piece is entitled "Katenka. A Forgotten Polka of the '80's."
*(Reproduced in N. Efros:* Teatr Letuchaia mysh, *Moscow: Solntse Rossii,*
*1918, p. 39)*

in 1911) derived immediately from the *balagan* or folk cabaret. Another case in
point is Meierkhold's production of Alexander Blok's Symbolist play *Balaganchik*
(Fairground Booth), in St. Petersburg in 1906, with sets and costumes by Nikolai
Sapunov. The play, dedicated to Meierkhold, was both a Symbolist presentation
in that he relied on fabulous visions of the other world, and a satire on Symbolism
as a philosophical worldview. Judging by his decor, Sapunov fully understood the
dual significance of the play with its motifs of depersonalization, spiritual insolvency
and inescapability (fig. 6.5). The artist created a stage within a stage, the original
or outer one being hung with blue canvases. The inner stage was "undressed"
so that the trappings—ropes, footlights, boards, prompter's box, etc.—were fully
visible to the audience, thereby lending the scene the aura of artificiality and duality
that the play required. Sapunov's choice of colors emphasized these basic qualities:
his dark greens, blacks, blues and mauves made a subdued, somber scale admirably
suited to the theme of despair. At the same time, the "illusion, the vacillation of
life"[5] manifested in Sapunov's decor was tempered by elements of prosaic

Figure 6.4.  *Balagany* and Other Entertainments on Admiralty
Square, St. Petersburg, in the 1850s
Print.
*(Reproduced in A. Nekrylova:* Russie narodnye
gorodskie prazdniki, uveseleniia i zrelishcha,
*Leningrad: Iskusstvo, 1984, plate 7)*

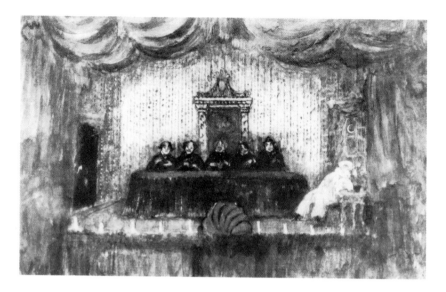

Figure 6.5.  Nikolai Sapunov, *Mystical Meeting* (Based on Alexander Blok's Play, *Balaganchik*), 1909
Tempera, 42 × 84 cm.
*(State Tretiakov Gallery, Moscow)*

domesticity—the wallpaper and the pseudo-Rococo table—which Sapunov was to exploit in his later still-life paintings and other stage designs.

Meierkhold's 1906 production of *Balaganchik* should be regarded as an important advance in the concept of intimate theater in Russia: the proximity of player to public and the compact, concentrated space of the auditorium were two key components of all "little theater" established in 1900s–1910s—whether the cabarets, Alexander Tairov's Chamber Theater in Moscow, or Yuliia Sazonova's Marionette Theater in Petrograd. This set of conditions—a select audience presided over by a dedicated producer or impresario (reminiscent of the *zazyvalo* or touter who would invite people to come and enjoy the *balagan*)—provided exactly the kind of ambience needed for the creation and maturation of new dramatic genres and new notions of stage design. Within the specific context of the cabaret, the communication between impresario and audience was of vital significance, although successful contact also presupposed a particular kind of public—an audience that had the time, means, and inclination to attend the cabaret evenings, an audience that possessed a fair degree of sophistication, and an audience that was willing to listen and respond to the impresario. By 1908, at the height of its Capitalist boom, Russia possessed such an audience, a fact demonstrated by the mushrooming of intimate societies and clubs in the metropolitan areas such as The Theosophical Circle, The Religious-Philosophical Society, The Spiritualist Circle, and The House of Song. Socialite salons also flourished, offering entertainment and enlightenment.

One manifestation of this fashion was The Society of Free Esthetics in Moscow which, to a considerable extent, might be considered as the precedent to The Bat. Founded in 1906, The Society arranged lectures, exhibitions, and dinner parties. It owed its existence to the financial support structure offered by wealthy Muscovites such as Genrietta and Vladimir Girshman, and most of Moscow's artists and patrons visited it. It was a comfortable, well-appointed club, conducive to intimate discussion and contemplation: "You come in on to a staircase covered in blue-grey carpet, you turn into three or four rooms given over to us for conferences; the same blue-grey walls; the carpets beneath your feet, the sofas, the armchairs and the little tables are of the same colors: blue-grey and blue-green; the light is dull."[6] Under the leadership of the Symbolist poets Andrei Bely and Valerii Briusov, The Society did much to propagate Symbolism, although it broadened its interests considerably after 1909–10, when mercantile members began to "raise their voices."[7] The intellectual membership of The Society was dominated by artists (e.g., Natalia Goncharova, Mikhail Larionov, and Georgii Yakulov) and musicians (e.g., Leonid Sabaneev and Alexander Skriabin) and enjoyed a steady stream of foreign visitors (e.g., Matisse, Verhaeren, and Vincent d'Indy). Like other cultural rendezvous in Moscow and St. Petersburg, The Society inspired a constant cross-fertilization between the representatives of various disciplines, something that resulted in the implementation of many joint projects. Sergei Sudeikin, for example, collaborated with Bely on the idea of a puppet theater there, with texts by Bely and designs by himself. In addition, carpets designed by Sudeikin were displayed in the rooms of the Society in 1907. In 1909 Briusov sanctioned a one-woman exhibition of Natalia Goncharova which caused a public scandal, and a Mikhail Larionov exhibition was also held there in 1912.

The Society of Free Esthetics lasted until 1917 when it closed, as Bely recalls, because of an "excess of lady millionaires."[8] Of course, there were other meeting places in Moscow such as the Polytechnic Museum which sponsored all kinds of public lectures, from Bely's "Art of the Future" in 1907 and the Cubo-Futurists escapades of 1912–13 to M.Ya. Lapirov-Skobl's discussion of interplanetary travel in 1924. There were also the bohemian cafés such as the Greek Café on Tveskoi Boulevard which inaugurated Moscow's café culture, culminating in the brilliant, if ephemeral Café Pittoresque. All these institutions, but especially The Society of Free Esthetics, can be regarded as symptoms of, if not stimuli to, the growth of a specific kind of little theater, namely the cabaret.

Perhaps it is not surprising to find that Meierkhold, a frequent visitor to The Society of Free Esthetics and a keen supporter of the *balagan* tradition, was a primary inspirer of the creation of The Stray Dog cabaret cofounded by Evreinov, Nikolai Kulbin, and Boris Pronin in St. Petersburg at the end of 1911 under the auspices of Meierkhold's Society of Intimate Theater. With an audience consisting of St. Petersburg's bohemia and with a night life that began at ten or eleven PM and lasted until four or five AM, The Stray Dog served as the prototype of several such cosmopolitan and intellectual meeting places such as The Comedians' Halt

(organized by Boris Grigoriev, Meierkhold, Pronin, and Sergei Sudeikin in 1916 in Petrograd) and The Café Pittoresque, and it hosted many cultural events (fig. 6.6). Although the artists who came there were not always radical, it is certain that Kazimir Malevich, Mikhail Matiushin, and their immediate colleagues passed by from time to time. Even the mystic philosopher Petr Uspensky and his friend, the music and ballet critic, Akim Volynsky, frequented The Stray Dog, and discoursed on an entire range of esoteric themes: "the Tarot, theosophy, Alexandrian Christianity, the French magical revival, Russian Orthodoxy, neo-Platonism, Jacob Boehme, the monks of Athos."[9] The Futurist poet Benedikt Livshits has left the following description of the milieu and programs of The Stray Dog:

> On so called "extraordinary Saturdays and Wednesdays," guests were required to put paper hats on their heads. They were handed these at the entrance to the cellar. Illustrious lawyers or members of the State Duma, famous the length and breadth of Russia, were taken unawares and, uncomplainingly, submitted to this stipulation.

> At masquerades, Twelfth-night and Shrove-tide actors, sometimes whole companies, would turn up in theatrical costume. . . .

> The programs were the most diverse—from Kul'bin's lecture "On the New Worldview" or Piast's "On the Theater of the Word and the Theater of Movement" to the "Musical Mondays," Karsavina's dancing or a banquet in honor of the Moscow Arts Theater.

> In some cases the program dragged on for several days. It swelled into a *Caucasian Week* with lectures on travels in the Fergana mountains and the Zaravshanskii Chain, or into an exhibition of Persian miniatures, majolicas and fabrics, evenings of Oriental music and dances, or a *Marinetti Week* or a *Week of Paul Fort, King of French Poets*, etc.

> However, the main point of the program was not the scheduled part, but the unscheduled one—the appearance of which had not been foreseen and which would usually enthrall us the whole night through.[10]

Until its closure in 1915, The Stray Dog entertained a varied clientèle, although its activities presupposed a sharp literary and artistic awareness, and many of the key representatives of Russian Modernism were to be seen at its gatherings. But the rapid interchange of numbers, rehearsed or impromptu, the close alliance between spectacle and spectator, and the marriage of "life" (the guests eating and drinking) and "art" (the performance) suggested the atmosphere of the fairground or marketplace and, perhaps for this reason, appealed to the *balagan* psychology of its audience (fig 6.7). For Evreinov, The Stray Dog, like his own cabaret, The Crooked Mirror, fulfilled what he felt should be the mission of the new theater, i.e., the creation of a "very special kind of theater, mobile, 'sharp,' one that can provide space for individuality and that is quite free of routine."[11]

These salient characteristics can also be associated with the Moscow Café Pittoresque, although its brief period of activity (January through June, 1918) gave it little time to develop. But, as a manifestation of the "cabaret mentality" of the early Soviet period, it was an important institution and one of the most vibrant, if ephemeral, cultural centers of the post-Revolutionary era.

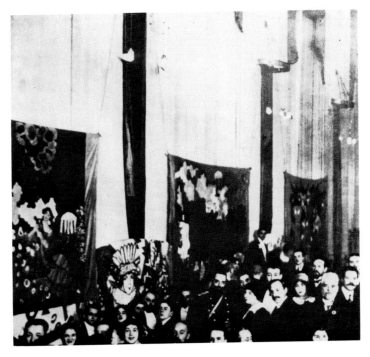

Figure 6.6.   Photograph of The Evening of Poetry, Music and Plastic
Movement, Sponsored by the Stray Dog Cabaret, St. Petersburg,
on 28 March 1913
The panels are by Sergei Sudeikin.
*(Reproduced in* Pamiatniki kultury. Novye otkrytiia, *Leningrad:
Nauka, 1985, p. 184)*

In the summer of 1917, the Moscow entrepreneur, Nikolai Filippov, owner
of the chain of Filippov cafés and pâtisseries in Moscow, acquired a disused iron
foundry on Kuznetskii Most. Filippov wished to turn the foundry into an elegant,
exotic, and fast-moving café; and, to this end, invited Yakulov to take charge of
the interior design. Yakulov was confronted with a rather narrow, but high space
that culminated in a huge, glass, hangarlike roof, which he proceeded to disguise
with a series of colored areas composed according to his "Simultanist" system.
He painted the walls and stage cupola according to the plot of Blok's play, *The
Unknown Woman* (figs. 6.8, 6.9)[12] Yakulov ensured that particular attention was
paid to the fixtures and he invited several leftist artists to help, not least Lev Bruni,
Alexander Rodchenko, and Vladimir Tatlin. As a result,

There were all sorts of fantastic configurations made out of cardboard, plywood and fabric;
lyres, wedges, circles, funnels, spiral constructions. sometimes light bulbs were inside these
solids. All this was interfused with light, everything revolved, vibrated—it seemed that the whole

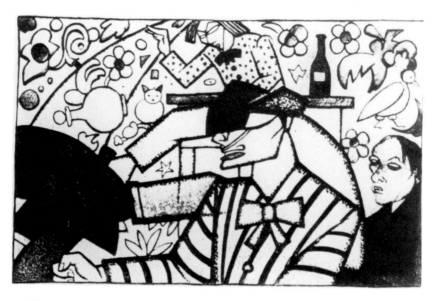

Figure 6.7.    Yurii Annenkov, *The Cellar of the Stray Dog,* 1913
Drawing (the drawing shows Vladimir Maiakovsky, Yurii Annenkov and
Nikolai Evreinov).
*(Reproduced in* Pamiatniki kultury. Novye otkrytiia, *Leningrad: Nauka,
1985, p. 169)*

decoration was moving. . . . All these things were hanging from the ceilings, from the corners
and from the walls.[13]

Still, the bold transformation of the Pittoresque did not really extend into the dramatic
repertoire produced on its tiny stage. True, the audience was most heterogenous
(from Blok to Vladimir Maiakovsky, from Anna Akhmatova to Meierkhold), but
the Pittoresque operated more as a rendezvous for disoriented bohemians than as
an experimental theater—just like such other intellectual venues of the time as The
Poets' Café and The Stable of Pegasus. True, Meierkhold staged *The Unknown
Woman* there in March, 1918, with sets and costumes by Aristarkh Lentulov.
However, critics immediately noted the incongruity, remarking that "no-one thought
that serious dramas such as *The Unknown Woman* would be produced" in such
an unlikely place.[14] Curiously enough, the Pittoresque seemed to be almost unaf-
fected, artistically or theatrically, by the major event of the October Revolution.
    At this juncture, it is worth questioning a standard critical interpretation of
the Revolution in the realm of art. Conventionally, October 1917 is regarded as
a dividing line between "good" and "bad," artistic progression and regression,
apolitical play and political commitment. If such a division has to be specified,

Figure 6.8.   General View of the Stage Area inside the Café Pittoresque
(also called the Red Cockerel), Moscow, 1918
Decorative figures above the stage by Georgii Yakulov.
*(Reproduced in E. Kostina:* Georgii Yakulov 1884-1928,
*Moscow: Sovetskii Khudozhnik, 1979, p. 78)*

then it must be in the late 1920s/early 1930s, not earlier: the more we examine the process of Russian culture of the Modernist period, the more we discover that the apparent innovations of the early 1920s (e.g., the mass action and Constructivism) owed much, if not all, to achievements preceding 1917. The concepts of instant theater, dynamic interaction of proscenium and auditorium, and the partial if not total destruction of the "fourth wall"[15] supported by the Constructivist theater were not especially novel in the history of the Russian stage. It is not fortuitous that many of the avant-garde producers and designers—e.g., Yurii Annenkov and Natan Altman, Evreinov and Meierkhold, who were involved in the mass actions—had been deeply involved in the cabaret just before 1917. There are reasons to assume, in fact, that the mass action and Constructivist theater were actually the ultimate extensions of the cabaret esthetic—a pseudo-democratic cabaret that was just as refined and as "unpopular" as the middle-class, intimate cabaret had been.

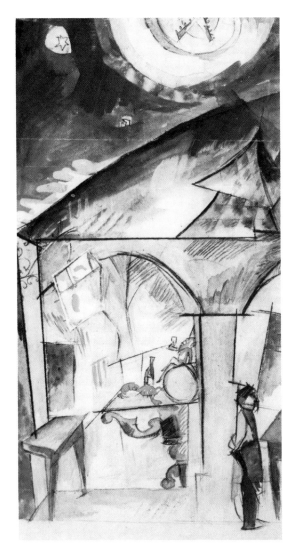

Figure 6.9.   Aristarkh Lentulov, Decor for Scene I of
             Alexander Blok's Play, *The Unknown Lady,*
             Produced at the Café Pittoresque,
             Moscow, 1918
             Watercolor and pencil, 50.2 × 29 cm.
             *(Collection of Mr. and Mrs. N. D. Lobanov-
             Rostovsky, London)*

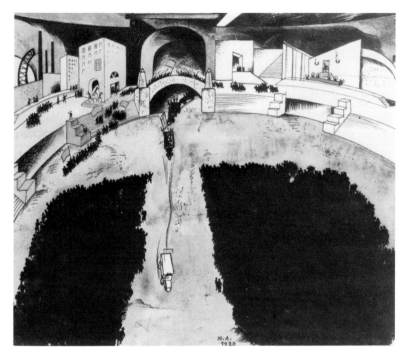

Figure 6.10.  Yurii Annenkov, Design for the Mass Spectacle, *The Storming of the Winter Palace,* Produced on Uritsky Square, Petrograd, November 7, 1920 Watercolor and India ink, 30 × 27 cm.
*(State Bakhrushin Theatre Museum, Moscow)*

The mass action was the loosely dramatized reenactment of a Revolutionary social or political event, the most famous of which were *The Storming of the Winter Palace* planned by Annenkov, Evreinov, et al. in September 1920 (fig. 6.10), and *Towards the World Commune* designed by Altman in June 1920, both in Petrograd.[16] The proposals to reproduce the historic events of 1917 were grandiose, if rather tedious ventures. Ultimately, the spectacles tended to regenerate and confirm historical fact and called for little in the way of interpretation or acts of imagination on the part of cast or audience. But, for the producers and artists this was not necessarily a defect. What excited them here was precisely the possibility to fuse the actors (hundreds, if not thousands) and the audience (tens of thousands), to bridge the space that separated the stage from the auditorium and not the thematic or ideological significance of the event (fig. 6.11). Alexei Gan, one of the ardent theorists of Constructivism, saw the genesis of constructivist theater to lie in the organic totality of the mass action. He wrote:

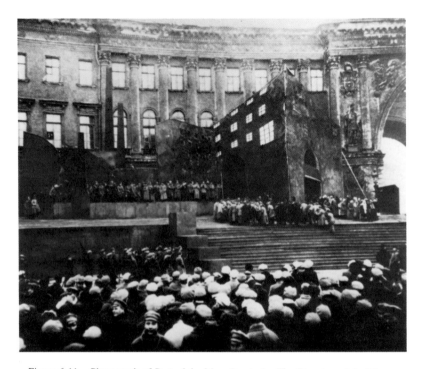

Figure 6.11.   Photograph of Part of the Mass Spectacle, *The Storming of the Winter
Palace,* Uritsky Square, Petrograd, November 7, 1920
*(Reproduced in V. Tolstoi (ed.):* Agitatsionno-massovoe iskusstvo.
Oformlenie prazdnestv, *Moscow: Iskusstvo, 1984, vol. 2, plate 196)*

The "mass action" is not an invention or a fantasy, but is an absolute and organic necessity
deriving from the very essence of Communism. . . . The "mass action" under Communism
is not the action of a civic society, but of a human one—wherein material production will fuse
with intellectual production. This intellectual/material culture is mobilizing all its strength and
means so as to subordinate unto itself not only nature, but also the whole, universal cosmos.[17]

In other words, as in Evreinov's *In the Side-scenes of the Soul* of 1912, the
material and the intellectual fused; the audience was now drawn right into the ac-
tion. The theater, like the fairground, once again became an active combination
of forces. Meierkhold emphasized these elements in his productions of the early
1920s such as the anti-Capitalist play *Earth of End* (1923), with its mobile set
designed by Liubov Popova and with its introduction on stage of a real automobile,
a real tractor, real telephones, etc. One conclusion that Meierkhold and Popova
reached in their preparations was that theater could and should happen at any time
and any place: it did not need a specific space (hall) or specific hour (7:30 PM).
That is why Popova's construction for *Earth on End* was, in her judgment, ad-

Figure 6.12.   Liubov Popova, Mobile Stage Construction for the Play *Earth on End,* Produced
by Vsevolod Meierkhold, Moscow, 1923
*(Reproduced in E. Rakitina et al.:* Khudozhnik, stsena, ekran, *Moscow: Sovetskii
Khudozhnik, 1975, p. 162)*

justable to any play. It could be stored on the factory premises and pulled out at
any moment so as to create instant theater (fig. 6.12). Again, Popova was exten-
ding principles of the cabaret—mixing "life" and "art," relying on the impromp-
tu act and enabling the uninitiated to participate in the theatrical sequence. But,
on this level, any political message became garbled, for the political or social event
now became subservient to the display of device. Clearly, such a state of affairs
could not last long, and for some observers, such as Anatolii Lunacharsky, Com-
missar for Enlightenment, such informality was an unsavory development; it was
a "corruptive theater . . . one of the poisons of the bourgeois world"[18] that
might have been acceptable in post-World War I Berlin, but not on board the flagship
of global Communism.

　　The antidote to this poison was found in the cabaret itself. A flexible and ac-
cessible medium, it was simply adapted to clear political ends, and the result was
the theater or, rather, system of theaters known as the Blue Blouse.[19] These Soviet
versions of the variety theater or cabaret presented contemporary revues, often

of a satirical nature, oriented exclusively to the mass audience. The repertoire of the Blue Blouse (founded in 1923) included works commissioned from various writers, some of them leftist, such as Nikolai Aseev, Osip Brik, Valentin Kataev, and Sergei Tretiakov. Designers included young, dynamic artists such as Nina Aizenberg and Boris Erdman. However, the title "Blue Blouse" signified a concept or genre of activity rather than a particular, concrete theater, since, at one time, there were fifteen groups operating under that name in Soviet cities. The subjects of the Blue Blouse performances tended to be contemporary, treating of the Red Army, the bureaucracy, the image of the new Russia abroad, etc., and, in the cabaret tradition, they were transmitted to the public through singing and dancing, gymnastics, jokes, mime, etc. (fig. 6.13). The political and social message was expressed loudly and clearly in these skits. But one wonders whether the Blue Blouse did not enjoy popularity because of its appeal to the *balagan* tradition rather than because of its ideological propagation. In other words, if the Blue Blouse elicited any ideological response at all, it did so through its artful invocation of the traditional little theater and through its reapplication of old esthetic conventions. A similar transmutation is to be found in the agit-processions of the 1920s, which simply adjusted the Orthodox procession of pre-Revolutionary times to new ends.

The cabaret is an art of dynamic dislocation. It is concerned with breaking hierarchies, uniting spaces, intertwining rituals. It reduces each artistic medium to its essential ingredients, pierces the world of facades, reveals the underlying structures. In this sense, the intimate theatrical space is a useful, although not indispensable component of the cabaret's operation, just as the event is of secondary importance to its esthetic effect. Under a totalitarian regime such as Stalin's Russia or Hitler's Germany, the cabaret cannot function because these preconditions are missing. With the comprehensive imposition of Socialist Realism in 1934, most lessons of the Russian avant-garde were soon forgotten. Art, performance, and design again came to rely on an external program, as the statements issued at the First Congress of Soviet Writers (Moscow, August, 1934) make quite clear: "we must know life so as to depict it truthfully in our works of art—and not to depict it scholastically, lifelessly, or merely as "objective reality"; we must depict reality in its revolutionary development. . . . *Create works with a high level of craftmanship, with high ideological and artistic content!*"[20] Artistic models from the past, such as the Italian Old Masters and the Realism of Stanislavsky's Moscow Arts Theater were reinvoked, and painting, literature, and the theater were called upon to defend and advocate the social and political event clearly and illusionistically. In an ambience of strict artistic control, of thematic prescription and preordained movement, there was little room to maneuver. As Ilia Shlepianov, one of Meierkhold's designers of the later period, wrote in 1938: "Moscow theaters . . . are now like a row of interlocking resorts in which the water level is the same."[21]

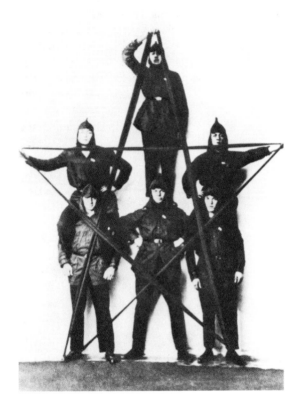

Figure 6.13.   Figures Forming the Finale of the Number Called
*Red Star* for the Blue Blouse Group, 1926
*(Reproduced in E. Uvarova:* Estradnyi teatr,
*Moscow: Iskusstvo, 1983, p. 105)*

Soviet theater of the Stalin period, however, carried many paradoxes and con-
tradictions, and it is a mistake to consider the artistic output of that time as com-
pletely worthless. Even though theatrical productions in the 1930s–50s were, by
and large, conservative and repetitive, there were particular forms of performance
that were novel and even inspiring in their functions and orientations. To a con-
siderable extent, the Stalin epoch *was* an epoch of theater—of appearance, facade,
ornament, illusion. As with any esthetic system beholden to political dictates,
Socialist Realism not only urged the viewer or reader to advance towards the Com-
munist goal, but it also deflected attention from the problems of the present; and
it achieved this by creating the "anti-cabaret": the theater returned to its 19th cen-

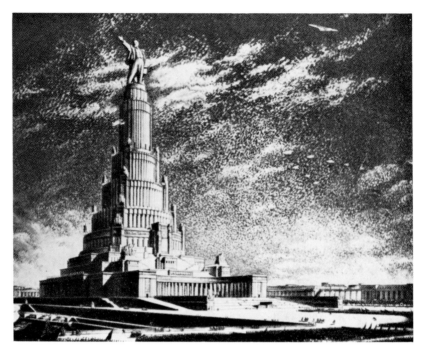

Figure 6.14.    Boris Iofan, Winning Entry for the Competition for the Palace of Soviets, Moscow, ca. 1933
*(Reproduced in I. Eigel: Boris Iofan, Moscow: Stroiizdat, 1978, p. 100)*

tury grandeur and to the enormous auditorium separated rigidly from the proscenium. The virtuoso returned, remote and inaccessible, playing to the audience, but not with it; interaction gave way to reaction; the inside of things was replaced by the outside.

That Stalin's public was called upon to stand and observe a spectacular illusion is implicit in many cultural manifestations of that era, perhaps most strikingly in the wedding-cake architecture (fig. 6.14). Furthermore, one of the most sophisticated art forms of the 1930s was the art of rhetoric, a dramatic medium that provided the vehicle whereby "events" such as the completion of the White Sea Canal or the construction of the Moscow Metro were publicized and propagated. If we examine the text of a Stalin speech of this period, we notice that the format within which the leader operated was a "theatrical" one: his was a monolog delivered to a prepared audience, a monolog that was part of an enormous and impressive performance. The gestures, instructions, responses and asides accompanying the political speech in the 1930s often recall the organization of a dramatic text (e.g., "A burst of applause, ovation. Smiling, Comrade Stalin applauds together with the audience"). This, in turn, emerges as part of the total spectacle of Stalinist

culture that incorporated illuminations, plafonds, and murals on public buildings, the dazzling gilt and marble, and the cut glass chandeliers.

Here was a Soviet Hollywood that seemed to ignore the conventions of the little theater. As the social hierarchy reestablished itself in the 1930s, so the arts also fell into line or, rather, into their independent disciplines. If the cabaret had served as a synthetic medium, integrating word, image, gesture, and sound as well as actor and audience, performance and eating, the arts under Stalin returned to formats that, a century before, had defined these arts: literature meant the epic novel, painting was the academic oil in the gold frame, music was the heroic symphony, and theater was the high drama. All of them depended upon the external event. Art, once again, was distanced and sanctified, regenerating the cold space between initiated and uninitiated.

In 1912 Evreinov had used an "intracorporeal" drama to concentrate and unite actor and audience in a single physical space. They moved *inside* the body. In Stalin's Russia, the reverse happened. In the theatricalized rituals or the gymnastic displays and athletic marches, the body, mechanical, efficient, streamlined, turned into a prop that assisted in the configuration of hammers and sickles and triumphant pyramids under the Moscow sun. Certainly, this was a long way from the spontaneity and flexibility of the cabaret, but, on the other hand, perhaps these parades can be deciphered as an ultimate flourish of the cabaret's facetious esthetic. In that time of deficit and coercion, were these performances not a gigantic parody of the political event that no traditional cabaret would ever have ventured to entertain?

**Notes**

1.  For information on Evreinov and The Crooked Mirror see Spencer Golub, *Evreinov: The Theatre of Paradox and Transformation* (Ann Arbor: UMI Research Press, 1984), pp. 145–90.

2.  For information on The Bat see N. Efros, *Teatr Letuchaia mysh N. F. Balieva* (Moscow: Solntse Rossii, 1918); John E. Bowlt, "Cabaret in Russia," *Canadian-American Slavic Studies* 19, no. 4 (Irvine, 1985): 443–63; on The Crooked Jimmy see E. Uvarova, *Russkaia sovetskaia estrada 1917–1929* (Moscow: Iskusstvo, 1976), passim; on *Kimerioni (Khimerioni)* see I. Dzutsova, "S. Yu. Sudeikin v Gruzii," *Muzei,* no. 1 (Moscow, 1980): 23–26. For other information on the little theaters in Moscow and Petrograd/Leningrad just after the October Revolution see E. Uvarova, *Estradnyi teatr: miniatiury, obozreniia, miuzik-kholly (1917–1945)* (Moscow: Iskusstvo, 1983).

3.  For information on The Stray Dog see A. Parnis and R. Timenchik, "Programmy 'Brodiachei sobaki,' " in *Pamiatniki kultury. Novye otkrytiia. Ezhegodnik 1983* (Leningrad, 1985), pp. 160–257. For information on The Café Pittoresque see A. Galushkina et al., eds., *Agitatsionno-massovoe iskusstvo pervykh let Oktiabria* (Moscow: Sovetskii Khudozhnik, 1973), pp. 60–63; S. Aladzhalov, *Georgii Yakulov* (Erevan: ATO, 1971), p. 62 et seq.; E. Kostina, *Georgii Yakulov* (Moscow: Sovetskii Khudozhnik, 1979), passim.

4.  V. Meierkhold, "Balagan," in A. Fevralsky, ed., *V. E. Meierkhold. Stati, pisma, rechi, besedy,* vol. 1 (Moscow: Iskusstvo, 1968), pp. 207–29.

5.  M. Alpatov and E. Gunst, *Sapunov* (Moscow: Iskusstvo, 1965), p. 25.

6.  A. Bely, *Mezhdu dvukh revoliutsii* (Leningrad: Izdatelstvo pisatelei, 1934), p. 244.

7.  A. Bely, *Na rubezhe dvukh stoletii* (Moscow: Zemlia i fabrika, 1931), p. 219.

8.  Bely, *Mezhdu dvukh revoliutsii, p.* 219.

9.  James Moore, *Gurdjieff and Mansfield* (London: Routledge and Kegan Paul, 1980), pp. 54–55.

10. B. Livshits, *Polutoraglazyi strelets* (1933). Translation in John E. Bowlt, *Benedikt Livshits. The One-and-a-Half-Eyed Archer* (Newtonville: ORP, 1977), p. 215.

11. N. Evreinov, *Istoriia russkogo teatra* (Letchworth: Bradda, n.d.). p. 400.

12. Yakulov maintained that he arrived at a ''Simultanist'' perception of space independent of Sonia and Robert Delaunay in Paris. In fact, he accused them of plagiarizing his ideas. For some discussion see *Notes et documents édites par la Société des amis de Georges Yakoulov*, no. 3 (Paris, 1972): 34–35.

13. As recalled by the artist Nikolai Lakov in Galushkina, *Agitatsionno-massovoe iskusstvo*, p. 101.

14. V. Ermans, ''Neznakomka,'' *Novosti sezona,* 18–19 (March 1918): 3. Quoted in V. Lapshin, ''Iz tvorcheskogo naslediia G. B. Yakulova,'' in I. Kriukova et al., eds., *Voprosy sovetskogo izobrazitelnogo iskusstva i arkhitektury* (Moscow, 1975), p. 289.

15. This is the name of one of Evreinov's plays (1915). For information see Golub, *Evreinov,* pp. 170–74.

16. For information on the mass action see C. Amiard-Chevrel, ''Les Actions de masse,'' in *Les Voies de la création théâtrale,* no. 7 (Paris, 1979): 243–76; V. Tolstoi, ed., *1917–1932. Agitatsionno-massovoe iskusstvo. Oformlenie prazdnestv,* vol. 2 (Moscow: Iskusstvo, 1984), pp. 194–200; Golub, *Evreinov,* pp. 191–208.

17. A. Gan, ''Borba za massovoe deistvo,'' in I. Aksenov et al., *O teatre* (Tverskoe izdatelstvo, 1922), p. 73.

18. A Lunacharsky, *Iskusstvo i revoliutsiia* (Moscow, 1924). Translation in John E. Bowlt, ed., *The Russian Avant-Garde: Theory and Criticism 1902–1934* (New York: Viking, 1976), pp. 190–96. This quotation is on p. 195.

19. For information on the Blue Blouse theater see Uvarova, *Russkaia sovetskaia estrada,* pp. 327–45.

20. From Andrei Zhdanov's speech at the First All-Union Congress of Soviet Writers, Moscow, 1934. Translation in Bowlt, *The Russian Avant-Garde,* pp. 293–94.

21. I. Shlepianov, ''Zametki po voprosam iskusstva,'' in S. Dunina, ed., *Ilia Shlepianov. Stati. Zametki. Vyskazyvaniia* (Moscow: Iskusstvo, 1969), p. 22.

# 7

# Reflections on the Cabaret: Art, Transaction, Event

*Allan Greenberg*

Perhaps the crucial role for art concerns its value as a means of communication. When considering the communicative bases of the visual, literary, and performing arts, we can speak of each of these different art forms as events. In a specific, if not special sense, communication is certainly an event for the individual or individuals involved in this process. At the same time, in visual art events, literary events, or performance events, the event is in some way unique. The manner in which the particular event comes into being varies. The environment of the event varies. The parties to the event vary, especially in their relationship to one another as part of the process of the transaction (the presenting of the work of art) or, in some cases, interaction. Essential to each event are at least two elements: the actor or initiator, whether artist or work of art, and the reactor, i.e., the audience. Without someone receiving that which an artist seeks to communicate, there is no social meaning or communicative event. In this context, I am talking about the art event as *process,* and a process that may serve to initiate other events. This process may take many different forms, although the two major ones involve 1) the process or event occurring as the audience "interacts" with a work of art in its final (i.e., completed) form, as with a painting or a novel; *and* 2) the process occurring as the audience interacts with a work of art as it is being created, e.g., with the realization of a play, the unfolding of a happening, or the presentation in a cabaret.

However, given different parameters for the event, even in this second category, there are specific elements that distinguish one from the other. For example, the traditional formal theater ordinarily has for its focus a finished work which, in its presentation (or realization), may be modified in order to meet the goals of the author, the director, or the actor(s). At the same time, the participatory nature of the event is significantly circumscribed, although the *effect* of the event might not

be (this depends to some—perhaps considerable—extent on the audience). In contrast with the formal theater, the nature of the cabaret is such that the event is, at least potentially, a much more fluid one. The cabaret environment (or setting) tends to be relatively small and intimate, and the atmosphere much less formal than that of other types of theater. Lyrics and short skits, the major content of the cabaret, may be much more rapidly composed than a play and, as a consequence, the cabaret performers/creators may choose to respond to current societal developments and concerns, or even to the changing moods of an audience. The goal is not merely to create a work of art in which form and content are harmoniously interwoven, but also to implement what, for the cabaret artists, seems to be the basic meaning of art: "opening people's eyes. . . . "[1] This view of art seems especially relevant to event-based art, which for the cabaret is inevitably art and transaction—or, perhaps more accurately, art as transaction. If, as I would suggest, artists are concerned with freedom as an ideal, freedom for their own creativity, freedom to communicate, and the possibility for change, then the cabaret—with its focus on changing content built upon underlying values and concerns, and its form which allows for this changing content—may present the ideal forum for the artist. We may discuss art *and* transaction, but we certainly must also be cognizant of art *as* transaction, art as an event: in the cabaret, the very efficacy of the art depends upon the effectiveness of the transaction. And the effective transaction is rooted in unmediated interaction with an audience. The artist-performer in the cabaret has the opportunity to communicate directly, and to somehow attempt to involve his audience in an event.

For transaction to be possible, and for interaction to be a way of creating the event, artistic endeavor must be bound to a society which is *sufficiently* open to allow such critical (public) events. But one might question what "sufficiently open" means. Is there, for example, an implication that a completely open society might *not* offer a desirable context for the cabaret? Given the particular moments in time and space when and where the cabaret has flourished, there seem to be certain connections between this form and its socio-political context as well as between the cabaret and socio-political activism on the part of many of the artists who participate in such performances. Lastly, because the cabaret seems to provide a vehicle whereby the artist can bridge the gap between her/himself and society, the cabaret becomes the locus for a social artistic event and transaction, providing the artist with a forum for both artistic and socio-political involvement with society. In particular, it is a framework which allows for individual freedom and the opportunity to play a role in determining the course of one's own life. The possibility of creating events in which one participates directly and meaningfully takes precedence over responding to events which are created by others and are directive rather than suggestive. Concerned with change, cabaret artists seek the openness and critical participation required of their view of individuals in society.

And so it came to pass in the little theater on the side street, a revolution of the heart and the mind and the soul. To those dedicated artist-intellectual-performers,

who committed their creative lives to opening a space through which a fresh wind might blow, we owe the cabaret. There they created skits and wrote songs, presenting them to many different kinds of individuals: receptive people whose sensitivities had arrived at the point where conflagrations might begin; individuals concerned that their world should not become ossified to the extent that a particular course of political or social action, once embarked upon, could not be changed, could not be questioned, could not be challenged when unanticipated ramifications appeared; and tired, jaded, and skeptical people for whom "revolutions" had become but words from which entertaining dreams might perchance be woven.

However, given the gaps in data and the difficulty of recreating events, looking at the cabaret is neither simple nor clear, but rather a labyrinth to traverse in word and deed. And so we must cast a long glance at the meaning and role of the cabaret in our attempts to determine whether it is a unique—or not so unique—phenomenon, suited for much or for little. Is this art form of particular significance; was it of peculiar significance at a particular time and place? Did it, or does it have special meaning, or has meaning been imposed upon it from without? Can we understand it in a social sense, or merely in an individual sense? May we, in fact, even consider it in light of art and transaction, or art as transaction? In the following attempt to identify the crucial questions and to concurrently seek a few answers, I ask that the cabaret be understood as an essentially political/satirical "little" theater, having social and/or political concerns as its major content, concerns which are related to events. The political cabaret, moreover, is specifically to be distinguished from the music hall, the variety, and similar kinds of primarily entertainment-oriented little theaters and from the literary-oriented cabaret, all of which have different aims, intentions and purposes.

In the political/satirical "little" theater, the cabaret event becomes, at least in part, an event-response to "outside" events. The ideal intention would *seem* to be the stimulation of a public action, and not merely of a verbal/intellectual (and private) reaction. On the other hand, is it possible that the cabaret-event is complete in and of itself, enwrapping the audience in some kind of minimal, fleeting change of an attitudinal/perceptual nature within the physical boundaries enclosing the event, and thus serving the "traditional" cathartic purpose, becoming little more than an intellectual exercise? Is the cabaret-event an open-ended affair which cries for completion in some broader context, or which cries merely for the context beyond which it may go? Effectively put by Arnold Hauser, whose view of art may be particularly relevant to event-based art in general, art—and perhaps especially the art of the cabaret—aims at an "opening [of] people's eyes, [and] also . . . preventing their closing their eyes again to facts, difficult tasks, uncomfortable solutions, and tragic alternatives."[2]

For there to be effective transaction, and for the cabaret to, in fact, realize an art-event, the traditional theater boundaries must be transcended. The entire theater must become a meaningful whole, where there is no separation between the public space of the performer and the private space of the audience. It was

with this in mind that the Dadaist performers of the Cabaret Voltaire in Zurich employed "shock and surprise [to forge] a bridge in the gap that traditionally separated the audience from the stage. . . ."[3] With this critical form, the ultimate issue continues to be a change in self-awareness and self-consciousness. If the cabaret-event is effective, there should be a change in the audience, and that change should eventually manifest itself in "personal" public actions. Without this change, the cabaret remains an art object, open to victimization through intellectualization: the audience member becomes concerned with what has occurred in the setting, and not what has happened to her/him and what the future may hold. Somehow, the cabaret, bound as it is in most cases to a particular type of performer/audience dichotomous setting, must assist the overcoming of the tension between an event observed and an event participated in, and must support the unmediated interaction of performer and audience.

What I would most like to demonstrate to our mutual satisfaction is that the fantastically appealing medium of the cabaret—by its very nature and through the commitment of its participants—inevitably and invariably stirs, drives, or demands that individuals in the audience rethink their approaches to the world around them; that it brings them eventually to reflect on events critically, delving beneath the surface and approaching issues of value and substance; that it forces them to critically reassess events that fostered the EVENT in which they were engaged; that personal events become the stuff whereby a rethought or refelt approach or response to other events is developed; and that this, in appropriately cast terms, is the goal of all art. Unfortunately, the evidence does not support such a supposition. If cabaret events do not *inevitably* lead to change in one's environment, particularly the socio-political aspects of that environment, do/can/should they, at the very least, lead to a change/a maturing/a modification of perspective? For the moment, even this causal sequence cannot be unequivocally asserted. There are serious questions to be resolved prior to initiating an effort to identify those sequences. But the very nature of the cabaret, and the cabaret event, make such a resolution difficult. On the one hand, we are concerned about the relatively limited and somewhat controlled interaction or transaction between artist/performer and audience. It is this of which Hauser speaks: "Only when the artist stands face to face with a real receptive subject who expresses himself unequivocally and the artist becomes the witness of the reaction of a spectator or listener who is experiencing his work and who paves the way for a reciprocal dynamic process . . . does what was purely a psychological process and a mere technical accomplishment change into a dialectical, historico-sociological happening."[4] And whether we call it "happening" or "event," or even dialogue, it is the same. The significance rests in both the process and in its effect. Furthermore, we cannot help but want to understand how the impact of the cabaret event may be played out in subsequent personal, public actions. We want to be made aware that something did happen and, as much as possible, of what did happen, and that this became part of us and our history, with some significance for our futures.

   Is there a direct relationship between the socio-political order and/or the value structure of a society and the existence and development of the cabaret? It is obvious that particular art forms may be more or less likely to appear under different conditions. I have, within the limits of my study, assumed that in an open society (characterized by a feeling of social mobility, a written constitution, a charter protecting individual freedoms or liberties, representative government, no *official* censorship, police and military under some form of civilian control) those cabarets that do exist tend to be relatively innocuous in their focus and that, if constraints are placed upon any aspect of an open society, critical reaction to such constraints often includes the development or flourishing of the political/satirical cabaret (i.e., the appearance of new cabarets or a change in focus for already existing ones). Thus, we see the development of the satirical/political cabaret in the United States during the 1950s and the 1960s, the time of the civil rights movement, anti-Vietnam activism, the Free Speech movement, the Cuban crisis, and the Eisenhowerian military-industrial complex. I have argued that specific events and issues may serve as the basis for inspiring the cabaret (and they certainly do provide the events to which the cabaret will react). There also may be an impetus of sorts in reaction to the constriction of parameters within which institutions operate, and to a sundering of an intimate relationship between ideals and action. The satirical/ political cabaret may develop provided there is a critical awareness of the societal changes needed or taking place, as well as some degree of concern beyond the restricted sphere of cabaret performers. Similarly, the cabaret may flourish in any society where the parameters of the society are changing, or are supposed to be changing; as an authoritarian society becomes more open, with norms and values being modified along with at least some of the basic structures in the society (such as Germany in the 1920s and France under the Third Republic). Similarly, something may occur as an open society becomes restricted or less democratic. A closely related third consideration might pertain to a society in which individuals begin to develop an awareness that the society does not operate with a reasonable congruence between values and actions—for example, when people identify the existence of double standards for different ethnic groups, for different racial groups, and for males and females. One focus for the cabaret may well become the elimination of "false consciousness." The gaps between theory and practice and between the ideal and the real give rise to a variety of critical movements, both of the left and of the right, and it would seem that the cabaret provides one appropriate form, or forum, for such movements. At the same time, the society must be sufficiently open to allow these public events to take place. Thus, it would *seem* that the cabaret is an art form of significance in *relatively* open societies, able or needing to tolerate and even invite criticism as a way to achieve its own ideals. But it is not that simple.

   What of closed societies? It has been argued that the cabaret cannot exist under totalitarian regimes. If this is the case, then what of the German Democratic Republic, where cabarets like the *Pfeffermühle* in Leipzig and the *Distel* in East

Berlin are active? Is there a particular role (or are there a number of different roles) that the cabaret may play in such a society? Are cabarets allowed to exist, and perhaps even fostered, as "escape valves" or "vents" in such cases, or are there ways in which the cabarettists in closed societies are able to make critical points without falling victim to official censorship? Do such instances give lie to the contention that "true" examples of cabarets appear only in relatively open societies?

Some time ago, I attended a cabaret performance entitled "Today Closed Society" (*Heute Geschlossene Gesellschaft*) at the *Pfeffermühle* in Leipzig. It was an evening of songs from the 1920s, including many by the most effective artist-critics of the struggling Weimar Republic, such as Kurt Tucholsky, Walter Mehring, and Erich Weinert. It would seem that, as the program's author contended , "great" satire was not strictly timebound because it had, in effect, penetrated to the roots of human weakness. I was struck by the parallels between issues represented in the content of the cabaret performance that had confronted Weimar Germany and which were confronting the German Democratic Republic (as well as the United States, for that matter). On the other hand, when I attended the *Distel* in East Berlin, a gentle good-natured humor formed the core of pieces dealing with East Germany, while hatred and bitterness permeated those that focussed on the German Federal Republic and the United States. In this particular cabaret, the elements of self-consciousness and self-criticism seemed not to exist. Either the *Distel* plays a different role from that which I have suggested for the cabaret, or, by the terms that I have established, the club is not a cabaret, but something else. (When art becomes propaganda, is it still art?)

If the nature of the cabaret is to be essentially critical and satirical, is its acceptance dependent upon a society perceiving itself to be sufficiently strong at base to withstand criticism, i.e., to incorporate criticism, to change as appropriate, or to allow people the cathartic and/or symbolic vehicle of the cabaret? If so, then a strong cabaret tradition is one sign of a healthy society. The difficulty of the problem nevertheless persists. Many people argue that the cabaret flourishes when times are bad or difficult, and that there is no such thing as a "pro-cabaret"; that there must be something to gripe about, something to attack. However, as one author postulates, during "the progressive demoralization of good society during the period of inflation," most German cabarets "sank to the level of cheap entertainment. Only in a few cabarets was there still a tendency to pure criticism of daily events . . . ,"[5] i.e., only a few little theaters were still cabarets. Is it true then, that during bad times the tendency is toward entertainment, to "bread and circuses" for a public attempting to escape the realities of their times, rather than toward criticism of those times?

Every society has different subgroups and, within a particular society, these subgroup classifications compose individual relationships to art forms that exist, or that are developing, within that society. Thus, any given society—especially one that is geographically spread out—may have a number of very different artistic forms or forums coexisting. Side by side may stand the cabaret as well as

other forms such as the variety theater and the music hall. In fact, this would more than likely be the rule. But the cabaret is a form of particular importance which seems to develop best at certain moments in time and place. And so there is a certain concatenation of circumstances when theater entrepreneurs or mediators (those who will supply the locale) are convinced that the cabaret will be financially viable, or that it will serve as an effective vehicle for achieving some goal in the society. As I have stated earlier, the other circumstantial considerations relate to the nature of the socio-political environment, which has to do, in part, with the receptivity accorded the event form of the cabaret.

In the cabaret, the performer (who I characterize as an artist-intellectual, a person with artistic as well as socio-political consciousness and conscience) seeks to affect his audience through direct interaction and in a context wherein she/he might have some opportunity to control the impact. One aspect of the medium's appeal to its performers is the fact that the intermediary disappears during the cabaret event. While the critic may play a role in people's decisions to attend a particular cabaret and the critic/theorist may suggest ways to better understand the cabaret performance, the medium itself provides the opportunity for direct interaction between artists and audience—and the bridge between the two can be traversed. It is as a direct result of the self-conscious concern among artist-intellectuals for communication with an audience that fruitful grounds are established for the flourishing of a cabaret.

Whatever the purpose, whether during good times or bad, one might assert that the quest for interaction between artists and audience does go on. One could argue that when times are good, criticism—if geared towards opening society up—might well be essential. It might, in these circumstances, be facing a greater challenge than when times are bad and people are looking for ways in which to change the perceived reality. In the end, though, there seems to be no disagreement that the cabaret of which we speak is always in opposition to society as it exists.[6] Infused in this opposition is the ability, required of both performers and audiences, to look at serious daily events and to take them not all that seriously. (Or, on the other hand, might it be the very best cabarets that demonstrate an ability to take humor seriously?)[7]

Are there ways in which the theater, and the cabaret in particular, is a special art form? As a type of theater, the cabaret is a public, audience-dependent art. In contrast to forms other than the theater (and architecture in a full sense), the cabaret necessarily requires an audience for its "completion" as a work of art; it requires a realization of its event nature, and a transaction between performer and observer. As a result, "theatrical art depends upon living and present mediators, actors and audience, for both its meaning and its existence."[8] Without a live audience, although cabaret materials may be functional (or at least much of what is presented in the cabaret may be), the form of the cabaret disappears. Without the live audience, the chance for interaction and effective communication disappears as well, and the event and transactional nature of the cabaret is virtually

eliminated. Thus, in the effective cabaret we have an intimate connection between art (both form and content) and its environment, between artists and their audience(s). The transactional nature of the cabaret requires communication, and the presentation of the cabaret requires an audience. There is really no existence independent of communication.[9] But just as one might argue about the relationship of words and deeds, especially when the anticipated deeds are to result from others' actions, so one must beware of words giving us, or giving socially and/or politically committed performers, a "false sense of control over the reality of objects, the unrepeatability of experiences, and the intangibility of emotions. . . . "[10]

In examining the Dadaists and the cabaret, I have argued that the cabaret has a particular nature that makes it unique, in part because of the potential for immediate interaction between artists and audience. When this potential is translated into action, the cabaret takes on a dimension that makes it a socio-political phenomenon going beyond the "imaging" of reality. In its event and transactional nature, the cabaret does assert itself as a vital institution. Thus, the Zurich Dadaists attempted to involve the audience directly in the cabaret-event process. Self-awareness and self-consciousness became more important than awareness or consciousness of the work of art itself, more important than the work of art as an object to be observed. The question was focused on the impact of the performance on the individual and on the possibility for a change of consciousness which would potentially be realized in the public arena. "Personal" actions were to have public significance in the realms of economics, politics, or society in general.

Seen as an event-focused institution, the cabaret is, by definition, social or socio-political. It may, at worst, be seen as a closed system comprised of artist-performer(s) and audience, isolated within the theater or physical setting; at best, as an open (and therefore not a complete) system wherein art and transaction are not isolated within the physical and, if you will, intellectual limits of the cabaret theater. While we can assume that the success of the cabaret as an art form, or as an event-art form, ultimately depends upon its meeting the conditions herein established, it is imperative that we do not end up in some kind of circularity based on having defined the criteria whereby the cabaret is to be analyzed after having derived those criteria from the study of the cabaret. One aspect of the success of the cabaret, for example, would be its longevity, rooted in its ability to attract an audience. But, given the argument that the cabaret is involved with social transaction, attacking closed systems, taboos, established modes of belief and customary ways of doing things, its *survival* might in fact indicate that it is not fulfilling its function (that it has been transformed into a vehicle for "pure" entertainment), and its *demise* might signal success. If the function of the cabaret is to stimulate reflection on, and critical appraisal of, the existing world (in part by identifying elements in the society and culture which "demand" criticism) how is its success relative to this concern determined? Is it rooted in an analysis of the content of the cabaret or in its success as a transactional "agent?" And, if it is to be seen as an agent of change, is its success to be determined in light of changes undergone in society as a whole or in individual attitudes, conceptions, and perceptions?

The general thrust of the cabaret is to bring into question basic societal arrangements: ways of doing things, ways of believing, ways of approaching issues. While the cabarettist might sincerely wish to effect social or political transformations via the medium of the cabaret, it seems likely that most performers would see this as a nice aftereffect. But is the cabaret event complete in and for itself? If it is not carried over into the "real" world, that is, carried outside the boundaries of the theater, has the cabaret in fact served its purpose? If the cabaret event involves its audience in some kind of minimal fleeting change, be it attitudinal or perceptual, limited to the physical boundaries enclosing the event, does it merely serve as a cathartic experience, or as an intellectual exercise?

One relatively recent critical approach to drama and modern performance theory no longer sees such art as mimetic, but as a part of the real world. In the theater, models are proposed of what *ought to be,* and these models are to be translated into "real life." As an open form of theater, the cabaret tends to point to *what is* with at least the implication that *it should not be so!* Regardless of how one approaches this perspective, if there is a call for sociopolitical change, then that change must first occur in the individual or individuals who compose the socio-political situation. In this context, the theater event is seen as a "kind of life event, not a copy of one,"[11] intended to lead people into "changing and change-making interaction."[12] As a vehicle for transaction, the theater (or cabaret) intentionally seeks to "leave . . . neither party unchanged."[13] Not only is there an impact on the audience, but there is interaction between audience and performer. If the cabaret functions as I have suggested it should, then the results of such interaction will become manifest in subsequent presentations, and/or in the larger world of social and political reality.

However, despite any efforts that have been made to create a typology of the cabaret, and despite the attempts to characterize the cabaret as a form of theater specific to a certain time period, we are in fact left with a significant problem; insofar as I am able to determine, we do not know who comprised the audience for the cabaret. While we might come up with some good guesses, more often than not we are left with rather unsupported speculation. I am led to conclude that cabaret audiences were, for the most part, comprised of individuals looking for confirmation or reinforcement of their beliefs, observations, and the conclusions they had drawn from them. In other words, it is highly likely that, as a vehicle for social or socio-political transaction, the cabaret, more often than not, is a gathering place for the committed and convinced, rather than for those who remain to be convinced or are aloof.[14] In reality, the cabaret audience is not composed of individuals who are uncertain and seeking answers, although in theory that public would appear to be the one for whom the cabaret would seem most appropriate.

If the concern of the cabaret is not the transmittal of values and commentary, but rather an opening of eyes, an unloosing of commitments, a challenging of convictions,[15] of ideologies and consciousness,[16] and of authority and uncertainty,[17] then attendance by a committed audience is truly desirable. In fact, it is then that

the cabaret begins to play a significant socio-political role—not by providing answers or by setting directions for visions of the future, but by helping people move toward goals that they themselves have deemed desirable. Whether we are talking about a so-called middle class cabaret, or a left-wing middle class cabaret, or a Marxist cabaret,[18] we are talking about groups that are committed to pursuing or continuing a particular course of action (or inaction). On the other hand, our acceptance of such characterizations of cabarets is based on our own propensities to categorization and model-building. While we may be able to develop legitimate bases for such an analysis and make a logical presentation in support of or in opposition to that analysis, it remains little more than an intellectual exercise. For example, we must inevitably rely on content, performers' statements, and statements by the critics as the basis for our analysis, and our coming to grips with the question of intent. But what about the people who were involved as an audience? Sources are difficult to come by and, although my own research has led me to believe that the middle class probably formed the bulk of cabaret audiences, I do not have enough hard evidence to refute the contention that cabaret lovers are in fact drawn from every social class.[19]

Under optimum conditions, the cabaret is a theater of openness, questioning, and living with uncertainty. Such a cabaret is a vehicle which provides a means whereby people might be moved to respond to their own lives, their own ideas, thoughts, and actions. In the context of the cabaret, they are invited to do so through action and events rather than through thought. Although a connection with broader and deeper "philosophical" issues may underlie the cabaret's focus, this would be the case only after the fact—or after the event—of the cabaret performance. Here, I would suggest, lies one of the contrasts between the cabaret and traditional "legitimate" theater: the play usually must eschew current events, and if it is to be considered in the category of "great" theater—or strive to be so considered, it must deal with concerns which are more generalizable than the focus of the cabaret would ordinarily be. The cabaret involves freedom within limits, an ordered freedom, if you will: in this, it is certainly related to Happenings, a very special form of theater. Its environment is relatively controlled, certainly by the fact that it requires an audience and a place for that audience to locate itself. The ultimate cabaret would probably be street cabaret (as distinct from guerrilla theater), where individuals happen upon each other and quickly, almost spontaneously, develop skits or sketches examining contemporary issues and events, and develop songs about those events on the run. We might here enter a realm of "controlled adhocism" which might seem, but is not necessarily, a contradiction in terms. The control is imposed by the boundary conditions set by the participants, by the artists; and while the creation might be impromptu (and certainly the connectors between skits, songs, and events almost inevitably would be), there are beginning and ending points. If the audience is caught up by the nature of the event, then the reconceptualizing or rethinking that takes place is itself an impromptu occurrence.

Another element to consider seriously in the ideal cabaret setting is that its size is conducive to freedom and participation (this is not true in all instances of the cabaret, for some of the theaters have been quite large, although not large enough to eliminate the possibility for audience involvement). In some ways, cabarets may be seen as paralleling fora for participatory politics, such as were the cases with the soviets during the revolutionary period in Russia and Germany, and with the town meetings of New England. To stretch an analogy, we might consider such "institutions of freedom [as being] small and active enough to allow everyone to engage in primary activities of politics—'expressing, discussing, and deciding.' They provide a form of public theater where liberty can emerge for everyone, not just representatives of everyone.''[20] But, of course, the cabaret is not serving a political function, except in the broadest sense, when it affects the political visions/ beliefs/values of its event-involved audience. It would seem that, given the proposed nature of the cabaret, the concept of adhocism is appropriate. The event nature of the cabaret, the openness and interaction which are essential concomitants, and a broader concern with how life is lived unmediated by formal structures such as bureaucracies and hierarchical organizations,[21] all parallel the concerns of the artists who sought to bridge the gap between themselves and their audiences, and for whom adhocism was desirable. Immediate responsiveness occurs in the transaction or event that is situated inside the cabaret; and there may be subsequent events for each individual. Words and deeds: both are essential. If the cabarettists failed, and if there were no events after "the event," then so much the worse. But that was the goal, and it is for us to understand.

**Notes**

1.  Arnold Hauser, *The Sociology of Art*, trans. K. J. Northcott (Chicago and London, 1982), p. 311.

2.  Ibid., p. 311.

3.  Annabelle Melzer, *Latest Rage the Big Drum: Dada and Surrealist Performance* (Ann Arbor, 1980), p. 135.

4.  Hauser, *Sociology of Art*, p. 438.

5.  Rudolf Hösch, *Kabarett von gestern nach zeitgenössischen Berichten, Kritiken, Erinnerungen*, Band I: *1900–1933* (Berlin, 1967), p. 158.

6.  E.g. Wolfgang Müller and Konrad Hammer, eds., *Narren, Henker, Komödianten: Geschichte und Funktion des politischen Kabaretts* (Bonn, 1956), p. 61.

7.  Werner Schumann, *Unsterbliches Kabarett* (Hanover, 1948), p. 85.

8.  Timothy J. Wiles, *The Theater Event: Modern Theories of Performance* (Chicago, 1980), p. 2.

9.  Ibid., p. 182.

10.  Ibid., p. 181.

11. Ibid., p. 114.

12. Ibid., p. 2.

13. Ibid.

14. Günter Meerstein, *Das Kabarett im Dienste der Politik* (Dresden, 1938), p. 48.

15. Jürgen Henningsen, *Theorie des Kabaretts* (Ratingen, 1967), pp. 74-75.

16. Henningsen, *Theorie,* pp.34-35.

17. Max Hermann[-Neisse], "Berliner Kabarett," *Die neue Schaubühne* IV, no. iii (March, 1922): 74.

18. Manfred Berger, *Kabarett nach vorn: Zu einigen Problemen der Kabarettbewegung* (Berlin, 1966), pp. 13-17.

19. Meerstein, *Kabarett . . . Politik,* p. 48.

20. Charles Jencks and Nathan Silver, *Adhocism: The Case for Improvisation* (Garden City, N.Y., 1973), p. 99.

21. Ibid., p. 15.

# 8

# The Dada Event:
# From Transsubstantiation to Bones and Barking

*Harriett Watts*

> *jolifanto bambla ô falli bambla*
> *grossgiga m'pfa habla horem*
> *égiga goramen*
> *higo bloiko russula huju*
> *hollaka hollala*
> *anlogo bung*
> *blago bung blago bung*
> *bosso fataka*
> *ü      üü      ü*
> *schampa wulla wussa ólobo*
> *hej tatta gôrem*
> *eschige zunbada*
> *wulubu ssubudu uluw ssubudu*
> *tumba ba-umf*
> *kusagauma*
> *ba-umf*
>
> Hugo Ball, *Karawane*

The date was June 23, 1916; the place, Cabaret Voltaire in the Spiegelgasse of wartime Zurich; the poet and performer, Hugo Ball (fig. 8.1), who had just recited the second of three sound poems premiered that evening. Ball recorded in his diary the special costume he had created for the occasion:

> My legs were in a cylinder of shiny blue cardboard, which came up to my hips so that I looked like an obelisk. Over it I wore a huge coat collar cut out of cardboard, scarlet inside and gold outside. It was fastened at the neck in such a way that I could make winglike movement by

Figure 8.1   Photograph of Hugo Ball in Zurich, 1916
*(Private collection, New York)*

raising and lowering my elbows. I also wore a high, blue and white striped witchdoctor's hat. I was unable to walk inside the cylinder so I was carried onto the stage in the dark and began slowly and solemnly:

> gadji beri bimba
> glandridi lauli louni cadori
> gadjama bim beri glassala
> glandridi glassala tuffm i zimbrabim
> blassa galassasa tuffm i zimbrabim[1]

The poems that Ball was performing were a first for the Cabaret Voltaire, although the genre itself was not Ball's own invention, as he claimed it to be in his diary. As we shall discuss later, the most likely source for Dada sound poems was the Russian *Zaoum* movement, whose founding predated the Zurich event by five years.[2] In Zurich, this new genre of "poems without words" or "soundpoems" or "phonetic poems" (as Ball called them interchangeably) were verse in which the lexical meaning of language is surpressed and total attention is concentrated on the sound of words, or more precisely, on the arrangement of vowels and consonants.

Ball had staged his reading in such a way that audience attention was being drawn as much to his own audaciously costumed presence (fig. 8.2) as it was to the measured vowel and consonant combinations issuing from his mouth. He found himself faced with a performer's dilemma: how to achieve a spoken poetic climax that would equal the expectations awakened by his costume. Flapping his wings, he turned to the music stand that held the final poem. In his diary Ball recounts what happened next:

> The stresses became heavier, the emphasis was increased as the sound of the consonants became sharper. Soon I realized that, if I wanted to remain serious (and I wanted to at all costs), my method of expression was not going to be equal to the pomp of my staging. . . . The heavy vowel sequences and the plodding rhythm of the elephants had given me one last crescendo. But how was I to get to the end? Then I noticed that my voice had no choice but to take on the ancient cadence of priestly lamentation, that style of liturgical singing that wails in all the catholic churches of East and West. I don't know what gave me the idea of this music, but I began to chant my vowel sequences in a church style like a recitative, and tried not only to look serious but to force myself to be serious. Suddenly it seemed as if there were a pale bewildered face behind my cubist mask, that half-frightened, half-curious face of a ten-year-old boy, trembling and hanging avidly on the priest's words in the requiems and high masses of his home parish. Then the lights went out, as I had ordered, and bathed in sweat, I was carried down off the stage like a magical bishop.[3]

The event precipitated by Ball's performance of the sound poems was none other than the celebration of the mass itself, with the word as logos reincarnated, its aura reestablished as the sacrificed body of Christ. Indeed, Ball's diary entries immediately prior to the performance indicate a presentiment of the nature of the event itself: "The word and the image are one. Painter and poet belong together.

Figure 8.2.  Photograph of Hugo Ball Reciting *Karawane* at the Cabaret
Voltaire, 1916
*(Private collection, New York)*

Christ is image and word. The word and the image are crucified."[4] In his diary Ball explained the search in which he had been engaged; the search for words with the potential to convert themselves into phonetic poetry. Shortly before reading his Dada poems, Ball concluded in his diary:

> To be precise, two-thirds of the wonderfully plaintive words that no human mind can resist come from ancient magical texts. The use of "grammalogues," of magical floating words and resonant sounds characterizes the way we write. Such word images, when they are successful, are irresistibly and hypnotically engraved on the memory.[5]

Five days before unveiling his sound poetry to the public, Ball summarized the results of his experiments: "We have now driven the plasticity of the word to the point where it can scarcely be equaled. . . . We have loaded the word with strengths and energies that helped us to rediscover the evangelical concept of the 'word,' or logos, as a magical complex image."[6] In the context of these reflections, it is scarcely surprising that Ball ultimately took recourse, although he had not planned to do so, in liturgical chant.

The soundpoem event was repeated the next evening, and it proved to be Ball's last appearance on the stage of the Cabaret Voltaire. Apparently unnerved by what the poems had demanded of him in terms of actual performance before spectators, Ball felt obliged on the second evening to give a preliminary explanation to his audience and to provide a rationale for what he was hoping to accomplish with this kind of poetry:

> Before the poems I read out a few program notes. In these phonetic poems we must totally renounce the language that journalism has abused and corrupted. We must return to the innermost alchemy of the word, we must even give up the word as well to keep for poetry its last and holiest refuge. We must give up writing secondhand: that is, accepting words (to say nothing of sentences) that are not newly invented for our own use.[7]

This effacing of lexical meaning in favor of sound organization was not necessarily aimed at meaning-as-such in language, but rather at the mass-media, commercialized discourse into which language had fallen. Words that had been used, and abused, by mass communication were, for Ball, words that had been emptied of all poetic and religious resonance that they might once have possessed. Walter Benjamin's classic analysis of how the aura of the individual work of art disappears in an age of mass reproduction applies as well to the crisis of words that Ball wished to address with his nonlexical "phonetic" poems.[8] The writer must give up writing "second-hand" if he is to reconstitute the word as Logos. Words "newly invented" and articulated in live performance were necessary to jar language loose from the mass-media grid where it is trapped in infinite commercial reproducibility. The word must be rendered unique, embodied and reenergized in unique human events that cannot be technically reproduced at will for unlimited mass consumption.

A year later, Ball reiterated his aim of purifying language from its abuse at the hands of what we would call today the mass media. On July 14, 1917, in the first public Dada soiree in Zurich's Waag Hall, Ball delivered a Dada manifesto that concluded with the question of sound poems:

> I shall be reading poems that are meant to dispense with conventional language and be done with it. . . . I don't want words that other people have invented. . . . I want my own stuff, my own rhythm, and vowels and consonants, too, matching the rhythm and all my own. If this pulsation is seven yards long, I want words for it that are seven yards long. . . . It will serve to show how articulated language comes into being. I let the vowels fool around. I let the vowels quite simply occur, as a cat miaows. . . . Words emerge, shoulders of words, legs, arms, hands of words. Au, oi, uh.[9]

With his image of a body materializing to illustrate what happens when the vowels begin to "fool around," Ball alluded, perhaps inadvertently, to what had occurred in his initial performance in the Cabaret Voltaire where the word had become flesh, the body of God, invoked by the priest's chant in the mass. But the transsubstantiated Ball, in his cardboard cylinder and witch doctor's hat, reverted to his human role as Dada theoretition in all subsequent accounts of the sound poems. He shied away from the irrational energies awakened in both himself and the public in the Cabaret Voltaire performance, and even referred to the incident as a "lamentable outburst." Later performances appear to have been toned down, for they no longer seem to provide any reason for being recorded in his diary. In the Dada manifesto read in the Waag Hall, he again stressed the need to get rid of worn-out meanings in order to make room for new energies that can be provided by actual performance of phonetic poems:

> A line of poetry is a chance to get rid of all the filth that clings to this accursed language, as if put there by stockbrokers's hands, hands worn smooth by coins. I want the word where it ends and begins. Dada is the heart of words. Each thing has its word, but the word has become a thing by itself. Why shouldn't I find it? Why can't a tree by called Pluplusch, and Pluplubasch when it has been raining? The word, the word, the word outside your domain, your stupendous smugness, outside all the parrotry of your self-evident limitation. The word, ladies and gentlemen, is a public concern of the first importance.[10]

And the spoken word, one might add to Ball's polemic, can become a public event of the first order. It is the means of encroaching on the established regime with its moral stuffiness, smugness, impotence, and repetitiveness, all of which is perpetuated in the language it uses. Ball's aim was to drive the stockbrokers out of the temple of human discourse; and successful temple purges are known to be events that stand existing hierarchies and social values on their heads. Although Ball left no further record of sound poems performed in the cadence of the priest, his philosophical musing on the primacy of the word over the image continued to circle around his unforeseen enactment of the role of the priest, incantating the

mass. The overpowering effect of language so employed contributed to Ball's growing reluctance to continue performing on the Dada stage. Exhausted and close to a nervous breakdown, he fled Zurich and his Dada comrades for a period of several months.

Scarcely two weeks before the initial soundpoem performance of 1916, another unexpected encounter with archaic, irrational forces had occurred when Ball and his fellow Dadaists had donned, for the first time, the masks prepared for them by Marcel Janco. Ball described the instantaneous effect of the masks:

> Something strange happened. Not only did the mask immediately call for a costume; it also demanded a quite definite, passionate gesture, bordering on madness. Although we could not have imagined it five minutes earlier, we were walking around with the most bizarre movements, festooned and draped with impossible objects, each one of us trying to outdo the other in inventiveness. The motive power of these masks was irresistibly conveyed to us. . . . The masks demanded none other than that their wearers start to move in a tragic-absurd dance.[11]

The grotesque, yet ritualistic, dance and mime that was precipitated by the performer's disappearance behind a mask seems but one step away from Ball's transformation into a witch-doctor-bishop two weeks hence.

Dance had been an important component of the Cabaret Voltaire soirees from the very beginning, thanks to the participation of dancers from Rudolph Laban's dance school in Zurich. Two of Laban's dancers, Mary Wigman and Katje Wolf, were among the best known performers in European avant-garde circles at the time. Another of the dancers, Sophie Taeuber, was to become the wife of Hans Arp. In the summer, Laban disbanded his school in Zurich and moved its operations to the Monte Verita above the town of Ascona in the Swiss Ticino. The Monte Verita had already gone through a quarter of a century of utopian, back-to-the-earth settlements which had included everyone from Russian anarchists to militant nudists and a variety of occult movements; thus, it was prepared for whatever Laban, his ladies, and their Dada companions might have to offer. Laban did not hesitate to appeal to irrational forces in his dance pageants. There is no record of any visiting Dadaists having staged events in the name of Dada in Ascona, but there are descriptions of Laban performances in the summer of 1917 that seem almost to aspire to archaic celebrations of Greek mystery rites. The puppeteer Jacob Flach, a friend of Arp and Sophie Taeuber, describes his own participation as dancer at a pageant in which Taeuber was one of the principal dancers and Arp was a spectator:

> Barefoot and shirtless like a Bantu, my head, emptied of everything but rhythm and ecstasy, I kindled and inflamed my demonic nature. Snatching a burning branch from the flames, I danced wildly around and around the bonfire, until a piercing cry from the youth Tomino broke the madness and a total silence fell.[12]

Rudolf Laban left his own account of the pageant, which ended at dawn with a pagan homage to the rising sun:

Shortly before midnight, the second part of the program began, the portion entitled Dance of the Demons. A group of dancers with tamborines, drums and flutes collected the spectators; torchs and lanterns lit the way to a mountain top; overhead, bizarre cliffs looked down on a circular meadow. Here five huge bonfires had been lit. Hopping around and through the flames was a troupe of gnomes. Then a group of masked dancers appeared. The masks were enormous, covering the whole body and made out of sticks and grass. These various compressed, towering, pointed and jagged forms concealed the witches and demons creeping up from behind, who suddenly attacked and exposed the masked figures and burned their disguises in a wild dance. Around the dying embers of the bonfire there arose a final dance of the shadows. Then the torchs were relit and the dancers led this long procession back to its starting point. These spectators, who came from all over the world to see us, had to put up with a lot. After their night promenade over boulders and tree trunks, they had to appear again by 6:00 the next morning at the third outdoor station, a sloping meadow before a precipitous drop on the east side of the mountain. This time the places were arranged in rows before the brink, behind which the sun was rising. This was the dance to morning. A company of women in bright flowing silk garments raced towards the precipice. The sun's rising disc appeared on the horizon, shining through their gowns. Met by the ring dance to the awakening day, the demon midnight faded before wave after wave of human dancers racing towards the precipice to symbolize the day-star's eternal return.[13]

One can scarcely overestimate the emotional susceptibility of Laban's audience after an evening spent hiking up a rugged mountain to witness a *Walpurgis Night,* with little or no sleep, and then a sunrise before the abyss, attended by waves of Laban ladies dancing across the mountain meadow in gowns of diaphanous silk. There seems to be no doubt that Laban, like the Dadaists, was able to generate events that produced a high degree of irrational involvement on the part of both audience and participants. Yet certain Dadaists, such as Ball, seemed also to be aware of the fact that they were literally playing with fire. Fifteen years later, the Nazi party rallying in Nuremberg was to find the torch light procession just as effective as Laban had. And the most successful mass-propaganda play staged by the Nazi's, in the context of their "Thing-theater" initiative, was the reworking of a passion play in which the good Nazi becomes the word made flesh and crucified. The witch-doctors Hitler and Goebbels also discovered the incantatory power of often unintelligible language as intoned to the masses by the magical bishop. Hugo Ball seems, in retrospect, to have had an intimation of the other uses to which a perverted variety of sound poetry could be put, uses that had absolutely nothing to do with the purification of words from their abuse by journalists, capitalist profiteers, or by demagogues. So the question might be posed: what was different about the "irrationality" of the Dada sound poem and the sort of event it could bring about?

Before addressing this question, let us consider another account of a series of Dada events by Kurt Schwitters, found in a letter he wrote in English to the Berlin Dadaist Raoul Hausmann. Both Schwitters and Hausmann became sound poets, and Schwitters was the only one of the Dadaists to raise sound poetry to a musical art. Their performances described here are of what one might characterize simply as "Dada sounds":

We opened in den Haag, in Konstruktivistik manner. Doesburg read a very good dadaistic Programm, in which he said, the dadaist would do something unexpected. At that moment I rose from the middle of the Publik and barked loud. Some people fainted and were carried out, and the papers reported, that dada means barking. At once we got Engagements from Haarlem and Amsterdam. I was sold out in Haarlem, and I walked so that all could see me, and all waited that I should bark. Doesburg said again, I would do something unexpected. This time I blew my nose. The papers wrote that I did not bark, that I blew only my nose. In Amsterdam, it was so full, that people gave phantastic prices to get still a seat, I didn't bark nor blow my nose, I recited the Revolution. A lady could not stop laughing and had to be carried out. Now we had lectures in Rotterdam, 's Hertogenbosch, Utrecht and Draghten and Leyden. The workmen and students sang Dutch songs, the students invited us to their houses in Utrecht, Delft and Leyden to discuss Dada. In Utrecht they came on the scene, presented me with a bunch of dry flowers and Bloody bones and started to read on our place, but Doesburg threw them into the basement, where the musik used to sit, and the whole public did dada. It was as if the dadaistic spirit went over to hundreds of people who remarked suddenly that they were human beings. Nelly lighted a cigarette and cried to the public, that as the public had become quite dada, we would be now the public. We sat down and regarded our flowers and nice bones.[14]

On the occasion of these Dutch performances, Schwitters did not elaborate his barking or nose blowing into a formal sound poem, although a few years later he was to compose sneeze and cough scherzos. Later performances of his sound poetry, such as the "Sonate in Urlauten," a half-hour phonetic piece composed in strict sonata form, provoked much the same reaction from audiences as had his Dada noises in Holland—surprise, uncontrollable laughter, and an immediate demand for more. The demand, however, was not for more of the same, but for more of the different. The Dutch audience increased evening by evening with a public half-anticipating the snort or bark from the night before, but hoping even more for some new, unimagined surprise. The Dada performers were more than willing to comply and they, too, were open to surprise and willing to assume the role of audience and contemplate the unawaited arrival on their stage of dry flowers and bloody bones. For every participant in the event, on or off the stage, the sudden juxtaposition of unforeseeable elements was transformed into an arrangement of "our flowers and nice bones." As Schwitters explained, "the whole public did dada . . . (and) hundreds of people remarked suddenly that they were human beings."

The catharsis achieved in this event would be of no use to the stagers of a fascist spectacle. An unforeseen composition of dry flowers and bloody bones is incommensurate with "Blut und Eisen," and a public that has just discovered itself capable of rejoicing at Schwitters's unexpected still-life will not be immediately receptive to the clichéd juxtaposition of blood and iron and to the appeal for human lives to be sacrificed for the glory of one's country—especially when those lives belong to spectator/participants who have just discovered that they are human beings rather than mass-manipulated robots. The Fascist catharsis to be reached in a mass event must be carefully staged, with no room for unexpected intrusions that might interrupt the progression of stimulii leading to the climax. This progression to a preprogrammed climax is designed to reinforce an emotional response

that the audience already expects of itself by means that the audience can largely anticipate in advance. Spontaneous laughter on the part of an individual spectator poses a deadly threat to the orchestration of a fascist event, and anyone laughing uncontrollably at such a rally would also be carried out, probably for instant execution. Surprise, spontaneity, and laughter were cardinal virtues to all the Dadaists, including Hugo Ball in his lighter moments, and it was by these means that Dada waged its most effective battle against stale language, stale images, stale aesthetic sensibility, and the ossified morality of a European civilization bent on destroying itself in a world war while justifying itself with endless words in the process. Spontaneity, surprise, and laughter are precisely those paths to human irrational response that cannot lend themselves to fascist manipulation in the mass event. Performances of Dada sound poems, although carried out with all seriousness and concentration by their performers, seem more often than not to have made it suddenly possible for people to laugh with such abandon that laughter itself becomes the event, an event that can ultimately have a most corrosive effect on established symbols of authority and power.

Laughter is literally the root of the first sound poem created in the tradition that Ball, Schwitters, and the Berlin Dadaist Raoul Hausmann were to perpetuate. This poem was composed in 1908 by Velimir Khlebnikov and consisted of variations on the morpheme which constituted the root of the Russian verb *smex* (to laugh). In his essay, "History of the Sound Poem," Hausmann gives special emphasis to the phonetic experiments carried out by the two Russian futurist poets, Kručënykh and Khlebnikov, in what they entitled *Zaoum*, a term that has been translated variously as trans-sense, transrational, and beyond-sense poetry.[15] By 1912, *Zaoum* had become a password amongst Russian Cubo-Futurist poets and painters and nascient Russian Formalist criticism. This was also the year that Hugo Ball and Hans Arp, independently, made the acquaintance of Wassily Kandinsky in Munich. Although Kandinsky had been living in Munich for a number of years, he made frequent trips back to Russia and was well informed on what was happening in Russian avant-garde circles. In his play, *The Yellow Sound*, published in the *Blue Rider Almanac* of 1912, Kandinsky had included phonetic verse of his own. According to Hausmann,[16] Kandinsky had recited Khlebnikov *zaoum* poems for Ball in 1916 in Zurich. Hugo Ball's rationale for the creation of sound poems often seems to echo the attitudes and approach towards language practiced by the *Zaoum* writers. Khlebnikov's fellow Futurist, Kručënykh, interpreted *Zaoum* as a call for the total dissolution of the word and an orchestration of vocal sounds with no regard for meaning. The language that resulted was to be a language of the future for the whole of the human race, a language that would effect the evolution of human consciousness and transport man to a higher plane. On this transcendental plane, logic and reason were to take on a new dimension, as would the "meaning" that words can communicate.[17] Khlebnikov, on the other hand, retained the morpheme as a basic unit of meaning—a unit awakening past and suggesting future meanings—and he argued for the free arrangement of morphemic

elements. Roots and affixes, as minimal meaningful elements, were to be reshuffled into new combinations. Khlebnikov regarded these new coinages as a way to break out of the ossified words of the present and as a means by which the poet could return to primal meanings, to an *Ursprache* in which words are directly related to things they name. This *Ursprache* was a language of nature as well as of men: there was a language of earth and of the stars and Khlebnikov, on occasion, produced further *Zaoum* examples of bird language, color language, the language of the gods, and of a restored primal language in which all men might understand one another. Arp and Ball were also preoccupied with the question of a preadamic language, or *Ursprache,* in their reading and discussions in Zurich. In his 1952 essay, "Kandinsky the Poet," Arp recalls how Kandinsky's poetry was received in the Cabaret Voltaire with what Arp described as preadamic howls.[18] this recitation could well have included *Zaoum* poems by Khlebnikov and Kručěnykh. Khlebnikov's own speculations on how the actual physical act of articulating initial consonants of words replicates the thing being named recall not the work of his contemporaries, the Russian linguists, but rather the speculations on a preadamic language three centuries earlier by the German mystic Jacob Boehme, a philosopher with whom Ball and Arp were also preoccupied during their Zurich days. Khlebnikov's ultimate premise, a return in the future to a primal language once shared by all men in the past, would unite all men and make both Babel and war obsolete. On numerous occasions he pointed out similarities between his own *zaoum* language and the incomprehensible liturgical writing of the world's great religions.

Khlebnikov's importance to Russian Formalism and to the Russian Cubo-Futurists is undisputed and has been examined in detail by formalist critics and linguists such as Roman Jakobson. What still remains to be examined carefully is the Blue Rider Expressionist/Zurich Dadaist encounter, via Kandinsky, with the *Zaoum* belief in transformation of human consciousness through the purification of language (as had been envisioned by the Russian's *Zaoum* movement). As we have noted, Ball's ultimate argument for the sound poem was not that of the magical bishop, but rather that of the aesthetic revolutionary, the poet-purifier who would change the world by purging and recreating words. Ball, like Khlebnikov, split open the word and worked with the morpheme—not as systematically as had Khlebnikov, but with similar intentions. Shortly before the sound poem performance in 1916, Ball summarized the language experiments of the Dadaists up to that point:

> We tried to give the isolated vocables the fullness on an oath, the glow of a star. And curiously enough, the magically inspired vocables conceived and gave birth to a new sentence that was not limited and confined by any conventional meaning. Touching lightly on a hundred ideas at the same time, this sentence made it possible to hear the innately playful, but hidden irrational character of the listener; it wakened and strengthened the lowest strata of memory.[19]

Ball's description of how to create words anew is couched more in the language of psychoanalysis than in that of linguistics. But his account also recalls the

metaphors with which Khlebnikov characterized what he called his sacred obligation to word creation in the *Zaoum* poem: "Word creation is an explosion of language's silence, the deaf and dumb layers of language. By replacing one sound with another in an old word we immediately create a path leading from one valley of language to another and like engineers we blaze trails of communication in the land of words across the mountain crest of the silence of language."[20] The silence of language is broken by the literal speaking of the word, and this sounding word is a stimulus that can prompt a spontaneous response on the part of its recipient. The sound, or *Zaoum,* poem was conceived as an act of liberation for human consciousness, a pronouncement of the word that went far beyond all existing conventional notions of the reception of a performed work of art.

## Notes

1. Hugo Ball, *Die Flucht aus der Zeit* (Luzern, 1956), p. 99.

2. Raoul Hausmann, "Bedeutung und Technik des Lautgedichts," *Nota* 3 (1959): 30-31; "Zur Geschichte des Lautgedichtes," *Am Anfang War Dada* (Giessen, 1980), pp. 35-44.

3. Ball, *Die Flucht,* p. 100.

4. Ibid., p. 93.

5. Ibid., p. 94.

6. Ibid., p. 7.

7. Ibid., p. 8.

8. See Walter Benjamin, "Das Kunstwerk im Zeitalter der technischen Reprodizierbarkeit," in *Benjamin, Gesammelte Werke,* ed. Tiedemann and Schweppenhauser, Band 1, 2 (Frankfurt: Suhrkamp, 1974), pp. 471-508.

9. This essay is included in translation in the English translation of *Flucht aus der Zeit* at the end of the book but is not included in the German original.

10. Ibid.

11. Ball, *Die Flucht,* p. 90.

12. Jacob Flach in Monte Verita.

13. Rudolf Laban, ibid.

14. Kurt Schwitters in reprint edition of *Pin,* ed. Schwitters and Hausmann. Hausmann's German translation of this letter of 14.11.46 is to be found in Schwitters: *Wir spielen bis uns der Tod holt: Briefe,* ed. Ernst Nundel, (Frankfort: Ullstein, 1974) pp. 247-48.

15. See Charlotte Douglas's discussion of *Zaoum* poetry in "Beyond Reason: Malevich, Matiuschin and Their Circles" in *The Spiritual in Abstract Painting, 1890-1985* (New York: Abbeville Press, 1985), pp. 185-201.

16. Hausmann, "Bedeutung und Technik des Lautgedichts."

17. Douglas, "Beyond Reasons," p. 186.

18. Jean Arp, *Jours effeuilles* (Paris: Gallimard, 1966), p. 369.

19. Hugo Ball, *Die Flucht,* p. 95–96.

20. Velemir Chlebnikov. *Werke,* Band II. Prosa, Schriften, Briefe (Hamburg: Rowohlt, 1972), p. 322.

# Part Four

# Social Theater

# Jarry's Inner Circle and the Public Debut of Père Ubu

*Dana Tiffany*

The story of the 1896 *première* of Alfred Jarry's *Ubu roi* in Paris has been told many times, and with good reason, for it was perhaps one of the most outrageous and significant openings (and closings) in the history of the Western theater. As Roger Shattuck noted: "There had been nothing like it since the wild *première* of Victor Hugo's *Hernani* in 1830, when Théophile Gautier and Gérard de Nerval carried the day for romanticism by highly organized demonstrations."[1]

The play that stimulated protests and demonstrations unknown to the French theater since the *première* of *Hernani* is little more than an outrageous and fiercely scatological schoolboy farce amiably plagiarized from numerous sources, Shakespeare only the most apparent and best known. *Ubu roi*'s main character, the comically monstrous Père Ubu, betrays and then murders the king of Poland in order to usurp his throne (figs. 9.1, 9.2). Ubu's own reign quickly turns into a grotesque comedy of extortion and murder, however, as Ubu feeds his gross and disgusting appetites for food, money, and power. He ultimately loses his throne as the czar of Russia restores the son of the dead king, and Ubu must flee with his no less disgusting wife Mère Ubu.

What I wish to suggest here is that this landmark of European theater should be seen as ritual performance art staged by Jarry and some of his close friends in the Symbolist avant-garde, particularly those who collected around the office of the *Mercure de France,* one of the few stable avant-garde publications of that period (figs. 9.3–9.6). Jarry and his crowd designed the first performances of *Ubu roi,* I believe, to establish the boundaries of their small artistic community, and to provoke a confrontation with the normative community that lay beyond those boundaries. The impetus for this conflict lies in the fact that the avant-garde is an adolescent creation. Its energy derives from the generational conflict between fathers and sons, so common to late nineteenth-century European society. The *première* of *Ubu roi* witnessed the sudden and unselfconscious irruption of an adolescent ethic onto the legitimate stage. The play and its raw adolescent power were

Figure 9.1.  Alfred Jarry, *Véritable Portrait de Monsieur Ubu,* 1896
Woodcut, 7.4 × 11.3 cm.
*(First published in* Le Livre d'art, *no. 2, April 25, 1896. Cover and page 7
of the first edition of* Ubu roi *in 1896)*

Figure 9.2. Alfred Jarry, *Autre Portrait de Monsieur Ubu (Another Portrait of Ubu)*, 1896 Ink drawing, 5.3 × 4.9 cm.
*(First published in* Le Livre d'art, *no. 2, April 25, 1896. Included in the first edition of* Ubu roi)

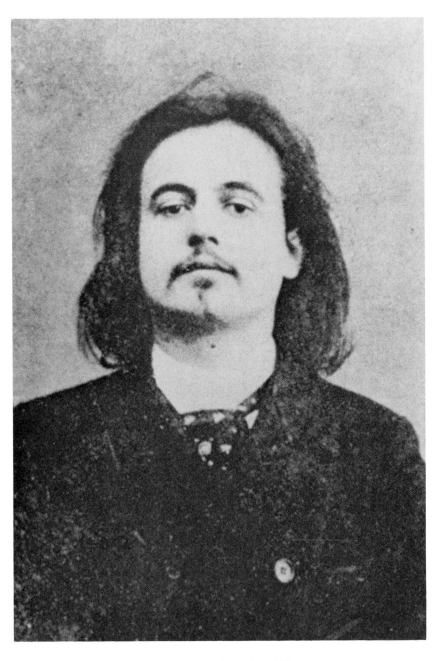

Figure 9.3.  Photograph of Alfred Jarry by Nadar, 1896
By the opening of *Ubu roi*, Jarry had cut off most of his long hair.

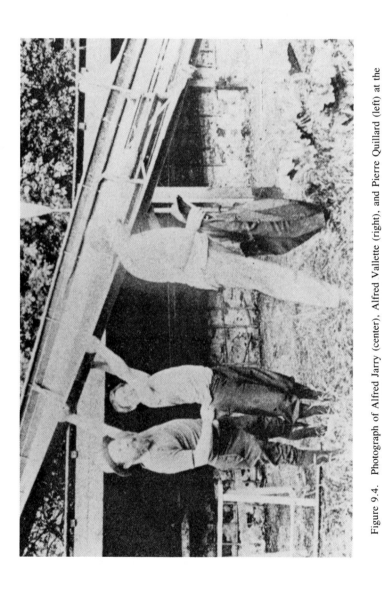

Figure 9.4.   Photograph of Alfred Jarry (center), Alfred Vallette (right), and Pierre Quillard (left) at the
Phalanstère, ca. 1898

Jarry maintained quarters at the Phalanstère (Jarry's name for a little country home at
Corbeil, southeast of Paris, rented by the editor of the Mercure de France, Alfred Vallette).
Here, the three assist in the maintenance of Vallette's canoe, or "as". This craft served as
inspiration for the much more complicated craft piloted by Jarry's Faustroll in his imaginary
pilgrimage through the avant-garde.
*(Collection: Mme G. Fort-Vallette)*

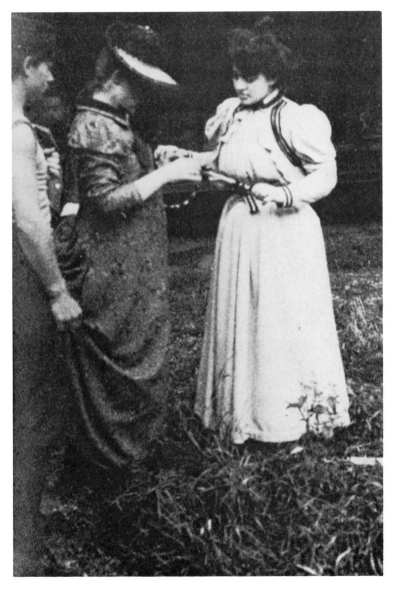

Figure 9.5. Photograph of Alfred Jarry and Rachilde at the Phalanstère, n.d.
Rachilde, Vallette's wife, was a highly regarded writer in her own
right. Here, Jarry submissively holds her skirts, dramatic evidence that
his celebrated misogyny did not extend to women of talent. The other
woman is Marie-Thérese Collière. This picture came to be known in
the Vallette family as "The Three Graces."
(Collection: Mme G. Fort-Vallette)

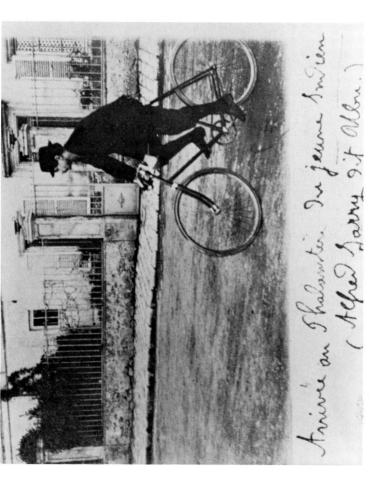

Figure 9.6. Photograph of Alfred Jarry outside the Gate of the Phalanstère, n.d. Jarry here is riding his beloved bicycle, a very expensive racer of the type used by competitors in the infant Tour de France. Jarry never paid for this bike, and spent much energy keeping its location hidden from its hapless seller. Jarry's taste for bicycling plays a major role in his 1902 novel *Le Surmâle* (*The Supermale*). (Collection: *Mme G. Fort-Vallette*)

to have lasting impact and influence in later decades. The ghost of Jarry seemed to have an affinity for postwar eras. In the years following the First World War, both Dada and Surrealism embraced and defended Jarry and his play as a forerunner. The dramatic theories that Jarry crafted for the *première* of *Ubu* form the headwaters of Antonin Artaud's Theater of Cruelty, which unknowingly resurrected Jarry's intense interest in religious ritual. In the years immediately following the Second World War Jarry once again found his place, most notably in the strong influence exerted by Jarry's work on Eugène Ionesco and the Theater of the Absurd. Even today, Jarry retains an important place within the circle of modern theories of performance art.

To judge from the treatment of the *première* in most recent histories, however, it seems clear that few today know what actually happened that night in December 1896. The specific context of that event can only be understood by an examination of the manner in which Jarry, though himself not actually the sole author of *Ubu roi,* inherited and preserved that work, and then transmitted it to the Symbolist avant-garde in Paris. The larger significance of the *première,* however, can best be understood in light of modern anthropological theories of ritual process developed and elaborated by Arnold van Gennep and Victor Turner to describe and to explain so-called rites of passage, including ceremonies to mark such life stages as birth, initiation, marriage, and death. In what follows, I shall attempt to make clear both the historical and the theoretical significance of the *première* of *Ubu roi.*

Despite the number of times that the story has been told, there remains much confusion about what actually happened, and even on what day it happened. Even the usually reliable Roger Shattuck stumbles, giving December 11, 1896 as the date of the *première,* when it actually took place the day before. This near-universal confusion stems from the fact that there were *two* performances of the play given on successive nights. The *répétition générale,* or full-dress rehearsal, took place on the 9th, followed the next night by the *première.* Because of the dramatic off-stage events on the night of the *première,* the two nights became confused in subsequent reports. Some who did not witness the *première* may believe they did, or may have convinced themselves in later years that they did. Consequently, over the years, the *"première"* of *Ubu roi* has been a moveable feast, travelling like a theatrical equinox from the 9th across the 10th to the 11th (figs. 9.7, 9.8).

Nevertheless, the two performances were nearly polar opposites. The *générale,* given on the 9th, passed largely without incident. This night had been eagerly anticipated for months by nearly everyone in the Symbolist avant-garde. Jarry had circulated Père Ubu through the artistic community in one form or another since at least 1893. The gross Ubu had initially been the self-invited guest who came to stay in "Guignol," then the far more dangerous terrestrial embodiment of the Antichrist in *César-Antechrist,* and finally Ubu roi in the spring and summer of 1896, the full text of the play appearing in both periodical and book form. Thus, demand for seats by those in the know became so intense that Jarry, acting not only as author of the play, but also as theater manager of director Lugné-Poë's

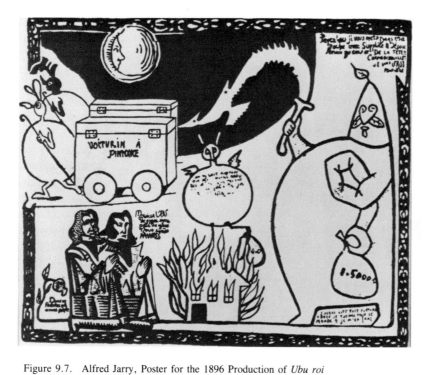

Figure 9.7.  Alfred Jarry, Poster for the 1896 Production of *Ubu roi*
Lithograph, 24 × 32 cm.
Ubu's three "palotins," made of inflatable rubber assist him in the
pillaging and killing of the Poles. Ubu himself displays leaf-like moustaches
and an extensible "oneille," or "n'ear" on top of his cone-shaped head.
His "croc a phynances" dangles booty at the end of a multi-jointed arm.
Jarry will return to this image in the character of Doublemain in *L'Autre
Alceste,* who rows the dead across the Styx to Hades.
*(Collection: Mme G. Fort-Vallette)*

Figure 9.8. Alfred Jarry, Program for the 1896 Production of *Ubu roi*. Lithograph, 24 × 32 cm. Here Jarry's lithograph has been altered to serve as the program for the production. The painter Paul Sérusier is credited with assisting in decors and set design. Jarry was very close to Sérusier and the rest of the Nabi circle. (Published as an advertisement for the play in La Critique, 1896)

Théâtre de l'Oeuvre had thoroughly papered the hall with free tickets to the *répétition générale*. Only a tenth of the estimated 1000 persons who saw the two performances actually paid their way in the door. As a result, not only did the two performances fall far short of the expected take at the box office, prompting Lugné-Poë's break with Symbolist productions of any kind for a number of years, but because Jarry gave away so many tickets to friends, there were far fewer seats than were normally available to reviewers for the *générale*.

Thus, when M. Firmin Gémier, masked and costumed in the role of the monstrous and comic Ubu, strode to the apron of the stage and let loose the resonant "Merdre!" that a group of provincial schoolboys had prepared for him more than a decade before, there was laughter in the audience, even though this word "Pshitt!," slightly altered by the *potaches,* or schoolboys, of the Lycée de Rennes, had never been uttered on the French stage before. David Grossvogel claimed that "this word, though known to the spectators, was unacknowledged by the decorous part which they had lent temporarily to the ritual."[2] Grossvogel maintains that, had the audience laughed at the word, that would have indicated "the successful absorption of the shock after the disturbance."[3] But this was, in fact, precisely what did happen, though Grossvogel, and most others, did not know it. Relating only the turmoil of the *première*, he wrote, "The spurious surface and the game were immediately forgotten: there was a genuine assailant on stage."[4] The fascinating aspect of the two performances of *Ubu roi* is that the reactions were so different. Two entirely different audiences attended each night. Gémier, in an interview twenty-five years later, remembered no problems with the word at all. "Everybody laughed. There were some laughs that 'limped' along, and others which deserved applause, but they laughed. The scenes . . . went off well, which is to say as well as they could."[5] Gémier is almost certainly recalling the events of the *générale*. He does, however, remember a fracas, but he insists that it did not erupt until the third act during a prison scene. "An actor stood on stage with his left arm bent. I put the key into his hand as though into a lock. I made the sound of the lock, 'creak, crack,' and I turned the arm as though I were opening the door. At that moment the public, finding no doubt that the foolishness had lasted long enough, set to screaming and storming."[6]

Gémier succeeded in quieting this demonstration of displeasure only by advancing to the apron and dancing a jig. He recalls being completely frustrated by the mask inflicted upon him by Jarry, and by the enormous stomach designed for Jarry's Ubu by a popular circus clown. "Imprisoned in that carcass, I was hot, I was *smoking* I was so furious . . . the feeling of my powerlessness beneath that mask made my blood boil. So I started to dance a jig to react and to exert myself."[7] It is impossible to know with any certainty today, but it seems to me unlikely, given the spare and anachronistic decor, the guignol or puppet style of the whole production, the scatology of the text—in short, the radical nature of the play from the opening word—that the scene that Gémier describes could have happened at the *générale*. The context of the interview also makes it appear that he

*146    Dana Tiffany*

is speaking about the *première*. He says, for instance, "The *première* took place the 10th of December 1896. The *générale had been given* the night before"[8] (my emphasis). It is only a small piece of evidence, of course, but his use of the word "public" suggests that the fracas he describes took place at the *première*. What has happened, I think, is that Gémier *accurately* remembered that there was no great outcry about his "Merdre!" so often repeated throughout the play, because there was no such outcry at the *générale*. But he does *remember* a great outcry, and he again does so accurately, for the next night was a Carnival of chaos. The result was that he transposed the controversy of the key in the hand from the *première* to the *générale*. The reason for this is that, right from the first review of the play in the press following the *première*, there was so much bitter hostility and confusion over what day the play had actually opened. This confusion was never cleared up, so that decades later, no one knew whether the *générale* took place the 9th or the 10th, or whether the *première* took place on the 10th or the 11th. It is no wonder that Gémier might have become mixed up. Everyone else was.

If this thesis is substantially correct, then there were two very distinct performances. The first was almost entirely dominated by those Jarry would have considered friends, and probably members of his theoretically ideal audience of 500 elite spectators. In advance of the opening of the play, Jarry had written that "the virtue of full dress rehearsals is that they are a free show for a select group of artists and friends of the author, and where for one unique evening the audience is almost completely expurgated of idiots."[9]

It becomes increasingly clear that for Jarry the actual *première* of his play took place, and was intended to take place, at the *générale*. The evidence is also clear that he, and everyone else in the Symbolist avant-garde intended the next night to be exactly what it turned out to be: performance theater in its most acute form, where the stage becomes the pretext for drama among the seats.

Jarry himself introduced the play to the *première* audience on the night of the 10th. There is no record that he had done this the night before, and the title he gave to this introduction, "Preliminary Address at the *première* performance of *Ubu roi*," though potentially ambiguous, suggests that he did not. He appeared on stage behind a rough table draped with sackcloth. He was made up in whiteface, and read a statement to the audience, which almost no one heard because he spoke too softly. He specifically acknowledged the distinguished character of the audience, which I take to mean the large number of theater critics. As soon as Jarry had retired from the stage, Gémier appeared and for the second time in as many nights launched his resonant "Merdre!" into the audience. The house exploded. As Rachilde, a novelist and one of Jarry's few female friends, would later recall:

Such a tumult followed that Gémier had to remain silent for a quarter of an hour, and that's a long time, a quarter of an hour on stage! . . . They call that a *hole*. More like a real precipice! The people of letters laughed, but the general public, above all the women, did not come back. People jeered from one loge to the other; there were insults, so much so that Willy, waving his famous flat-brimmed hat of legendary memory, ended up crying out to the public: "Bring

on the chains!'' as though esteeming the scene to be going on above all in the seats. Each time, in addition, that the word was said, throughout the play, and it is said quite often, it received the same reception: angry shouts, indignation or crazy laughter.[10]

Here indeed, was the genuine assailant on stage. Jean de Tinan, who teamed with Rachilde to play practical jokes on their friend Jarry, clapped and hissed at the same time. This has often been cited as evidence of the conflicting emotions the play evoked in those who witnessed it.[11] It was nothing of the sort. It was exactly the same sort of practical joke de Tinan and Rachilde pulled on Jarry, except that Jarry himself initiated this one. According to Georges Rémond, Jarry planned these demonstrations, inviting a scandal which ''should surpass that of *Phedra* or *Hernani*. It is essential that the play be halted and that the theater explode.''[12] Jarry suggested to Rémond that, following their plan, ''we were to provoke the tumult by crying out in fury, if people applauded, which after all, was not impossible, or with screams of admiration and ecstasy if they whistled. We were also, if possible, to combine with those around us and rain down projectiles onto the seats in the orchestra.''[13] This revelation means that even if (as I do not believe) Gémier's recollection about the *générale* is correct, that fracas in the third act was probably also a set-up job. Like the defense of *Hernani*, then, the demonstrations at the *première* of *Ubu roi* were also, in Shattuck's words ''highly organized,'' though it made no difference whatsoever to Jarry whether they were in its defense or not. Jarry seemed perfectly conscious *before the fact* that he was ''competing'' with Hugo. He succeeded in grand style. The owner of the restaurant in the rue Saint Jacques where Jarry spent much of his time among the local sewer men attended with Rémond. The restauranteur was much impressed that the whole night was entirely due to his slightly built customer, but he could make nothing of the turmoil in the house. He assumed, given Ubu's revolution and the presence of the czar in the play, that it was Republicans fighting Monarchists or Dreyfusards against the anti-Dreyfusards.[14]

Jarry, then, got exactly what he wanted, and probably without too much need of any prompting, from a hostile *première* audience. His supporters proved effective foils, and insults flew back and forth. Jarry's friend and fishing companion, A.-F. Hérold, turned the house lights up at one point, ostensibly in an attempt to calm the storm. At one point Rachilde called out ''Enough!''—a logical response to such a situation. Presumably, she did so out of irritation at the disrespect exhibited in the house. But if Rémond is correct, Rachilde would almost certainly have been in the know about Jarry's planned demonstrations. She, and perhaps Hérold as well, may have been trying to communicate with Jarry's *claques*, telling them to quiet their side of the demonstrations so as to get on with the play. It probably would not have mattered to Jarry one way or the other. Both sides had clearly come prepared to do battle. Meanwhile, the actors, forgotten and frozen on stage, watched an unscheduled performance in the seats.[15]

The Battle of *Ubu roi,* then, was a kind of ritual performance art, by and for the Symbolist avant-garde. The first night, at a relatively quiet performance, they had celebrated together, and then reconvened the following night for combat on the same premises. These two performances epitomize the distinction Jarry drew between the elite audience and the public.

In the wake of the bitter controversy that surrounded *Ubu roi* in the public press in the days following the *première,* one item completely escaped notice. This was a letter sent December 17 by a M. Charles Morin to Henry Bauer, one of Jarry's only supporters in the press (support that ultimately cost the reviewer his position). In his letter to Bauer, Morin both claimed authorship of "Jarry's" play and yet denigrated it at the same time. He also offered to send M. Bauer other works with Ubu as their protagonist.[16]

Incredibly as it may have seemed to Jarry's defenders when the controversy finally became public in the early twenties, Morin's claim to authorship is substantially valid. The earliest history of *Ubu roi,* in fact, goes back to the Lycée de Rennes in Brittany more than a decade before the *première* in Paris (fig. 9.9). Morin and his younger brother Henri Morin had been members of a group of Rennais *potaches* who began a mocking epic cycle of stories and poems aimed at a universally despised instructor, the hapless M. Félix Hébert, professor of physics. The cycle of tales about the corpulent Ebé as he was then known, ultimately swelled to such a size that they achieved written form after an early oral tradition, and were then handed down from one "generation" of *potaches* to another. Jarry intersected this extended *potache* literary project when he moved to Rennes with his mother and sister in the fall of 1888 and enrolled at the lycée. He quickly made friends with his age-mate Henri Morin, and soon had convinced the entire group of boys to turn the Ebé tales into a theatrical production. This was the origin of the Théâtre des Phynances that figures in the complete title of Jarry's most famous work, *Ubu roi or les Polonais; Drama in five acts in prose; restored in its integrity as it was performed by the marionettes of the Phynancial Theater in 1888.* This schoolboy theater lodged first at the Morin residence and then at the Jarry residence, representing a gradual transition of control of the Ebé cycle from the hands of Charles Morin to his brother and ultimately to Jarry. Their theater evolved in form from early attempts at true marionette production, abandoned for lack of skills at the strings, to the later, and definitive shadow puppet theatre (fig. 9.10). It was this theater that saw the first production of a work then known as *Les Polonais,* later to become *Ubu roi* after modifications by Jarry's friends in Paris (the extent of which are still unknown and still controversial, since the possibility of any such modifications would seem to be precluded by the title of the present work). After graduation from the lycée at Rennes, both Jarry and Henri Morin went to Paris, Morin to follow his brother into the Ecole Polytechnique and a career in the French army, Jarry for preparatory studies at the Lycée Henri IV for the Ecole Normale Supérieure. Despite his aspirations, Jarry never gained admission to the prestigious ENS, and ultimately stopped trying in order to exploit his increasingly successful

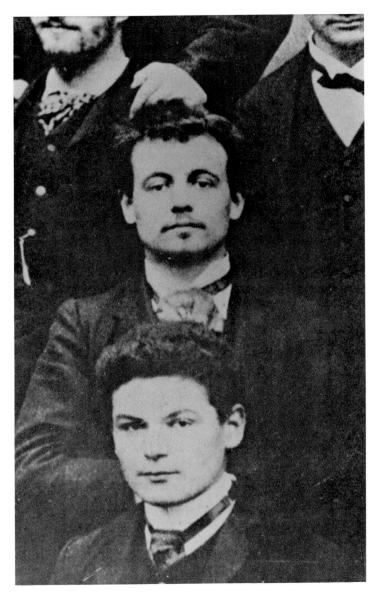

Figure 9.9.   Photograph of Alfred Jarry (top), from a Group Photograph
Taken at the Lycée Henri IV, Paris, 1893
Jarry prepared unsuccessfully at the Lycée Henri IV for the entrance
examinations for the Ecole Normale Supérieure. The young man
below Jarry is believed to be the poet Léon-Paul Fargue, at the time
of this photo Jarry's poetic collaborator and his lover. Jarry was
nineteen at the time the photo was taken.

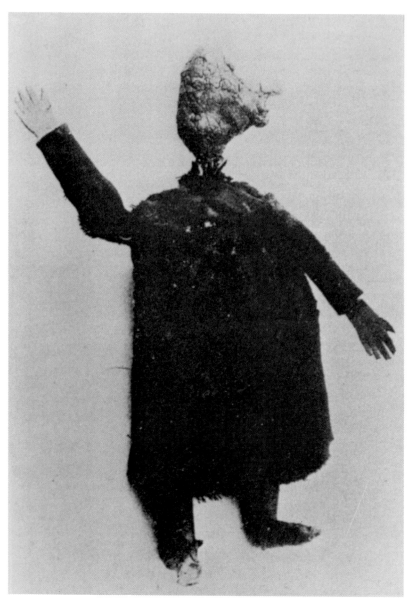

Figure 9.10.   Alfred Jarry (with Assistance from His Sister, Charlotte), Rudimentary
Childhood Marionette of Ubu, ca. 1888
Clay. This is one of the oldest of the Ubu figures, crafted for schoolboy
productions of pieces of the ''Ebé'' cycle that came out of the Lycée
de Rennes.
*(Musée des Arts et Traditions Populaires)*

entry into the Symbolist avant-garde. For a time, both the Morins and Jarry conserved the Ebé spark, leaving a lasting mark both on the avant-garde community and on the French Army's corps of engineers. At last, however, Jarry found himself in sole possession of the "sacred documents," and apparently secured the younger Morin's assent to publish parts of the tale—an assent that necessitated changing some names in order to protect both Charles and Henri, who retained close ties to Rennes, and who now found themselves of the same class and station as their former victim, Professor Hébert. Hence, the scorned Ebé became Jarry's Ubu.

Jarry's inheritance of the Ubu cycle was legitimate, then, given his long association with and substantial contributions to the tales after 1888. But Jarry had been prepared for Ubu well before he moved to Rennes in 1888. He had already written a similar cycle of mock epic poetry and drama at Saint Brieuc, centering around a Trojan War-like struggle for control of a device that Jarry variously called the Antlium, or Pump, or Taurobole, a kind of Apocalyptic organ. By whatever name, however, the device is nothing more than a "shit-pump," a malodorous mechanism all too well known in the provinces before the introduction of modern sewage pipes. With unerring adolescent instinct Jarry found the weakest spot in the armor of propriety in the community around him. The connection that Jarry makes between his shit-pump and the Tauroboly (an ancient Mediterranean initiation ritual sacred to Cybèle and Attis, involving baptism in the spurting blood of a sacrificial bull), makes clear that both the St. Brieuc Pump Cycle of epic poetry and the later Ubu Cycle at Rennes should be taken far more seriously than they have been up to now. They are not just juvenalia of only passing significance to the literary historian. They are, in fact, collaborative self-initiated attempts at crafting rites of passage, something like adolescent ceremonies of initiation, intended to span the dead space between childhood and adulthood.

Nineteenth-century Europe saw a progressive erosion of the significance of public and private rituals, victims of accelerating secularization, urban expansion, and rapid industrialization. It is, in fact, in this period that the modern concept of adolescence arises, finally achieving academic status in 1904 with the publication of Stanley Granville Hall's *Adolescence.* That same year saw the publication of *Peter Pan,* the story of an adolescent who saw the future and refused to go. Schools became the repositories of these adolescents, individuals stripped of any useful social roles, too old for the thoughtless play of the modern bourgeois child, and yet still too young for the hard life of work and death in an industrial society. These adolescents experienced a protracted period of what the late social anthropologist Victor Turner called "liminality," a suspension "betwixt and between" one social condition and another. Turner took this concept from the earlier work of a French folklorist and ethnologist, Arnold van Gennep. It was van Gennep who coined the phrase "rite of passage" to describe a large body of the most important rituals in premodern societies. Previous scholars had collected and organized this data, but it was van Gennep who went beyond taxonomy and discovered the central element of social change inherent in the most important rituals. Van Gennep

saw the structure of all rites of passage as tripartite, involving separation from one's previous condition, a transition period, and reaggregation into society with a new social role. But he stressed the central importance of the transition period in the rite of passage by noting that the three parts of the rite should be considered as preliminal, liminal, and postliminal.[17] For both van Gennep and Turner, the epitome of the rite of passage is the adolescent initiation ceremony in premodern societies.

It is most certainly *not* coincidental that Arnold van Gennep was not only a contemporary of Alfred Jarry, but an associate as well. Nor is it accidental that their association focused on the offices of the *Mercure de France,* the small but hearty Symbolist periodical and publishing house. The *Mercure* served as the most important locus of the Symbolist avant-garde in Paris at the turn of the century. From the *Mercure* came most of the talent and most of the support that made the *première* of *Ubu roi* the event it became. The *Mercure* first published both *Ubu roi* and van Gennep's *Rites de passage.* I would argue, in the strongest fashion possible, that van Gennep, forever excluded from French academic circles by his too effective criticism of Emile Durkheim's theories of totem and taboo, should himself be considered a member of the avant-garde, or at least a fellow traveller. Secondly, I would point out how intensely felt in a personal way was van Gennep's discovery of the rites of passage. As he wrote, "I confess sincerely that though I set little store by my other books, my *Rites de passage* is like a part of my own flesh, and was the result of a kind of inner illumination that suddenly dispelled a sort of darkness in which I had been floundering for almost ten years."[18] I am inclined to take van Gennep's claim that his work on the rites of passage was "like a part of my own flesh" at face value. His anthropological discoveries concerning the rites of passage, which were based on absolutely no original fieldwork on his part, should be seen as far more applicable to the immediate cultural context that formed van Gennep himself than to the rather remote African and Australian cultural contexts to which they have been directed.

The most important recent elaborations of these essentially personal discoveries by van Gennep have come in the work of Victor Turner. Turner added two central contributions to our understanding of rites of passage, and particularly to our understanding of the concept of liminality. These are Turner's concepts of communitas and antistructure, which he opposes to societas and structure. "Societas" is Turner's term for the normative community and its values. "Structure" is the term he uses to describe the mode of social interaction within that community during normal times. Societas and structure are the world of the indicative, the everyday where things are what they seem. Individuals relate to one another primarily on the basis of less-more comparisons of wealth or status. Liminality, however, conjures up the realms of communitas and antistructure, the realm of the subjunctive, the world of Carnival. Communitas levels social distinctions, and introduces a kind of ritual poverty that elicits a *solitary* egalitarian community largely without structure. "It is almost everywhere held to be sacred or 'holy,' possibly because

it transgresses or dissolves the norms that govern structured and institutionalized relationships and is accompanied by experiences of unprecedented potency.''[19] This dissolution of social structure is Turner's definition of "antistructure." Because of their potency and their position (literally betwixt and between normal social definitions of life and death), liminal individuals, and especially liminal *groups,* are seen by the normative community as both uncommonly dangerous and as taboo, that is, both sacred and polluted. Liminal groups are also seen to be invested with uncommon creativity, an aspect which by itself often justifies the danger run by the normative society in suffering such groups to exist for short periods in their midst (for instance, in initiation ceremonies). Their creativity is placed in service to societas after reaggregation.

The problem, however, with the modern adolescent liminal groups, such as the Théâtre des Phynances in Rennes and the Symbolist avant-garde in Paris, is that there are no certain mechanisms for reaggregation. With the adolescence of Jarry in Rennes, and the Symbolist avant-garde in Paris fueled by adolescence like Jarry, we have entered the realm of protracted liminality (and hence of protracted creativity), but also of protracted danger, pollution, and taboo. It is no wonder, then, that the response of normative society to the avant-garde is one of undisguised hostility, if not horror. Hence, whenever any substantial fragment of the avant-garde gathers for what a modern anthropologist would call rites of intensification, intended to reaffirm the communitas of the group, the response of the normative community, or societas, will be precisely what faced *Ubu roi* at the *première,* and in the press following the premiere (figs. 9.11–9.13). This, in fact, is what elicits the Event—a ritual act designed to define the boundaries of the group, a definition that is by necessity both positive and negative at the same time, since it defines by including some and excluding others. By 1896, both Charles and Henri Morin had made their uncertain way into societas, and thus rejected their own work. Jarry never made the transition. He, like so many of his contemporaries, remained within the magic circle. Writing after the "failure" of *Ubu roi,* Jarry reflected about the public beyond the boundaries of the avant-garde: "It would have been easy to alter *Ubu* to suit the taste of the Paris public by making the following changes: the opening word would have been Zut (or Zutre) . . . the army uniforms would have been First Empire style, Ubu would have been knighted by the Czar, and various spouses would have been cuckolded—but in that case it would have been filthier.''[20] Jarry, however, had entirely different aims in mind. He intended, he said, that once the curtain went up, the scene should

> confront the public like the exaggerating mirror . . . in which the depraved saw themselves with dragon's bodies . . . or whatever corresponded to their particular vice. It is not surprising that the public should have been aghast at the sight of its ignoble self, which it had never before been shown completely. . . . What no one seems to have understood . . . is that Ubu's speeches were not meant to be full of witticisms . . . but of stupid remarks, uttered with all the authority of the Ape.[21]

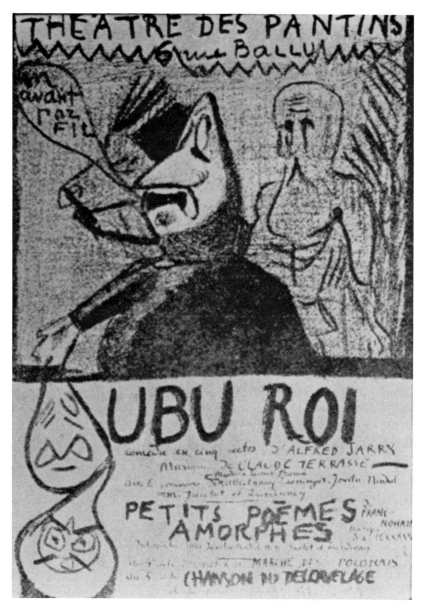

Figure 9.11.  Alfred Jarry, Poster and Program for the Marionette Production of *Ubu roi* at
the Théâtre des Pantins, Paris, 1898
Lithograph. The former soldier Jarry has Ubu cry to his Polish troops ''En
avant par fil'' a delightful pun which can mean either ''Forward by
columns,'' or ''Forward by strings.''

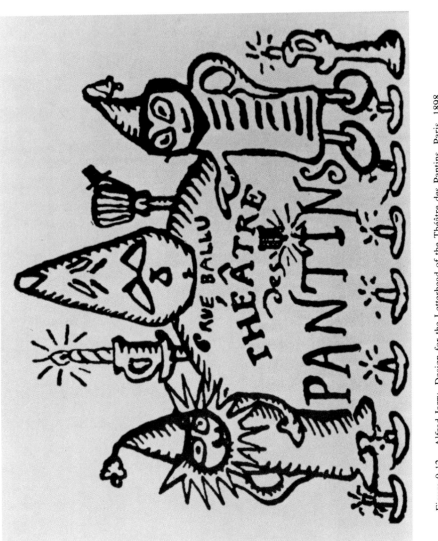

Figure 9.12. Alfred Jarry, Design for the Letterhead of the Théâtre des Pantins, Paris, 1898 Published as an advertisement for the theater in *La Critique*, no. 70 (January 20, 1898).

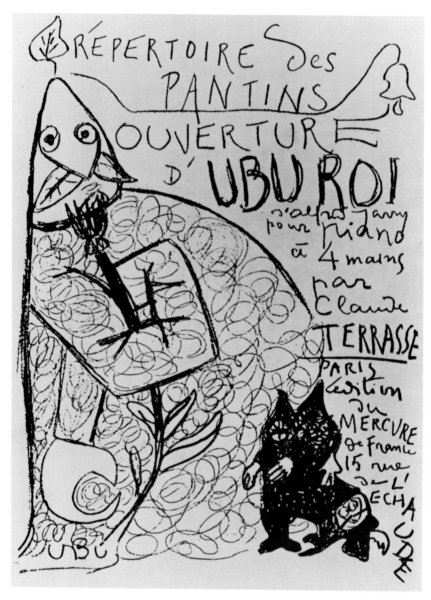

Figure 9.13. Alfred Jarry, Cover Illustration for *Répertoire des Pantins, Ouverture d'Ubu roi,*
Paris: *Mercure de France,* n.d., but Known to Be 1898
Lithograph, 27 × 35 cm. Note that Jarry has signed this work "UBU" in the
lower left corner. The dark figures below Ubu's gidouille are his palotins, here
in their unexpanded phallic shape.

There is no remedy to this opposition. It is desired as much by the artist as it is by the public.

> Since Art and the public's understanding are so incompatible, we may well have been mistaken in making a direct attack on the public in *Ubu roi;* they resented it because they understood it only too well, whatever they may say. Ibsen's onslaught on crooked society went almost unnoticed. It is because the public are a mass—inert, obtuse, and passive—that it's necessary to strike them now and then so we can tell from their bear-like grunts where they are—and what they're about.[22]

In the same article, however, Jarry looked forward, perhaps with some wistfulness, to what he thought was the inevitability of reaggregation:

> We too shall become solemn, fat, and Ubu-like, and shall publish extremely classical books which will probably lead to our becoming mayors of small towns where, when we become academicians, the blockheads constituting the local intelligentsia will present us with Sèvres vases . . . and another lot of young people will appear, and consider us completely out of date, and they will write ballads to express their loathing of us, and there is no reason why this should ever end.[23]

None of this happened to Alfred Jarry, of course. Too little food and too much absinthe and ether, combined with tuberculosis, killed him at 34 in 1907. Unlike the Morin brothers, he never played traitor to his childhood. For the rest of us, our children will prepare their ballads for us. There are only two avenues of escape from this fate that Jarry staked out for us. One of these is to find a reason why the process should come to an end, and a way to make it so. This would lead inevitably to a removal of the causes that brought the avant-garde into being in the first place, and clear the way for a truly postmodern existence. The other avenue is the one that Jarry found, the same end that typifies the avant-garde—whether it is the quiet disappearance of an Alfred Jarry in the Parisian cemetery at Bagneux, or the wildly hallucinatory disappearance of a "Jim" Morrison across town at Père Lachaise.

**Notes**

1. Roger Shattuck, *The Banquet Years: The Origins of the Avant-Garde in France, 1885 to World War I*, rev. ed. (New York: Vintage Books, 1968), p. 206.

2. David I. Grossvogel, *Twentieth Century French Drama*, (New York: Columbia University Press, 1958), p. 20.

3. Ibid.

4. Ibid., p. 21.

5. Firmin Gémier, "La Création d'*Ubu roi* racontée par son principal acteur," Interview with Roger Valbelle, *Les Nouvelles littéraires*, no. 2780 (March 26–April 2, 1981): 38–39. Reprinted from the original interview in *Excelsior* (Nov. 4, 1921).

6. Ibid.

7. Ibid.: 39. Gémier's recollection conflicts with Shattuck's assertion that he did not wear a mask. Shattuck's description of Gémier's costume indicates that he mistook photographs taken from the 1908 production for the 1896 production. In the reprise, Gémier was both main actor and director as well, so the masks were suppressed.

8. Ibid.: 38.

9. Alfred Jarry, "Theater Questions," in *Selected Works of Alfred Jarry*, Roger Shattuck and Simon Watson Taylor, eds. (New York: Grove Press, 1965), p. 89. Translation is by Stanley Chapman.

10. Rachilde, *Alfred Jarry ou surmâle des lettres* (Paris: Bernard Grasset, 1928), p. 80.

11. Shattuck, *The Banquet Years*, p. 208.

12. Georges Rémond, "Souvenirs sur Alfred Jarry et quelques autres," *Mercure de France* (April 1, 1955): 664.

13. Ibid.: 664-65.

14. Ibid.: 667.

15. Noël Arnaud, *Alfred Jarry: d'Ubu roi au Docteur Faustroll* (Paris: La Table Ronde, 1974), p. 314.

16. Charles Chassé, *Dans les coulisses de la gloire: d'Ubu roi au Douanier Rousseau* (Paris: Editions de la Nouvelle revue critique, 1947), p. 78. Most of this work is a republication of Chassé's earlier attack on Jarry, *Sous la masque d'Alfred Jarry (?): Les Sources d'Ubu-roi* (Paris: H. Floury, 1922). Chassé published the text of Charles Morin's letter to Henry Bauer in *Figaro* (January 3, 1922).

17. For van Gennep, see Arnold van Gennep, *Rites of Passage* (Chicago: University of Chicago Press, 1960). Translated from the French by Monika Vizedom and Gabrielle L. Caffee. Originally published as *Rites de passage* (Paris: *Mercure de France*, 1909). For Turner, see Victor Turner, "Betwixt and Between: The Liminal Period in *Rites de passage*," reprinted in Victor Turner, *Forest of Symbols: Aspects of Ndembu Ritual* (Ithaca: Cornell University Press, 1969); and "Process, System and Symbol: A New Anthropological Synthesis," in *Daedalus* (Summer 1977): 61-81.

18. Arnold van Gennep, *Religions, moeurs et légendes: Essais d'ethnographie et de sociologie*, 5 (Paris: *Mercure de France*, 1914), pp. 39-40. Translation is by Dereck Coltman, from Nicole Belmont, *Arnold van Gennep: The Creator of French Ethnography* (Chicago: University of Chicago Press, 1979), p. 58. Originally published as *Arnold van Gennep: Le Créateur de l'ethnographie française* (Paris: Payet, 1974).

19. Turner, *The Ritual Process*, p. 96.

20. Alfred Jarry, "Theater Questions," in *Selected Works of Alfred Jarry*, Roger Shattuck and Simon Watson Taylor, eds. (New York: Grove Press, 1965), p. 83. Translation is by Barbara Wright, which I have altered slightly. (First published in *La Revue blanche* [January 1, 1897]: 16-18.)

21. Ibid.

22. Ibid.

23. Ibid, p. 85.

# 10

# The Religious Ritual as Social Event

*Nicoletta Misler*

*Anaxagoras and Democritus substituted a paralyzed spectator for the living person, as if that spectator had been poisoned by venom, and in this way they clarified the rules according to which the spectator is deceived.*
Pavel Alexandrovich Florensky, ''Obratnaia perspektiva''

This description[1] was used by Pavel Florensky to define the theater after the invention of the perspectival procenium, a discovery which eventually led to the total illusionistic space of late Roman painted architecture in Pompeii, and to the one point perspective space of the Italian Renaissance. The contrary model for Florensky was the continuously moving spectator who viewed the inverted perspective of the icon[2] and who participated in the Orthodox mass; an antitheatrical, antiillusionistic, synthetic performance of a religious event.

Who was this man, and how did he dare to maintain such a position in 1918, in Soviet Russia immediately following the October revolution? Pavel Florensky (1882–1943)[3] was a man of many complexions. He was an Orthodox priest and a mathematician, a philosopher and an art historian, a folklorist and an archaeologist. Florensky studied mathematics and physics at Moscow State University and took his vows as a priest in 1911 (fig. 10.1). In 1918–19, he lived in the Sergiev Posad (Zagorsk), the old monastery and center of the Russian Orthodox faith, where he taught mathematics and was in charge of the Commission for the Preservation and Restoration of the icons and monuments in this monastery complex. In 1921–23, Florensky taught *Theory of Spaciality* at the Vkutemas (Higher State Artistic and Technical Studios), the avant-garde school of painting, architecture, and design, in Moscow. Working and researching in the capacity of a physicist, he concurrently made fundamental discoveries in magnetism and electricity. Being aware of the latest investigations into the Theory of Relativity and quantum physics, Florensky took part in the ongoing international debates among scientists. He also attempted

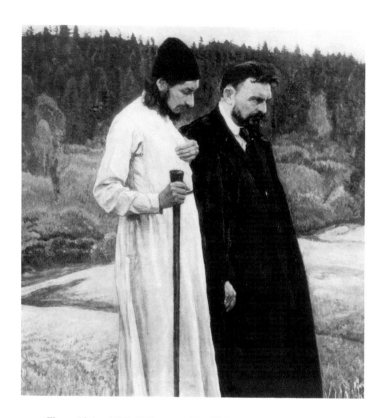

Figure 10.1.   Mikhail Nesterov, *The Philosophers* (Portrait of Pavel
Florensky and Segei Bulgakov), 1917
Oil on canvas, 123 × 125 cm..
*(State Tretiakov Gallery, Moscow)*

to apply his multifaceted scientific knowledge to art criticism.[4] In 1932, Florensky published his last article[5] and, eventually in 1933, was sent to a Stalinist camp in Siberia, where he died in 1943.

In 1919, Florensky affirmed: "The goals of my scientific research had been and continue to be the principles of the understanding of life in their historical, logical and psychological structure. . . . My studies of mathematics, biology, geology, and, recently, art history, must be seen as a path to the understanding of the above principles."[6] These words serve as a pertinent introduction to the 1918 text of Florensky's lecture, "The Orthodox Rite as a Synthesis of the Arts,"[7] a lecture which focused primarily on the preservation of individual, isolated art objects—namely the icons in the Zagorsk churches and monasteries.[8] However, in the course of his argument, these art objects came to serve as the crossroad for the entire network of conditions which create a totality, and the religious ritual became an artistic event (fig. 10.2).

There is, of course, a long historical tradition which claims the religious ritual to be an artistic event: it is an event because, even though regularly repeated, it remains cut off from everyday life; it is artistic because the highest forms of the ritual appeal synergetically to the senses of vision, hearing, taste, smell, and touch, all of which lead to an artistic appreciation of the event. This tradition began with the Greek and Roman Mysteries and continued through Romanticism, at which time the painter Phillip Otto Runge, who also regarded the Catholic mass as a synesthetical performance, attempted to attain a parallel synthesis in his experiments with color (fig. 10.3).[9] The Symbolists picked up the Romantic legacy (particularly from Wagner) and expressed it in their own theory of the synthesis of the arts;[10] a utopian representation of a physical and spiritual totality—the Event, the Uniquum, as in Alexandre Skriabin's *Misterium*.[11]

In compiling his lecture, "The Orthodox Rite as a Synthesis of the Arts," Pavel Florensky was aware of this tradition, relied upon it, but went much further. His conception of material culture as a means by which historical events serve to contextualize and elucidate cultural artifacts, regardless of whether or not these objects are "artistic," was prophetic. He was unafraid of internal contradictions and, as usual, his argument was complex, analytical, and wide-ranging. As scientific consultant for the Preservation Commission, Florensky's point of departure for the lecture was the need to preserve the icons of the Monastery.[12] He began by explaining that each art object, or rather each aesthetic phenomenon, has its own particular preconditions for perception; i.e., for painting and sculpture—light; for music—silence; for architecture—space; and that alongside these general conditions, additional specific qualities interweave with the aesthetic phenomenon as a whole. Florensky posited that the icon was intended to be perceived within an iconostasis, or a specific "narrative" and visual system.[13] For example, the icon was painted with a golden background in order to emphasize the iconostasis itself, to reflect the rays from the narrow windows of the darkened Russian church. Also, there were other, more subtle conditions known to the icon-painter before he started to

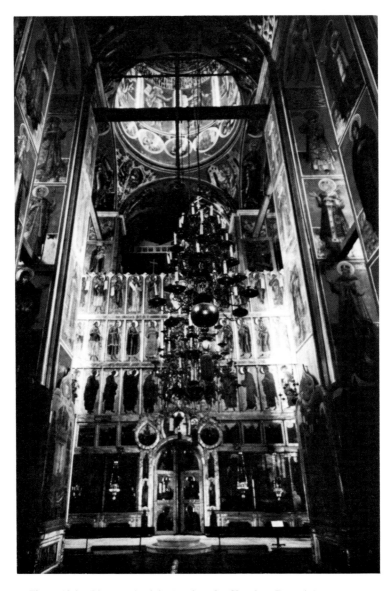

Figure 10.2.   Photograph of the Interior of a Church at Zagorsk Monastery
(near Moscow), Built in Early Fifteenth Century

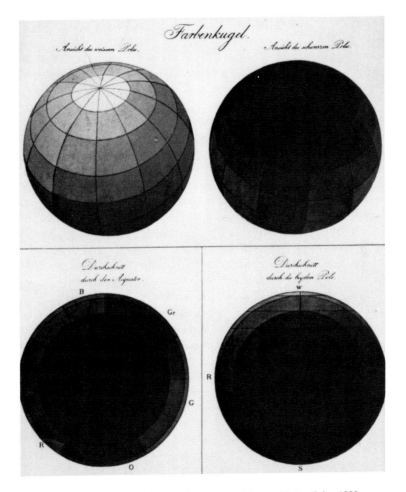

Figure 10.3.  Philipp Otto Runge, *Sections and Views of Color Orbs*, 1809
Copperplate engraving, aquatint and watercolor, 22.5 × 18.9 cm.
*(Published originally in* Farben-Kugel *[Hamburg: Perthes, 1810])*

paint: the bluish smoke of the incense, the tiny flames of the candles, the trembling light of the church lamps—all of which softened "the barbaric, heavy gold, futile in the diffuse light of day" (fig. 10.4).[14] Florensky was against putting icons in museums because of the garish electric lights of those institutions. He believed that the spectator could perceive the icons in an authentic manner only when they were seen through their original smokey atmosphere which evoked a sense of depth and luminescence. According to Florensky, the architecture and the spaciality of the church caused the bluish smoke to uncoil slowly and calculatedly,[15] and that these movements vitalized the aridity and rigidity of the architectural lines and expanded the architectural space. This space became even more alive through the regular, calculated movements of the clergy and their assistants, the rhythms of their gestures, and the reflected iridescence of the folds of their rich vestments. Florensky further explained that those rhythms were meant to be accompanied by vocal litanies, by choirs, and by the special recitatives of the ritual (fig. 10.5).

In the Orthodox event, the audience took part in the living drama: hearing, singing, smelling incense, and tasting the blessed bread that was prepared in the Monastery according to the ancient recipe. Furthermore, the audience experienced a deep sensuality incited by kissing the sacred images, softened by centuries of exposure to wax candles. Florensky's description coincides with the Symbolists' avant-garde theories of synesthetic performance.

As far as rhythmic movement is concerned, it is worth recalling Kandinsky's experiments with synesthetic drama. Kandinsky devoted particular attention to the "inner sense" of movement in his drama, *The Yellow Sound* (1909),[16] where he attempted to use movement in a dissonant way (that is, as a kind of contrast or antithesis to the music and color of the piece). This dissonance was based on Kandinsky's conviction that new art must be created by means of contrasting, rather than harmonious, stimuli and that it must relate to the different senses. In the late 1920s, during the course of a lecture, Kandinsky recalled:

> While abroad [Munich], I myself experimented together with a young musician and a dancer. The musician picked out from a series of my watercolors the one that seemed the clearest to him with regard to music. In the absence of the dancer, he played this watercolor. Then the dancer joined us, the musical work was played for him, he set it as a dance, and then guessed the watercolor that he had danced.[17]

Alexander Sakharov was the young dancer who experimented with Kandinsky in 1909–10. Sakharov was probably scheduled to dance a principal role in Kandinsky's *The Yellow Sound* and, significantly enough, was later to invent a personal synthetic method of dancing that was not unaffected by Kandinsky's assumptions.[18] During those same years, there were other individuals, for example the composer Alexander Skriabin, who also attempted to achieve this consonance—or dissonance—between music, painting, and the body dynamic.

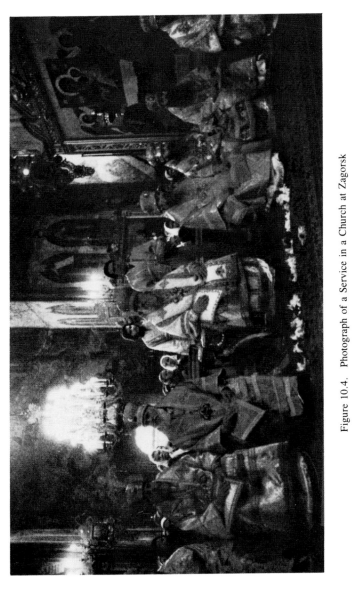

Figure 10.4. Photograph of a Service in a Church at Zagorsk

Figure 10.5.    Photograph of a Service in a Church at Zagorsk

Alisa Koonen, the wife of Alexander Tairov, and the primary actress of his Chamber Theater in Moscow, recalls in her memoirs[19] that in 1908 she was invited to "work" with Skriabin in an experimental capacity. Her task was to express his music in symbolical gestures. At the very beginning of the collaboration, Skriabin and Koonen attempted to interpret certain moods from different musical pieces and études, and to then represent these interpretations in a short narrative format.[20] These sessions occurred in a dark room, and Skriabin simultaneously operated a small apparatus of colored lights, the original *tastiera per luce,* or the keyboard of light, for the *Prometheus.* In correspondence with different gestures and sounds, the room would suddenly be illuminated by blue, green, or violet.[21] Kandinsky's experiments with Sakharov and Skriabin's with Koonen were chamber events similar to the Orthodox ritual. They were investigations in anticipation of a project for experiencing a totality (fig. 10.6), and in his rather chaotic and delirious way, Skriabin understood this when he spoke of the *Misterium* as the *definitive event.* He believed that the music was simply a background for color tactility and aroma, and that through this synthesis the ecstatic totality of the ancient ritual could be recreated. Skriabin's first idea for a *Misterium* (a total rite) arose at the same time as his *Prometheus* and during subsequent years, the concept of the *Misterium* metamorphosed in accordance with the composer's expanding philosophical readings and concerns.[22] He later attempted to invent a new language for the rite based on Sanskrit roots and including cries, interjections, and the sounds of the inhalation and exhalation of a Yoga exercise.[23]

A pencil drawing by Skriabin, the date of which is still debated,[24] illustrates his "Temple of Celebration" for the *Misterium.* It consists of a globe, half above water, supported by twelve columns, presumably meant to project the twelve color chords that he wanted to include in *Prometheus* (fig. 10.7). Skriabin's temple was to have housed a total ritual of poetry, declamation, mime, dance, light and color play, and music. The *Misterium* was intended to be nothing less than the universal dissolution in Ecstasy, redefined as Nothingness or, in other words, the end of the world.[25] By the winter of 1913–14, Skriabin was compelled to limit his activities to his project for a *Prefatory Action,* another total ritual.[26] *Prefatory Action* involved audience participation and was to take seven days, each day representing a new stage of elevation. The audience, as one body, was to move through its various terrestrial and spiritual levels and, at each new phase, would receive new sensations and vibrations. The choreography was to include bells suspended from the sky, dances, glances, touching of hands, smells and perfumes such as frankincense and myrrh, fires, and colored light effects. The members of the orchestra were also to participate physically, as well as rhythmically, in the general movement.

The description of Skriabin's *Prefatory Action* demonstrates that it was as mystical as his *Misterium* but, strangely enough, its mysticism appealed to the Marxist Soviet government after the revolution. Indeed, the so-called mass actions of

Figure 10.6.   Alexander Skriabin, Untitled Drawing (Probably for *Prefatory Action*), n.d.
Drawing from Skriabin's notebook, reproduced in M. Gershemzon, ed., *Zapisi
A. N. Skriabina. Russkie Propilei* (Moscow: Sabashnikov, 1919), vol. 6, p. 156.

Figure 10.7.   Alexander Skriabin, Untitled Drawing (Scheme for the *Misterium*), ca. 1914
Drawing from Skriabin's notebook, reproduced in M. Gershemzon, ed., *Zapisi
A. N. Skriabina. Russkie Propilei* (Moscow: Sabashnikov, 1919), vol. 6, p. 157.

1918–21, such as *The Storming of the Winter Palace* and *Towards the World Commune*[27] in Petrograd, relied more or less openly on the *mystical* involvement of their audiences. This contradiction did not escape Florensky's attention since his provocative lecture "The Orthodox Rite as the Synthesis of the Arts" was based on Skriabin's concepts. Florensky believed that *Prefatory Action* and *Misterium* could demonstrate the need to preserve the old icons in their legitimate locations (the churches) and within their legitimate context (the Orthodox Rite): "As its primordial activity, our time aspires not towards the arts, but towards Art—right into the depth of the very heart of Art. And our time is aware not only of the text, but also of the total artistic incarnation of the '*Prefatory Rite*.'"[28] By using Skriabin's term "*Predvaritelnoe deistvo*" (Prefatory Action/Rite) in the context of the *Khramovoe deistvo* (Church Action/Rite), Florensky was also confronting the Soviet regime with its own contradictions: on the one hand, Skriabin was being praised; on the other hand, the traditional Orthodox totality was being destroyed. Florensky maintained that the Church Action/Rite was the very social medium which could ensure the *sobornost,* or popular collectivity.[29] Florensky concluded in his essay that the Orthodox rite was the realization of the artistic wholeness of which Skriabin dreamt, the incarnation of the *Prefatory Action,* itself the liturgy of the senses that the composer Skriabin, the symbolist poet Viacheslav Ivanov, and the philosopher Vladimir Soloviev had affirmed. Skriabin stated that his music belonged to those "theurgic arts of lost, ancient, mystic culture,"[30] a clear reference to Ivanov's concept of ancient tragedy. Actually, Ivanov's conception is derived, in part, from the theories of Soloviev, one of Florensky's mentors. Soloviev affirmed that the poet and the artist should be theurgics who created myths and that, in order to attain that role, they must be "possessed by religion" as the ancient practitioners of rhythm and divinity had been.[31]

Ivanov understood that true synthesis could not be invented rationally but must be derived liturgically. That Skriabin agreed is illustrated by the following statement: "The problem of the synthesis of the arts which—creatively—respond to our collective consciousness inwardly renewed, is a long-term task, and pursues a single aim—in art the Highest—and the name of this is the Mystery."[32] In his attempt to explain Skriabin's path toward synthesis, Ivanov, in turn, wrote:

> According to the example of the ancient who brought upon their delirium through ecstatic music and the exciting rhythm of the dance, we must seek the intensification of the effect as a medium that can provide a salutary resolution. The theater must reveal once and for all its dynamic essence. In this way it must stop being "theater" in the sense of "spectacle."[33]

This same synesthetic tradition, although free of its strictly liturgical aspects, manifested itself after the Revolution when, in 1919, Viacheslov Ivanov served as consultant for the organization of the mass actions in Petrograd. Ivanov extended his liturgical concept of artistic synthesis to encompass both religious ritual and

the orgies and ecstatic rituals of the classical world. "The crowd of the audience must fuse with the body of the choirs, as the mystical community of the ancient orgy and mysteries."[34] Based in part on Ivanov's influence, the Soviet government became aware of the value inherent in providing the public with *new* forms of ancient ritual, for example, by "recreating" events from the Revolution. The government also understood that in order to obtain a mass consensus, people must be enticed into emotional participation in these reconstructions. However, unlike the religious ritual which reiterates and reconfirms a *symbolic* event, their attempts to revive *historical* events could not help but become *mere* ritualization that is, a formal, external repetition bereft of any meaningful content.

Florensky was aware that an authentic ritual must be symbolic and that the religious event was such a ritual. He challenged the Soviets by insisting that it would be more rational to destroy the Monastery of Zagorsk and its precious artifacts than to allow the objects and the walls to survive stripped of their symbolic content. He argued that it was through the cyclical event of the mass that they achieved their totality. Assuming the point of view of his more materialistic contemporaries, he maintained that (from the standpoint of material culture) the rare animal in the forest, the rags and tamborine of the shaman, and the icon were equally displaced when perceived outside their context, or the event that brought them to life—the environment of the forest (and he cited the example of the Hamburg Zoo), the frenzy of the shaman, and the Orthodox ritual. He demanded, from an anthropological standpoint, that the Orthodox rite be protected, just as the last specimens of the European bison were protected in the Lithuanian forest.[35]

Florensky, too, was an endangered species whose very survival contradicted the structure of his new society. Tragically, without his rightful, ecological ambience, Florensky was also destined for extinction; but, perhaps, in the Academic Zoo, we can at least revitalize his extraordinary system of belief.

**Notes**

1. Pavel Aleksandrovich Florensky, "Obratnaia perspektiva," *Trudy po znakovym sistemam* 3, no. 198 (Tartu, 1967): 381–416. The quotation is on p. 386.

2. The essay on *Inverted Perspective,* quoted above, was read at a session of the MIKhIM (Moscow Institute for Historical-Artistic Research and Museology) on October 29, 1920. For information on the organization of this institution, which was within the Academy of the History of Material Culture (in which Florensky was involved), see the unsigned report, "MIKhIM," *Khudozhestvennaia zhizn* (Bulletin of the Artistic Section of Narkompros) 2 (Moscow, January–February 1920): 11–12. The expression "inverted perspective" derives from Oskar Wulff, "Die umgekehrte Perspektive und die Niedersicht," *Kunstwissenschaftliche Beitrage, August Schmarsow Gewidmet* 5 (Leipzig, 1907): 1–40. For a general approach to the inverted perspective, see Corrado Maltese, "Tecniche e modelli proiettivi nella storia della figurazione piana tra antichità e Rinascimento," *Dimensioni* 1 (Roma, 1981): 11–28.

3. For updated Florensky biography and bibliography, see Deacon Andronik, "Osnovnye cherty lichnosti, zhizni i tvorchestva sviashchennika Pavla Florenskogo," *Zhurnal Moskovskoi patriarkhii*

4 (Moscow, 1982): 12–19; idem, "K 100-letiu so dnia rozhdenia sviashchennika Pavla Floren-skogo (1882–1943)," ibid. 23 (Moscow, 1982): 264–309. An Italian version of Florensky's writings on art is presented in Nicoletta Misler, ed., *Pavel Florenskij, la prospettiva rovesciata ed altri scritti* (Rome: La Casa del Libro, 1983).

4. Florensky also traced parallels between Dante's conception of space in the *Divine Comedy* and Einstein's theory of relativity. See his book, *Mnimosti v geometrii—Rasshirenie oblasti dvuchmer-nikh obrazov geometrii* (Moscow: Pomore, 1922). See also the accurate introduction to the reprint of the above, published by Michael Hagemeister (Munich: Verlag Otto Sagner, 1985). I am presently preparing a collection of unpublished texts on art by Florensky for La Casa del Libro, Rome.

5. Pavel Florensky, "Fizika na sluzhbe matematiki," *Sotsialisticheskaia rekonstruktsiia i nauka* 4 (Moscow, 1932): 43–63.

6. Quoted in Kirill Florensky, "O rabotakh P. A. Florenskogo," *Trudy po znakovym sistemam* 5, no. 284 (Tartu, 1971): 502. (Kirill Florensky was one of Florensky's sons.)

7. Pavel A. Florensky, "Khramovoe deistvo kak sintez iskusstv," *Makovets* 1 (Moscow, 1922): 28–32. A French translation is provided in "Le spectacle liturgique, synthèse des arts," *Art et poésie russe 1900–1930. Textes choisis* (Paris: Centre Pompidou, 1979), pp. 110–17; an Italian translation appears in *Pavel Florenskij, la prospettiva rovesciata*, pp. 57–66.

8. As early as November 9, 1917, the Presidium of the Soldiers' Section of the Moscow Soviet sent a letter to the military-revolutionary Committee of the Sergiev Monastery urging the latter to protect the treasures of the monastery. On the bureaucratic and political intricacies concerning the protection and preservation of ancient Russian monuments, particularly religious ones, see Maria S. Trubacheva, "Iz istorii okhrany pamiatnikov v pervye gody sovetskoi vlasti," *Muzei* 5 (Moscow, 1984): 152–64.

9. Philipp Otto Runge, *Briefe und Schriften* (Munich: Beck, 1982); Heinz Matile, *Die Farbenlehre Philipp Otto Runges—Ein Beitrag zur Geschichte der Kunster Farbenlehre* (Bern: Benteli, 1973). See also Rudolf M. Bisanz, *German Romanticism and Philipp Otto Runge—A Study in Nineteenth-Century Art Theory and Iconography* (DeKalb: Northern Illinois University Press, 1970), pp. 73–75.

10. See Andrew G. Lehmann, *The Symbolist Aesthetic in France* (Oxford: Basil Blackwell, 1950); Filiz Eda Burhan, *Vision and Visionaries: Nineteenth-Century Psychological Theory. The Occult Sciences and the Formation of the Symbolist Esthetic in France* (Ann Arbor: UMI, 1979).

11. See Faubion Bowers, *Scriabin: A Biography of the Russian Composer 1871–1915* (Tokyo and Palo Alto: Kodansha International Ltd., 1969); idem, *The New Scriabin—Enigma and Answers* (New York: St. Martin's Press, 1973); Hugh J. Macdonald, *Skryabin* (London: Oxford University Press, 1978); in Mikhail Gershemzon, ed., "Zapisi A. N. Skriabina," *Russkie Propilei*, vol. 6 (Moscow: Sabashnikov, 1919).

12. The first meeting of the Commission (October 28, 1918) led to the organization of a Collegium (later called Commission again), the president of which was Dmitri M. Gurevich and the vice president, Iurii A. Olsufiev. Florensky's text on "The Orthodox Rite" was intended as a lecture for the commission and bears the date 24 December 1918. In November 1918 the monastery was nationalized and a commission, directly dependent on the Moscow Collegium for Museum Affairs, was organized. This new commission contained the same scholars as had been in the Collegium. Florensky gave a lecture on the necessity for a *catalogue raisonné* for the Monastery museum. A scientific catalogue of the icons, the first ever issued, was indeed published by I. Olsufiev: *Opis Ikon Troitse-Sergievoi lavry do XVIII veka i naibolee tipichnikh XVIII i XIX vekov* (Sergiev Posad, 1920).

13. Florensky was to devote an entire treatise to the notion of the iconostasis in 1922. See Pavel A. Florensky, "Ikonostaz," *Bogoslovskie trudy* 9 (Moscow, 1972): 83–184.

14. Florensky, "Khramovoe deistvo," 30.

15. Florensky was also interested in color theory and always gave close attention to the link between color and space—not only on a psychophysiological level, but also on a symbolic one. See Pavel Florensky, "Nebesnye znamena" (Rasmshlenie o simvolike svetov) (1919), *Makovets* 2 (Moscow, 1922): 14–16. An Italian translation is provided in *Pavel Florenskij, la prospettiva rovesciata*, pp. 68–71.

16. Recent publications have described in detail the genesis of this work and its links with the contemporary cultural environment in Munich. See Armin von Zweite, ed. and comp., *Kandinsky und München* (Munich: Prestel Verlag, 1982). For information on Kandinsky's, Skriabin's, and Schoenberg's attitudes toward the synesthetical problem, see Jelena Hahl-Koch, ed., *Arnold Schoenberg-Wassily Kandinsky—Letters, Pictures, and Documents*, John C. Crawford, trans. (London: Faber and Faber, 1984); Fritz C. Weiland, "Der gelbe Klang," *Interface* 10 (March 1981): 1–13; Philip Truman, "Synesthesia and *Die glückliche Hand*," *Interface* 12 (March 1983): 481–503.

17. Vasilii Kandinsky, "Untitled speech by Kandinsky," *Vestnik rabotnikov iskusstv* 4, no. 5 (Moscow, 1921): 74–75. The quotation is on p. 74.

18. Emile Vuillermoz, *Clotilde et Aleksandre Sakharoff* (Lausanne: Imprimerie Centrale, n.d.); Hahl-Koch, *Schoenberg-Kandinsky*, p. 198, n. 81.

19. Alisa Koonen, *Stranitsy zhizni* (Moscow: Iskusstvo, 1975).

20. Ibid., pp. 121–27.

21. Bowers, *The New Scriabin*, p. 31.

22. Concerning the popular appreciation of the "mystical" Skriabin, see Alfred J. Swan, *Scriabin* (London: John Lane The Bodley Head, 1923); Katherine Ruth Heyman, *The Relation of Ultramodern to Archaic Music* (Boston: Small, Maynard and Co., 1921), pp. 110–37; Leonid Sabaneev, "Scriabin and the Idea of a Religious Art," *The Musical Times* 72 (September 1931): 789–92; Martin Cooper, "Scriabin's Mystical Beliefs," *Music and Letters* 16 (March 1935); Malcolm Brown, "Skriabin and Russian 'Mystic' Symbolism," *Nineteenth Century Music* 3 (July 1979): 42–51.

23. Bowers, *The New Scriabin*, pp. 124–25.

24. In Skriabin's notebook this drawing is attributed to the years 1904-5. See "Zapisi A. N. Skriabina," in *Russkie Propilei*, p. 157. However, in the catalogue *Der Hang Gesamtkunstwerk—Europäische Utopien seit 1800*, Harald Szeeman et al., eds. (Aarau: Sauerländer, 1983), p. 283, it is dated 1914 (?).

25. "Zapiska B. F. Shletser o Predvaritelnom Deistvii," in *Russkie Propilei*, vol. 6, p. 109.

26. Ibid.

27. See Anna S. Galushkina et al., *Agitatsionno-massovoe iskusstvo pervykh let Oktiabria—Materialy i dokumentatsiia* (Moscow: Iskusstvo, 1971); Vladimir P. Tolstoi, ed., *Agitatsionno-massovoe iskusstvo—Oformlenie prasdnestv* (Moscow: Iskusstvo, 1984).

28. Florensky, "Khramovoe deistvo," 32.

29. The basis of Soloviev's philosophical system constituted the search for the extension of individuality. He attempted to discover this enhancement through the creation of a universal fraternity of God-men and of a single, all-encompassing religious credo. Essentially "sobornost" for Soloviev was the immersion of the self and the collective body without loss of this self. See Bernice Glazer Rosenthal, *D. S. Merezhkovsky and the Silver Age: The Development of a Revolutionary Mentality* (The Hague: Martinus Nijhoff, 1975), pp. 81–83.

30. Bowers, *The New Scriabin*, p. 107.

31. See Christopher Read, *Religion, Revolution, and the Russian Intelligentsia, 1900–1912* (London: The Macmillan Press Ltd., 1979).

32. Viacheslav Ivanov, *Borosdy i mezhi—Opyty esteticheskie i kriticheskie* (Moscow: Musaget, 1906), p. 347.

33. Viacheslav Ivanov, *Po zvezdam-Staty i aforizmy* (St. Petersburg: Ory, 1909), p. 205. Ivanov valued Skriabin's theory and wrote on him. See, for example, "Vospominanie o A. N. Skriabine, Pamiati Skriabina," in *Svet Vechernii* (Oxford: Clarendon Press, 1962), pp. 51–52, 92–93.

34. V. Ivanov, *Po zvezdam*, p. 205.

35. P. Florensky, "Khramovoe deistvo," 32.

# 11

# Architecture and Theater: The Street in Fascist Italy

*Diane Y. Ghirardo*

When the Fascist government of Italy attempted to fashion a united Italian state out of an unruly collection of cities and territories, one of the chief strategies began with that traditional locus of Italian public life, the street. A lively street scene is an Italian tradition which dates back at least to Roman antiquity; and because of cultural traditions, design, and living patterns, the street persisted as a dynamic element in Italian public life.

Without abandoning any of its traditional functions, the street in Fascist cities took on the character of a theatrical event: it served as a temporary stage for official visits by the head of state, a semipermanent one for exhibits and cultural events, and a permanent one by virtue of new buildings constructed under the aegis of Benito Mussolini's government. Street activities were largely coordinated by the Fascist Party and its supporting agencies (especially the youth groups). Fascist street theater in all of its manifestations served multiple purposes, including summoning forth unity in a country divided by parochial loyalties, and legitimizing and exalting the figure of the leader.

Mussolini rose to power in the anticommunist hysteria of the immediate post-World-War-I years. High unemployment among returning veterans, economic distress, "red scares," and the incompleteness of the nineteenth century unification served as sources of unrest which Mussolini and his Blackshirts shrewdly exploited to their own benefit. The government seemed helpless in the face of increasing violence in the streets, and the socialist and communist organizing groups seemed to be making headway in enlarging their membership rolls. In this highly charged atmosphere, Mussolini's promise of domestic peace and order found significant support not only in the general population, but among wealthy industrialists and other powerful figures. Their primary goal was social and political order, and if Mussolini could supply this, he was their man. The Blackshirts marched on Rome in late October 1922 in a showdown to force the king's inclusion of Mussolini and his Fascist Party in the government. To their surprise, King Vittorio Emanuele II

announced that Mussolini would henceforth be premier. The significance of symbolism in the fledgling regime was already apparent: the Fascist March on Rome took place on October 28, 1922—exactly 1,610 years after Constantine defeated Maxentius at the Milvian Bridge outside of Rome on October 28, 310.[1]

The March on Rome grew in Fascist mythology in the ensuing years, and it also inspired an ever-increasing round of parades and troop reviews, as blackshirted men, women, and children re-created the earlier glorious moment of Fascism's debut in history. These events—the parades and military reviews—were institutionalized in a series of organizations established for Fascists of all ages and walks of life, from children to university students to factory laborers to housewives. Although the organizations served multiple goals, with their reliance upon uniforms, coordinated and unified displays, and mass activities, they played to the very human desire to be part of a group.[2] But they also served highly specific political goals: they both manifested and summoned forth unity and, most importantly, identity with the leader—Il Duce, Mussolini. For each parade, each rally, Mussolini secured a privileged seat, elevated above the masses, and typically framed by a building of major symbolic importance, such as the Duomo in Milan, or Palazzo Venezia in Rome. The masses would be grouped around this powerful, hypnotic figure, themselves part of the elaborately constructed theatrical display (fig. 11.1). A key aspect of Fascist politics was the cult of control by the leader and, by extension, the submission of the masses in extravagantly orchestrated displays.

In these almost religious events, architecture at once facilitated, reinforced, and indeed, became a part of the events themselves. In his search for ideal spaces to play out the fantasy of a united, participating, and powerful polity, Mussolini ended up constructing his own theatrical settings, orchestrating the public spaces—the streets and piazzas—to suit his symbolic needs. Much like those of his antique and Renaissance forebears, Mussolini's structures aimed both to participate in the events and to remain afterwards as an enduring memory of that event. The sources of his imagery were rooted directly in Italian traditions. In ancient Rome, for example, consular roads such as the via Appia and the via Flaminia represented major technical enterprises which served the important political and military functions of carrying troops and supplies as well as linking the capital with its colonies. These and other streets persisted as crucial elements in the Roman urban fabric, guiding the development of other streets and of the city itself. But at the same time, they gained symbolic significance for the Roman military: the triumphs of Roman generals were commemorated by arches which served as temporary or permanent passageways for the troops and for processions.[3] So in modern Italy did the Fascists fashion temporary triumphal arches and, indeed, they even acknowledged new modes of travel and arrival (figs. 11.2, 11.3): when Adolf Hitler visited Italy in 1937, an entirely new and modern facade was grafted onto an older railroad station in Rome—through the artful use of plywood and paint, the Fascist Party gave the old station a modern, twentieth-century aura, and reassured their northern partner

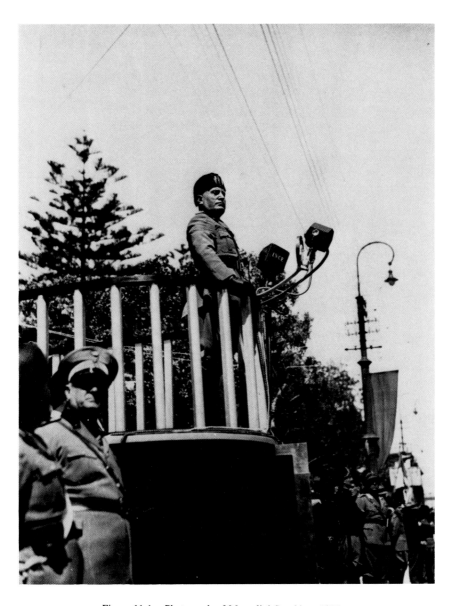

Figure 11.1.  Photograph of Mussolini Speaking, 1936
*(Archivio Centrale dello Stato)*

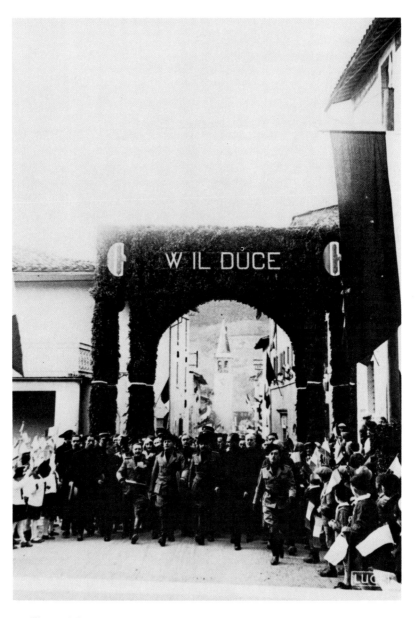

Figure 11.2. Photograph of the Temporary Triumphal Arch for Mussolini, Terni
*(Archivio Centrale dello Stato)*

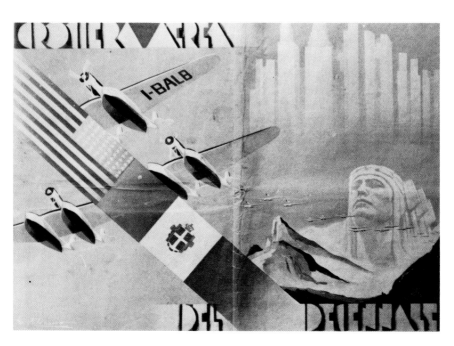

Figure 11.3.   Publicity Poster for the Ten Year Anniversary of the Fascist Revolution, 1932
Poster, 58.4 × 44.5 cm.
*(Collection: Author)*

of Italy's modernity. Albert Speer orchestrated a much different kind of "temporary setting" for Mussolini's visit to Germany: a columnar screen of lights to mark his passage down Berlin's main boulevard, Unter den Linden. Of this kind of project Speer remarked, "The *Volk* has become the living bearer of the State. Its celebrations are therefore *Volk* celebrations in the deepest sense of the term."[4]

Even though until the Renaissance the street served as little more than a utilitarian interval between houses or buildings, some streets were endowed with a ritual significance in ancient Rome even during the time of Etruscan control. Deities were consulted about the placement and orientation of streets, and later Romans embellished and enlarged upon the rituals in their foundation of new towns. In some cases, a single event itself gave a street its significance. The via Sacra, which winds through the Roman Forum, supposedly marked the site where Romulus signed a peace treaty with the Sabines—thereafter sacrifices and religious ceremonies took place monthly to commemorate that event. Such links between streets and significant events persisted: again in the Renaissance they were marked by obelisks and/or served as thoroughfares from one major monument to another. Until the Renaissance, however, the street itself received little architectural definition. The antique Roman domus turned inward to interior atria, with the street facade free of special architectural treatment. Even monumental representational buildings bore only incidental relation to the street, and rarely were part of a larger scheme of street relationships. Only with the Renaissance did streets in Italy begin to become controlled visual experiences: panoramic and focused vistas along streets and city squares lined by buildings with classicizing revetments and elaborately articulated surfaces. A new and wealthy urban class, most especially the aristocratic strongmen who gained control of most northern and central Italian cities, were largely responsible for this change. But functional ends—ease of movement and transport—do not explain the new attitude: their motives were also to advertise their status, not just inside their houses, but on the exterior as well. They also brought the new discoveries in perspectival representation off of the canvas and out into the streets.

Not incidentally, the rise of the theater as we know it took place at about the same time.[5] By the sixteenth century, new covered theaters began to move out of private courtly residences into an urban setting: they replaced the earlier open-air models and temporary stages for itinerant performers. The quintessential Renaissance stage consisted of a steeply foreshortened architectural vista representing an urban setting. By contrast, the antique Roman theater used as a backdrop an architecturally defined palace facade. The effect of the shift in Renaissance theaters was two-fold: it brought the city into the theater as a microcosm of the world outside, and it set the city as the appropriate stage for the important events in life. At the same time, urban settings began to take on a theatrical quality, complete with privileged viewpoints and controlled vistas: spectacular piazzas such as the Piazza Ducale in Vigevano or the thoroughfares planned by Sixtus V in Rome replaced the dense and apparently random medieval urban arrangements. In the stage

sets for Renaissance theaters, disorderly medieval settings were appropriate for the average citizen, while the dramas of exalted persons and events could only unfold in or around the great buildings of the upper classes.

I raise these examples from ancient and Renaissance Italy because they bear in fundamental ways upon the theatrical space of the streets in Fascist Italy. Although in many ways beset by conflicting imperatives, Mussolini wanted his fascist movement to be perceived as standing well within longstanding traditions; but at the same time, given his desire to "modernize" Italy, his regime had to give the impression that it could outstrip the past and also be modern (fig. 11.4). The streets and architectural enterprises therefore straddled the line between modern image and traditional references.[6]

The idealized arrangement of urban spaces, through the adroit adaptation of older buildings and the construction of new ones, constituted an important arm of Fascist policy. While in Holland and Germany, modern architecture was associated with revolutionary social and political ideas, the Fascist state already laid claim to being revolutionary. Modern architecture in Italy presented itself as a revolutionary style, best suited to presenting an image for the revolutionary pretensions of Fascism. "Fascism is a glass house into which all can see," said Mussolini, and Rationalist architecture presented that image.

The balcony on the new Fascist Party headquarters, or Casa del Fascio, served specifically as the spot where Mussolini presented himself to his countrymen: as the leader, he had to be seen in order to convey the enormity of his power; hence his elevation above crowds (fig. 11.5). And the crowds were essential: they confirmed his status and their own unity—albeit as junior partners—with him in the Fascist State (fig. 11.6). That balcony, indeed, was called an arengario, and recalled the medieval assemblies of Northern Italy, when adult male citizens met to determine community policy—to "harangue" among themselves. Mussolini's balcony recalled that assembly, but shifted the focus from the undifferentiated mass to the single powerful leader. As in the post-Renaissance theater, there is a fixed spatial relationship between the viewer and the event. While the viewers were to applaud, to roar approval—in other words, to provide consent, consensus, and an image of unity—the actor—the leader—supplied the most powerful focus for that consent.[7]

The iconography of spatial configurations of hierarchies of power in this photograph of a rally in Milan is telling (fig. 11.7): to the right of the speaker is the nineteenth-century monument of commerce and capitalism, the Galleria Vittorio Emanuele; to his left, the palace symbolic of foreign and princely power, the Palazzo Reale, the home of Spanish and Austrian rulers; behind him, the monument to medieval Christianity and religion, and beyond him, just around the corner, the medieval townhall (which had already undergone a transformation during the Renaissance); before him, the assembled citizens of Milan; and at the center Mussolini stood, symbolically uniting these disparate power structures in one united

Figure 11.4.  Photograph of Mussolini Testing Airplane, 1936
(*Archivio Centrale dello Stato*)

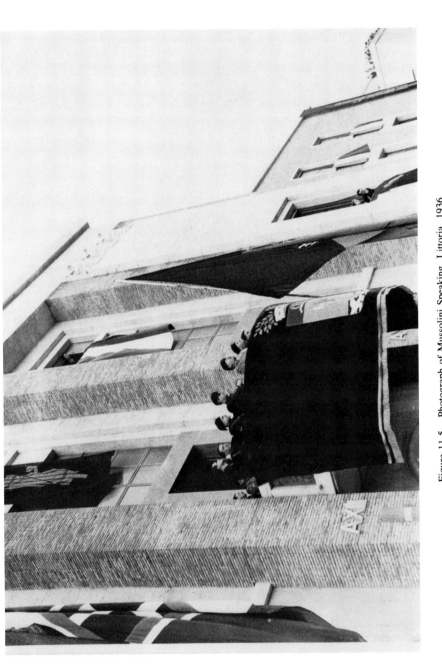

Figure 11.5.    Photograph of Mussolini Speaking, Littoria, 1936
*(Archivio Centrale dello Stato)*

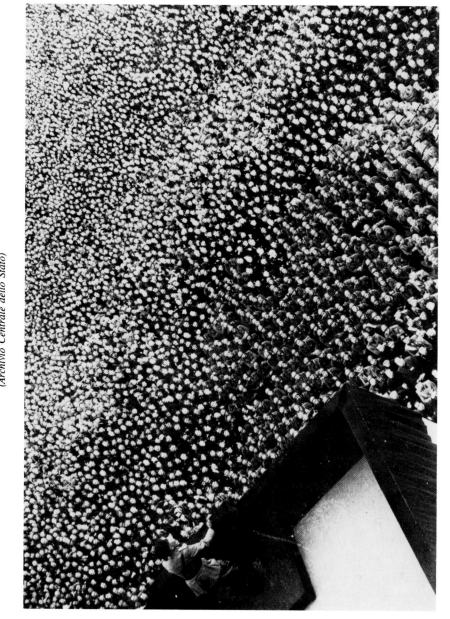

Figure 11.6. Photograph of Mussolini Speaking, Bologna, 1936
(*Archivio Centrale dello Stato*)

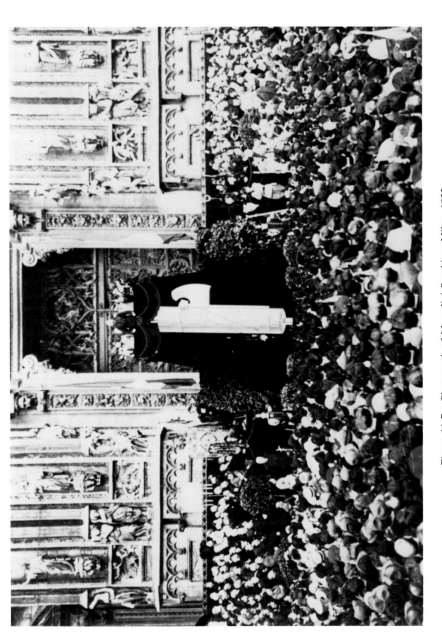

Figure 11.7.    Photograph of Mussolini Speaking, Milan, 1932
(*Archivio Centrale dello Stato*)

state and one cult figure—himself. All the major roads in Milan radiate out from this piazza—or, indeed, converge at this point; and Mussolini thus stood at the heart of what was then and still is Italy's industrial, commercial, and financial heart. The masses were the one unknown quantity in this group. They had not yet tested their power; and before another decade passed, they had turned against him. In the end, they left him in another, smaller square in Milan, not erect and commanding, but hanging humiliatingly upside down.

It is no accident that Mussolini's expressions, gestures and even stature were grand, larger than life: with his ramrod straight posture and jutting jaw, he became the actor *par excellence* mediating between the audience participants and the larger events. Modern technology also allowed him to magnify his voice on a scale which even exceeded that of his gestures: loudspeakers throughout the public spaces telescoped the distance between the speaker and those even on the remote edges of the crowd, annulling the actual distance between speaker and listener. And even when not present, Mussolini's voice could be heard from loudspeakers addressing the nation in remote villages hundreds of miles from Rome. But the loudspeaker and booming voice reverberating off of old buildings were not enough: these events only occurred sporadically. Here, again, architecture played a crucial role. The most characteristic image of, and structure in, central and northern Italian towns from the Middle Ages on was the Town Hall. Fascist Party headquarters in towns and villages throughout Italy adopted this building type for their office buildings. By 1300, the configurational elements of the Town Hall type had been defined and incorporated within one building. Those elements were: an assembly room, usually on the second floor, rusticated tower, bell, loggia, ceremonial stairs, courtyard, and often crenellation. However the elements were arranged, joining them together with a tower which loomed over others in the town symbolized the free, medieval city-republic. The community held the main claim on the loyalty of its citizens, symbolized by the tower, or campanile, of the town hall. Even today, parochial loyalty is known as "campanilismo." Mussolini directed his program for Italy toward shifting those loyalties to the new Fascist state, therefore, when the new guy appeared on the block, the Fascist Party headquarters emerged in the familiar guise of the town hall, but now representing not local loyalty, but a pan-Italian locus of authority. Mussolini characteristically appeared to the public on the balcony of Palazzo Venezia in Rome. When he visited other Italian towns, he stood on the arengario, or balcony, and addressed the public, surrounded by the fasces and other party symbols. When he was not visiting, the local or provincial party secretary could address the populace from the arengario "in loco parentis." And in the ordinary course of the day, when no party events were scheduled, the balcony stood as a constant reminder of Mussolini's virtual presence (as in Mario Radice's mural, in the Como provincial party council chambers, where Mussolini's figure occupied the last chair to show that he was virtually, or symbolically, present at every meeting).

The symbolic potency of the tower extended beyond just the new party offices. When a town could not afford a new party office building, the party would at least add a tower—as here at Grosseto—to an existing building (fig. 11.8). Two historical models for this are Montepulciano, where Michelozzo grafted a Florentine town hall type of facade onto a group of houses in the main square, following the city's loss of autonomy to Florence; and Milan, where the Visconti family likewise took the old town hall, robbed it of its objective civic role, and turned it into a school for civil servants. The architectural resolution of this change is the new Giure consulti (1562), tidied up to accommodate Renaissance notions of balance and order.

A new Fascist Party building could include a tower as an integral element of the design, but when Giuseppe Terragni designed his Casa del Fascio in Como, the tower progressively shrank from tower, to altana, to unfenestrated corner block—which, along with the other typological elements, rendered the medieval town hall in a modern idiom (fig. 11.9). Party officials, however, wanted more decoration. The architect's solutions included Mussolini photomontages and even a plan to project films of Mussolini on the marble facade. Both the film and photograph showed Mussolini larger than life—exactly the goal of the image process.[8]

"All roads lead to Rome," went the old saying, and under Mussolini roads received greater definition than they had had for centuries, and grand new ones were fashioned. The Via del'Impero is perhaps his most well-known street in Rome: though the Fascist state was responsible for many streets and roads—including the first autostrada, or highway—Mussolini is best known for this particular street.[9] The road takes off from Piazza Venezia along the flank of the monument to the nineteenth-century Italian King, Vittorio Emanuele, and then bisects the Imperial Fora and the Roman Forum, passes the Basilica of Maxentius and terminates at the Colosseum. A second road then departs from here around the arch of Constantine and past the Circus Maximus toward the antique port of Rome at Ostia. In short, the road literally slices through the Roman Empire from its earliest days to its last days of glory under Constantine, symbolically cutting a thoroughfare through them on behalf of the twentieth century return to Empire under Mussolini. Mussolini had ordered excavation of the Republican and Imperial Fora, but his road and its embankments again covered with asphalt most of the Imperial Fora, including that of Julius Caesar. Two of the great uncompleted projects of Caesar—excavating the port of Ostia and draining the Pontine Marshes—Mussolini could proudly proclaim to have finished 2000 years later. Here and elsewhere, Mussolini at once paid homage to ancient Rome's powerful emperors, emphasized the connection between his state and theirs (and indeed, he legitimized his state by appropriating symbols, rituals, and monuments from them), and at the same time, declared the superiority of his modern recreation of the Roman Empire. Along the via del'Impero, Mussolini installed four panels outlining the land conquered by the old Roman

Figure 11.8. Photograph of Casa del Fascio, Grosseto, ca. 1936
(Photo: Author)

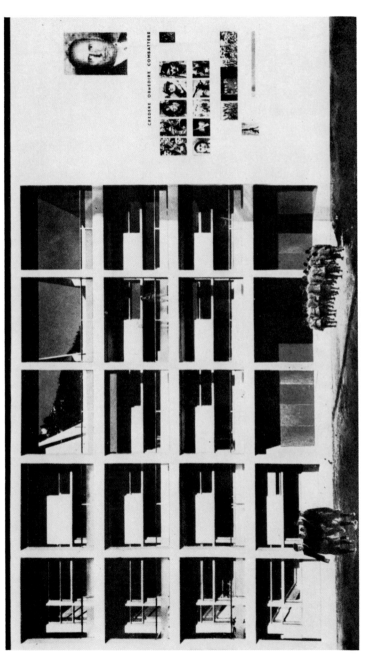

Figure 11.9.   Giuseppe Terragni, Casa del Fascio, Como, 1936 (with Photomontage by Marcello Nizzoli)
*(Photo: Author)*

empire, with the addition of one which outlined the conquests of its twentieth-century reincarnation. This road carried most of the great parades during the second decade of Mussolini's rule: almost a visual metaphor, it seemed, for his triumphant passage into Italian and Roman history.

When the Party decided to hold an open competition for a new headquarters building on the via del'Impero, Italian architects obliged. Among the entries was one by a team headed by leading Rationalist architect Giuseppe Terragni. The enormous wall proposed by the team would have extended deep into the street, and the configuration of its cobwebbed surfaces directed attention to the raised balcony and Mussolini (figs. 11.10, 11.11). Even the mode of presentation emphasized the primacy of the leader.[10] At the other end of the city, another new street led to Mussolini's Forum, a sport and athletic complex.[11] Stone markers inscribed with important events in Fascist history border the mosaic path to the stadium; among the mosaics in the pavement are the fasces, the "M" for Mussolini, slogans (such as "It is necessary to win, more necessary to fight") and even a plan of the complex and of the Theater of Marcellus. In both cases, the street is conceived as a procession, a testimony, and a reminder that Fascism could be found at every turn.

Mass politics in Fascist Italy drew the population into the political process: Fascism promised a change from the old aristocratic governments by allowing the masses to participate in the political process. The parades, the street demonstrations, and the new buildings for new institutions comprised the visible testimony of that participation (fig. 11.12). The change was more apparent than real, for involvement was limited to ritualized participation in parades and demonstrations for Fascist organizations (figs. 11.13, 11.14). But the illusion of greater participation, the heightened sense of taking part in an event which was larger than life, corresponded to the overscaled public events and to the monumental public buildings accommodating them. The Fascist Party slogan—"Believe, Fight, Obey"—summoned forth the kind of behavior appropriate for the street displays, and those words stood on buildings throughout Italy to remind Italians of the limits of their role. Because the events focused on image, attention was effectively directed away from more substantial issues.

I have mentioned the goals of the Fascist Party in the street activities as those of fashioning a national consensus, replacing local loyalties with national loyalty, legitimizing the Fascist regime by reference to the ancient and medieval past, and exalting the figure of the leader. But there were other objectives at play as well. As I mentioned earlier, socialist activism was met head on after World War I by blackshirted Fascist troops, who "took to the streets" to stem the leftist tide and to accomplish their own goals[12]. The violent clashes helped to polarize the rest of the citizenry (particularly other social groups, such as wealthy industrialists, aristocrats and the middle classes). These groups worried that Italy would be engulfed in a left-revolution of the sort seen in Russia in 1917. The Fascists presented themselves as the forces of order who would save the country from the Reds. Once

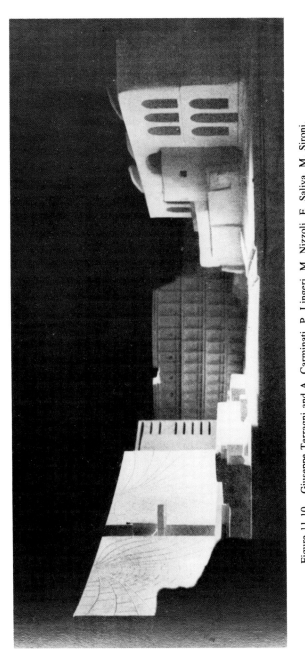

Figure 11.10. Giuseppe Terragni and A. Carminati, P. Lingeri, M. Nizzoli, E. Saliva, M. Sironi, L. Vietti, Project for the Palazzo Littorio, Rome, 1934
(Photo: Author)

Figure 11.11. Giuseppe Terragni and A. Carminati, P. Lingeri, M. Nizzoli, E. Saliva, M. Sironi, L. Vietti, Project for the Palazzo Littorio, Rome, 1934
*(Photo: Author)*

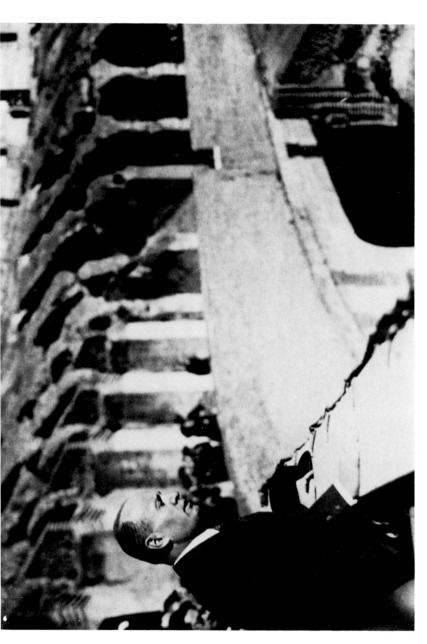

Figure 11.12.   Photograph of Mussolini Speaking to Representatives of the Corporations in the Colosseum, Rome, 1928

*(Archivio Centrale dello Stato)*

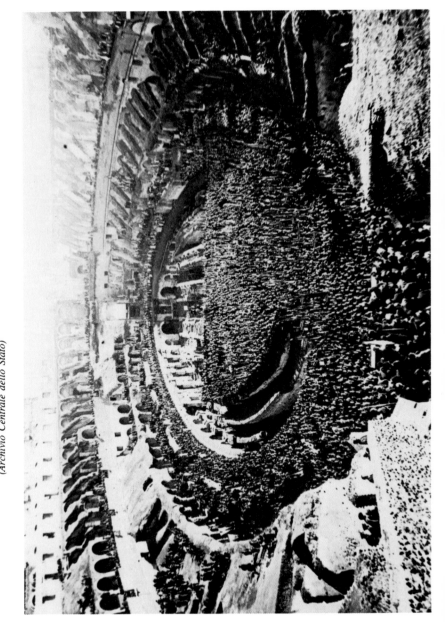

Figure 11.13. Photograph of Representatives of the Corporations Assembled in the Colosseum to Hear Mussolini, Rome, 1928
*(Archivio Centrale dello Stato)*

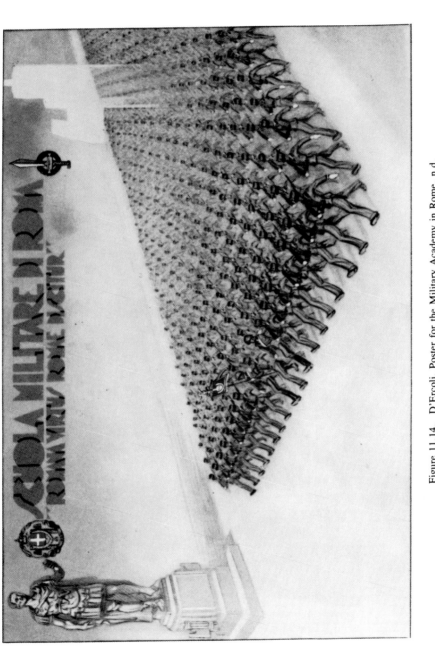

Figure 11.14.   D'Ercoli, Poster for the Military Academy in Rome, n.d.
Poster, 12.7 × 17.8 cm.
*(Collection: Author)*

Mussolini had come to power, however, violent behavior by the Blackshirts—billyclub-wielding toughs—was no longer appropriate. By instituting the massive parades and demonstrations played out in the streets and piazzas of Italy, the party helped to tame and channel the unruly behavior. The historical model for this solution dates back to ancient Rome, when Roman city planners placed amphitheaters for bloody shows for the unruly Celts and Gauls well outside urban centers in order to provide an outlet for their blood lust and (the Romans hoped) to tame their violence. Bureaucraticization of the party and the ritualization of mass demonstrations helped to routinize and thereby dull violent impulses: the aim was not to kill, but rather to control the violence. Events such as the celebration of the ten-year anniversary of the Fascist takeover kept the mass street activity fresh in people's minds, as did the memorials to the men who died during the turbulent post-war years.[13] These memorials—which were built into the public area of every party office—and the demonstrations stood as constant reminders, and they also kept the emotions smoldering. When the occasion arose in the 1930s—for the Ethiopian war, for example, or later for World War II—the emotions could be summoned forth again in their violent form.

In 1935 Walter Benjamin observed that Fascism introduced aesthetics into political life; it violated the masses in the same way that it produced ritual values. Benjamin further observed that rendering politics aesthetic logically culminates in war. He quoted from Filippo T. Marinetti's manifesto on the Ethiopian War: "we Futurists have rebelled against the branding of war as anti-aesthetic. . . . Accordingly we state: . . . War is beautiful because it establishes man's dominion over the subjugated machinery by means of gas masks, terrifying megaphones, flame throwers, and small tanks. War is beautiful because it initiates the dreamt-of metalization of the human body. . . . War is beautiful because it combines the gunfire, the cannonades, the cease-fire, the scents, and the stench of putrefaction into a symphony. War is beautiful because it creates new architecture, like that of the big tanks, the geometrical formation flights, the smoke spirals from burning villages, and many others. . . . Poets and artists of Futurism! remember these principles of an aesthetics of war so that your struggle for a new literature and a new graphic art . . . may be illuminated by them!" (fig. 11.15).[14] It is no coincidence that postwar Futurism turned out to be an ardent supporter of Fascism. Perhaps the most dangerous aspect of the aestheticization of politics in Fascist Italy was the exclusive emphasis on image as a substitute for thought: and to the fulfillment of this goal, architecture lent itself beautifully.

Eugene Atget's photographs of turn-of-the-century deserted streets in Paris were photographed, in Benjamin's words, like "scenes of crime"—photographed for the purpose of establishing evidence. Perhaps the Fascist piazzas and streets are also evidence of crimes. Elias Canetti speaks of the monumental interior spaces Albert Speer created for Hitler—interior spaces which became increasingly monumental, more and more gigantic, as the years progressed: they are interior

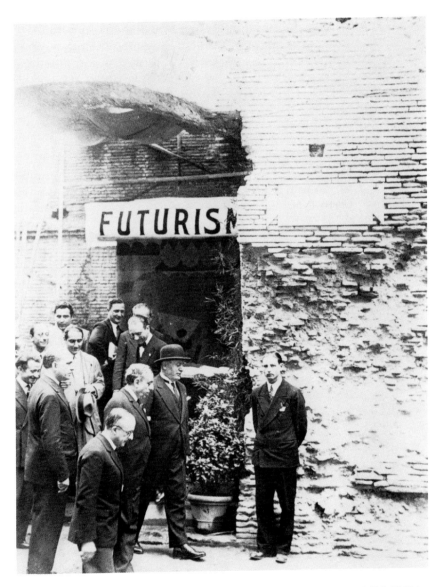

Figure 11.15.  Photograph of Mussolini Visiting the Futurist Exhibit at the Book Fair Held in
the Trajan's Markets, Rome, Date Unknown
*(Archivio Centrale dello Stato)*

containers, says Canetti, which will allow crowds to *GROW,* and to be *repeated.*[15] But especially, they are for "crowd arousal," and "rearousal," when the Führer would no longer be there. As we have seen, the monumental spaces created for Mussolini were largely exterior ones, but their purposes were the same. The streets, the piazzas—old ones refashioned, new ones refabricated: the historical trajectory I have traced here from the Roman stage in the semblance of palace, to the urban setting which formed the stage for Renaissance theatricals, culminates in the metropolis and the street as the mise-en-scène for Fascist mass political theatricals.

### Notes

1.  For recent studies of Fascism, see Anthony Cardoza, *Agrarian Elites and Italian Fascism: The Province of Bologna 1901-1919* (Chicago, 1982); Paul Corner, *Fascism in Ferrara 1915-1925* (New York, 1975); Adrian Lyttleton, *The Seizure of Power: Fascism in Italy 1919-1929* (London, 1973); and of course Enzo Sartorelli's three-volume history, *Storia del Fascismo* (Turin, 1978). For architecture, see Cesare De' Seta, *La cultura architettorica in Italia tra le due guerre* (Rome-Bari, 1983); Giorgio Ciucci, "Il dibattito sull'architettura e le città fasciste," in *Storia dell'Arte Italiana, VII: Il Novecento* (Turin, 1982): 263-378; Spiro Kostof, *The Third Rome* (Berkeley, 1973).

2.  Victoria De Grazia, *The Culture of Consent: Mass Organization of Leisure of Italy* (Cambridge, 1981); Philip V. Cannistraro, *La fabbrica del consenso, fascismo e mass media* (Rome-Bari, 1975).

3.  Matthias Schmidt, *Albert Speer: The End of a Myth,* translated by Joachim Neugroschel (New York, 1984), p. 39.

4.  J. B. Ward-Perkins, *Roman Imperial Architecture* (London, 1981); Frank Sear, *Roman Architecture* (Ithaca N.Y., 1983), pp. 43-45.

5.  K. W. Foster, "Stagecraft and Statecraft: The Architectural Integration of Public Life and Theatrical Spectacle in Scamozzi's Theater at Sabbioneta," *Oppositions* 9 (Summer 1977): 63-87; Elie Konigson, *L'espace Theatrale Medieval* (Paris, 1925).

6.  Diane Ghirardo, "Italian Architects and Fascist Politics: An Evaluation of the Rationalists' Role in Regime Building," *Journal of the Society of Architecture Historians* 39, no. 2 (May 1980): 109-27.

7.  D. Ghirardo and K. W. Forster, "I modelli delle città di fondazione in epoca fascista," in C. de Seta, ed. *Insediamenti e territorio;* Storia d'Italia, Annali 8 (Turin, 1985), pp. 646-49.

8.  D. Ghirardo, "Politics of a Masterpiece: The 'Vicenda' of the Facade Decoration of the Casa del Fascio of Como," in *The Art Bulletin,* 62 (September 1980): 446-78.

9.  Antonio Cederna, *Mussolini Urbanista: Lo Sventramento di Roma negli anni del consenso* (Rome-Bari, 1981), pp. 167-208.

10. Manfredo Tafuri, "Giuseppe Terragni: The Subject and the Mask," *Oppositions* 11 (Winter 1977): 1-25.

11. Mussolini's plans for Rome incorporated three new fora for the city: an educational forum (the University of Rome); a sports forum (Foro Mussolini); and a government forum (EUR). All were sited on the outskirts of the city so that there would be ample room for lavish architectural displays.

12. Corner, *Fascism in Ferrara;* see also Cardoza, *Agrarian Elites.*

13. Partito Nazionale Fascista, *Mostra della Rivoluzione Fascista* (Rome, 1932).

14. Walter Benjamin, "The Work of Art in the Age of Mechanical Reproduction," in Benjamin, *Illumination,* edited by Hannah Arendt (New York, 1984), p. 39.

15. Elias Canetti, "Hitler according to Speer," in *The Conscience of Words* (New York, 1984), pp. 146–47.

# Part Five

# Event Works

# Photomontage, the Event, and Historism

*Estera Milman*

Photomontage became an element central to German Dada's program of cultural criticism. Its suitability for such a task was guaranteed by the fact that the photograph, the primary substance of which a photomontage is constructed, is perceived to be primary evidence that "the everyday events, doings and sufferings that are universally recognized to constitute experience"[1] (and to which art must ultimately relate), have transpired. The Dada photomonteurs, like many of the vernacular composite image makers who preceded them, often juxtaposed mass-produced photographic imagery with snippets borrowed from their personal photographic histories. In both their choice of format and in their selection of materials, these early-twentieth-century avant-gardists were attempting to remove their art-making from a "separate realm"[2] and to reassociate their activities with the materials and aims of other forms of human effort. In so doing, they reaffirmed their very membership in the avant-garde, as that term was originally defined by Saint-Simon. It is interesting to note that the use of photomontage by members of a number of early-twentieth-century avant-garde movements in Russia as well as in Europe, coincided, for the most part, with periods of extreme social crisis. Thus, photomontage can be viewed as one recurrent formal response by twentieth-century artists to those great events which most directly affected the course of history.

It is generally maintained that photographic imagery carries its subject; that is, that the photograph is perceived to be a substitute for that which is photographed. However, the photograph is, at one and the same time, a "surfaceless substitute" for its subject and a reference to the act of its subject having been photographed. We are aware not only of the subject of the photograph, but also that the photograph is evidence that its subject has been extracted from the real world. Photographic information is not easily separated from its origin or its operation in experience even when such imagery is recomposed into an overtly unrealistic or surrealistic photomontage. Because the material of which it is composed retains its status as

clusters of photographic imagery, the photomontage becomes a construction which speaks directly to the abstraction of its subjects from the flow of things.

Understanding how the photograph came to be perceived as a substitute for its subject is an obvious prerequisite to any dialogue about photomontage. So too is the explication of the extent to which the photographic process is intrinsically tied to the event and, thus, to popular perceptions of how history is made. The former assumption is primarily dependent upon a contractual relationship between concepts of reality, photographic verisimilitude, and culture at large; the latter, upon the public's belief that private and public events succumb to the same historical process and that it is because the camera functions as a faithful witness, that the passing of events can be discerned and their course accurately charted.

Evidence of our period's deep-rooted historism is available in many books about history published for the general reader. John Canning, for example, opens his editor's note to *100 Great Events That Changed the World* with the following statement: "The history of the human race on earth is rather like the history of individual human beings: important events do not occur in an orderly progression at regularly spaced-out intervals of time, but in irregular pulses."[3] Canning goes on to explain that it had been his objective "to choose from the period of recorded history one hundred events which have marked a quickening of the human spirit or have been turning-points in the paths that men have taken."[4] Among occurrences qualifying as such events, Canning includes "the foundation of a great religion or philosophic system, a water-shed battle, a seminal political event, an epoch-making invention or discovery, or a book that has changed a mental climate."[5] The discovery of photography is one of these 100 "epoch-making" events. Douglas Collier, the author of the chapter entitled "Invention of the Camera: The Birth of Photographs, Moving Pictures, and Television," reminds us that the seminal importance of the modern camera depends, in part, upon "it's built in memory."[6] Collier does well to make this point since, one and one-half centuries after its discovery, it has become difficult for most of us to imagine how either a culture's or an individual's "history" could have been verifiably chronicled before the existence of the "mirror with a memory."[7] Furthermore, it has become almost impossible to separate the existence of camera images from the normal delineation of the event from everyday occurrence, and consequently from one's very concept of history itself.

From the announcement of its discovery to the present, the photographic camera has continued to function as both the individual's and the collective's primary chronicler (chron' i· cler, n. A writer or compiler of a chronicle; a recorder of events in the order of time).[8] Although the general public was not introduced to the fixed camera image until 1839, when Louis Jacques Mandé Daguerre's experiments with the photographic process were announced in the French press, his colleague Joseph Nicéphor Niepce had already succeeded in his attempts to chemically fix sun drawings in the third decade of the nineteenth century. In the middle of that same decade, Saint-Simon was to formally position the artist within the

ranks of society's new "avant-garde." It is more than probable that this coincidence had far-reaching implications for the period's extreme historical self-consciousness, as it is described by Stephen C. Foster in his foreword to this volume.

It will be this author's task in the following essay to first elaborate upon the interrelationship between the photodocument, the event, and the modern period's vernacular concept of history, and then to investigate the relationship between the manipulated photodocument, the composite photograph and photomontage, and the period's historism. History as a discipline, philosophy, or branch of knowledge will rarely be discussed, for it is not the concerns of professional historians, historiographers, or philosophers of history that are here under investigation but rather the prevalence of the general public's conception of the course of events as a fundamental aspect of the historical process and the widespread assumption that history is made visible through the reification of these events. In the course of the discussion, parallels will be drawn and distinctions made between vernacular composite imagery, montages by commercial photographers, and works by members of the early-twentieth-century avant-garde. It should be pointed out at the onset, however, that, with very few exceptions, all of the above can collectively be called amateur historians and, as such, participate in our period's most popular pastime.

As is the case with most seminal inventions, the collaborative realization of the long standing desire to fix nature's image and to carry away the resulting document for posterity's reflection was a direct response to a powerful set of preexisting conditions and requirements. There is little question but that the final incentive that led to the invention of the modern camera came, in part, from a prevalent fever for reality and from an unprecedented demand, by the rising middle class of the late nineteenth century, for pictures of a particular kind. It was this same new bourgeoisie, replete with materialistic values and interested in pictorial verisimilitude, that was concurrently responsible for the stimulus that led to the invention of photography and, as new patrons for the fine arts, for the rise of Realism.[9]

Discussions of the symbiosis between painting and photography abound in today's literature. For the present investigation, it is far less relevant to argue the relative merits of either than to relate that, within thirty years after their public debut, photographs were to serve as a means by which the authenticity of paintings of a particular genre was determined. While discussing Manet's series of late Realist history paintings entitled *The Execution of the Emperor Maximilian,* Aaron Scharf, author of *Art and Photography,* writes,

> It is difficult to know to what extent Manet, a Republican sympathizer who had good cause for grievance against Louis Napoleon, conceived of these paintings as a criticism of the regime and its cowardly part in the Maximilian affair. Like his earlier painting the *Battle between the Kearsage and Alabama* it may have been intended principally as a straightforward history painting of an important contemporary event. In either case photographs would have been very relevant

documentary material and in using them Manet was acting in accordance with the tradition of reportage in modern painting in which literal accuracy, exacerbated by the camera, had become imperative.[10]

The author's natural juxtaposition of the words "criticism," "history painting," "an important contemporary event," "photograph," and "tradition of reportage" makes the statement particularly relevant to the present discussion. Regardless of whether they were intended to function as forms of cultural criticism or as acts of visual reportage, paintings like Manet's *The Execution of Emperor Maximilian* and the *Battle between the Kearsage and Alabama* were always event-based. However, regardless of whether or not such images can be *validated* by photographic evidence, all that the public has access to when viewing a painting from this tradition are the tracks of the artist's personal transaction of information about a particular historical moment. The painter could not help but maintain his or her position as interpreter. The photographer, on the other hand, despite the aesthetic prowess of his or her work, remains relatively invisible to all but the most sophisticated viewer, and is visible even to that small segment of the public only under certain circumstances. With access to photographs of events, *despite* the formal qualities that they may exhibit, the public is allowed to indulge in the act of making *direct* inferences about the historical moments that have been recorded. Furthermore, the fact that the camera extracts the extraneous as well as the essential as it records a segment of the real world, combined with the easy availability of the numerous images so endemic to the photographic process, make possible further indulgence in theories of causality, a fundamental aspect of historical thinking for both amateur and professional historian alike.

The painter, draughtsman, and printmaker have long since ceased to function as our culture's reporters. Today, a reporter, whether he or she be a journalist or a photographer, is, by definition, employed by a branch of the mass media. This shift in responsibility from artist in the studio to professional purveyor of media information is logical, particularly in view of the fact that the expansion of the popular press and the advent of a new kind of critical journalism coincided with the rise of Realism in the fine arts and with the popularization of photographic imagery. As early as the mid-nineteenth century, distinctions were already being made between the subjectivity of the journalist's pencil and the supposed veracity of the photodocument; for example, the following are excerpts from an 1863 *Atlantic Monthly* article by Oliver Wendell Holmes (the elder) in which the author refers to the Civil War photographs of Matthew Brady.

Brady received the highest praise for his courage and determination, and his pictures were valued for their authenticity far more than the accounts of newspaper correspondents. . . . His are the only reliable records at Bull's Run [*sic*]. The correspondents of the Rebel newspapers are sheer falsifiers; the correspondents of the Northern journals are not to be depended upon, and the

correspondents of the English press are altogether worse than either; but Brady never misrepresents. . . . His pictures, though perhaps not as lasting as the battle pieces on the pyramids, will none the less immortalise those introduced in them.[11]

Although Brady's courage and determination were tested at Bull Run when his photographic wagon became caught in the action, we have since learned that he was personally responsible for few of the photographs of the Civil War which bear his name, and that his greatest contribution to the Civil War Project was his "visionary belief in the camera as historian."[12] Despite Holmes's claims for the pictures' authenticity, we are aware that Civil War scenes had to be *chosen* and frequently *arranged*, either to suit the photographers' intentions or to conform to the camera's limited capabilities. Exposure times for the collodion plate process used to make these records of grim-visaged war were four seconds long and, as a result, each photograph excised a four-second interval of time from its natural flow. Thus, it was only relatively inanimate segments of the war that could be recorded. Furthermore, from our perspective in the present, we cannot ignore the fact that the photographer's eye and intentions could not help but determine the final effect of the "photodocument." For viewers of the 1860s, however, the camera was the ultimate, faithful witness and its images indelible records of events that had transpired.

Despite our present awareness of their imperfection as records of specific events, we still peruse photographs of the Civil War with an unshakable belief that we have access to the period which precipitated their making. Like all photographs, these mid-nineteenth-century images are tied to the past. Intrinsic to all responses to the photograph is the awareness that, although something like it may be happening in the present or may happen again in the future, the very existence of the image is evidence of the passing of an actual event that has been excised from the past by the very act of its having been recorded. For us, as was the case for their original audience, the photographs of the Civil War Project retain their authority as frozen surfaceless substitutes for past realities.

The perception of the photograph as a surrogate for its subject is ultimately based on our continued faith in its verisimilitude. This belief in the camera image's veracity is first evident in the press release that served as its introduction into the modern era. On January 6, 1839, one day before the official public announcement of the existence of the daguerrotype, H. Gaucheraud published a report of the new process in the *Gazette de France*. Six days later, the article was reprinted in *The Literary Gazette* of London.[13] Included in this piece of "on the spot" reportage is the announcement that the new apparatus provides direct access to both nature and truth, or, more specifically, that the "Daguerotype" [*sic*] was like a "solar microscope" that allowed one to "trace and examine" every nerve and fibre of "nature itself" and that, although the effects of the new process resembled the mezzotinto to some extent, "as for truth, they surpass everything."[14]

That the news of the invention was first communicated through the popular press rather than via the official channels of the *Académie des Sciences* is appropriate. True to his calling as reporter, Gaucheraud opened his article with the prediction that the discovery promised to do no less than "make a revolution in the arts of design."[15] That the reporter, as agent of the press (the primary means by which the passing of great events was communicated), chose to use the word "revolution" to describe the epoch-making invention of photography is also telling, for revolutions are clearly included in the rostrum of those great events that most directly effect the course of history and, as such, are clearly of interest to the press.

Although it was published under the heading "Fine Arts," Gaucheraud closed the article with yet another prophecy: that Daguerre's discovery would lead "to nothing less than a new theory on an important branch of Science."[16] One day before its public debut, the French press could have had little idea of the actual effect that photography was to have in areas such as science, medicine, and the arts. Furthermore, despite his excitement, Gaucheraud could not possibly have suspected to what extent the photographic image would affect his own field. Had its application been restricted to the fine arts, or even to the sciences, the photograph would not have gained ascendency as an essential element of the vernacular concept of how history is made.

In 1844, the Englishman Henry Fox Talbot, an amateur draughtsman[17] who is also credited with the invention of photography, published *The Pencil of Nature.* The book included a set of original photographs executed by what he called "the new art of Photogenic Drawing," pictures realized "without any aid whatever from the artist's pencil" but which were "impressed by Nature's hand."[18] Under the heading "Brief Historical Sketch of the Invention of the Art," Talbot explains that it was during his travels on the continent that he first began to plan his experiments.

> On the first days of the month of October 1833, I was amusing myself on one of the lovely shores of the Lake of Como, in Italy, *taking sketches* [emphasis mine] with Wollaston's Camera Lucida, or rather I should say, attempting to take them: but with the smallest possible amount of success. For when the eye was removed from the prism—in which all looked beautiful—I found that the faithless pencil had only left traces on the paper melancholy to behold.[19]

That the traveler and frustrated draughtsman used the word "take" rather than "make" in this statement has exciting implications for the issue at hand. In so doing, Talbot suggests that even before the modern camera could provide the "true" record of reality (or more specifically the "fixed and durable impress"[20] of nature which could be removed from its presence) which the nineteenth century so desired, its prototypes, by providing a means by which nature's reflection could be traced, allowed their users to perceive that they were "taking" nature's picture. Thus, the contract between the belief in the veracity of photographic reality and culture at large was signed even before it could be delivered.

Despite its inherent relationship to veracity, the photograph would not have accrued its essential, familiar photographic appearance independently of its mass reproduction and dissemination. Although photographs could be included in books, the popular press had to depend upon engravings and lithographs, traced from photographs, for the dissemination of pictorial information until the last decade of the century. In the 1890s, screen printing techniques were developed which finally liberated the popular journal and newspaper from the intervention of the printmaker's hand. However, just as its use by the artist and professional photographer could not possibly have accounted for the photograph's ascendency as the official chronicler of historical events, so would its employment by the popular press not entirely explain the pervasiveness of the concept. It has been said that "no one is interested in the news until it gets personal"[21] and, despite its visibility in the press, the photograph would not have been imbued with its familiar power were it not for its use by the individual as a means by which private events could be chronicled. It is fitting, then, that the general public had been provided with its own, direct access to camera images a few years *before* photographs could be easily and directly reproduced by the mass media.

The individual was able to photographically record his or her own history by 1888, when George Eastman marketed the first Kodak camera. The Kodak was a box camera with fixed focus which, when purchased, came fully loaded with film. Once the photographs were shot, the individual returned the camera to the company and, after processing, the finished photographs and the camera, now loaded with fresh film, were returned to the photographer. Liberated from the need for the technical prowess and equipment formerly required of even the amateur photographer, almost anyone could take pictures of their own lives, and a large segment of the public did so. The extent to which the public responded to the availability of such cameras can be illustrated by an estimate that during the Paris *Exposition Universelle,* at the turn of the century, seventeen of every one hundred visitors came equipped with a portable camera.[22] We can assume that during one day of the exposition, approximately 50,000 vernacular photographers would have been actively involved in attempts to document the event.

The assumption that when we look at a photograph we first see the thing photographed, and only afterwards the image's "objectness," is closely tied to the general public's use of photography in the ongoing act of self-documentation. The vernacular photographer is often criticized by his or her professional counterpart for a prevalent concern with subject rather than with the formal criteria by which the art-maker judges the merits of the medium.[23] However, it is through this very relationship to its subject that the photograph escapes its actual two-dimensionality. Furthermore, it is through its use as the means by which the ordinary rather than the spectacular is recorded, the basis of another criticism often levied against the amateur, that the photograph best demonstrates the *full* extent of our culture's historical self-consciousness.

Photographs are not capable of being read cross culturally. We have, as heirs to pictorial traditions of Western culture, learned to decipher the information hidden away on their two dimensional surface. Our belief in the camera image's inherent verisimilitude depends on conventions; the camera, regardless of the level of sophistication of the lens through which it sees, registers that which it sees differently than does our own optical device.[24] We are aware, even as we hold a photographic document in our hands, that "reality" does not stop in our "real" world and that it is only through the "natural magic" of the photograph that we can observe frozen time and reflect upon past events at our leisure. By its very act of recording a segment of time, the camera image abstracts occurrences from their ongoing flow and turns them, willy nilly, into events. It is while involved in the act of photographically recording his or her own history that the individual is most acutely aware of this, for the very taking of the picture is an event.[25] The graduation, the birthday party, the picnic, the wedding, the family gathering, the child playing, all have been excised from everyday occurrences and have attained the status of events through the act of being recorded. Personal photographs retain their position as historical evidence even as they are stored in shoeboxes and envelopes, but those that are culled and organized into their proper format and viewed sequentially become records of the private events of which vernacular histories are composed. Thus, for everyone, from aesthetician to photographer, avant-gardist to househusband, the familiarity of the family photo album provides ultimate proof of our period's pervasive historism.

For the most part, it is impossible to take a photograph without manipulating that which is photographed. The very decision to abstract a particular rectangular or square frame from the real world implies an imposition of the photographer's will upon his or her subject. Any "arrangement" of subjects within the frame, before one takes their picture, presents a second level of interference with reality. In the latter third of the nineteenth century, before the general public had access to portable cameras, individuals responsible for keeping the family album would arrange cut out photographs of their subjects in much the same way that vernacular and commercial twentieth-century photographers arrange the people themselves. A number of such Victorian scrapbook albums have resurfaced in the recent past, and these intricate photographic reconstructions provide exciting examples of early vernacular photoassemblage. Robert Sobieszek, author of "Composite Imagery and the Origins of Photomontage," writes of these montages,

> If, as some critics have maintained, the photograph is not seen as a thing in itself but, rather as a surfaceless substitute for the primary subject—as the thing represented and not the representation of a thing—then the cutting out of recognizable portraits and insertion of them into a landscape is the logical outcome of this perception. The portraits are not seen as "photographs" but as the people themselves. But when, as every so often appears in these albums, the maker groups together cut out figures arranged within, say, an interior scene, and also includes some cut out portrait *cartes* presented as paintings hung over the mantle, with painted frames sur-

rounding them, then another order of acceptance is in operation. For the photograph is no longer treated as a surrogate reality, but as a pictorial reference to reality. On a single page, therefore, is found evidence that the nineteenth-century "folk" artist was capable of multileveled perception of the photographic image: it was the subject represented and it was a picture of the subject. The final montage becomes a tableau in which there coexist pictures of nature, pictures of pictures of nature (a photographic portrait used or seen as a signal of a photographic or painted portrait) and a pictorial ensemble that presents a representation of another reality.[26]

The particular albums to which Sobieszek refers date from the 1860s and 1870s (fig. 12.1) and contain series of mixed media compositions which juxtapose photographic imagery (most of which was cut out of *cartes de visite*) with watercolor, pen, and ink. The makers of these conceptually and visually complex pages attempted, to the best of their abilities, to construct believable environments within which they could manipulate both photographic surrogates for, and pictorial references to friends and family. It is important to note that, like all keepers of the family album, the "folk" artists of whom Sobieszek speaks were charged with the responsibility of keeping family histories. In this context, by taking unrelated photographic portraits and placing them within a constructed domestic scene or landscape, the makers of these photoassembled pages were representing events that never happened. Furthermore, by placing these pages in family albums, they were fabricating histories.

The physical manipulation of photographic imagery in the studio—either by retouching, multiple printing, or by the cut, paste, and rephotograph technique— is as old as the photographic process itself. For example, the retouching of portrait dageurreotypes was a common and necessary device, employed by studio photographers in their attempts to please members of the public less than satisfied with the fixed and durable impress that the mirror with a memory reflected. Based on the limits inherent in the photographic process, multiple printing of sky and landscape was a skill that most early photographers cultivated by necessity. So too was the insertion of a figure, or groups of figures, into unpopulated landscapes.

If he or she so chose, the nineteenth century world traveler could also make use of multiple photographic printing as a means by which events could be fabricated. Studio portraits of less adventurous individuals were superimposed over chosen photographic backdrops, and thus souvenirs or other vacation remembrances of trips that had never occurred could be taken.[27] Not only was it no longer necessary for traveler's pencils to intervene in "taking" the sketches from nature required to validate their experiences, but, through the magic of composite photography, nature's charms, having once been documented, could become part of the travelers' past without the intervention of actual experiences. If the photograph is perceived to be a "surfaceless substitute" for its subject, and if that subject is an event that never occurred, then these studio fabrications of travelers' adventures construct both document and event simultaneously—for one cannot conceive of a surrogate without bringing an original to mind.

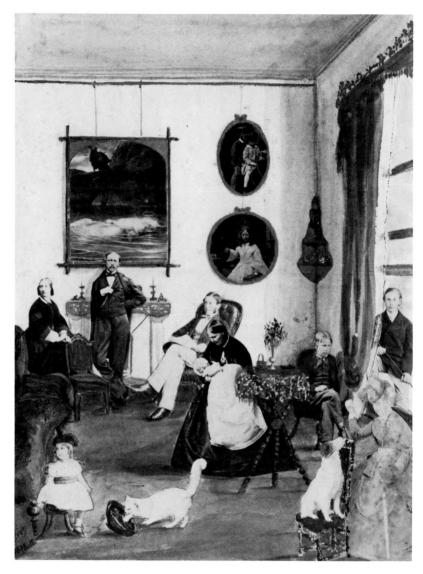

Figure 12.1.   E.P.B., *An Interior Scene,* folio from the "E.P.B. & J.P.B." Scrapbook
Album, 1872
Montaged albumen prints with watercolor.
*(International Museum of Photography at George Eastman House, Rochester,
New York)*

Besides the reshaping of personal histories toward which some of the earliest overt manipulations of photographic reality were directed, many such efforts were undertaken in service of the mass media, even before actual photographs could be mass reproduced for their use. The popular press, in response to the limits imposed by early photographic technology, and in its understandable attempt to please the public, inserted additional information into the photo-based, hand-executed prints that appeared in its pages. The early daguerreotypes required very long exposures and, as a result, people and other animate objects were often rendered invisible. The lithographers and engravers who worked from daguerreotypes of inanimate nature and architecture would reinsert "figures and traffic imaginatively drawn in the romantic style"[28] into the scenes that the camera had depopulated and that the public consequently abhorred. While it could be argued that these images are not photoassemblages in the pure sense, the newspaper's use of these manipulated prints was ultimately based on the literal accuracy of photographic images from which they were drawn. The positioning of figures and traffic, imaginatively drawn in the romantic style, within environments traced directly from photographs, cannot help but bring to mind some of Max Ernst's juxtapositions of visual information, excised from prints that had also been traced from photographic sources. While the encounter of the sewing machine and the umbrella on the dissecting table[29] was by no means consummated in these early-nineteenth-century newspaper illustrations, it was, at the very least, implied in these widely circulated images.

Other early examples of vernacular composite imagery have direct implications for such well-known twentieth-century works as John Heartfield's mature "political" photomontages. For example, composite photography was used for propaganda purposes, albeit malicious ones, as early as 1867 when "nude" pictures of Empress Eugenie and Duchess de Morney were made available to the public who attended the Exposition Universelle, and, with more benevolent intentions, in 1861, when the cut and paste technique of photoassemblage was used to fabricate "photodocuments" of scenes from the Paris Commune's uprising.[30] These examples are by no means isolated instances of such activity. During the mid-nineteenth century, photographers would regularly use montage techniques to produce documents of "real" events. Furthermore, as would be the case for the twentieth-century montages of both Heartfield and Ernst, the greatest care was taken by makers of these nineteenth-century composites to erase all evidence of the composers' intervention in the reconstructed images. By the turn of the century, the public could easily buy composite photographic reconstructions of exciting local events such as balloon races and disasters. These would be available in postcard format and would appear on the streets within hours of the event. Such cards were often produced as sets of narrative, serial images charting the full course of locally important occurrences. Although each was constructed of more than one photographic image, the words "A Real Photograph" would appear on the back of the postcard in an attempt to attest to the "photodocument's" verisimilitude.[31]

When Heartfield later published his antifascist, and overtly event-based, photomontages in *Arbeiter-Illustrierten Zeitung* (AIZ), he included unaltered copies of his mass media source.[32] While it is true that such acts would identify his photomontages as pieces of propaganda rather than as private works of art, they would also attest to the fact that his montages were composed of "Real Media Photographs."

In each of the aforementioned examples of nineteenth-century photoassemblages, great care was taken by the makers to fabricate believable images of the real world. There is a parallel tradition of early popular composite image making that intentionally juxtaposed photographic "reality" and deliberate pictorial "illusion." Most scholars of the early-twentieth-century avant-garde wave this tradition aside as the isolated experiments of a few whimsical individuals; however, all told, images of this sort were circulated to a far wider public than ever was a photomontage by a Dadaist. Included in this tradition is the *carte-de-visite-"mosaique"* (fig. 12.2), a form of photoassemblage patented in 1863 by portrait daguerreotypist and self styled romantic artist André Adolphe Eugène Disdéri, in response to popular demand. These highly popular *mosaiques* were sometimes composed of less than ten, and sometimes by thousands, of individual images juxtaposed against one another with a deliberate lack of concern for naturalistic space. The fashion for these conceptually complex montages, both as parlour guessing games and in photographic advertisements, lasted until the turn of the century,[33] at which time another aspect of this tradition came into its own in the form of the "fantasy" postcard, a highly popular vernacular form of composite imagery.

The postcard itself was patented around 1861. Barbara Jones, in her all too brief but suggestive introduction to William Ouellette's carefully annotated *Fantasy Postcards,* quotes the following statistics that had been printed on a 1904 card: "Germany holds the record of correspondence by postcard, 1,013,500,000 cards, France, 600,000,000; Japan, 453,000,000; Austria, 250,000,000; Belgium, 55,000,000; and Switzerland, 43,000,000."[34] Jones is quick to point out that many of these early cards were not fantasy postcards and that most had real live people, places, and events as their subjects.[35] While the producers of these realistic cards would, in all probability, have reverted to techniques of naturalistic photoassemblage on a regular basis, what is more relevant to this stage of the present discussion is the fact that a sizable percentage of the cards that were printed from 1900 through 1914 were composite representations of pictorial fantasies. Of these particular cards, Jones writes: "The care with which some fantasy cards were drawn, photographed, montaged or faked, would please Bosch himself, and so would the horror and the sex, both in great variety—subtle or overt, delicate or violent."[36] Attempts to analyze the event structure of photoassembled collotypes, which represent naked dolls with human heads, babies and beautiful women hatching from egg shells, cigarette smoke recomposed into lover's portraits, automobiles flying over Manhattan's East River Bridge, and sailors and their sweethearts floating over battleships, could prove unrewarding were it not for the fact that most of the

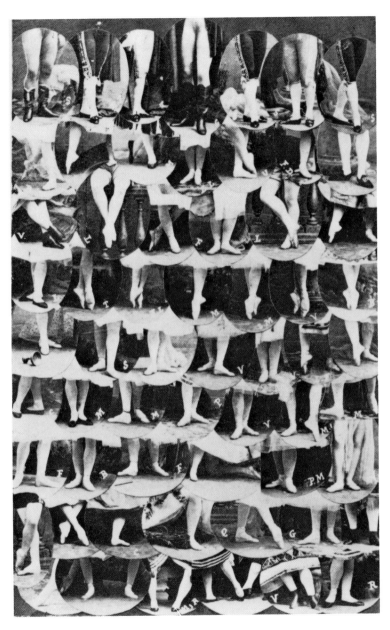

Figure 12.2.   André Adolphe Eugène Disdéri, *The Legs of the Opera*, 1863
Rephotographed montage, albumen print.
*(International Museum of Photography at George Eastman House,*
*Rochester, New York)*

estimated one-and-one-half billion realistic postcards mailed before the fantasy postcard gained ascendency at the turn of the century had as their subjects real people, places, and events. All questions of inherent relationships between photographic imagery and the event aside, a public familiar with the postcard as a means by which real events were both reproduced and communicated would carry that association into their response to the more overtly fantastic versions of the medium.

Ouellette states that photomontage "is the major technique of the fantasy postcard" and further posits that the "early postcard artists were responsible for developing this valuable technique into what is now considered a valid art form."[37] While the latter part of this statement is exaggerated, as our discussion of nineteenth-century photoassemblage indicated, it is true that cards of this genre were dependent upon the deconstruction and reconstruction of photographic information. Ouellette describes fantasy postcards as follows: "These small miracles are usually drawings, paintings, or photographs created especially for reproduction as postcards. Very often they were produced by the *new* [emphasis mine] technique of photomontage, using the persuasively 'real' images from several photos cut and recomposed to give the illusion of reality. This effect of altered reality is sometimes heightened further when elements of painting are applied to the montage and areas are retouched to add, remove or accent detail."[38] The subjects of these small miracles include the population explosion, eroticism, visual puns, high art, and progress. Included in the last category is a particularly popular genre which Ouellette calls "fantasy transport," a form of vernacular photomontage that calls to mind the association between the postcard and the traveler and which was developed in response to the early-twentieth-century public's excitement about its new mobility and its fascination with the possibilities that future innovations promised.[39]

The visual complexity and sophisticated humor inherent in some of these widely circulated photomontages should not be underestimated. For example, one such card, a montaged collotype entitled *A Flying Family from Aachen,* postmarked 1908 (fig. 12.3), presents a smiling man, his happy wife, and two of their small offspring, all supported by the man's umbrella as they hover over a cityscape. This card is one of a series of German photomontages in which the same man and various other members of his family fly over a number of towns, in both Europe and America,[40] as they complete their trip around the world. A French card entitled *Souvenir of Bellevue,* postmarked 1909 (fig. 12.4),[41] shows a woman in full Victorian dress demurely waving her handkerchief as she floats, suspended over a body of water, in a composite flying machine; and another, a German version entitled *Barmaid and Airship,* postmarked 1910 (fig. 12.5),[42] presents a far less reserved composite fantasy of the woman and the airplane; for here the heroine straddles an airborne, obviously phallic, zeppelin and, hand on hip, raises her beer mug to the toast *BRUDER STOSS'AN!* Another card, the *Removal of the Arch of Triumph from the Etoile by Zeppelin,* postmarked Paris, 12/10/1916 (fig. 12.6),

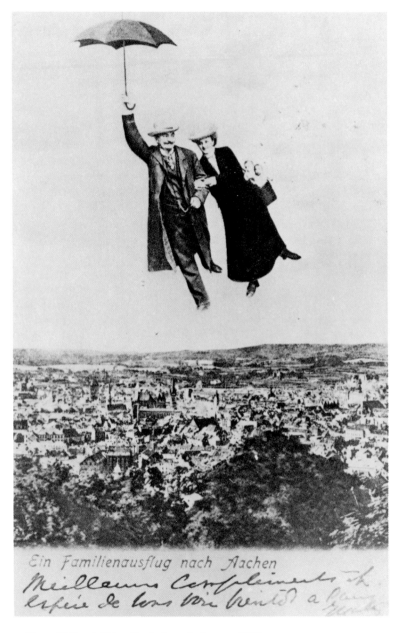

Figure 12.3. *A Flying Family from Aachen*, ca. 1908
　　　　　Postcard, tinted collotype (Germany; A. Dressler, Berlin; postmark
　　　　　9/6/1908).
　　　　　(*Reproduced in William Ouellette,* Fantasy Postcards, *Doubleday
　　　　　and Company, Inc.*)

Figure 12.4.  *Souvenir of Bellevue*, ca. 1909
Postcard, tinted collotype (France; E.L.D. postmark Argenteuil 7/22/1909).
*(Reproduced in William Ouellette, Fantasy Postcards, Doubleday and Company, Inc.)*

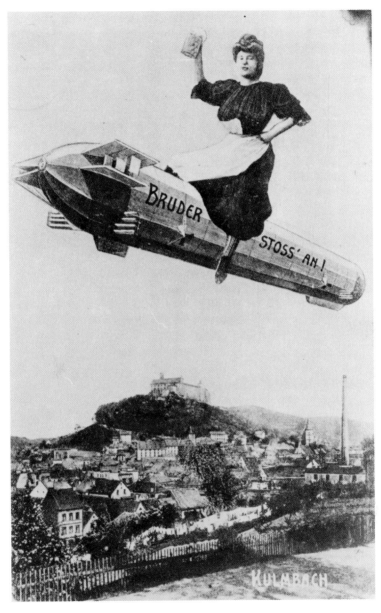

Figure 12.5.  *Barmaid and Airship,* ca. 1910
Postcard, tinted collotype (Germany; Carl Senfft, Kulmbach;
postmark Kulmbach 9/3/1910).
*(Reproduced in William Ouellette,* Fantasy Postcards, *Doubleday
and Company, Inc.)*

Figure 12.6. *Removal of the Arch of Triumph from the Etoile by Zeppelin,* ca. 1916
Postcard, collotype (France; E.I.D.; postmark Paris 12/10/1916).
*(Reproduced in William Ouellette, Fantasy Postcards, Doubleday and Company, Inc.)*

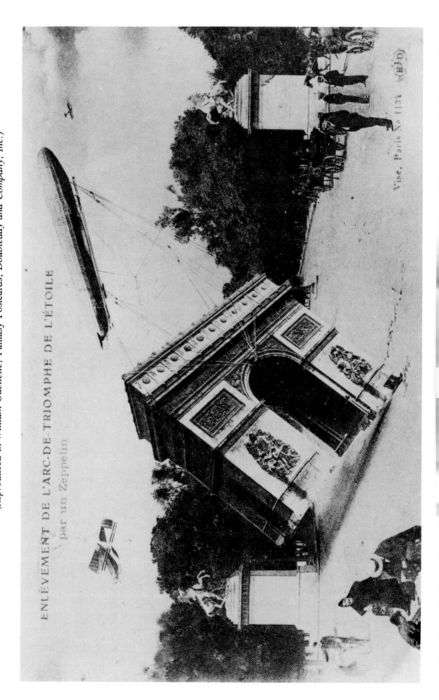

ENLÈVEMENT DE L'ARC-DE-TRIOMPHE DE L'ÉTOILE
par un Zeppelin

Vise, Paris No 1134 (gJD)

suggests the care and expertise that was often committed to the execution of these popular photomontages. In this case, the zeppelin can be identified as the "République" which was constructed in 1908. Ouellette suggests that "an aura of documentary authenticity is given off by the deadpan title."[43] Indeed, attempts to mimic photographic reality are evident in the montage itself, within which photographs of traffic, pedestrians, bicyclists, and other characters have been intricately and realistically repositioned within the scene to further play with our sense of photodocumentary verisimilitude. Not one of these figures, by the way, seems visibly shocked by the removal of the "Arch of Triumph." They are, in fact, quite unwilling to interrupt the pursuit of their Sunday afternoon pleasures for such an event.

It can be said that Berlin Dada was formally launched with the publication of the May 1917 issue of the journal *Neue Jugend* (John Heartfield, ed.). According to George Grosz, photomontage had been discovered exactly one year earlier.

In 1916, when Johnny Heartfield and I invented photomontage in my studio at the south end of the town at five o'clock one May morning, we had no idea of the immense possibilities, or of the thorny but successful career, that awaited the new invention. On a piece of cardboard we pasted a mischmasch of advertisements for hernia belts, student song-books and dog food, labels from schnaps- and wine-bottles, and photographs from picture papers, cut up at will in such a way as to say, in pictures, what would have been banned by the censors if we had said it in words. *In this way we made postcards supposed to have been sent home from the Front, or from home to the Front.* [emphasis mine] This led some of our friends, Tretjakoff among them, to create the legend that photomontage was an invention of the "anonymous masses." What did happen was that Heartfield was moved to develop what started as an inflammatory political joke into a conscious artistic technique.[44]

It is impossible to fully understand Grosz's statement if the existence, in 1916, of a highly popular, and therefore thoroughly familiar, form of vernacular photoassemblage is ignored. Yet, many scholars fail to see the full implications inherent in the coexistence of popular photoassemblage and avant-garde experiments with the medium. For example, William S. Rubin, in his catalogue *Dada, Surrealism, and Their Heritage*, writes the following of photomontage or "photocollage," the medium that for him constitutes Berlin Dada's most significant contribution to the plastic arts: "In its pure form, photomontage entirely eliminated any need to paint or draw; the mass media could provide all the material. One could attack the bourgeoisie with distortions of its own communications imagery. The man on the street would be shocked to see the components of familiar realistic photography used to turn his world topsy-turvy, and the familiar lettering of his newspapers and posters running amuck."[45] However, it is probable that after decades of familiarity with the medium as part of his or her leisure activities, the man or woman on the street would not have been shocked by a world turned topsy-turvy through the medium of photoassemblage (although he or she may well have been somewhat surprised to see something that resembled a familiar form of visual

playfulness—and therefore usually associated with humor, pleasure, and mild irony—attempting to do something else). It would have been the individual who was positioned within the rarified world of the fine arts that would have been most shocked to find images of this sort presented within the context of the high arts. For the early-twentieth-century avant-gardists using the medium, the familiarity of the public with images that were both "like" and "unlike" their own works could not help but contribute to photomontage's applicability to their attempts at cultural criticism; for, in order to *communicate* with a public, a fundamental aspect of any critical act, that public must first be literate, and literacy is dependent upon familiarity. Furthermore, by choosing to mimic postcard imagery, Grosz and Heartfield carried direct references to events into their "inflammatory political jokes." Just as the overtly fantastic, vernacular versions of this genre carried the relationship between the post card itself and "events," so too did Heartfield's and Grosz's pre-Dada experiments with the medium.

Grosz's statement about his collaboration with Heartfield, and their subsequent invention of photomontage, describes two World War I artists making handmade versions of mass-produced photoassembled images, albeit with intentions very different from those that informed the production of the more commercial models. Members of the early-twentieth-century avant-garde continued to be involved in similar attempts to investigate imagery that was mass produced, and to mirror the mass media itself. These experiments were undertaken not only as a means by which to break formal boundaries, but also in an attempt to expand the range of effectiveness of their art making by broadening the public base for their works—an elemental characteristic of utopianism. While one objective of these actions was to restore continuity between their own activities and other forms of experience, most members of the early-twentieth-century avant-garde concurrently maintained their position as artists and, as such, continued their ongoing dialogue with their own profession.

Dada was not the first avant-garde to introduce segments of photographic reality and mass media information into its works. In 1914, Kazimir Malevich included a reworked photographic reproduction of the Mona Lisa, and cut outs from texts, in a painting entitled *Composition with Mona Lisa*.[46] (In another painting from this period, *Private from the First Division* (1914),[47] Malevich included a postage stamp, text cut outs from mass-produced sources, and a thermometer in his cubofuturist composition.) The Italian Futurist, Carlo Carrà, positioned a photograph of uniformed officers in place of the head of a standing figure in *French Official Observing Enemy Movements* (1915).[48] For the Futurist work, the use of the photograph provides an almost literal visual translation of the concept "simultaneity," for we can observe the French official and the enemy movements at the same time. Curiously enough, it is what the French official perceives, rather than the official himself, that is rendered visible through the inherent realism of the photographic medium. In *Composition with Mona Lisa,* the reproduction of the

familiar visual cliche[49] serves to introduce a note of parody, particularly as the photograph has been negated by two marks of the modernist's brush. In Carrà's and Malevich's works, the photographic information serves to activate the paintings; however, in each case the artists merely used the photograph to "color in" a section of a composition that sits squarely within a syntax derived from Cubism. On a formal level, photocollages by the Dadaist George Grosz, such as *Life Model* (1919) and the *Montage-Paster (The Engineer) Heartfield* (1920) (fig. 12.7), do much the same thing except that in his case the structures of the pieces are based on a late expressionist interpretation of cubist syntax rather than on a futurist or cubo-futurist one.[50]

Carrà's *French Official Observing Enemy Movements* brings to mind photographs of men who had participated in the Civil War, despite the fact that in twentieth-century images, the men could be photographed while they marched or fought, and not only if they rested, posed, or had died. Through his use of a photograph of "enemy movements," Carrà presents an overt reference to actual military service in the field. The inclusion of the photograph in the "abstract" futurist composition energizes the piece and corroborates the artist's concern with, and his art's relationship to, real events. As is the case for Malevich's *Composition with Mona Lisa*, photocollages like Grosz's *Montage-Paster (The Engineer) Heartfield* (fig. 7) are far more static, and their relationship to the event more oblique. Despite the fact that the postcard of a photographic segment of a city block, pasted onto the upper right hand corner of the watercolor, carries its mass media source—and thus its event basis—along with it, the inclusion of the photographic information speaks more directly to the Expressionist's concern with the urban experience than it does to the event per se. However, the juxtaposition of the portrait and the photograph of the unpopulated cityscape brings to mind the nineteenth-century popular press' reinsertion of figures, imaginatively drawn in the romantic style, within environments traced directly from photographic sources. In the early-twentieth-century version, the romantic style has been superseded by an expressionist one, and the individual, despite his mechanized organs, has gained precedence over his urban environment.

Raoul Hausmann, who, along with Johannes Baader and Hannah Höch, is credited with having produced some of the most conceptually complex and overtly event-based Berlin Dada photomontages, distinguished between images like Grosz's *Montage-Paster (The Engineer) Heartfield* and "true" photomontages. Hausmann described some of the early experiments of both Grosz and John Heartfield in the following manner:

> Grosz and Heartfield, too taken with their caricaturistic ideas, remained faithful to collage until 1920. At the beginning this was a mixture of drawing and cut-outs from catalogues. Later in 1919, under the influence of American magazines, which came to Grosz via his brother-in-law a subway *engineer* [emphasis mine] in San Francisco, Grosz and Heartfield added to their paintings reproductions of advertising articles in color. Another detail—although in France one would

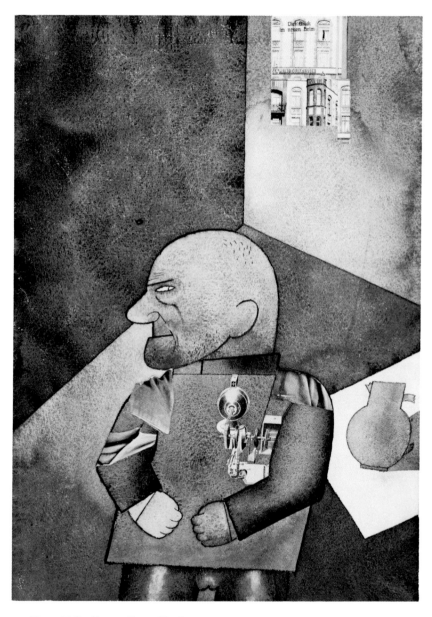

Figure 12.7. George Grosz, *The Engineer Heartfield*, 1920
Watercolor and collage of pasted postcard and halftone, 42 × 30.5 cm.
*(The Museum of Modern Art, New York. Gift of A. Conger Goodyear)*

call these things collage, in the same sense that one connects whimsical objects and even opposites at first, in Berlin we called them *Klebebild* (pasted painting).[51]

Hausmann's statement is flavored somewhat by his attempt to prove that he discovered the new process and that, in its early stages, the only members of the Berlin Dada group who used the medium with integrity were Hausmann, Höch and Baader. While it is true that Berlin photomontage can, for the most part, be subdivided into two formal tendencies along lines similar to those suggested by Hausmann, works from both groups exhibit equal probity. Whether or not one accepts Hausmann's distinction between photomontage and photocollage, and cubist syntax notwithstanding, the element that distinguishes Dada's "pasted paintings" from their futurist and cubo-futurist high art precursors, as well as from their constructivist counterparts, is that the Dada works are first and foremost statements by artists about the moribund state of post-World War I German culture. Above and beyond their formal considerations, the montages are about the causal relationship between "great events" and crisis, on the one hand, and about the entrapment of the individual in spurious cultural systems, on the other.

Like photography itself, Dada photomontage was a collaborative invention. Hausmann makes brief mention of the existence of a vernacular form of photoassemblage when he presents his own version of how photomontage was discovered.

I began to make paintings with cut-outs of colored paper, newspaper, and posters in the summer of 1918. But it was on the occasion of a visit to the Baltic seacoast, on the island of Usedom, in the little village of Heidebrink, that I conceived the idea of photomontage. On the wall of almost every house was a colored lithograph depicting the image of a grenadier against a background of barracks. To make this military memento more personal, a photographic portrait of a soldier had been used in place of the head. This was like a stroke of lightning, one could—I saw it instantly—make *paintings* entirely composed of cut-out photographs. On returning to Berlin in September, I began to realize this new vision by using photos from magazines and the movies. Captured by a renovating zeal, I also needed a name for this technique, and in general agreement with George Grosz, John Heartfield, Johannes Baader, and Hannah Höch, we decided to call these works *photomontages.* This term translated our aversion to playing artist, and, considering ourselves as *engineers* [emphasis mine] (from that came our preference for work clothes—"Overalls" [monteur-anzuge]), we claimed to construct, to *mount* our works.[52]

Artists who profess an aversion to "playing artist" and who adopt the dress of the workers would not ignore their other popular affiliations. For the Dadaists, living as they did during the early twentieth century, the existence of a popular tradition of composite imagery could not help but be a given. I would posit that it was the medium's very relationship to imagery common to the man and woman of the street that made photomontage a particularly productive means by which both the Berlin and the Cologne Dadaists could work out their concepts of cultural

criticism. Montages like John Heartfield's 1919 cover for *Jedermann sein eigener Fussball* (fig. 12.8), Johannes Baargeld's *Self-Portrait* (1920), Erwin Blumenfield's *Bloomfield President Dada-Chaplinist* (1921), and a host of other dada photomontages bear direct resemblance to hundreds of vernacular photoassembled images. Some of Max Ernst's montages appear to speak directly to their popular counterparts. For example, if one were to remove the cut out of the two soldiers carrying their wounded comrade, the lower third of Ernst's *Untitled or the Murderous Aeroplane* (1920) (fig. 12.9) would be identical to the landscape over which the composite flying machine in *Souvenir of Bellevue* (see fig. 12.4) floats. The 1909 postcard places the woman within the airship, whereas in Ernst's version she has become part of the murderous airplane itself. The skeleton fish in Ernst's *Here Everything Is Still Floating* (1920) could easily be read as post-World War I interpretation of the flying "April Fish," itself a parody of the French symbol for April Fool's Day which sometimes appeared in prewar popular composite imagery as a little fish airplane that carried, as its passengers, such fools as bridegrooms.[53]

Dada montages stand removed from their vernacular counterparts because of the disparate intentionality that informed the two kinds of photoassemblage. Both the late-nineteenth-century mosaiques and the early-twentieth-century fantasy postcards were produced for popular consumption by a public filled with optimism, faith in progress and innovation, excitement about the new age, and an overwhelming readiness for the great events that the future promised. As artists responding to the aftermath of the Great War, and to the failure of the revolution that followed, the German Dadaist's choice of a format associated with prewar optimism seems particularly appropriate in view of the movement's intentions, its criticism of the cultural systems that failed, and of Dada's well known presentation of its public face.

Just as cut out portions of photographs carry their subjects with them, segments of texts borrowed from the mass media retain their references to the act of reportage. Furthermore, both the photograph and the newspaper text, the two most common components of Dada photomontage, allude to their original usage even after they have been repositioned into new contexts. Thus, not only was Dada photomontage developed in response to events of major consequence, but the medium itself is composed of event-based materials. Hausmann, Johannes Baader, and Hannah Höch often included photographs and other mementos of their personal lives, alongside mass media materials, when they constructed their photomontages and thus added yet another dimension to the underlying event-structure of these works. In this respect, their photomontages have, on the one hand, something in common with images that appear in the vernacular composite family albums, and, on the other, with fabricated souvenirs of experiences that never happened.

Montages like Höch's autobiographical *Cut with the Cake Knife of Dada through the Last Beer-swilling Epoch of the Weimar Republic* (fig. 12.10), through the inclusion of recognizable portraits of famous Dadaists, bring to mind some of the involved guessing game *cartes mosaiques* that were so popular in the nine-

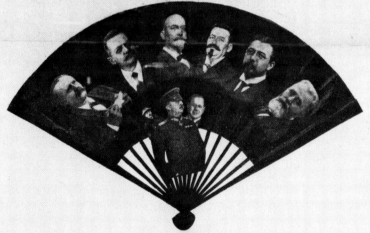

Figure 12.8.   John Heartfield, Cover of *Jedermann sein eigner Fussball*, No. 1, Ed.
Wieland Hertzfelde, 15 February 1919
*(From the Library of the Getty Center for the History of Art and the
Humanities, Santa Monica, California; photo: Estera Milman)*

Figure 12.9. Max Ernst, *Untitled* (Formerly *L'Avionne Meurtrière*), 1920
Montage: reproductions cut out and glued on paper, 6.7 × 14.3 cm.
*(Menil Foundation, Inc., Houston, Texas)*

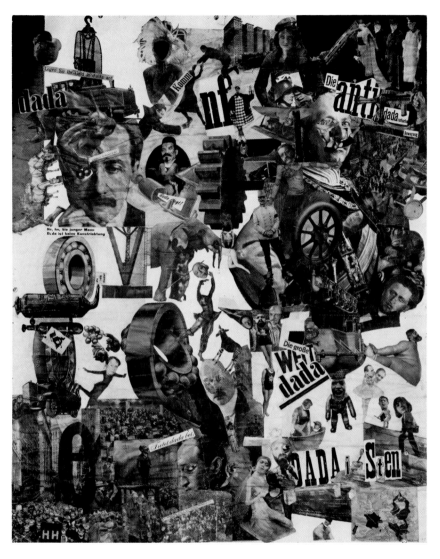

Figure 12.10.  Hannah Höch, *Schnitt mit dem Küchenmesser DaDa durch die erste Weimarer Bierbauchkulturepoche Deutschlands (Cut with the Cake Knife of DaDa through the Last Beer-Swilling Epoch of the Weimar Republic)*, 1920
Montaged photographs and typography, 113.7 × 90.2 cm.
*(Staatliche Museen Preussischer Kulterbesitz, Nationalgalerie, Berlin (West). Photo: Jorg P. Anders)*

teenth century; for example, the entertaining 1876 mosaic entitled *Bradley & Rulof-son's Celebrities* (fig. 12.11). However, the very title of the Dada image attests to the fact that the game in question is a deadly earnest one. Baader's *The Author at Home* (fig. 12.12) is a representation of the active element inherent to the making of a photomontage. The author is presented as the same dummy who plays a central role in Baader's architectonic assemblage, *Grosse Dio-Dada-Drama,* (1920). In the photomontage, Baader presents us, through the very formal structure of the piece, with direct access to the process of deconstruction and reconstruction of information that is endemic to the medium. The armature, which stands exposed to our view, is constituted by the almost diaristic nature of the materials of which it is composed, including the media photographs pinned to the bulletin board at the upper left corner of the montage, all of them in readiness for their insertion into a future photoassemblage. Hausmann's self portrait, *The Art Critic* (fig. 12.13), significantly includes in the materials of which it is composed a visiting card, photographs, media information, and references to his own works as an artist.

A great many of the Dada photomontages of Hausmann, Höch, and Baader are autobiographical. In these works, imagery which served to document and chronicle the course of events of which their "ordinary" private histories were made was juxtaposed with photographic references to those "spectacular" events which effected the course of their culture at large. These montages speak directly to both the abstraction of their subjects from the flow of things and to an awareness of the positioning of the individual within a particular "moment in history." Their visual statements were not simply about the arrangement of their subjects and themselves within new realities; they were reiterations of the belief that public and private events succumb to the same historical process and that history is made visible through the reification of these events. At their best, Hausmann, Höch, and Baader attempted to make responses to extreme social crisis personal.

For the most part, photomontages by the German Dadaists were informed by their awareness of the particular moment of history within which they participated. When they collectively deconstructed vehicles of mass communication, not only were they decomposing written and visual language, the two primary building blocks of the foundation upon which all cultural systems depend, but they were also, in a very real sense, deconstructing and reassembling history. As Hausmann reminds us, Dada was "a kind of cultural criticism."[54] Although overtly committed to tearing down social structures held culpable for the war, Dada could not help but surreptitiously maintain schemes of social regeneration. If the event is perceived to be a means by which the course of history is changed, the Dada photomonteurs could have chosen no better medium through which to act.

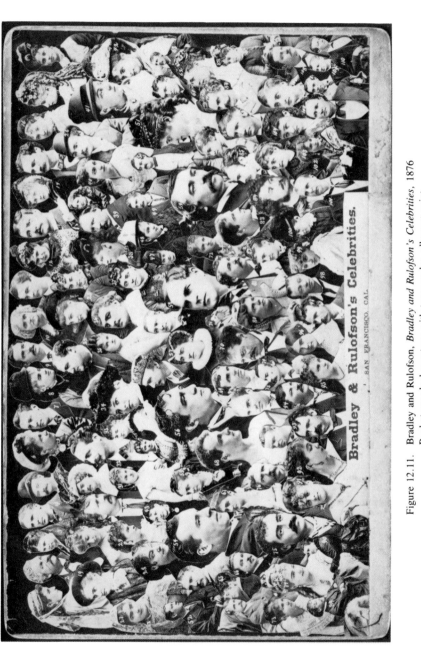

Figure 12.11. Bradley and Rulofson, *Bradley and Rulofson's Celebrities*, 1876
Rephotographed montage with typography, albumen print.
*(International Museum of Photography at George Eastman House,
Rochester, New York)*

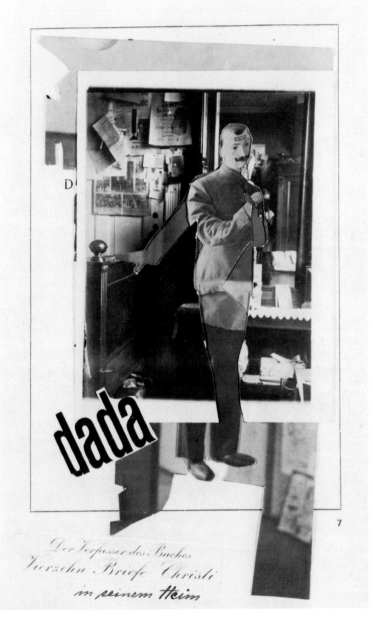

Figure 12.12.    Johannes Baader, *The Author in His Home,* ca. 1920
                 Collage of pasted photographs on book page, sheet 21.6 × 14.6 cm.
                 *(The Museum of Modern Art, New York. Purchase)*

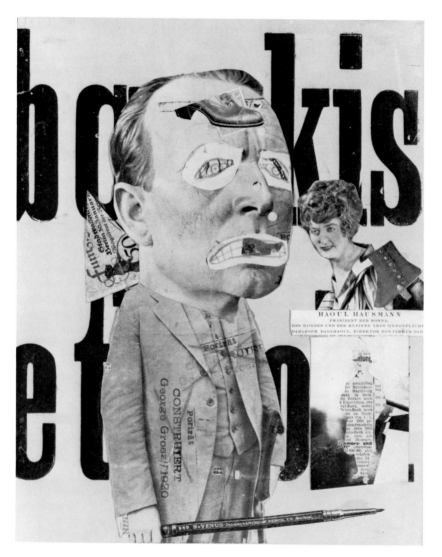

Figure 12.13.  Raoul Hausmann, *The Art Critic,* 1920
Montaged photographs, newsprint, currency, stamp, fragments of drawing, and
ink on paper, 32 × 25.4 cm.
*(The Tate Gallery, London)*

## Notes

1. I am here making reference to John Dewey's discussion of the need to restore continuity between works of art and "everyday" experience. Dewey's statement makes no mention of photography and reads as follows:

   > When artistic objects are separated from both conditions of origin and operation in experience, a wall is built around them that renders almost opaque their general significance, with which esthetic theory deals. Art is remitted to a separate realm, where it is cut off from that association with the materials and aims of every other form of human effort, undergoing, and achievement. A primary task is thus imposed upon one who undertakes to write upon the philosophy of the fine arts. This task is to restore continuity between the refined and intensified forms of experience that are works of art and the everyday events, doings, and sufferings that are universally recognized to constitute experience.

   John Dewey, *Art as Experience* (New York: Perigee Books, 1980), p. 3.

2. Ibid.

3. John Canning, ed., *100 Great Events That Changed the World: From Babylonia to the Space Age* (New York: Hawthorn Books, Inc., 1965), p. 15.

4. Ibid.

5. Ibid.

6. Douglas Collier, "Invention of the Camera: The Birth of Photographs, Moving Pictures, and Television," in Canning's *100 Great Events That Changed The World*, p. 431.

7. Oliver Wendell Holmes (the elder) is generally credited with having coined the term "mirror with a memory" to describe the daguerreotype. One of Holmes's mid-nineteenth-century articles on photojournalism will be discussed in this essay.

8. The words "chronicle," "history," "event," "drama," and "picture" are lexically connected as is illustrated by the following excerpts from *Webster's New International Dictionary* (Second Edition), a publication which, on its end page, describes itself as "The Most Notable Publishing Event of the Century."

   > chron'i·cle, *n.* 1. A historical register or account of facts disposed in the order of time; a history; esp., a bare or chronological record of events.
   > chron'i·cle, *v.t.*, to record in a history or chronicle, to record, to register.
   > chronicle drama. Drama composed of chronicle plays.
   > chronicle history. A chronicle play.
   > his'to·ry, *n.* 1. A narrative of events connected with a real or imaginary object, person, or career; a tale; story; now esp. such a narrative devoted to the exposition of the natural unfolding of and interdependence of the events treated; as, Thackeray's *History of Pendennis* . . .
   > 5. A historical play; a drama based on real events . . .
   > 8. Obs. a. A picture of a historical subject. b. Any series of events. c. A drama.

   (*Webster's New International Dictionary*, Second Edition [Northampton: G&C Merriam Co., 1934], p. 480, end page, 1183.)

9. H. H. Arnason, in his well-used *History of Modern Art*, opens his chapter on "Realism and Impressionism" with a section subtitled "The Invention of Photography and the Rise of Realism." In it he says of this new class of patrons:

Being fundamentally materialistic in its values, this increasingly dominant segment of society had less interest in the vagueness and fantasy of Romantic art than in a kind of pictorial verisimilitude that could convey meticulous visual facts verifiable in the external world of here and now. Since the interest was primarily in such facts for their own sake, quite apart from whatever role they might play in expressing some higher meaning, as in the elevated realism of the Renaissance and Baroque eras, it served as an all-important stimulant to the research that finally brought about the invention of photography.

See H. H. Arnason, *History of Modern Art* (New York: Harry N. Abrams, Inc., 1986), p. 23. Aaron Scharf, in *Pioneers of Photography*, writes that the longstanding "dream of fixing an image of nature on some surface and then carrying it away was a necessary stimulus to the invention" of photography. See Aaron Scharf, *Pioneers of Photography* (New York: Harry N. Abrams, Inc., 1976), p. 9. Beaumont Newhall, in his book *The History of Photography*, states that the "incentive to work out a practical technique (to trap the elusive image of the *camera obscura*) was stimulated by the unprecedented demand for pictures from the rising middle class of the late eighteenth century," and that "the fever for reality was running high." See Beaumont Newhall, *The History of Photography* (New York: The Museum of Modern Art, 1964), pp. 12–13.

10. Aaron Scharf, *Art and Photography* (Baltimore: Penguin Books, 1975), pp. 66–67. It is apt that Scharf chose to use the word "reportage" while discussing the photograph's influence upon the tradition of history painting. As was cited earlier, the 1934 edition of *Webster's New International Dictionary* lists "a picture of a historical subject" as one obsolete definition of "history." The edition also defines the word "reportage" *first* as an obsolete form of "report" (a word that basically means to bring back an account of something and to then communicate this information to someone else) and then as a form of journalistic writing. "Report" is both verb and noun. As verb, it once meant "to picture or describe in a graphic manner," yet one more definition that has slipped into obsolescence. See *Webster's New International Dictionary*, p. 2113.

11. Portions of Oliver Wendell Holmes's 1863 article for the *Atlantic Monthly* are reproduced in Scharf's *Pioneers of Photography*. See Oliver Wendell Holmes, "On the Civil War," in Aaron Scharf's *Pioneers of Photography*, p. 124.

12. Naomi Rosenblum, *A World History of Photography* (New York: Abbeville Press, 1984), p. 184.

13. Aaron Scharf notes the fact that Gaucheraud's article for the *Gazette de France* preceded the official announcement of Daguerre's photographic process by the *Académie des Sciences*. The English version of the piece is reprinted in *Pioneers of Photography*. See Aaron Scharf, *Pioneers of Photography*, p. 41.

14. H. Gaucheraud, "Fine Arts: The Daguerotype," excerpted from *The Literary Gazette*, London, January 12, 1839. See *Pioneers of Photography*, p. 41.

15. Ibid.

16. Ibid.

17. Although the professional draughtsman and painter are mentioned in Gaucheraud's 1839 article, it is to the amateur that the reporter most directly speaks when he suggests that the new apparatus would test the truth of pencils and brushes: "For a few hundred francs travellers may, perhaps, be soon able to procure M. Daguerre's apparatus, and bring back views of the finest monuments, and of the most delightful scenery of the whole world. They will see how far their pencils and brushes are from the truth of the Daguerotype [*sic*]". Ibid. Another such amateur, the French landowner Joseph Nicéphore Niepce, had succeeded in his attempts to fix the photographic image by 1824, seven years before François Arago announced Daguerre's process to the *Académie des Sciences*. Niepce undertook his experiments because he lacked the skill required to make

lithographs of appropriate quality. Amateur lithography was fashionable at the time and Niepce, as a member in good standing of the nineteenth-century French middle class, could call upon his combined interests in the arts, science, progress and veracity as he attempted to chemically arrest the image of the *camera obscura,* one of the early prototypes for the modern camera. The *camera obscura* is also made mention of in Gaucheraud's 1839 press release for the daguerreotype:

> M. Daguerre has discovered a method to fix the images which are represented at the back of a camera obscura; so that these images are not the temporary reflection of the object, but their fixed and durable impress, which may be removed from the presence of those objects like a picture or an engraving. . . . Let our readers fancy the fidelity of the image of nature figured by the camera obscura, and add to it an action of the solar rays which fixes this image, with all its gradations of lights, shadows, and middle tints, and they will have an idea of the beautiful designs, with a sight of which M. Daguerre has gratified our curiosity.

Ibid.

18.  Henry Fox Talbot, *The Pencil of Nature,* 1844, in Scharf's *Pioneers of Photography,* p. 17. Scharf's book, which he undertook after serving as a consultant for a series of television programs of the same title, is a valuable source book for readers interested in having easy access to key nineteenth-century documents about photography.

19.  See Talbot in Scharf's *Pioneers of Photography,* p. 18. Because it could reflect objects in space with much precision, the *camera obscura* served as an artist's tool since its development in the early Renaissance. Its use by the professional is described in print as early as 1558 by Giovanni Battista della Porta in a book with the suggestive title, *Natural Magic.* See Newhall's *The History of Photography,* p. 11. In 1807, William Hyde Wollaston, responding to the imperatives of his period, invented a modern, more portable, version which he called the *camera lucida.* Wollaston's camera was widely used by travelers—most of whom were, by necessity, also amateur draughtsmen—as they collected the drawings from nature that served as their souvenirs of experiences in the field. However, like the *camera obscura,* the *camera lucida* required the faithless intervention of the individual's hand and its images could therefore not serve as true indelible records of those experiences.

20.  See note 17.

21.  I have borrowed this adage from the 1961 British science fiction film classic, "The Day the Earth Caught Fire." The film, which chronicles the personal responses of members of the British press to a fictional event of major proportions, is described as follows: "Suspense on high as Earth is thrown off its orbit and hurtles toward the sun. Edward Judd, Janet Munro. Bill: Leo McKern." See *TV Guide* Iowa Edition (Feb. 7–13, 1986): A-146.

22.  See Aaron Scharf, *Art and Photography,* p. 233.

23.  One example of such negative criticism is found in Helmut Gernsheim's book, *Creative Photography:*

> We can also ignore the billions of snapshots taken every year by the estimated hundred million camera users all over the world for no other purpose than to serve as mementoes of family events and holidays. For the snapshooter a photograph is merely 'a mirror with a memory', to borrow the expression from Oliver Wendell Holmes. It bears the same relationship to a composed creative picture, as noise does to music.

See Helmut Gernsheim, *Creative Photography: Aesthetic Trends 1839–1960* (New York: Bonanza Books, 1974), p. 13.

24. One need only look through the "lens" section of any of the numerous technical publications on photography to find examples of how pervasive lens aberration actually is. Many such manuals also give photographers information about how to use shutter distortions and spherical aberrations for creative purposes. Some texts explain that when the camera actually "sees objects in perspective just as the eye does," the ensuing *problems* can be corrected. See Phil Davis, *Photography* (Dubuque: Wm. C. Brown Co., 1976), pp. 72–73.

25. Statements like Helmut Gernsheim's criticism of popular photographs (see note 23) were countered by a position that came to be identified as the "snapshot aesthetic." In this context, the snapshot was elevated from its status as visual noise to "folk art." Unfortunately, many artists and art writers of this persuasion persisted in maintaining their privileged "high art" position and made distinctions between those snapshots that were ordinary and those that were "extraordinary," based on their "photographic intuition and sensitivity." See, for example, Ken Graves and Mitchel Payne, *American Snapshots* (Oakland: The Scrimshaw Press, 1977), p. 9. In the introduction to this volume, Jean Shepherd writes:

> DON'T EVER LET (*sic*) this book, this definitive collection of twentieth-century American folk art, get out of your hands. I say this for two very good reasons. First it is a touching, true, Common Man history of all of us who grew and lived in America in this century, in addition to being very funny and highly informative. Second, it is a collection that will grow in value, both historically and intrinsically, with each passing year.

Shepherd goes on to say that "A few years back, and it wasn't that long ago, taking pictures was always something of an event. Everyone trooped out into the backyard to stand next to the garage, squinting in the sun, while Chester or Martha struggled with the camera, usually winding up with a picture that cut off the tops of all heads or hacked everyone off at the kneecaps." See "Introduction by Jean Shepherd" in Graves's and Payne's *American Snapshots*, pp. 5–6. This patronizing perspective on the "Common Man's" act of compiling a personal photographic history, filtered as it is through normative aesthetics, misses the point.

26. See Robert A. Sobieszek, "Composite Imagery and the Origins of Photomontage, Part I," *Artforum* (September 1978): 63.

27. Ibid., p. 62.

28. See Newhall, *The History of Photography*, p. 19.

29. Lautréamont's phrase, "as beautiful as the chance encounter on a dissecting table of a sewing-machine and an umbrella," was picked as a banner by the Surrealists.

30. See Sobieszek's "Composite Imagery and the Origins of Photomontage, Part I," p. 62.

31. See Barbara Jones's introduction to William Ouellette's *Fantasy Postcards* (Garden City: Doubleday and Company Inc., 1975), p. 9.

32. See Dawn Ades, *Photomontage* (New York: Pantheon Books, 1976), p. 13.

33. See Robert A. Sobieszek, "Composite Imagery and the Origins of Photomontage, Part II," *Artforum* (October 1978): 42–44.

34. See Jones in Ouellette's *Fantasy Postcards*, p. 10.

35. Ibid.

36. Ibid.

37. See Ouellette, *Fantasy Postcards*, p. 43.

38. Ibid.

39. Ibid., n. 68.

40. Ibid., n. 71.

41. Ibid., n. 69.

42. Ibid., n. 71.

43. Ibid., n. 68.

44. See George Grosz, cited in Hans Richter, *Dada Art and Anti-art,* trans. David Britt (New York and Toronto: Oxford University Press, 1978), p. 117.

45. See William S. Rubin, *Dada, Surrealism, and Their Heritage* (New York: The Museum of Modern Art, 1968), pp. 42–43.

46. A reproduction of Kazimir Malevich's *Composition with Mona Lisa* (1914, Oil on Canvas, 62 × 49.5 cm., Private Collection, Leningrad) appears in John Bowlt's article, "H2SO4: Dada in Russia," *Dada/Dimensions,* Stephen C. Foster, ed. (Ann Arbor: UMI Research Press, 1985), p. 233.

47. Malevich's *Private of the First Division* (1914, Oil on canvas with collage of postage stamp, thermometer, etc., 53.7 × 44.8 cm.) is reproduced in Magdalena Dabrowski, *Contrasts of Form* (New York: The Museum of Modern Art, 1985), p. 39.

48. Carlo Carrà's *French Official Observing Enemy Movements* (1915) appears in Scharf's *Art and Photography,* p. 278.

49. It is interesting to note that Malevich, Duchamp, and Picabia were not the only individuals who 'improved' the Mona Lisa. Makers of early-twentieth-century popular postcards treated her with equal irreverence. Ouellette reproduces two such cards in *Fantasy Postcards*: in one, she has been retouched and brightened and the background of the original painting replaced with a soft golden haze; in the second, a man's face appears in the upper left corner and a child has been nestled in her arms. Of the latter card, Ouellette writes:

    > *Her Return!* Photograph; France; message dated 12/28/1913. In 1911, Mona Lisa left the Louvre under the arm of an Italian painter, Vincenzo Perugia, who took her back to Italy where he felt she belonged. This card, picturing the pair and their "little stranger," commemorates her eventual return from Florence in 1913.

    See Ouellette, *Fantasy Postcards,* n. 37. Paul Eluard reproduced two montaged Mona Lisa postcards in his "*Les Plus Belles Cartes Postales.*" See, *Minataure,* 3–4 (December 1933): 100. The original surrealist periodical was published by Editions Albert Skira, Paris. Skira was also responsible for the publication of a beautiful reprint of the full run of the journal, printed by Rizzoli International Publications, Inc. (Switzerland 1978) in three volumes.

50. I am indebted to Stephen C. Foster, who many years ago made me aware that, just as Futurism provided most subsequent early-twentieth-century avant-gardes with a strategy for their actions, Cubism provided succeeding movements with a visual vocabulary through which to enact their formal revolutions. It is interesting to note that in some of the Dada photomontages of Raoul Hausmann, Hannah Höch, and Johannes Baader, the existence of an armature derived from a cubist syntax is difficult, if not impossible, to discern.

51. See Raoul Hausmann, "New Painting and Photomontage," (1958), trans. Mimi Wheeler, in *Dadas on Art,* Lucy R. Lippard, ed. (Englewood Cliffs: Prentice Hall, 1971), pp. 61–62.

52. Ibid.

53. See Ouellette, *Fantasy Postcards,* n. 71.

54. See Hausmann, "New Painting and Photomontage," in Lippard's *Dadas on Art,* p. 64.

# 13

# Marcel Duchamp's "Instantanés": Photography and the Event Structure of the Ready-Mades

*Craig Adcock*

Marcel Duchamp never characterized his activities in the specific terms of their being "events," but he did understand that time could affect artistic outcomes. The word "event," from the Latin *e + venire,* implies an "outcome," and it was this concept of a distinct moment in a temporal sequence that Duchamp used in his examination of the art process. In order to prescind aesthetic change from the flow of time, he entailed photography and photographic metaphor with choosing ready-mades. When he reached out into the world of everyday things and selected, say, a bicycle wheel or a bottle rack, at that instant of time, the objects became something other than themselves.

In a moment, Duchamp froze the passing continuum of spatio-temporal events as if he had snapped a photograph. He took a conceptual *"instantané"* by releasing the shutter of his mind and created a new thought for an object. At such times, the ready-made, the three-dimensional snapshot, shifted from being an ordinary manufactured object to being an extraordinary chosen object. After the choice, it was no longer the same. In one of his posthumously published notes, Duchamp dealt with "sameness, similarity, and mass production." He says that, "in time, the same object is not the same after a one-second interval."[1] Through Duchamp's attention, the bicycle wheel, the bottle rack, the snow shovel, the hat rack, and the other ready-mades changed—they became intricated with basic art processes, and their selections constituted temporal events. The moments of their choice were turning points before which things were one way and after which they were quite another way.

Events have temporal significance. Most often they are short-lived and at the epicenters of important times. If they are deeply ramified, they change future circumstances and, because they have meaning, can be interpreted. Events thus stand out from the flow of history. They remain behind and resist oblivion. In precisely

this sense, Duchamp's ready-mades can be thought of as events. They are not only physical objects, but also important disruptions in the history of twentieth-century art. Prior to being chosen, they were manufactured goods that existed outside the boundaries of art and art making. But their elections transformed them and gave them consequence. Duchamp says in one of his notes from the *Green Box* that he wanted to plan for such and such a time in the future and then, when that moment arrived, to inscribe a given object as a ready-made; the action was a kind of "rendez-vous," as he put it, involving an instantaneous intersection in time, or a "snapshot effect."[2]

The notion of an "*instantané*," or a "snapshot," allowed Duchamp to emphasize the temporal, or the eventual, nature of the ready-mades. By connecting them with photography—a medium that freezes the passage of time—he could examine their structure as events; he could separate them from their normal contexts, and present them in his art.[3] The discreteness of the ready-mades and the moments of their choice—something Duchamp could conceptualize in photographic terms—allowed him to detach them from their normal positions in the world. By choosing ready-mades, he was taking conceptual photographs. Duchamp's stop/frame way of thinking about his chosen objects can be clarified by examining the so-called *Box of 1914* (figs. 13.1, 13.2) a work closely related to both the ready-mades and the *Large Glass* (fig. 13.3).

The *Box of 1914* involves random ordering and photography—both processes that implicate the passage of time. The notes in this collection are contained in boxes that originally held glass photographic plates. The advertisement on one of the boxes says the plates are "extra rapid" (see fig. 13.1), and, in the sense of making the world stop quickly, the *Box of 1914* is concerned with extra rapid "snapshot effects." Snapshots capture specific moments; they capture events. Duchamp felt it was only when objects—objects such as ready-mades and art works—were isolated at specific times that they could be critically seen. But because time is so fleeting, discrete moments come into view according to no discernible pattern. Events are random. Snapshots are a way of representing this randomness. They take "slices" out of a continuum of occurrences in the passing world.

The notes in the *Box of 1914* can also be thought of as "snapshots." The fifteen short statements in this collection describe everyday objects and experiences: seeing, hearing, electricity, a game similar to quoits, military conscription, the bateaux-mouches that float by on the Seine, and so on.[4] Duchamp's reasons for taking these particular descriptive slices out of the world and then including them in a box of notes for the *Large Glass* are obscure. But it may be that it was their sense of being random intersections with the passing world that appealed to him. The aleatory quality of the notes helps to explain both his choices and his decision to place them loose in boxes that originally held glass photographic plates; their snapshot character is part of their iconography.

The notes, however, are not quite so straightforward. They are not snapshots

Figure 13.1.   Marcel Duchamp, *(2) Boxes of 1914*, 1914
*(Owned by Mme Marcel Duchamp; photographed
by Eric Mitchell, 1983)*

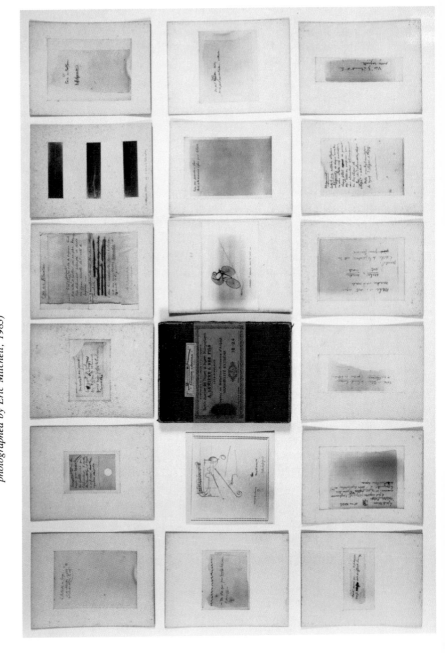

Figure 13.2.    Marcel Duchamp, *Box of 1914*, 1914
(Philadelphia Museum of Art: Archives of the Louise and Walter Arensberg Collection;
photographed by Eric Mitchell, 1983)

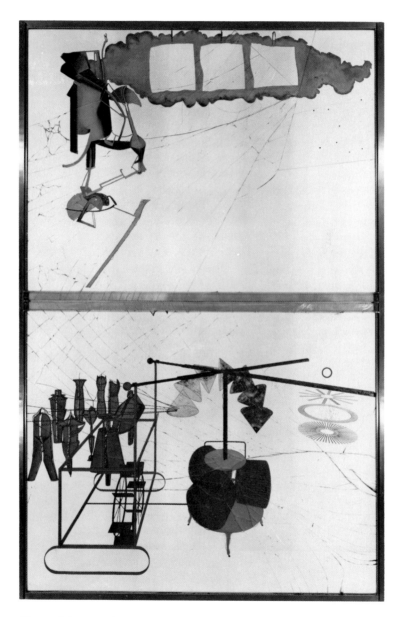

Figure 13.3. Marcel Duchamp, *The Bride Stripped Bare by Her Bachelors, Even (The Large Glass)*, 1915–23
Oil and lead wire, 277.5 × 175.6 cm.
*(Philadelphia Museum of Art: Bequest of Katherine S. Dreier; photographed by Philadelphia Museum of Art)*

in the sense of being simple descriptions of normal everyday events. Duchamp combines commonplace aspects of the world in ways that evoke numerous associations. What does he mean by a "world in yellow," a "bridge of volumes," or a "sculpture of skill"? How do you use "electricity widthwise" or "make a painting of happy or unhappy chance" or "of frequency"? Not only the haphazard arrangements, but also the bizarre iconographical abutments make the meaning of the notes in the *Box of 1914* provisional. The order in which we read the notes is determined by chance, just as what might become available for us to photograph in the passing world of events is largely a matter of luck, dependent solely on what comes in front of the camera at any number of nonordered spatio-temporal intersections. Moreover, in ways that go beyond sequential arrangement, the meaning of the notes is contingent because each of us brings our own random set of associations to bear on reading meaning out of the *Box of 1914*. In terms of interpretation, the notes are like the ready-mades: they are a kind of rendezvous.

The specific nature of how he arrived at an intersection with a manufactured object interested Duchamp, and he often emphasized that he was careful not to let his own personal taste enter into any given rendezvous. He said that he wanted to find objects that were neither attractive nor repellent to him:

> The great problem was the act of selection. I had to pick an object without the least intervention of any idea or suggestion of aesthetic pleasure. It was necessary to reduce my personal taste to zero. It is very difficult to select an object that has absolutely no interest for us, not only on the day we pick it, but that never will and that, finally, can never have the possibility of becoming beautiful, pretty, agreeable or ugly.[5]

Duchamp's neutrality was also expressed through his nonchalance in allowing the original ready-mades to be duplicated. He often reiterated that he chose the ready-mades from a position of aesthetic indifference and was not concerned with them as unique objects.[6] His position is of interest: it emphasizes the philosophical origins and the epistemological purposes of the ready-mades.

In another note from the *Green Box* (first published in 1934), Duchamp uses the notion of a "delay" to describe the *Large Glass*.[7] He says that an appropriate subtitle for his master work would be "delay in glass"—a remark that can be taken as a reference to the glass plates used in photography. The French word that Duchamp uses here (retard) is not the same term he used in his note about the ready-mades referred to earlier. In the context of his earlier discussion, he uses the word "délai" rather than "retard." Both can be translated "delay," but a "délai" is a specific period of time, a segment of time, and does not have the "hold back" implications of "retard." In the sense of "délai," and the sense that Duchamp seems to have intended, the ready-mades had duration, or "exposure time." After being chosen, or snapped, they became three-dimensional "instantanés," They were aesthetic events, and in some additional sense, photographic events that confounded typical notions of aesthetics, and they were located in the mainstream of modern art historical time. In Duchamp's

note about the ready-mades, he goes on to say that "the important thing is just this matter of timing, this snapshot effect."[8]

Duchamp also stressed the temporal quality of the ready-mades by pointing out that they were simply individual examples of potentially infinite numbers of ready-mades. In the note about choosing ready-mades, he refers to their "serial characteristic (côté exemplaire)."[9] When he chose a bicycle wheel (fig. 13.4) or a bottle rack (fig. 13.5), he was taking a slice out of a continuum of manufactured objects, and the location of that slice was purely arbitrary. The ready-mades were self-determined, and Duchamp was not responsible for the form they took. They were "a kind of rendezvous" at such and such a time in an area devoid of aesthetic delectation.

Duchamp was once asked if he had ever actually had a specific rendezvous with a potential ready-made, and he replied that no, he had not, because the whole process would have been hopelessly pretentious.[10] Nevertheless, at some conceptual level, the idea of a discretely bounded segment of time clearly became a useful intellectual metaphor for him. He used it as a way of discussing changes in the temporal flow of art-making—changes that were all too often affected by suspect shifts in things no more significant than momentary taste. At least one of Duchamp's ready-mades—the comb (fig. 13.6)—is inscribed with an exact date: "February 17, 1916, 11:00 A.M." Its choice thus seems to be pinpointed in the precise way that Duchamp later disavowed.

In 1916, when the comb was chosen, the instantaneous nature of an intersection between an object and a set of aesthetic presuppositions must have seemed to Duchamp worth emphasizing. The ready-mades, in general, were ordinary objects moving through time until, suddenly, they became extraordinary objects because of the more or less random, or at least, aesthetically neutral choices of Duchamp. That physical objects like the ready-mades could change dramatically simply through the way they were conceptualized fascinated him, and because the change represented something fairly interesting—the transmutation or transmogrification of nonart into art—his choices became events. The choice of a ready-made was like a rendezvous—and it had meaning. Rather than being concerned about the absurd specificity of the act of inscribing the object, it seems more likely that Duchamp was involved with the sequential, mathematical, qualities of the ready-made. In another late interview, he says that the comb was "a remark about the infinitesimal."[11] This emphasis on the mathematical aspect of the comb suggests that he was using it as a metaphor for more complex ideas.

In Duchamp's system, the ready-mades had epistemological significance. He made this significance more powerful by entailing it with geometrical, space/time concepts. It is even possible that he understood some aspects of the Special Theory of Relativity, particularly since he had access to the theory through the writings of Henri Poincaré.[12] Although it is unlikely that Duchamp understood the theory fully, his notes—particularly, those discussing the "clock in profile"—contain a

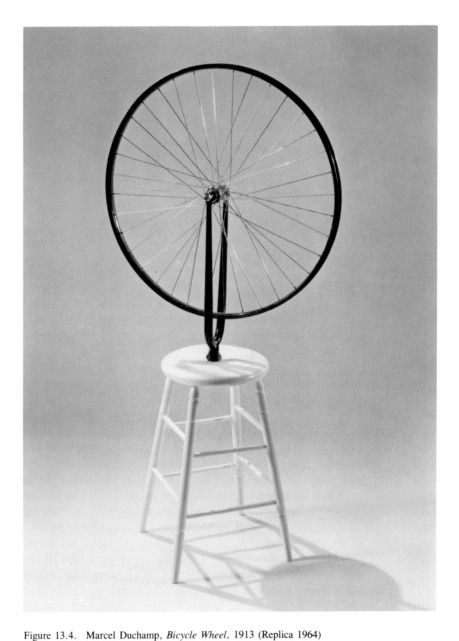

Figure 13.4.   Marcel Duchamp, *Bicycle Wheel*, 1913 (Replica 1964)
Ready-made.
*(Philadelphia Museum of Art: Given by Schwartz Galleria d'Arte; photographed
by Philadelphia Museum of Art)*

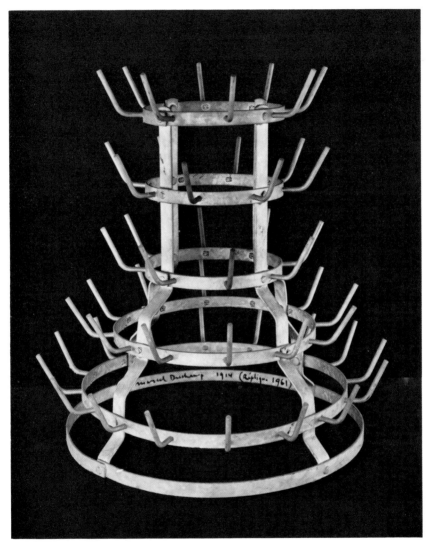

Figure 13.5.    Marcel Duchamp, *Bottle Rack*, 1914 (Replica 1961)
                Ready-made.
                *(Owned by Mme Marcel Duchamp; photographed by Philadelphia Museum of Art)*

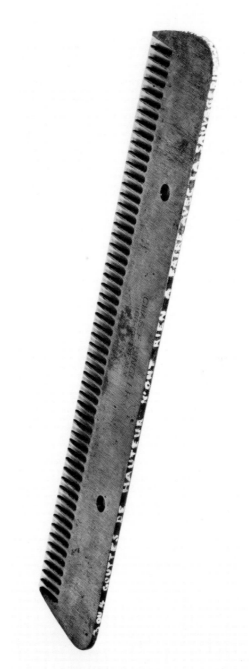

Figure 13.6. Marcel Duchamp, *Ready-Made Comb*, 1916
Steel comb, 16.5 × 3.2 cm.
*(Philadelphia Museum of Art: The Louise and Walter Arensberg Collection; photographed by Philadelphia Museum of Art)*

number of suggestive references.[13] In one published posthumously, he makes the following interesting observation:

> In each fraction of duration *all future and antecedent fractions* are reproduced. All these past and future fractions thus coexist in a present which is really no longer what one usually calls the instant present, but a sort of present in multiple continua. See Nietzsche's eternal Return, neurasthenic form of a repetition in succession to infinity. The clock in profile—with the clock full face, allowing one to obtain an entire perspective of duration going from the time recorded and cut up by astronomical methods to a state where the profile is a cut and introduces other dimensions of duration.[14]

Duchamp's remarks suggest the so-called dilation effects of Relativity Theory. In relation to stationary observers, normal geometric configurations fold-up as they approach relativistic speeds.[15]

What Duchamp seems to have done in his work was to take something fairly complex from the world of mathematics and physics, such as Relativity Theory, and then to combine it with something fairly simple from the world of manmade objects. He wanted to know how art was made, evaluated, and then placed within the world of aesthetics. The ready-mades helped him formulate his questions. They and the philosophical issues they raised were tied to mathematical developments that Duchamp was also adopting "ready-made" from the world of things that already existed—particularly developments in $n$-dimensional and non-Euclidean geometry. These geometries had raised questions about the foundations of mathematics.[16] Duchamp conjoined the physical objects he chose with complex mathematical constructs; the ready-mades were used as visual analogues or illustrations for such notions as translation and rotation. In these respects, they became metaphors for complex mathematical continua and multidimensional spaces.

Duchamp thus chose his ready-mades with purpose, despite his aesthetic indifference to them. They were, in very important ways, focused events at the center of his art. He could move around them, observe them from different points of view, and watch them undergo transformations. In metaphorical terms, shifts in points of view affected meaning and resulted in interpretive distortions. Changes, both in the position of the object and the viewpoint of the observer, seemed to instantiate artlike changes in the objects themselves. As an object such as the bicycle wheel spins, time passes. As it moves through history, its significance changes. In a remark to Guy Wheelan, Duchamp said, "I probably accepted with joy the movement of the wheel as an antidote to the habitual movement of the individual around the object contemplated."[17]

Duchamp put serious aspects of time into his ready-mades. By adopting a geometric—and photographic—*façon de parler,* he could heighten their impact as aesthetic happenings. He was aware of the newly articulated descriptions of an "event" within the mathematical, physical terms of Relativity Theory, but it is probably too simple to think that he was using the physical theory as a model for

the "relativity" of value judgments. The epistemological implications of *n*-dimensional and non-Euclidean geometry allowed him to examine judgment and knowledge at still deeper levels.

It is important to keep in mind that Duchamp never said the ready-mades were works of art. They were for him ready-mades, nothing more, nothing less. But despite his warning, they became works of art simply by their proximity to other works of art. This change had to do with a conceptual shift in context. The adoption process, the transferral from one area of aesthetics to another, became the event. Duchamp moved an object across a barrier and that action was transformational. The very possibility of changing an object in this way seemed to cast serious doubt on our ability to know what art is: How can our beliefs about what constitutes an object of art be held with any surety when the warrants for our beliefs are so easily manipulated? This line of questioning became even more relevant to valuational processes, tied to suspect categories such as taste—something that was clearly evanescent and provisional.

In the vocabulary of Relativity Theory, an event is a locus in a four-dimensional space time. Its position can be given by four coordinates, three for its location in space, and one for its location in time. In this now-familiar characterization, time functions like a fourth dimension of space. Duchamp understood that time itself could effect significant changes. His own ready-mades had changed over the years, and in this regard they again shared characteristics with snapshots. The importance of a snapshot shifts and changes as the circumstances that occasioned its snapping are lost in memory. The meanings of both snapshots and ready-mades are subject to the vicissitudes of time passing.

Time as a fourth dimension interested Duchamp, but he also thought of it as a spatial dimension perpendicular—in some hypothetical sense—to the three dimensions of ordinary experience. By necessity, Duchamp dealt with four-dimensional geometry through metaphor. One of his most important techniques involved photography. Since two-dimensional glass plates contain the changing events of the three-dimensional world exposed on their photo-sensitive emulsions, they can stand for both the spatial and the temporal interrelationships of the third and the fourth dimensions. In specific iconographical terms, the photographic images contained in the glass plates can stand for the complexity of the fourth dimension. Duchamp intended for the *Large Glass* to be four-dimensional, and he used photography in his formulation. Just how this worked is suggested in the mathematical discussions of Esprit Pascal Jouffret, another of Duchamp's most important primary sources, In his *Mélanges de la géométrie à quatre dimensions,* Jouffret cites Carl Friedrich Zöllner: "Starting from the fact that the projection of a four-dimensional body onto our space is a three-dimensional body, [Zöllner] considers our world as the *shadow* or the *projection* of a four-dimensional world which we cannot see directly, and which is *more real* than ours, just as three-dimensional bodies are more real than their shadows cast onto a wall or their images

on glass photographic plates."[18] There is good reason to believe that the glass plates used in the *Large Glass* were intended to be references, not only to photography in general, but also to this four-dimensional implication of photography. Duchamp used terms very similar to those in the above passage to explain the fourth dimension:

> Since I found that one could make a cast shadow from a three-dimensional thing, any object whatsoever—just as the sun on the earth makes two dimensions—I thought that, by simple intellectual analogy, the fourth dimension could project an object of three dimensions, or, to put it another way, any three-dimensional object, which we see dispassionately, is a projection of something four-dimensional, something we're not familiar with.[19]

Duchamp apparently used photography as a metaphor for taking slices through more complex kinds of geometrical configurations that cannot be seen in normal three-dimensional space. One of his works, in particular, is involved with this kind of approach. The long strips of heavy plate glass used in the *3 Standard Stoppages* (fig. 13.7) were meant to imply a process analogous to photography. When Duchamp's pieces of string twisted themselves "as they pleased" through time and space, they were stopped in the manner of a photographic "instantané" by their impact with the canvas strips glued onto the narrow pieces of glass.[20] The "stoppage" of the string is comparable to the "stoppage" of the real world by the quick exposures made possible by photographic plates. The pieces of string represent slices out of the continuum of configurations that they could have taken.

Duchamp used the geometrical implications of photography in a number of ways. He may have related the frozen line segments in *3 Standard Stoppages*—in French, *3 Stoppages étalon*—to Etienne-Jules Marey's and Eadweard Muybridge's interesting multiple photographs of animal locomotion. Both Marey and Muybridge produced studies of moving horses, and Marey, in particular, analyzed their movement through linear diagrams based on chronophotographs (fig. 13.8). Their studies of moving horses may help to explain how Duchamp arrived at his particular title: the word "étalon" can mean both "standard" and "stallion." Be this as it may, the lines moving through space in Marey's diagrams, and those implied in Muybridge's photographs (fig. 13.9), are conceptually similar to the moving pieces of string in the *3 Standard Stoppages.*

These kinds of associations also align the *3 Standard Stoppages* with Duchamp's cubo-futurist paintings, and in this latter context, he gave credit to chronophotography on numerous occasions. Discussing *Nude Descending a Staircase* (fig. 13.10), he told James Johnson Sweeney that "chronophotography was at the time in vogue":

> Studies of horses in movement and of fencers in different positions as in Muybridge's albums were well known to me. . . . A form passing through space would traverse a line; and as the form moved the line it traversed would be replaced by another line—and another and another.

Figure 13.7. Marcel Duchamp, *3 Standard Stoppages*, 1913–1914
Assemblage: three threads glued to three painted canvas strips, 13.3 × 120 cm., each mounted on a glass panel and wooden templates, shaped along one edge to match the curves of the threads; the whole fitted into a wood box, 28.3 × 129.2 × 22.9 cm.
*(The Museum of Modern Art, New York. Katherine S. Dreier Bequest)*

Figure 13.8.  Etienne Jules Marey, "Epure des mouvements des membres antérieur et postérieur droits du Cheval à l'allure du pas." (*From E. J. Marey, Le Mouvement, Paris: G. Masson, Editeur, 1894, p. 206; linear diagram based on a chronophotograph*)

Figure 13.9.   Eadweard Muybridge, *Animal Locomotion*, 1887
Collotype.
*(Philadelphia Museum of Art: Gift of the city of Philadelphia, Trade and Convention Center,*
*Department of Commerce; photographed by Philadelphia Museum of Art)*

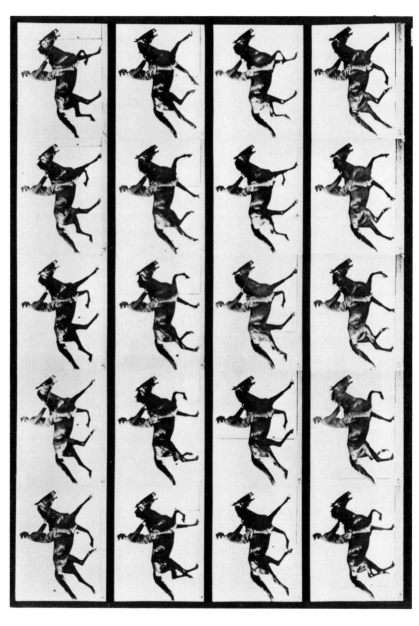

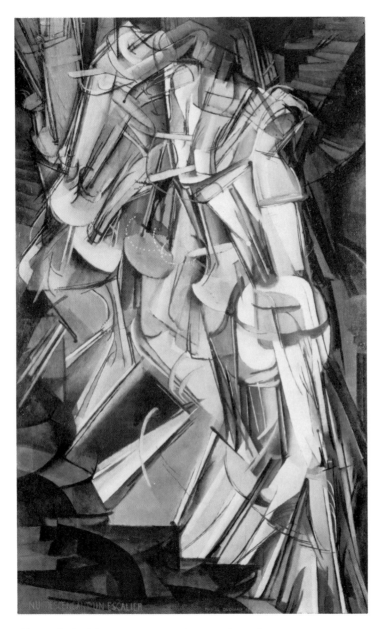

Figure 13.10.    Marcel Duchamp, *Nude Descending a Staircase, No. 2*, 1912
Oil on canvas, 147.3 × 13.8 cm.
*(Philadelphia Museum of Art: The Louise and Walter Arensberg
Collection; photographed by Philadelphia Museum of Art)*

> Therefore I felt justified in reducing a figure in movement to a line rather than to a skeleton. Reduce, reduce, reduce was my thought—but at the same time my aim was turning inward, rather than toward externals. And later, following this view, I came to feel an artist might use anything—a dot, a line, the most conventional or unconventional symbol—to say what he wanted to say. The *Nude* in this way was a direct step to the *Large Glass.*[21]

Twenty years later, Duchamp said much the same thing to Pierre Cabanne: ''In one of Marey's books, I saw an illustration of how he indicated people who fence, or horses galloping, with a system of dots delineating the different movements. . . . That's what gave me the idea for the executions of the *Nude Descending a Staircase.*''[22]

Photographs could, as Duchamp said, ''de-multiply'' the passing continuum. But in addition to their ability to snap individual exposures—something implied in both *Nude Descending a Staircase* and the *3 Standard Stoppages*—Duchamp was interested in photographs as metaphors for time and space folding up to form an infinitely thin layer. In these geometrical terms, they could symbolize both spatial and temporal relativistic effects. In an early photographic self-portrait, probably taken in 1917 (fig. 13.11), Duchamp combined photography, rotation, and the surface of a mirror—another $n$-dimensional slice that, like a photograph, contains the $(n+1)$-dimensional world within it—to suggest a complex point of view. Duchamp's de-multiplied image of himself was taken with a hinged mirror. The angle of incidence of the reflections causes him to appear to be displaced around an axis of rotation. One of the consequences of this rotation is that it gives him an instantaneous multiple viewpoint, or a ''view of the whole'' as he called it—something that he postulated would be required to see four-dimensional objects.[23] Duchamp had a more encompassing vision than most artists, and he used speculations about the fourth dimension—a realm demanding a very abstract and hypothetical way of seeing—not only to look at himself and his role in the art world, but also to arrive at important conclusions about the event structure of making aesthetic judgments.

Because Duchamp occupied a position in the three-dimensional world, his photographic metaphor could only give him a view of an axis of rotation, a vanishingly thin line; it could not give him a view of the truly complex spatial situations involved in the perception of a four-dimensional object. Our position in relation to the fourth dimension is analogous to being a two-dimensional being living inside a sheet of photographic paper. Only by stepping out of the paper could we flat-beings see images on our plane world in their entirety. From inside the paper, we could only see them edge-on as line segments. Duchamp seems to have believed that our abilities to see works of art were circumscribed in similar ways. His use of photographic glass plates and other $n$-dimensional configurations containing $(n + 1)$-dimensional configurations gave him a way of conceptualizing an ancient epistemological problem, namely: How is it possible to define the boundaries of human knowledge without stepping out of those boundaries?

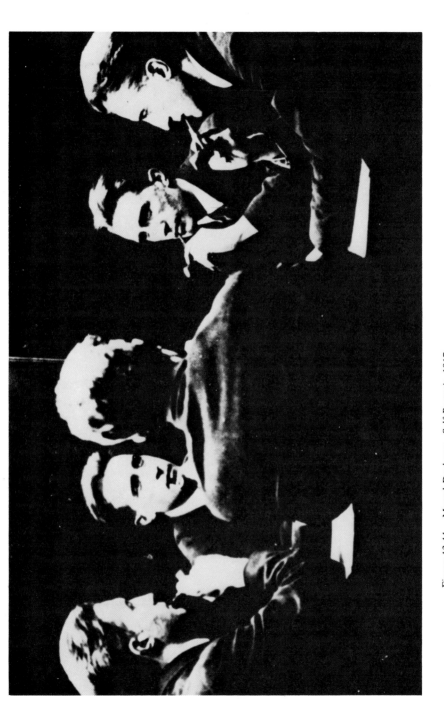

Figure 13.11. Marcel Duchamp, *Self Portrait*, 1917
Photograph, taken with a hinged mirror.
*(Carlton Lake Collection, Humanities Research Center, University of Texas at Austin)*

Duchamp's entire career was concerned with the problem of how we know what we know. In terms of modern art, his whole life can be considered an important epistemological event. His search was effective, in part, because of the great care he exercised in making his activities seem unified. Duchamp was an intensely self-mythologizing artist and deeply involved in building his own legend. In the well-known characterization of H.-P. Roché, "his finest work [was] his use of time."[24] Duchamp spent much of his time working on the *Large Glass*, although he never seemed to be working on it very hard, and the majority of his works or nonworks—including his silences and inactions—were clustered around his conception of this master work. Its construction and reconstruction, its analysis and reanalysis, allowed Duchamp to return again and again to his central questions— questions that concerned artistic outcomes.

Duchamp's events were iconoclastic, but they did not involve image breaking so much as rule breaking. Some of the events in his early career served to give him ideas about which rules to break. When he tried as a young man to participate in the organized movement of Cubism, he discovered that decisions were often made in arbitrary ways. The rejection of *Nude Descending a Staircase* from the 1912 Indépendants exhibition in Paris by friends of his brothers is the event Duchamp often cited as having caused him to abandon organized art activity.[25] In this case, the random intersection of circumstances—certain jurors being blind in just such and such a way—led to Duchamp's launching himself on a very individual journey.

Something similar happened when Duchamp submitted his infamous *Fountain* (fig. 13.12) under the pseudonym R. Mutt to the Independents Exhibition in New York in 1917. The object was suppressed. Duchamp explained:

> I had written the "mutt" on it to avoid connection with the personal. The "Fountain" was simply placed behind a partition and, for the duration of the exhibition, I didn't know where it was. I couldn't say that I had sent the thing, but I think the organizers knew it through gossip. No one dared mention it. I had a falling out with them, and retired from the organization. . . . I have never been able to do anything that was accepted straight off, but to me that wasn't important.[26]

Duchamp used aesthetic events, particularly his invention of the ready-mades, to cast doubt on systems of evaluation. The ready-mades thus had a definite character. He instructed his sister to hang a geometry book on a Paris balcony in order for the wind "to go through the book, choose its own problems, turn and tear out the pages."[27] Suzanne photographed the book, and Duchamp later manipulated the snapshot to suit his own purposes.[28] He turned it upside-down and added some ready-made geometrical diagrams (figs. 13.13, 13.14). He also seems to have felt that hanging a work of art in front of an audience involved similar risks: it could be distorted and manipulated, inverted and misinterpreted. Because Duchamp did not believe that art was consistent or, once done, that it was placed within art history in satisfactory ways, he attacked specific aspects of the art world. He was exhausted

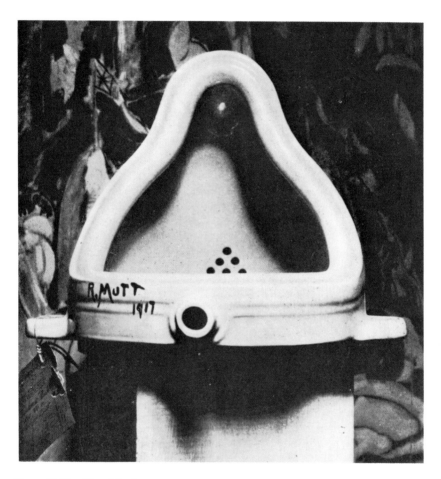

Figure 13.12. Marcel Duchamp, *Fountain*, 1917 (Photograph by Alfred Stieglitz)
From the *Blind Man*, ed. Henri-Pierre Roché, New York, 1917, p. 4.
*(Philadelphia Museum of Art: The Archives of the Louise and Walter Arensberg
Collection; photographed by Philadelphia Museum of Art)*

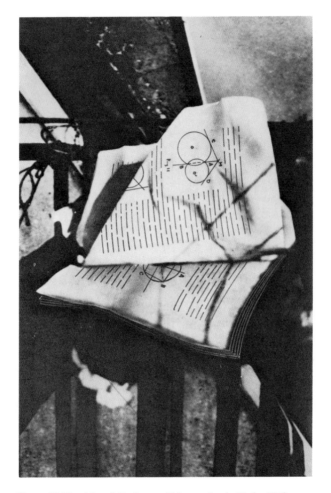

Figure 13.13.   Marcel Duchamp, *Unhappy Ready-Made*, 1919
(from the *Box-in-a-Valise*, 1941–42)
Constructions, reproductions, leather,
6.3 × 37.5 × 11 cm.
*(Philadelphia Museum of Art: The Louise and
Walter Arensberg Collection; photographed by Eric
Mitchell, 1982)*

Figure 13.14.  Unretouched Photograph of Duchamp's *Unhappy Ready-Made*, 1919
(Photographer Unknown)
*(Philadelphia Museum of Art: Marcel Duchamp Archives. Gift of
Dr. William A. Camfield; photographed by Eric Mitchell, 1981)*

by arbitrary rules for art making and demonstrated that they were defeasible. By constructing his events from an iconoclastic position, he could imbue his project with serious purpose. Duchamp was out to upset the system and to overturn bourgeois conventionality. He wanted to introduce untidiness into the orderly world of pictures and picture hangers. By inventing ready-mades, by using geometry and photography, he replaced the picture windows of established tradition with the glass plates of dadaistic *"instantanés."* Such contrary systems helped him to articulate his skepticism.

Duchamp was a great doubter. When asked about his philosophical beliefs he said that he did not believe in anything; that he doubted everything: "I always asked myself 'why' a lot, and from that questioning came doubt, doubt of everything. I came to doubt so much that in 1923 I said, 'Good, that's going well.' "[29] Ostensibly, Duchamp stopped working on the *Large Glass* in 1923 and started playing chess, but, of course, the story is not so simple. He did not stop working on the *Large Glass* in 1923; rather, he turned inward and began a conversation with himself. The particular event structure that he could symbolically deal with using glass plates had a great deal of potential for addressing serious issues, and he spent the rest of his life reexamining the *Glass,* the ready-mades, and his other "photographic" works from multiple points of view.

Duchamp sometimes sounds like a radical skeptic, but this interpretation of his attitudes is difficult to reconcile with the great consistency and quality of his artistic production. On the one hand, he says that he does not believe in art at all, and, on the other, he produces masterpieces. This approach could only have been successful in the hands of a very thoughtful artist. Duchamp's system amounted to a complex way of contradicting himself, but it was purposeful contradiction. He wanted to disclose the basic fallibility of judgment and knowledge. In his famous remark to Alfred Stieglitz, Duchamp said that he "would like to see [photography] make people despise painting until something else makes photography unbearable."[30]

Duchamp was not interested in either ready-mades or photographs as aesthetic objects. His gestures involving mechanical reproductions of either the two-dimensional or the three-dimensional variety had a dada contrariness about them, and, beyond their pure willfulness, the ready-mades—with all their photographic implications—had philosophical content. Duchamp raised questions about basic epistemological processes involving both the simple identification and the more complex processes of interpreting and evaluating art objects. He said that "every few years there's a revision. . . . An oeuvre by itself doesn't exist, it's an optical illusion. It's only made to be seen by the people who look at it. The poor medium is only gratuitous. You could invent a false artist. Whatever happens could have been completely different."[31]

Duchamp used ready-made events in his examination of art: they were like snapshots. They froze the changing world of taste at given instants. They were

*instantanés;* and they were a matter of interpretation. His doubt about our ability to understand what we are doing in relation to our art—a doubt articulated through photography and photographic metaphor—was very much to the point. Aesthetic events, even when we try to freeze them via photography, or description, will not stay frozen. A snapped ready-made will not remain a ready-made; it becomes a work of art. It moves through interpretive time, changing. Like other significant events, it is only memory made tangible through conceptual and historical imaging. But we have forgotten what occasioned the snapshots. Everything not only could have been completely different, it was completely different.

**Notes**

1.  The complete note reads as follows:

    Semblabilité
    similarité
    Le même (fabricat. en série)
    approximation pratique de la similarité.
    Dans le temps un même objet n'est pas le
    même à 1 seconde d'intervalle—
    quels
    Rapports avec le principe d'identité?

    A facsimile, transcription, and translation appear in Marcel Duchamp, *Notes,* ed. and trans. Paul Matisse (Paris: Centre National d'Art et de Culture Georges Pompidou, 1980), no. 7.

2.  The text of Duchamp's note appears in *Duchamp du Signe, écrits de Marcel Duchamp,* ed. Michel Sanouillet and Elmer Peterson (Paris: Flammarion, 1975, p. 49:

    Préciser les "Ready-mades".

    en projetant pour un moment
    à venir (tel jour, telle
    date, telle minute), *"d'inscrire*
    un readymade."—Le readymade
    pourra ensuite
    être cherché (avec tous délais)
    L'important alors est donc
    cet horlogisme, cet instantané, comme
    un discours prononcé à l'occasion
    de n'importe quoi mais *à telle heure.*
    C'est une sorte de rendez-vous.

    —Inscrire naturellement cette date
            sur le readymade
    heure, minute, comme renseignements.

    _____

            aussi le côté exemplaire
            du readymade.

    An English translation appears in *Salt Seller: The Writings of Marcel Duchamp (Marchand du Sel),* ed. Michel Sanouillet and Elmer Peterson (New York: Oxford University Press, 1973), p. 32.

3.  For Duchamp and photography, see Jean Clair, *Duchamp et la photographie: Essai d'analyse d'un primat technique sur le développement d'une oeuvre* (Paris: Editions du Chêne, 1977); Rosalind Krauss, "Notes on the Index: Seventies Art in America," *October* 3 (Spring 1977): 68–81; Herbert Molderings, "Film, Photographie und ihr Einfluss auf die Malerei im Paris um 1910: Marcel Duchamp, Jacques Villon, Frank Kupka," *Wallraf-Richartz Jahrbuch* 37 (1975): 247–86.

4.  For the texts of the notes, see *Duchamp du Signe*, pp. 36–38; *Salt Seller*, pp. 22–25.

5.  Quoted in Octavio Paz, *Marcel Duchamp, Appearance Stripped Bare*, trans. Rachel Phillips and Donald Gardner (New York: Viking, 1978), p. 28.

6.  Interview with Katherine Kuh, in *The Artist's Voice: Talks with Seventeen Artists* (New York: Harper & Row, 1962), pp. 91–92; also with Otto Hahn, "Marcel Duchamp," *L'Express* (Paris), no. 684 (July 23, 1964): 22–23.

7.  The note (*Duchamp du Signe*, p. 41) reads as follows:

> Sorte de sous-titre
> *Retard en Verre*
>
> Employer "retard" au lieu de tableau ou
> peinture; tableau sur verre devient
> retard en verre—mais retard en
> verre ne veut pas dire tableau
> sur verre—
>     C'est simplement un moyen
> d'arriver à ne plus considérer
> que la chose en question est
> un tableau—en faire un retard
> dans tout le général possible,
> pas tant dans les différents sens
> dans lesquels retard peut être pris, mais
> plutôt dans leur réunion indécise
> "retard"—un retard en verre
>     comme on dirait un poème en prose
>     ou un crachoir en argent.

A translation appears in *Salt Seller*, p. 26.

8.  See note 2 above.

9.  Ibid.

10. Duchamp in an interview with Pierre Cabanne, *Dialogues with Marcel Duchamp*, trans. Ron Padgett (New York: Viking, 1971), p. 49.

11. Duchamp quoted in Arturo Schwarz, *The Complete Works of Marcel Duchamp* (New York: Abrams, 1970), p. 471.

12. For discussions of Duchamp's mathematical sources, see Linda Dalrymple Henderson, *The Fourth Dimension and Non-Euclidean Geometry in Modern Art* (Princeton: Princeton University Press, 1983), pp. 117–30; also Craig Adcock, *Marcel Duchamp's Notes from the* Large Glass: *An N-Dimensional Analysis* (Ann Arbor, Michigan: UMI Research Press, 1983), pp. 29–39; for a specific discussion of Poincaré's influence on Duchamp, see Craig Adcock, "Conventionalism in Henri Poincaré and Marcel Duchamp," *Art Journal* 44 (Fall 1984): 249–58.

13. See *Duchamp du Signe*, pp. 47, 141; *Salt Seller*, pp. 31, 101.

14. The complete text (*Notes*, No. 135) reads as follows:

   = à chaque fraction de la durée (?) se reproduisent
   *toutes les fractions futures et antérieures—*
   Toutes ces fractions passées et futures
   coexistent donc dans un présent qui n'est
   déjà plus ce qu'on appelle ordinairement
   l'instant présent, mais une sorte de
   présent à étendues multiples—
   Voir Retour éternel de Nietzsche, forme
   neurasthénique d'une
   répétition en succession à l'infini
   —Le Pendule de profil,
   avec la pendule de face permettent
   d'obtenir toute une perspective
   de durée allant du temps enregistré
   et découpé par les moyens astronomiques
   jusqu'à un état où le profil est une
   coupe et fait intervenir
   d'autres dimensions de la durée
   Revoir.

15. Because Duchamp very likely learned what he knew of this theory from Poincaré, it becomes instructive here to quote at some length from the great mathematical physicist's discussions. In his *Dernières pensées*, Poincaré points out that: "It is the transformations of 'the group of Lorentz' which do not falsify the differential equations of dynamics. If we suppose that the system no longer relates to fixed axes but to axes which are characterized by varying transformations, we must admit that all bodies must become deformed; that a sphere, for example, is transformed into an ellipsoid in which the minor axis is parallel to the translation of the axes. Time itself must be profoundly modified. Here are two observers, the first linked to the fixed axes, and the second to the rotating axes, but each believing the other to be at rest. Not only will such a figure, which the first one considers as a sphere, appear to the second as an ellipsoid; but two events which the first will consider as simultaneous will not be so for the second. Everything happens as if time were a fourth dimension of space, and as if four-dimensional space resulting from the combination of ordinary space and of time could rotate not only around an axis of ordinary space in such a way that time were not altered, but around any axis whatever. For the comparison to be mathematically accurate, it would be necessary to assign purely imaginary values to this fourth coordinate of space. The four coordinates of a point in our new space would not be $x$, $y$, $z$, and $t$, but $x$, $y$, $z$, and $t\sqrt{-1}$. But I do not insist on this point; the essential thing is to notice that in the new conception space and time are no longer two entirely distinct entities which can be considered separately, but two parts of the same whole, two parts which are so closely knit that they cannot be easily separated." See Henri Poincaré, *Dernières pensées* (Paris: Flammarion, 1913), pp. 52–54; the translation is from his *Mathematics and Science: Last Essays*, trans. John W. Bolduc (New York: Dover, 1963), pp. 23–34.

16. See Morris Kline, *Mathematical Thought from Ancient to Modern Times* (New York: Oxford University Press, 1972), pp. 1023–39.

17. Letter dated June 26, 1955, quoted in the *Catalogue raisonné*, Vol. II of the Marcel Duchamp catalogue (Musée National d'Art Moderne, Centre National d'Art et de Culture Georges Pompidou, Paris, January 1977), p. 70.

18. My translation from E. Jouffret, *Mélanges de la géométrie à quatre dimensions* (Paris: Gauthier Villars, 1906), pp. 216–17; Jouffret cites Zöllner's *Wissenschaftliche Abhandlungen* (Leipzig, 1872).

19. Duchamp in his interview with Cabanne, *Dialogues,* p. 40.

20. See *Duchamp du Signe,* p. 36; *Salt Seller,* p. 22.

21. Interview with James Johnson Sweeney, "Eleven Europeans in America," *Bulletin of the Museum of Modern Art* 13 (1946): 20.

22. Interview with Cabanne, *Dialogues,* p. 34.

23. See *Duchamp du Signe,* pp. 122–35; *Salt Seller,* pp. 88–96.

24. H.-P. Roché in Robert Lebel, *Marcel Duchamp* (New York: Grove Press, 1959), p. 87.

25. See Duchamp's interview with Cabanne, *Dialogues,* p. 17.

26. Ibid., p. 55.

27. Ibid., p. 61.

28. See William A. Camfield and Jean-Hubert Martin, *Tabu Dada: Jean Crotti & Suzanne Duchamp, 1915–1922* (Bern: Kunsthalle, 1983), pp. 20–21, 38–39; for a discussion of the added diagrams, see Adcock, *Marcel Duchamp's Notes from the Large Glass,* p. 166, and idem, "Conventionalism in Henri Poincaré and Marcel Duchamp," pp. 253–54.

29. Interview with Cabanne, *Dialogues,* p. 18.

30. In a letter published in *Manuscripts,* no. 4 (December 1922), reprinted in *Salt Seller,* p. 165.

31. See Duchamp's discussion with Dore Ashton, "An Interview with Marcel Duchamp," *Studio International* 171 (June 1966): 246.

# 14

# Schwitters' Events

*Friedhelm Lach*

Schwitters' works are events, events whose thorough discussion cannot rely exclusively on historic accounts of *Merz*-happenings and performances. An analysis of Schwitters' works requires a defining general concept and theory of art events, per se. *Merz* events are here examined as prototypes for developing tools of interpretation generally usable for event-analysis—from theater and performance to the fine arts and literature. In this paper I will discuss Schwitters' event-concept, which he applied to many disciplines and which is partially responsible for his great influence over subsequent generations.

*Merz* was Schwitters' answer to the destruction of the First World War. In 1918, he proclaimed *Merz* through the environments of cabarets, galleries, and little magazines. Later in his career, he held his *Merzabende* in bourgeois living rooms or in community centers and published as often in newspapers as in the small avant-garde periodicals. His performances corresponded in concept and manifestation to his famous theories of the *Merz*-stage of 1918,[1] themselves based, to a degree, on futurist and expressionist ideas, known to him through Herwarth Walden who, in 1918, founded the *Sturm-Bühne* in Berlin. According to such concepts, everything happening on the stage was part of a stage-language used to reflect the dynamics of modern industrial life. Schwitters' friends, Vilmos Huszar (Netherlands), Oskar Schlemmer (Bauhaus), El Lissitzky (Russian theater), and Moholy-Nagy (Bauhaus) also proclaimed theater as an integral art and introduced machines, technical know how, abstraction, and geometrical form into the stage setting. Schwitters reflected these ideas in his *Normalbühne-Konzept,*[2] as he had in his earlier *Merzbühne-Text.* Although his performances were characterized as frenetic and nonsensical by contemporary viewers, merely classifying them as provoking, absurd, and disorderly does not help our analysis of these events. On the contrary, through a refined approach to his works we can identify a didactical and intentional organization of the event-process in Schwitters' art.

The randomness of Schwitters' materials has been stressed in recent research in the area. Schwitters contradicts such perspectives when he writes: "Materials for the stage set are all solid, liquid and gaseous bodies, such as white wall, man, wire-entanglement, waterjet, blue distance, cone of light. . . . Materials for the score are all the tones and noises that violin, drum, trombone, sewing-machine, tick-tock clock, waterjet, etc. are capable of producing. Materials for the text are all experiences that stimulate the intelligence and the emotions."[3] The last phrase refers to "signals" which Schwitters receives from the materials. He describes them more precisely later on. They point to transformations, to kinetic energies, movements, and gestures: "Use is made of surfaces, which can compress or can dissolve into meshes; surfaces which can fold like curtains, expand or shrink. Objects will be allowed to move and revolve, and lines will be allowed to expand into surfaces. Parts will be inserted into the stage set, and parts taken out. . . . The parts of the set move and transform themselves, and the set lives its life."[4]

Schwitters projects his personal life processes into his materials. Through his experimental handling of them, they become catalysts for his discovery of both personal needs and patterns of reactions. He projects not only his feelings, but his inner vibrations, his pulse, his bloodstream—and he interprets instantly. In all his experiments, he remains careful, one could say, to consciously create a complicity with his chosen material, treating it in such a way that it serves his personal creative practice. What many researchers identify as a distorted and brutal assembly of randomly chosen materials was, in fact, a refined, experimental use of them, a procedure for exploring new values and the multiplicity of their interrelations.

Schwitters stressed the importance of transformations when he wrote the following in 1920:

> Take gigantic surfaces, conceived as imaginative infinity, cloak them with color, shift them menacingly and break with vaulting their smooth bashfulness. Shatter and embroil finite parts, and twist perforating parts of night infinitely together. Paste smoothing surfaces over each other. . . . Wire lines movement, real movement rises, real tow-rope of a wire mesh. Flaming lines, creeping lines, surfacing lines. Make lines fight together and caress one another in generous tenderness. . . . Make locomotives crash into one another, curtains and portieres make threads of spider webs dance with window frames and break whimpering glass. Explode steam boilers to make railroad mist. Take petticoats and other kindred articles, shoes and false hair, also ice skates and throw them into place where they belong, and always at the right time. For all I care, take man-traps, automatic pistols, infernal machines, the tinfish and funnel, all of course in artistically deformed condition. Inner tubes are highly recommended. Take in short everything from the hairnet of the high class lady to the propeller of the S.S. Leviathan, always bearing in mind the dimensions required by the work.
>
> Even people can be used.
>
> People can even be tied to backdrops.
>
> People can even appear actively, even in their everyday position, they can speak on two legs, even in sensible sentences.
>
> Now begin to wed your materials to one another.[5]

All these depictions and propositions seem to be made to provoke interactions, to experiment with new ideas and to explore new realities. Then comes a complete change: Schwitters proposes abruptly, after a series of dissolutions and distractions, a series of connections or "weddings" of materials. He then focuses on self-observation, names a multitude of different reactions and reception strategies for the art process. Making art is his main objective, therefore he warns us to follow the conventional logic of the materials: "The materials are not to be used logically in their objective relationship, but only within the logic of the work of art. The more intensively the work of art destroys rational objective logic, the greater become the possibilities of artistic building. As in poetry, word is played off against word, here factor is played is played against factor, material against material."[6]

Schwitters used the event as a "personal art process" when he made his early dadaistic appearances in Prague and Holland. His sneezing-event in Holland (performed at the Hague *Kunstkrug* on December 27, 1922 and later in Haarlem, Amsterdam, and Rotterdam), is directly related to his later cough- and sneezing-poems. What was experimentally explored at the Dada-event was later on refined into a poetic process. The experience of public reactions to phonetic poems in Prague was the beginning of a thorough exploration of sound poems and nature sounds which culminated in hundreds of recitals of his Ursonata (fig. 14.1).

One could say that all of Schwitters' performances build a unity, by conflating art and life. This is obvious in the performances for which he was renowned in the twenties and thirties, the *Merzabende*. They were derived from earlier recitals of poems given in the Sturm gallery in Berlin and at the *Kestner-Gesellschaft* in Hanover—all in the tradition of the *Sturmabende* of Rudolf Blümner who taught Schwitters the ABC of reciting. What began as recitals of avant-garde poetry increasingly became performances with "happening-character". Schwitters characterized them as public events through newspaper advertisements, and he frequently offered to perform at every conceivable artistic center. In *Merz 20* he wrote:

> My poems led me to public readings, and I have already appeared in many places, among others, Amsterdam, Berlin, Braunschweig, Bremen, Delft, Dragten, Dresden, Einbeck, The Hague, Haarlem, Hamburg, Hanover, s'Hertogenbosch, Hildesheim, Holzminden, Jena, Leer, Leiden, Leipzig, Lüneburg, Magdeburg, Prague, Rotterdam, Sellin, Utrecht, Weimar, Zweickau. Now it is one place, now another. Wiesbaden, Frankfurt, Paris and Cologne are in prospect. I recite willingly and with great enthusiasm, and I should be grateful for opportunities elsewhere. Please write to me.[7]

In the early 1930s he gave more private readings at Basel and Zurich, and during his internment in England he organized *Merz*-evenings for the camp inmates. But his most famous performances were his *Merzabende* at his own home in the Waldhausenstrasse, where every two to four weeks he invited friends, intellectuals, and bourgeois guests from Hanover society to what seemed an intimate friendly meeting with coffee and dancing. The highlight was the "recital" of experimental poetry by Schwitters, who, according to participants, played the role

Rakete bee bee.
Rrummpff tillff toooo?

Rum!                                                                    (G)
Rrummpff?
Rum!
Rrummpff t?
Rr rr rum!
Rrummpff tll?
Rr rr rr rr rum!
rrummpff tillff?
Rr rr rr rr rr rum!
Rrumpff tillff toooo?
Rr rr rr rr rr rr rum!
Rrummpff tillff toooo? Ziiuu!
Rr rr rr rr rr rr rr rum!
Rrummpff tillff toooo? Ziiuu ennze!
Rr rr rr rr rr rr rr rr rum!
Rrummpff tillff toooo? Ziiuu ennze ziiuu!
Rr rr rr rr rr rr rr rr rr rum!
Rrummpff tillff toooo? Ziiuu ennze ziuu nnzkrrmüüüü!
Rr rr rr rr rr rr rr rr rr rr rum!
Rrummpff tillff toooo? Ziiuu ennze ziuu nnzkrrmüüüü,
        ziiuu ennze ziiuu rinnzkrrmüüüü,
Rr rr rr rr rr rr rr rr rr rr rr rum!!!
Rrummpff tillff toooo? Ziiuu ennze ziiuu nnzkrrmüüüü,
        ziiuu ennze ziiuu rinnzkrrmüüüü,
Rakete bee bee!
Rr rr rr rr rr rr
Rr rr rr rr rr rr
Rr rr rr rr rr rr
Rr rr rr rr rr rrumm!!!!!! *(gekreischt, mit erhobener stimme)*
rrummpff tillff toooo? Ziiuu ennze ziiuu nnzkrrmüüüü,
        ziiuu ennze ziiuu rinnzkrrmüüüü,

Figure 14.1.  Kurt Schwitters, Reproduced Pages from *Ursonate,* Special Issue *Merz* (No. 24),
        ed. Kurt Schwitters, 1932, Hanover.
        *(Private collection, New York)*

Rakete bee bee,
Rakete bee zee.

Fümms bö wö tää zää Uu, pögiff, kwiiee.
Dedesnn nn rrrrrr, li Ee, mpfiff tillff toooo, tillll, Jüü-Kaa.
*(gesungen)*
Rinnzekete bee bee nnz krr müüüü, ziiuu ennze ziiuu
     rinnzkrrmüüüü,
Rakete bee bee.
Rrummpff tillff toooo?

Rum!
    RrRrRrummpff?
Rum!
    RrRrRrRrummpff t?
Rum!
    RrRrRrRrRrummpff tll?
Rum!
    RrRrRrRrRrRrummpff tillff toooo?
Rum!
    RrRrRrRrRrRrRrummpff tillff toooo ziiuu!
Rum!
    RrRrRrRrRrRrRrRrummpff tillff toooo ziiuu ennze!
Rum!
    RrRrRrRrRrRrRrRrRrummpff tillff toooo? Ziiuu ennze
        ziiuu nnzkrrmüüüü,
Rum!
    RrRrRrRrRrRrRrRrRrRrRrummpff tillff toooo? Ziiuu
        ennze ziiuuz nnzkrrmüüüü, ziiuu ennze ziiuu
        rinnzkrrmüüüü!
Rum!
    RrRrRrRrRrRrRrRrRrRrRrRrRrRrRrRrRrummpff tillff
    toooo?
        Ziiuu ennze ziiuu nnzkrrmüüüü?

(H)

G:
1
2
3
3a
4
4

of a brilliant, artistic and enthusiastic performer with an enormous voice and an innate sense of how best to rally or to provoke an audience.

To talk about such *Merz* events as historic entities has often been a sentimental affair. It is easy to remember far gone enthusiasms as voices of fruitless exaltations and become defensive. The historic event easily fell prey to this mood—a somewhat glorified description was seen as a promise for a better present or future, or as an example of significance and change. Personal participation was often stressed. This is one reason why we so often find contradictory or astonishingly different accounts of the same event. We search in vain for ''objective documentation.'' The most personal accounts of such events are the most revealing. I will choose from the many available descriptions, one which shows clear signs of enthusiasm but which assembles a great deal of detailed information about the interrelationship between the *Merz* performer and his audience.

Hans Richter described the reaction of the public at a reading in the house of the publisher Frau Kiepenheuer, in Potsdam around 1925, in the following way:

> The reaction was total consternation, a kind of psychological shell shock—which, though, wore off rapidly, in about two minutes. After that the audience, brought up to respect the hostess and too polite to protest, generated steam. I saw with delight how two generals in front of me pressed their lips together in order not to laugh, and got first red, then slightly blue in the face above their collars . . . and then suddenly burst. . . . Everyone burst. The audience, suddenly relieved of the pressure, went into an orgy of laughter, shrieking, gasping, coughing. But all that was no match for Kurt. He did not stop his *Ursonata* a second. He just raised his trained, enormous voice, till it dominated the hurricane, which blended with his well-articulated sounds, as the sea might have counterpointed Demosthenes' words two thousand years ago at the Aegean seashore. . . . The storm finally subsided and Schwitters continued uninterrupted to the end. The result was fantastic. The same generals, the same jewel-bedecked dowagers who before had laughed to tears, came to Schwitters shaking with emotion to express their admiration and gratitude, nearly stammering in their enthusiasm. Something had been opened for them, something they had never expected to encounter there, a great joy—the break through the conventional.[8]

Schwitters took all the reactions he caused into account, consciously giving stimuli to provoke and to create tension in order to even better control his audience. The imitations of a barking dog or a birdsong were surprising additions to stir the mood of those invited or to incite shouts of disgust and laughs of disbelief. These inventions created an atmosphere of latent happenings, of volatile situations, and prepared the participants for ever new surprising experiences. One could say that this openness to ''adventure'' was the prerequisite for a *creative practice of participation.* How can we understand and describe this creative practice?

The easiest way is to say that the public should become an assembly of *Merz*-artists, who observe and experiment constantly, reacting freely to all stimuli and taking on new sound materials derived from all kinds of sources: train rhythms, speech patterns, animal sounds, commanding voices, music intonations, typewriter noises, and so on. But we have to pursue our question in a more direct and precise

way, by analysing the psychological conditions of internalization or obsessionaliza-
tion, the transformation of the materials used, the strategies of human interaction,
and the serial techniques of control. If we understand the functions of Schwitters'
event-process, we have a key to the whole *Merz*-world, because the *Merz*-artist
projected his concept onto all disciplines which interested him.

At the basis of this internalization is a composure, often neglected by researchers
who focus on the revolutionary or avant-garde, which is at the core of his catalytic
enigma: the composure of intimacy. In *"Ich und meine Ziele,"*[9] Schwitters ex-
plains his total complicity with the material he uses. He describes how personaliza-
tion in the art process, *"das Sichversenken in die strenge Gesetzmässigkeit der
Kunst,"* is a total commitment to the pursuit of rhythms, which excludes the in-
terference of outside influences such as nationalistic or social imperatives. Enter-
ing the art process is compared by Schwitters to a religious experience where all
daily troubles are forgotten and human existence is purely experienced. Whenever
he gives examples of how caringly and lovingly he experiments with the materials
used—how he juxtaposes, correlates, transforms them to show their inherent mean-
ingful messages—he shows himself as a creator of complicity and intimacy. Natur-
ally, he wants the recipient to enter this realm of art as an experience of privacy,
purity, depth, understanding, and self-indulgence. One could also conclude that
most of his collages are small because he wanted to create the same intimacy be-
tween the spectator and the work of art that existed between himself and his
materials; they invite the spectator to discover new correlations. In his collages,
Schwitters consistently avoided everything which was monumental, official,
"noble," or stylized.

In his poetry, Schwitters also created an intimate relationship between the
text/material and the recipient. By means of repetitions and variations, the recip-
ient is constantly invited to reinvestigate each detail he has observed, questioned,
and interrelated with other elements, to intrude into new spaces created by ever
new correlations, and to receive them as new realities. With this method, Schwit-
ters explored new material—thematical in poetry, iconographic in fine arts—with
the clear objective of evoking reality, a multiple reality, by means of language,
painting, and space arrangements.

The image of Schwitters as a caring, intimate *Merz Künstler* must raise the
eyebrows of critics who see him primarily as a revolutionary artist. For such critics,
it must be paradoxical, at the very least, to think of the revolutionary innovator,
the aggressive deautomatizer, the prophet of an ephemeral art of constant destruc-
tion, as a proponent of intimacy and privacy. But following the lead Schwitters gave
us in *"Ich und meine Ziele,"* we discover a different creator of *Merz* than previously
described. For confirmation, we can refer to his *Schacko* text of 1931, where he
explains that only form transforms materials into art; actually, the text is the lament-
ing story of an old lady concerning the death of her husband and her parrot: "How
the expressions of the lady complete each other, how they anticipate or confirm,

how they form a totality, in order to show more and more clearly the love of the lady to her husband, an abstraction, that is the content of this poetic text."[10] According to Schwitters, constituents of this process are an awareness of the constant interrelations of all materials used; a process which leads forward to the future (anticipation) and back to the past (confirmation) and to the optimism of creating a totality around a message. This message derives from a serial process in which all elements are reused and reexperienced in a multiple way. The same material—for instance, part of a dialogue—when used again and again, acquires a multiple meaning by means of ever new correlations. At the end of this open process, one stands before a kaleidoscope of possible meanings, but one has discovered a multitude of new connections, attitudes, formalities, language-patterns, behavioral patterns, and so on. In short: if you hear twenty variational, juxtapositional interpretations of the same element, you explore a multiple reality and, at the same time, you discover your need for totality.

In the case of Schwitters' art, the serial process is therefore not a random or irrelevant choice; rather, it is directed and composed, leading to the experience of totality. Thus, he presents us with poems as creative devices, collages, fetishes of events, and plenty of theoretical and practical advice to help us celebrate art in life. On the one hand, the variational device serves psychologically—enhancement, concentration, and focus further the internalization and obsessional process—and, on the other hand, as the exploration and exuberance of creative practice, because it simultaneously projects and transcends, opens up and connects. In order to give a full account of the event-process, we must include such psychological and sociological data, but we must also consider the ways in which the materials themselves are transformed. Although it may appear farfetched to identify a picture or collage as an event (as opposed to a statement about an event), I would like to illustrate Schwitters' transformation of historic data, of personal events, of iconographic and poetic material, of conventions and traditions, through the event analysis of an early *Merz*-collage. I will do so by first discussing the relationship between historic and art events and then will address the production and perception of the event-object. The work which will be analyzed refers to the political revolution of 1918 in Germany, and to Schwitters' personal revolution which coincided with this historic event.

In her article, "*Die Handlung spielt in Dresden,*"[11] Annegreth Nill analyzed the collage *Zeichnung A2 Haus* (1918) (fig. 14.2) in reference to the events in Germany which began on November 9, 1918, and led to the downfall of the Wilheminian Empire and the rise of the Republic. According to Nill, the colors *Schwartz-Rot-Gold* symbolize the new Weimar Republic; the red cross marks the change in art and of the constitution. "*Dresden Ade,*" the textual background of the collage, refers to Schwitters' farewell to the city where he received his academic training. Thus, we may conclude that this collage juxtaposes historic and personal events

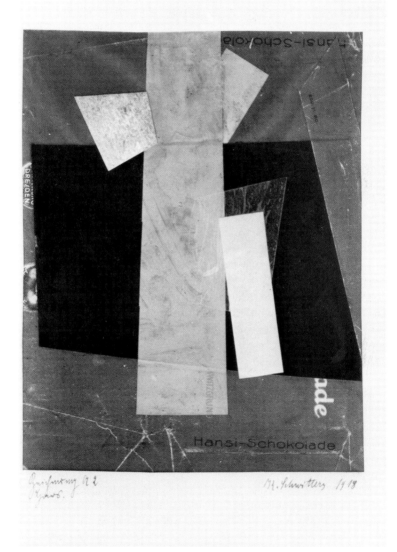

Figure 14.2.  Kurt Schwitters, *Drawing A2: Hansi-Schokolade*
(*Zeichnung A2: Hansi*), 1918
Collage of colored papers and wrapper.
(*Collection, The Museum of Modern Art, New York. Purchase*)

of 1918. Nill suggests that the piece symbolizes the beginning of the Weimar era and of *Merz*-art.

Because it points to the intricate relationship between historic events and art processes, such iconographic analysis and contextual interpretation have their obvious merits. However, I would like to use a serial interpretation to push Nill's analysis further.

The axiological structure of the collage is actually debalanced and transformed into a dynamic revolving movement around a black center. The warm colors—brown, red, and ochre—are scattered around in a roughly spiral movement. Once we start to see the proposed gestures of color and form we realize that textures are spreading through each large form. The vertical red form, for instance, has textures which unfold in all directions. The moment we read this unfolding as a growing element, it becomes a symbol for an organic plant or tree. At the same time, we interrelate these textures in red with the white lines at the bottom which meander like roots. Such a set of interrelating signs refers to a referential system of a life cycle and of nature's growth. It gives all forms, colors, textures and texts a new meaning. A dialogue is established between two series of spiraling compositional movements (in juxtaposition), from large forms to ever smaller textures (from black to red-ochre to white lines to the white text: *"Dresden ade"*) or from small textures to large forms (from textures to yellow and two black forms). The active yellow pushes down into the black, the receptive ochre attracts the white. Following these movements, we experience something like the basic compositional concept—a breathing in and out procedure. We know Hans Arp's credo, "art is nature," refers to breathing rhythms as a basis of art organization. Only in this sense can we understand his statement, *"Kunst ist Natur."* The collage *Zeichnung A2 Haus* reveals itself as a transformation of an important personal event in Schwitters' life, his meeting Hans Arp and his introduction to Arp's art concept. It becomes a sign of a creative practice developed in collaboration with Arp.

Annegreth Nill's interpretation operates on a more intellectual level, reading the semantic information of the words *"Dresden, ade"* and the symbolic significance of the rising red cross over a *"schwarz-rot-gold"* center. In his theoretical writings, Schwitters stressed the importance of a total involvement in the art process. The intellectual entailment is accompanied by an emotional engagement, an instinctive captivatedness and a physical reaction. The exploration of breathing rhythms focuses on the latter activation.

In order to understand Schwitters' event concept, it is essential to focus on the whole circle of activation. Critics often operate intellectually, stressing that the materials used in these collages only become meaningful in terms of their reference to circumstantial events, and that they have to be treated historically. In these collages, we definitely find the humorous play of autobiographical details, which, for the iconographic researcher, constitute an intricate and complex referential system, intriguing and entreating him to enter the mind-space of the *Merz*-artist.

The complicity thus achieved with Schwitters' world is in line with the intentions of the artist. The involvement, engagement, and activation of the spectator on all levels was Schwitters' answer to the destruction around him (especially in 1918, after the First World War). In a world of *"Unheimlichkeit,"* of chaos, *Merz*-art produces realms of intimate events, a practice of human experience with the full participation of body, soul, heart, and mind.

William S. Rubin criticized the plethora of charming autobiographical detail and poetic surprise in Kurt Schwitters' amalgam of life and art; he found that, as a result, critics had too often been seduced into describing the way Schwitters lived and worked, rather than analyzing and evaluating the artistic results he achieved.[12] However, unless we realize that Schwitters' personalization is not merely an anecdotal, propagandistic description of elements of his life, but rather an important component of the organization and transformation of his art, we cannot fully understand his *Merz* works.

The fabrication of Schwitters' collages is not simply a combinational task of fitting elements together; nor is it just an assembly of discovered materials. It is a more complex process of the constant reinvestigation and exploration of dialogues between serial processes on different levels. The radiating patterns—similar to those of futurist compositions—and the diagonals in the *Merz*-collages are an external expression of dynamism. They create a cosmic space, ready for the intrusion of curvilinear elements. Once we search for the elaborate transformation of each form with the help of textualization, decoloration, punctuation, and inprinting, what seemed, at first, to be a brutal act of dislodgement, of rupture and destruction, actually reveals itself to be a delicate, evocative handling of a multitude of different materials. By this constant touching and displacement, retexturing and coloring, he signals his emotions, instinctive reactions and interrelations.

This sensualization and emotionalization is Schwitters' main picture-language. Formal aspects such as the axiality or the radiating pattern serve only as stepping stones for the onlooker, enabling him to enter into highly personalized realms filled with exaltations, interreactions, and correlations. Each form is open to dialogue with all others, each movement is understood as an answer and a proposition to others, each gesture acquires meaning by a sensitive contextualization. Each element becomes a ''reality'' in itself. In this sense, the picture or collage displays a constant process of semiosis within a randomized assembly of elements. As soon as we shift our interest from the composition to the processes of correlation, transformation, and interpretation within the picture, we grasp the intention of *Merz:* to establish a creative practice and, at the same time, to accept a free, randomized, multiple reality as a playground and basis for this artistic event.

The strategies of interacting materials can be seen as constituents of all Schwitters' events, whether they deal with color, sound, or the public. This was explained by Schwitters in his dialogue with Franz Rolan, published under the title ''Aus der Welt Merz.''[13] The described seriality functions finally as a ''social event,''

inciting us to participate in a very personal psychological and social experience of Schwitters. Even in Schwitters' $i$-art,[14] a found-object concept projected into all kinds of art forms, the seriality is not lost and Schwitters concentrates on the reception process. What is quite simple from the production perspective—making art by simple separation of something from its "normal" context or by elimination of its unessential features—becomes a rather complex process when viewed in terms of perception. One could say that there is a deliberate contrast between simplicity of material—well known children's poems or printed matter—and complexity of interpretation. In his $i$-*Gedicht* (figs. 14.3, 14.4) for instance, Schwitters correlated $i$, the symbol of schooling, with the ritual process of deautomatization. He leads us out of the restrictions of a specific order into a playful creative practice.[15] Schwitters often used the $i$-techniques to comment on various historic events, from revolutions, exhibitions, and fairs to changes in the environment and very personal encounters. But it is not so important that the $i$-material can be dated and related to historical events; what is essential is that serial, sequential operations become apparent and lead us away from the specific historic event to a more totalistic view of the world. Schwitters' $i$-art can be considered to be "event deformalization" achieved through his use of well known but previously unobserved materials.

Regardless of the specific medium or media of which they are composed, Schwitters' art events are experienced by their participants not so much as communications with didactic purposes and clear messages, but rather as fun, joyful, often exuberant practices of life, as a discovery of new rituals of collectivity, as social and aesthetic laboratories and as examples of creativity; for the art-event ritualizes, it creates the feeling of being part of a community of common interests of equals.

These events, which for the traditionalist appear to be processes of constant demolition, are, in fact, about a new collectivity; they are rituals and celebrations of a collective self-construction. The space of these events is a codified space, everything in them is meaningful, for a moment, and creates expectations, reactions, and satisfactions. The space is personal but its subjectivity is consciously negated by the search for collective experience. Between tension and action, expectation and satisfaction, these events become nonsubjective, volatile, and dynamic.

How does the individual cope with such concepts? Personally, I think that the acceptance of the exuberance of events is a positive sign of coping responsibly with the experience of a multiple reality. From within the arts, only the art-event recreates a totalistic view of the world-experience. That is why Schwitters' works are intentionally events.

**Das i-Gedicht**

[lies: »rauf, runter, rauf, Pünktchen drauf«]

Figure 14.3.  Kurt Schwitters, "Das i̇ -Gedicht"
Originally published in *Die Blume Anna*,
Kurt Merz Schwitters, 1922, Berlin
*(Private collection, New York)*

**p p p p p p p p p**
pornographisches i–Gedicht

Die Zie ▌
Dies  Meck  ist ▌
Lieb und friedlich ▌
Und sie wird sich ▌
Mit den Hörnern ▌

Der Strich zeigt, wo ich das harmlose Gedichtchen aus
einem Kinderbulderbuch durchgeschnitten habe, der Länge
nach. Aus der Ziege ist so die Zie geworden.

Und sie wird sich ▌nicht erboßen,
Mit den Hörnern ▌Euch zu stoßen.

Figure 14.4.  Kurt Schwitters, "PPPPPPPP Pornographisches i̇ -Gedicht"
Originally published in *Merz* (no. 2), ed. Kurt Schwitters,
1923, Hanover.
*(Special Collections Department, The University of
Iowa Libraries)*

**Notes**

1. Kurt Schwitters, "Die Mersbühne," in Friedhelm Lach, ed., *Das literarische Werk*, vol. 5 (Cologne, 1973), p. 42; also, "Erklärungen meiner Forderungen zur Merzbühne," ibid., p. 43.

2. Kurt Schwitters, "Normalbühne Merz 1925," ibid., pp. 202–3; "Einige praktische Anregungen zur Normalbühne=Merz," ibid., p. 204; "Normalbühne," ibid., pp. 206–12; "Einige praktische Anweisungen zur Normalbühne," ibid., p. 213.

3. English translation in Werner Schmalenback, *Kurt Schwitters* (London and New York: Abrams, 1967), p. 189.

4. Ibid.

5. Ibid., p. 190.

6. Ibid., p. 189.

7. Kurt Schwitters, *Merz 20 Kurt Schwitters Katalog* (Hanover, 1927), p. 100.

8. Hans Richter, *Dada Profile* (Zurich: Arche, 1961).

9. Kurt Schwitters, "Ich und meine Ziele," *Das literarische Werk*, vol. 5, pp. 340–49.

10. The original German text: "wie die Aussagen der Frau einander erganzen, wie sie vorwegnehmen oder bestätigen, wie sie in derer Gesamtheit zusammenstehen, um immer deutlicher die Liebe der Frau zu ihrem Manne, einen abstrakten Begriff, und ihre Verzweiflung wiederum einen abstrakten Begriff, immer klarer werden zu lassen, und das ist der Inhalt dieser Dichtung."

11. Annegreth Nill, "die Handlung spielt in Dresden," *Kurt Schwitters Katalog* (Propyläen, 1986), pp. 36–41.

12. William S. Rubin, *Dada and Surrealist Art* (New York, 1969), p. 88.

13. Kurt Schwitters and Franz Rolan, "Aus der Welt Merz," *Das literarische Werk*, vol. 5., pp. 153–67.

14. Kurt Schwitters, "$\dot{W}$" (Ein Manifest), ibid., p. 120; "$\dot{W}$," ibid., pp. 137–41.

15. Kurt Schwitters, "$\dot{W}$-Gedicht," ibid., vol. 1, p. 206.

# Afterword

# Eventually Events—Some Unjudged Sentences

*Michael Erlhoff*

## Note

When a German-speaking person writes a text in English, he is aware of the poverty of his sentences and of his much more relaxed use of words and grammar. Nevertheless, avoiding a translation seems necessary because, sometimes, a foreigner is able to produce a strange concreteness in another language. Maybe his text is readable, if you take it literally.

### eyevent

Certainly the event, the subject of this publication, is one response by art to the loss of its former existential, auratic presence. We all know that this loss did not occur voluntarily but was due to changes in society and, quoting Walter Benjamin, to the new reality of "the age of technical reproducibility." If the former base of art's existential legitimacy was aura, the ensuing damage to this objective perspective kicked art into a deep schism; into a crisis of justification, of importance and of relevance. This crisis caused a breakdown of art's self-evident self-confidence and (analogously to the ideology of parliamentary democracy) probably raised both the idea of *representative* art, on the one hand, and an awareness of the fading possibility to be object, on the other. Undoubtedly this loss of aura (obviously a response to more conditions than just "the age of reproducibility") produced an enormous and visible incision within the history of the fine arts (for example, they started to be "fine"). This was because without the auratic circle, art no longer made sense, neither for the artists, nor for the potential audience, nor for art itself. *Id est,* while aura had been objective, *representation* offered a mediated factious existence; and indeed (and in experience) representation was a poor substitute for the loss of art's ability to be object. Art took on a "senseless" existence, although people got used to it and began—hopeless and full of hope—to ask the new art

the old, and only slightly changed, questions (at least the aim of those questions was the same). Because they did not experience aura, they now asked "what is the matter?" and they themselves gave the answers through projections of their own wishful thinking. Certainly, this was not a peaceful or convenient situation. More and more people considered art to be a handy good, and art fell to the position of being more or less illustrative material for whatsoever. Art lost its self.

Because of these conditions, it is quite understandable that art (and artists) began to revolt, to build up a new metaphysic of presence for art. Proceeding from this unfixable point, the discontinuous route of art can be described as a series of attempts to gain back its aura, or a concrete equivalent thereof. Even if we neglect the nineteenth century, we have to recognize Malevitch's *Black Square,* Mondrian's paintings, Klebnikov's and Krychenyk's *zaoum,* and the events and fights of the Dadaists as radical/deeply conservative (in the same sense that Benjamin's argument is conservative) attempts to adhere to aura or to get it back. With all their impressing, dominating, and distancing characteristics and their autonomous existence, these pieces of art became (as they were intended to become) the new icons. Their purity and irrational exactness reconstructed the auratic circle and turned art itself, and people's confrontation with art, into events. Through his experience of real revolution (and through his controversies with the much more didactic El Lissitzky and with the aesthetics of Productivism formulated by Rodchenko and others), Malevitch was forced to give his *Black Square* to the revolutionary public for free (for cups and plates, the walls of houses, etc.). It is evident that the *Black Square* was drawn for the event, *Victory over the Sun;* that all the Russian exhibitions of those post-revolutionary years were designed to be perceived as events; that Mondrian (who used music as a stimulus for his art) offered the mythologically positioned event of flat painting; that van Doesburg was directly involved in events and turned paintings to stand at their angles; and that Kassák praised the new arts as "events of electricity." Because, as Stephen C. Foster (quoting Webster) has stated, the "event" is perceived to be "raising from an antecedent state of things," art emphasized and exaggerated the character of (and tried to be like) events.

And what about Dada? Kurt Schwitters' assemblages and even his material drawings, for example, present events that are like certain fairy tales. You turn your back on the objects and they (their materials) begin to live and to move out of their ordinary order; you turn back again, rapidly, and the objects stop their movement and remain in their sometimes strange new order (see Hegel's *Phänomenologie des Geistes*). Pictures and sculptures become materialized results, or visible souvenirs of events. Schwitters' *Kathedrale des erotischen Elends* (sometimes called *Merzbau*) was such a synchronization of events, an ensemble of events, as event so impressive that it became a myth for all its visitors who were overwhelmed by their own phantasmagories. Perhaps these visitors felt that they were in a kind of movie in which all the images converge at one moment (or two or three). Perhaps "movie" is a recurrent indicator of all such produc-

tions and receptions (see the theoretical descriptions of Hirschfeld-Mack, for example); perhaps the "panoramas," which one could find in almost every small German town at the turn of the century, are even better examples of such reminiscences of auratic glamour.

The event inherited the auratic circle. Because it was an "eyevent" (German: *Ereignis* equals *Eräugnis*), it deeply stirred people through the distinguished glance of art, and it liberated art into a new "old" autonomy. It offered art a means by which to speak for itself through unknown and *unrepresentative* processes. That is, the event parallels the myth of Genesis; it is born ready, as an entity, as a genius' (or God's) stroke. With the end of real heroes (like "Emile" or "Wilhelm Meister"), art started its strange route back to the roots of originality, towards the very extreme and peculiar quality of objectiveness. At the same time, however, it was conscious that times had changed, and it was aware of the new realities of everyday life, of new techniques of reproducibility . . . (probably this contradiction provoked Benjamin's definition of Italian futuristic gestures as the "aestheticization of politics").

If the reader follows my admittedly hypothetical analysis, it becomes evident why the event was a substantial category for Dada, especially for Berlin Dada. Collage or assemblage can be looked at as demonstrations of events, or as results of events. Then there is the Dada event itself: sound poetry, *soirées* and *matinées*, Raoul Hausmann's dancings and Schwitters' barkings, Baader's actions and Zurich Dada's quarrels. All these events had (and continue to have) the extraordinary quality of being unique (in time and space). Combined with the fictive concreteness of any solvent space (church, Weimar, the Alps, show rooms . . . ) and fictional time (endless or momentary, too fast or too slow . . . ), the event provided a touch of aura to everything (as we learned from Duchamp, at least). It was the same for Lourdes, Tschenstochowa, Veronese, Michelangelo and the famous Dadas (only the media may have been different). Dada's aura was that of the newspapers and movies; nevertheless, it was as real as any of the others. It is, of course, through events that the performer also gets his aura, and that his actions become myths (this happened at John Cage's concerts, for instance, or at La Monte Young's butterfly concert).

**invent event**

Or, learning by acting. Because he did not want art to be drawn into didactic or surface psychological processes, Theodor W. Adorno pleaded for recordings and against live concerts. In this, he was different from Bertolt Brecht, or from the nineteenth-century tradition which established shows and genuine entertainment as a means toward the organization of experience. For example, Faraday had presented some of his experiments in the Parisian Pantheon, in a circus-like format (people had to buy tickets in order to participate); magicians like Houdini

explained the ideas and inventions of the beginning of the mechanical age (visitors could participate in his mathematical and physical experiments when they paid admission fees). Learning by participation or acting seems to have been an invention of the nineteenth century (culminating in Sigmund Freud's psychoanalysis) and became an existential and permanent dream of Western civilized mankind. The structure of Brecht's *Lehrstücke* was based on such concepts. The *Lehrstücke* was not written—as is so often maintained—to teach an audience, but rather to improve the actors. A situation (or "an antecedent state of things") is constructed, and the actors start to play. Moving within this structure, they begin to examine themselves, to improve, and to draw their inferences from their more or less defined experiences.

This tradition changed art into a didactic tool and concentrated it on the performer: when Schwitters did his *Merzbau* (which, in fact, was a private psychological digestion), or when Hausmann (whose personal problems are to be found in his correspondence with Hannah Höch) acted on the stage, or when Baader performed his pieces of emancipation. Nothing but the event (better than "happening") could offer such opportunities for art to be functional.

The event created a new kind of artistic form; art for artists' or performers' sake; i.e., a new kind of representative art that was not a substitute for something else, but which represented the artists' *actions as examples* which people should (or might) follow (for example, Friedrich Schiller shaking hands with Dada). It was this tradition that so radically influenced the Vienna Group of the late fifties and early sixties, the European students' movement of 1968 (to have been beaten by policemen seemed to be more realistic—as I remember—than to read books), and its perversions like all those (today fashionable) psycho-groups ("Gestalt," "psychodrama" . . . ), as well as the helpless belief in creativity (millions of self made ashtrays, videos, or self made men) and the success of those timeless "wild painters."

**evence**

"Event" is the propaganda of experience which transforms the category of "experience" into a reduced, one-dimensional form: that is, the intellectual (and probably also corporal) insight. The historical experience of diversifications, or the camouflage of objects (Karl Marx expressed this several times quite clearly in coalition with romantic literature) into exchangeable market goods, produced a false sense of liberation. One should not forget that it was the nineteenth century's announcement that a physical proof was suddenly possible without experiments and evidence (Helmholtz) that increasingly separated the human and natural sciences from each other. It appeared that *ratio* (reason) was dissociated from its ground, from perception, from sensations, and from the image of experience. Hands caught hold of second-hand material more and more often, and the reality of original material or of profound experience rushed away. At the same time, machines, trains,

and optical impressions became so fast, and acoustical novelties exploded so violently, that human sensuality was no longer capable of understanding these movements, sounds and realities. *Ratio* could construct theoretical sketches of objects, but not their empirical possibilities.

It was this severe dislocation that art tried to resist, in part through an increasing consciousness of artistic materials (from Manet to Matjustin and to Raoul Hausmann's photographs) or by phantastic overlays (from Mary Shelley to Scheerbart and others). Other intellectual domains pursued similar paths; Neo-Kantianism misunderstanding Kant (by neglecting his critical fundaments), Mach's or Ernst Marcus' sensualistic theories, the religious attitudes of Stirner or Monte Veritá, and, quasi-naturally, the position of the anarchists. All these (more or less) theories were new prophecies of an unheralded experience; or, in other words, of a new reality of human sense as the true reality. Not too far from Anglo-Saxon empiricism (but historically more sophisticated), they hatched the myth of empirical senses by escamoting the process of the genesis of experience, its ambivalences, and its contradictions. At the end of the nineteenth and the beginning of the twentieth centuries, it was common to consider phenomena as "true" instead of merely as "real" (which would have stressed the critique of experience as the beginning of empirical process and would have insisted—as Kant did—on the peaceless antagonism between subject, object, and system). An ideology (or utopia) asserting the possible identity of senses and reality, or of human being and nature, was extremely attractive for art and had an immense impact on the spreading of events. For, events seemed to guarantee the real experience, the moment of identities (time and space, human being and nature, actor and observer, art and life), and a glance at the experience of origins (or the infantile situation of omnopotentia). That is, for the actors as well as for the participants, events offer access to the auratic moment. Lie down on the sofa, have an event, and be a new person. . . .

**even event**

The avant-garde artists of the twentieth century had to learn, on the one hand, how to reconstruct their ability for artistic production and, on the other, to distrust any given structures or spontaneities. "Construction" seemed to be the magic formula, but it had to be legitimizable construction. The idea was born that situations could equal constructions, and could even be better because, although situations are similar to constructions, they are better able to evoke the unforeseen and unbelievable despite the fact that they are internally controlled (by the situation itself). Search out, or construct a situation, change it into a new situation through action (i.e., situate the situation), and you will have an event.

If you perceive society or reality to be a situation, or a series of situations, or a spectacle (like the movies do, or like the heirs of events, the Dadaists and the Situationists, did), this could be imagined, at the conceivable end of *ratio,* to

be a new prototype for acting and experiencing. Society becomes a massmediated thing, full of fictive new stories, pseudo-objects, robots, and images. Thus, every serious answer or reaction is, at best, a naive mistake. If the whole world is an event, you can only oppose it with events and by the consciousness of this oppositive action as event (by combining the latin etymology with Webster's, the wind is an event). The Situationists (Jorn, Debord, Vaneigen . . . ) explained this as an event, and the Dadaists felt it or knew about it.

## advent

On its backside: considering the world as an event diminishes reality to the status of hand luggage, or a tiny toy to be played with. Although this might be a reasonable perspective for certain psychological techniques seeking to establish staircases of self confidence, it is too simple and, in political terms, obviously dangerous (about fifty years ago Löwenthal and Guterman explained this in their analysis of fascist propaganda; Hollywood demonstrates it permanently: make all enemies—Jews, Blacks, communists, whatever you want—small like insects, and Rambo or somebody else will clean up his pretty home).

Turn round the telescope and all the obstacles are removed. Everything seems to become a question of image, strengthened by the mechanical transformation of history into convertible models. This is exactly what happened with the Dadaists reception of the Russian revolution: what was real in Moscow, Petersburgh or Kiev, was only an impressive event for the people of Berlin, Hannover, or Paris. What was near to the Russian artists, defined their experiences, changed their minds, offered new materials, and was concrete, could only be abstract to the outside observers—became just an artificial adoption or a dream (see, for example, Franz Jung's famous trip to Russia). In Russia, or at least in the Russian cities, the revolution and the revolutionary art forms entered reality through a mass movement (as Fülöp-Miller and many others have described), while in Germany, with but a few exceptions, revolution was *executed* by bureaucrats and only *dreamt of* by a few leftist workers and artists who looked at the Russian activities as if they were particular events which could be transformed into models for action (the Munich *Räterepublik* was as much affected by this vision, as were several street fights in Berlin, the foundation of KAPD and USPD, or dada activities). From a distance, revolutions always keep their romantic glamour or their imagined aura.

## event, even

To survive, romantic reason was forced to search for models, or shadows, of utopian image of virtual totality (models, events and even situations are basically romantic ideas of categories). Because this search was valid only so long as utopia and empirical reality were not confused and as long as the overwhelming, self-fulfilling

process of abstraction was resisted, it was extremely fragile. Whenever you look into a shop window at the exhibited and desired goods, or out through the window of your room at the existing and desired outside, de *facto* you always look through your own portrait reflected on the glass, between you and the goods or the outside. Similarly, the romantic view of society had to involve the perspective of subjects as the aims of a self-acting reality; the persecuted and divided individual is "regarded as arising from an antecedent state of things" (Webster, again). Most romantic novels or poems respond to the same problem: how to become free of the status quo. All these poetically described situations reveal helpless attempts to perform events of utopian freedom. The poets and artists behaved quasi-traditionally; to them the event appeared to be a bridge from the status of objects to that of subjects. Hölderlin acted toward this end (*Pallaksch*), as did the anarchists, Dada, and even Surrealism, maybe; each changed situations into more or less identical positions.

**evenio ergo sum**

Theodor W. Adorno, in explaining his *Negative Dialektik,* accused "the totality" of being the contrary of truth. Indeed, at present, the event is locked into and occupied by all kinds of stupidities: computer games, "wild painters," *Dallas.* . . . It has decayed into a conversation piece, a vulgar story of sex and crime, characteristics that were always latent in the event. Therefore, my conclusion (whatever this may be) is nothing other than that the event is a category central to our attempts to understand and to explain avant-garde art movements, but it is also as ambivalent and full of contradictions as is everything else. The event is not a solution (as the Fascists tried to enforce it, for example), but it can be the projection of a concrete utopia. Sometimes.

**Note 2**

I apologize, not only for the crude wavy line of my text (I had to walk this way to be serious) and for the German structure of many of my sentences, but also for such a long, yet fragmentary, journey through German intellectual history. It was essential to my intention that this text be read as a reflection from the inside to the outside. Very often I would prefer to be on the outside:

> "*Event*
> pulse start
> pulse stop"

<div align="right">(George Brecht).</div>

# Contributors

**Craig Adcock** is Professor of Art History at the University of Notre Dame and specializes in twentieth-century art. He has published essays about Dadaism and its influence, and several studies of Marcel Duchamp including a book in the Avant-Garde series of UMI Research Press, entitled *Marcel Duchamp's Notes from the Large Glass: An N-Dimensional Analysis* (1981). He is currently preparing a monograph on contemporary artist James Turrell.

**Roy F. Allen**, Associate Professor of German and Spanish at Wartburg College, Waverly, Iowa, has taught at universities in both the United States and West Germany. His past publications include *German Expressionist Poetry* (1979), *Literary Life in German Expressionism and the Berlin Circles* (1983), and "Zurich Dada, 1916–1919: The Proto-Phase of the Movement" (1985). Currently at work on a book-length study of the tradition of the avant-garde, he is also co-curating an exhibition entitled *The Avant-garde and the Text* and co-editing the catalog (*Visible Language*) of the same title. In keeping with his areas of concentration, Dr. Allen's interests move freely between the literary and fine arts.

**John E. Bowlt** is a specialist in the history of Russian art, particularly of the early twentieth century. He has published widely on the subject, has done extensive research in the Soviet Union, and has organized or co-organized many exhibitions dealing with the Russian avant-garde, Russian Symbolism, and Russian Realism. At present he is a Professor in the Department of Slavic Languages and Literatures, Department of Art, University of Texas at Austin. He is also Director of the Institute of Modern Russian Culture at Blue Lagoon.

**Michael Erlhoff** has served, since 1982, as editor for the *Kurt Schwitters Almanach.* He is author of numerous studies on early twentieth-century German art, including a critical edition of the writings of Raoul Hausmann (*Texte bis 1933*) and a monograph on the same artist (*Raoul Hausmann, Dadasoph*). Recent work has produced several publications on new design, the subject in which he is serving as curator for sections of "Documenta 8." Much of his time is committed to free-lance writing.

**Stephen C. Foster** is Professor of Art History at the University of Iowa where he has served, since 1979, as the Director of the Fine Arts Dada Archive. Concentrating on both the early twentieth century and mid-century arts, his publications include *The Critics of Abstract Expressionism, Dada Spectrum: The Dialectics of Revolt* (co-edited with Rudolf E. Kuenzli), and *Dada/Dimensions* (contributing editor) as well as the exhibition catalogs, *Dada Artifacts, Lettrisme: Into the Present* (contributing editor), and *The Avant-Garde and the Text* (co-curated and co-edited with Roy Allen and Estera Milman). Professor Foster is currently preparing a comprehensive Dada exhibition and catalog for the Taipei Fine Arts Museum.

**Diane Y. Ghirardo** received her Ph.D. in History and Humanities from Stanford University. She has just completed a book comparing New Deal and Fascist New Towns (Princeton, 1988), and has published in the *Art Bulletin,* the *Journal of the Society of Architectural Historians, Telos, Perspecta,* the *Harvard Architecture Review,* and *Modulus.* She has taught at Stanford University, Texas A & M University, and currently teaches the history and theory of architecture at the University of Southern California.

**Allan Greenberg**, Professor of Politics and History and Director of Registrarial Services at Curry College in Milton, Massachusetts, many years ago became trapped in a dadaswamp, and has since tried to be simultaneously serious and amused about the issues which he has found or imposed upon the Dadaists and their artistic-intellectual relatives: everyone who is willing to live with ambiguity and uncertainty, anguish, anxiety, and joy. While birding and bicycling he thinks about his efforts to develop a theoretical model for the analysis of responses by individuals and/or groups to domination, of a political, economic, social, or cultural nature.

**Friedhelm Lach** is Professor of Ancient and Modern Studies at the University of Montreal. His five-volume critical edition, *Kurt Schwitters, Das literarische Werk,* was published between 1973 and 1982. Professor Lach's interests range from Dada to semiotics and the avant-garde. Alongside his scholarly pursuits, he continues to work as a successful artist, editor, and performer. He is particularly well known for his public readings of Kurt Schwitters' texts and has derived many of his insights about Schwitters from such reconstruction performances.

**Steven Mansbach** is currently on leave from his position as art historian at the National Endowment for the Humanities in order to serve as acting Associate Dean of the Center for Advanced Study in the Visual Arts (CASVA) at the National Gallery of Art. Dr. Mansbach has published widely on the art and theory of the early twentieth-century European avant-gardes. At present he is preparing a large, interpretive exhibition on the Hungarian avant-garde, 1908–1930, which will begin an American tour in late 1989.

**Estera Milman** serves as Program Coordinator for the University of Iowa's newly established Avant-Garde Studies Program and as Director of the School of Art and Art History's Alternative Traditions in the Contemporary Arts. Centering her work on the relationship between the early twentieth-century avant-garde and popular culture, Milman's past publications range from "Dada New York: An Historiographic Analysis" (1985) to "The Media as Medium," with Stephen C. Foster (1985). She is currently co-curating an exhibition entitled *The Avant-garde and the Text* (1988), co-editing its catalog (a special issue of *Visible Language*), curating *Fluxus: A Gathering* (The University of Iowa Museum of Art, Spring 1988), coordinating *Lunapark,* an interactive teleconference linking artists in The Netherlands and Iowa City and, in collaboration with Stephen C. Foster, working on a new book entitled *Modern Heroes for the Postmodern Age.*

**Nicoletta Misler** has done extensive work on the history of twentieth-century Russian and East European art and art criticism, especially of the 1920s. She has spent long periods in Moscow and Leningrad researching her topic, and is presently working on the history of the Russian Academy of Artistic Sciences. The author of many books and articles, she has recently published an appreciation of Pavel Florensky, *Pavel Florenskij. La Prospettiva rovesciata* (1983) and, with John E. Bowlt, co-authored a monograph on the painter Pavel Filonov, *Pavel Filonov: A Hero and His Fate* (1984). She is a professor at the Istituto Universitario Orientale, Naples, Italy.

**Rainer Rumold**, Associate Professor of German and Humanities, Northwestern University, has written extensively on the history and theory of modernism, the literary avant-garde, and more recently on interart cultural issues (George Grosz, Carl Einstein) from Expressionism to exile. His major publications, besides articles on Nietzsche, Carl Sternheim, Heinrich Mann, Brecht, and East German poetry, include *Gottfried Benn und der Expressionismus* (1982) and *Sprächliches Experiment und Literarische Traditon* (1975). A major study in progress (in English) focuses on the crisis of the intellectual and artist from 1910 to 1986.

**Dana Tiffany** is currently Instructor of Humanities in the Cultural Arts Department at Daytona Beach Community College. Earning his Ph.D. in modern European history at the University of California at San Diego in 1984, he has since served as Visiting Assistant Professor in the Revelle College Humanities/Writing Program at UCSD, and as Assistant Professor of History at the University of Nevada, Las Vegas. Dr. Tiffany has recently begun a large research collaboration directed toward the book publication of a comprehensive analysis of the avant-garde. He is currently working as dramaturge for *La Lettre de Cachet,* a new play by Kenneth Walker, on the forced marriage of the Marquis de Sade in 1763.

**Harriett Watts**, scholar and translator, has held teaching posts at a number of American and European institutions. She has also served as translator-in-residence, National Translation Center, has published numerous translations of scholarly works and poetry, and has prepared a number of musical translations for performance. Her scholarly publications include *Three Painter-Poets: Arp/Schwitters/Klee* (1974), *Chance: A Perspective on Dada* (1980), and ''Periods and Commas: Hans Arp's Seminal Punctuation'' (1985). She is currently completing her newest book, *Hans Arp and Seminal Form,* and, as the recipient of an Alexander von Humboldt Research Grant, is living and travelling in Europe, keeping as close to the sea as her work permits.

**Hellmut Wohl** is Professor of Art History at Boston University. He received his Ph.D. from the Institute of Fine Arts of New York University. In 1978 he directed and wrote the catalogue for the exhibition *Portuguese Art since 1910* at the Royal Academy of Arts in London. The author of several studies on Marcel Duchamp, Professor Wohl also organized and wrote the catalogue essay for the exhibition *Dada: Berlin, Cologne, Hannover* at the Institute of Contemporary Art in Boston (1980). Besides his work in the twentieth century, he has published a monograph on the Italian fifteenth-century painter Domenico Veneziano and is currently at work on a book on the Ornate Style in the Italian Renaissance.

# Index

A *Capital*, 78–79
Adolescence: concept of, 151–52; Hall on, 151; liminality of, and reaggregation, 153
Adorno, Theodor W., 285; *Negative Dialektik*, 289
*A Idea Nacional*, 73
Aizenberg, Nina, 102
Akhmatova, Anna, 96
*Aktion, Die*, 42, 67
Altman, Natan, 97; *Towards the World Commune*, 99
Annenkov, Yurii: *The Cellar of the Stray Dog* (1913), 96; *The Storming of the Winter Palace*, 99, 100
*Apokolypse, Umbrisch, etwa 1490*, 23
Architecture, 32
—Fascist, in Italy: balcony and, 181, 186; Canetti on, 196, 198; party headquarters, 190, *191, 192;* public events and, 176, 178–80; tower in, 186–87, *188, 189;* town hall in, 186–87; tradition and, 176, 180; triumphal arches, 176, *178,* 179; urban, power and, 181, *183, 184, 185,* 186–89
—modern: in Germany, and revolution, 181; in Holland, and revolution, 181
Arp, Hans, 64, 125, 128; and Kandinsky, 128; "Kandinsky the Poet," 129; Schwitters and, 276
Art: as process and event, 107–8; crisis of, 25–26; cultural function of, 19–21; goal of, A. Hauser on, 109–10; loss of auratic presence, event as response to, 283–86; Nietzsche on, 26; political-historical context, 14–15, "Sturm"-Kreis theory of, 11; totality of, and critical analysis, 61–62; value of, as communication, 107–8
Art, African, 14
Art movements, rediscovery of past and, 77–78
Art nouveau, 32
Artaud, Antonin, 142

Arts, decorative, 32
Aseev, Nikolai, 102
*A TETT* (The Deed), 42, 49
Atget, Eugene, 196
*Atlantic Monthly*, 206
Audience: cabaret, and event, 107–8; confrontation of, and event, 3; event, and perception of, 3–4; of theater and perspectival proscenium, Florensky on, 159
Avant-garde
—and event: artistic response to, 9; as rationale for, 4; historical concept of, 7
—and politics, identification with, 4
—as adolescent, 135, 142, 153, 157
—crisis in, 21
—disillusionment of, political and, 11
—Hungarian, revolutions and heroic response to, 31
—photomontage and, 203, 222
—political-historical context of, 11
—revisionism, social, and, 4–6
—revolutionary claims, 11
—Symbolist, Jarry and, 135
—term, 4

Baader, Johannes, 8, 67, 223–25, 285–86; and Dada Republic, 8–9; *The Author at Home* (ca. 1920), 230, *232;* "The Green Corpse," 9; Grosse Dio-Dada Drama (1920), 230
Baargeld, Johannes, *Self-Portrait* (1920), 226
Baia Mare, Rumania (formerly, Nagybánya, Hungary), 31
*Balagan:* and Russian cabaret, 89–90; Meierkhold on, 90, 92; tradition, and Blue Blouse Theater, 102
Ball, Hugo, 64, *120,* 128; and Dadaism, 64–67; and Kandinsky, 128; Dada manifesto of, 124; "Karawane," 68, 119, 121; on sound poetry, Dada and, 129–30; sound poems of, 121, 123–24, 126, 129
Barrès, Maurice, 67